Critical Acclaim for *Portrait of Dr. Gachet*

"Ms. Saltzman has succeeded in giving us an understanding of van Gogh's ascendant reputation, the shifting fortunes of modernist art and the headlong expansion of the art market. . . . A unique and fascinating biography: the biography of a painting."
—Michiko Kakutani, *The New York Times*

"A brilliant idea for a book, executed wondrously. . . . Vivid art history. Saltzman offers an incisive survey of the previous century's intellectual and economic cycles, as well as a savvy analysis of the art world and its politicking. . . . Marvelous."
—Gerald Walker, *The Washington Post Book World*

"As Saltzman spins tales of the painting's travels and encounters, one glimpses a rich cross-section of lives deeply touched by the love of modern art, the debasing power of greed and the psychological toll of war. . . . Lively, well-researched . . . A passionate and detailed history."
—*The New York Times Book Review*

"This is a rare and wonderful achievement—a scholarly thriller. With intellectual rigor and literary tact, with grace and tension, Cynthia Saltzman traces the fate of van Gogh's famous last portrait. . . . Fascinating . . . Illuminating . . . Breathlessly suspenseful."
—*The Boston Globe*

"An extraordinary—at times almost incredible—tale. . . . Cynthia Saltzman tells the story vividly [and] concentrates, with equally fascinating results, on the haunting picture itself . . . recalls most impressively the entire van Gogh saga and illuminates brilliantly many of the curious events that have changed the nature of the art world over the last one hund
—*Parade*

"Meticulously researched. . . . Gripping real-life drama. . . . An illuminating case study of provenance."
—*Publishers Weekly*

"Saltzman has taken the provenance of van Gogh's *Portrait of Dr. Gachet* and fleshed it out with thick biographical detail. . . . An engrossing project from which even art specialists will learn."
—*San Francisco Chronicle*

"What a good idea for a book this is! Cynthia Saltzman has shrewdly set out to trace the principal themes of the modern age by recording the movements and the vicissitudes of a painting . . . Inspired . . . [an] amazing story . . . I read it with much pleasure."
—Eugene Thaw, *The New Republic*

"A fascinating case . . . [that] moves briskly along at the pace of a spy thriller."
—*The Philadelphia Inquirer*

"Ms. Saltzman has managed to keep this complex narrative fixed at a human level . . . [and] to synthesize years of research into a page-turner of a history, an achievement that few historians ever realize. Would that Vincent van Gogh, who sold only one (minor) canvas during his lifetime, were here to read it."
—*Richmond Times-Dispatch*

"Fascinating . . . a savvy combination of financial reporting, artistic sensitivity and hard-nosed scholarship: in short, the perfect approach to art history in our time."
—*Cleveland Plain Dealer*

"An astonishing journey. . . . The history of the Gachet portrait is as colorful as that of the Maltese Falcon."
—*Raleigh News & Observer*

PENGUIN BOOKS

PORTRAIT OF DR. GACHET

Cynthia Saltzman has degrees in art history from Harvard and the University of California, Berkeley, and an M.B.A. from Stanford. A former reporter for *Forbes* and *The Wall Street Journal,* she lives in New York.

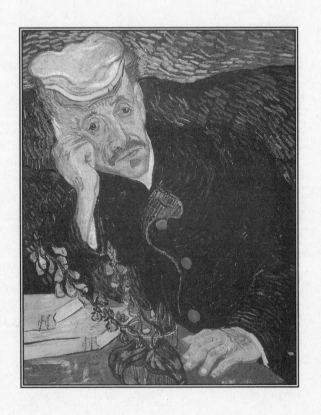

CYNTHIA SALTZMAN

Portrait of Dr. Gachet

THE STORY OF

A VAN GOGH

MASTERPIECE

Money, Politics,

Collectors,

Greed, and Loss

PENGUIN BOOKS

PENGUIN BOOKS

Published by the Penguin Group
Penguin Putnam Inc., 375 Hudson Street,
New York, New York 10014, U.S.A.
Penguin Books Ltd, 27 Wrights Lane,
London W8 5TZ, England
Penguin Books Australia Ltd, Ringwood,
Victoria, Australia
Penguin Books Canada Ltd, 10 Alcorn Avenue, Toronto,
Ontario, Canada M4V 3B2
Penguin Books (N.Z.) Ltd, 182–190 Wairau Road,
Auckland 10, New Zealand

Penguin Books Ltd, Registered Offices:
Harmondsworth, Middlesex, England

First published in the United States of America by Viking Penguin,
a member of Penguin Putnam Inc. 1998
Published in Penguin Books 1999

1 3 5 7 9 10 8 6 4 2

THE LIBRARY OF CONGRESS HAS CATALOGUED THE HARDCOVER AS FOLLOWS:
Saltzman, Cynthia.
Portrait of Dr. Gachet : the story of a van Gogh masterpiece / Cynthia Saltzman.
p. cm.
Includes bibliographical references and index.
ISBN 0-670-86223-1 (hc.)
ISBN 0 14 02.5487 0 (pbk.)
1. Gogh, Vincent van, 1853–1890. Dr. Gachet. 2. Gachet, Paul-Ferdinand, 1828–1909—
Portraits. 3. Gogh, Vincent van, 1853–1890—Criticism and interpretation. I. Title.
ND1329.G568A64 1998
759.9492—dc21 97–37006

Printed in the United States of America
Set in Adobe Garamond
Designed by Francesca Belanger

For Warren, Matthew, and William
and to the memory of my mother
(1921–1996)

ACKNOWLEDGMENTS

THE MAGNANIMITY of many people who answered countless questions, found documents, and gave advice has left me deeply in their debt. Marianne Feilchenfeldt responded to a telephone call out of the blue with her recollections of the *Gachet* portrait and of Amsterdam in the 1930s and continued the dialogue for several years, sometimes in her kitchen in Zurich. At the Städel in Frankfurt, Margret Stuffmann offered encouragement and ideas, sent catalogs, and introduced me to the late Hermann J. Abs. Also at the Städel, Martin Sonnabend directed me to critical archival material, and replied to years of inquiries on Georg Swarzenski and others. At the Institute for Advanced Study in Princeton, Peter Paret shared his formidable knowledge of German history, in particular of Paul Cassirer and the Berlin Secession. In interviews on both sides of the Atlantic, Walter Feilchenfeldt unstintingly dispensed information and allowed me access to the Cassirer gallery archives. And from Mannheim and Zurich, Roland Dorn fielded a running transatlantic interrogation on van Gogh, and read the manuscript.

For giving so generously of their expertise to improve parts of the manuscript I am tremendously grateful to Paul Blustein, Laird Easton, Colin Eisler, James Grant, and especially to Emily Kernan Rafferty, Bogomila Welsh-Ovcharov, and Jonathan Petropoulos, who also directed me to documents in Berlin archives. Particular thanks go to members of the Kramarsky family. Bernard Kramarsky, Sonja Kramarsky, and Wynn Kramarsky courteously shared recollections of their parents; Susan Kramarsky evoked her grandmother in her later life.

A number of others, including Beatrice von Bismarck, Timothy W. Guinnane, and Markus Kersting, contributed significantly to the research. At Christie's, Christopher Burge repeatedly found time in his jammed schedule to discuss the art market, past and present. Susan Alyson Stein gave me a file of van Gogh clippings. Lynn Nicholas sent me a crucial document. Andrew McClellan supplied information on art dealing in eighteenth-century France. Wolfgang Swarzenski alerted me to Oswald Goetz's memoir. From Tokyo, Kay Itoi advised on reporting in Japan. In Auvers, Lucien Vandenbroucke took me through Gachet's house. At the Vincent van Gogh Foundation in Amsterdam, Han Veenenboss showed me Ambroise Vollard's letters. Research on the art market depended upon the observations of knowledgeable participants: Daniel Barr, Ernst Beyeler, Richard Feigan, Thomas Gibson, Hugh Hildesley, Jeffrey Hoffeld, Sandra Kasper, David Nash, Ikkan Sanada, Eric Stiebel, Gerald Stiebel, Eugene V. Thaw, David Tunick, and particularly Michael Findlay. I am also indebted to Louis van Tilborgh in the Netherlands, as well as to Franje van der Waals (who drove me to see her mother), Christine van der Waals–Koenigs, Christine Koenigs, and W. O. Koenigs, A. W. F. M. Meij, Manfred Sellink, and Ester Wouthuysen; in Copenhagen to Birgitte Johannesson (for her extensive research), Thor A. Bak, and particularly Jan Bredholt (whose introduction to the late Bernt Hjejle led to the discovery of the painting's first owner); in Frankfurt to Herbert Beck, director of the Städelsches Kunstinstitut und Städtische Galerie, Heike Drummer, Andreas Hansert, Michael Lenarz, Konrad Schneider, Johannes Wachten, and Hans-Joachim Ziemke. In Frankfurt, Richard Kahn and Lois and Mark Wingerson kindly let me stay with them.

Others for whose help I am grateful are Susan Adams, Arthur Altschul, Doris Ammann, Stephanie Barron, William Baumol, Carolyn Boyle-Turner, Miriam Budner, Betty Buvelot, Sharon Cott, Han van Crimpen, Steven Diamond, Anne Distel, Benita Eisler, James Fallows, Hanne Finsen, Yoshiko Fukushima, Tony Geyelin, George Goldner, Peter Greenberg, Anne Gruson, Gisela Helmkampf, Sachiko Hibiya, Daniel Hinckley, Ay-Whang Hsia, Dominique Janssens, Hideto Kobayashi, Samuel Josefowitz, Stephen Lash, Fritz Metzinger,

Holger Möhlmann, Kasper Monrad, Toshihiro Nakayama, Richard Oldenburg, Martha Op de Coul, Margot Pehle, Ian Penna, Anne Poulet, Isabel and Laurance Roberts, Elaine Rosenberg, Mark Roskill, William Rubin, Bente Scavenius, Frank Schramm, Abigail Smith, John Tancock, Gary Tinterow, Litschan Volhard, Will Washburn, Heyden White, Barry Wigmore, Michael Wivel, Susan Woodland, and Yolanda Vogelzang.

My thanks go also to the staff of the following libraries and archives: the Boijmans Van Beuningen Museum Archives, Rotterdam; the Deutsches Literaturarchiv, Marbach am Neckar; the Geheimes Staatsarchiv Preussischer Kulturbesitz, Berlin; the Fine Arts Library, Harvard University; the Frick Art Reference Library; the Harvard University Art Museum Archives; the Hirschsprung Collection, Copenhagen; the Institut für Stadtgeschichte, Frankfurt; the Metropolitan Museum of Art Archives and the Thomas J. Watson Reference Library; the Museum of Modern Art Department of Registration and library; the National Archives, Washington, D.C.; the New York Society Library; the Royal Library, Copenhagen; the Van Gogh Museum, and the Vincent van Gogh Foundation, Amsterdam.

Above all, I thank Melanie Jackson, for her candor, wit, efficiency, and long-standing support as the best of literary agents; and, at Viking, Carolyn Carlson, whose excellent and steadfast editing contributed immeasurably to the structure of the book. Also at Viking, Francesca Belanger created the book's splendid design, Gail Belenson its striking jacket. Alex Gigante advised on legal and historical issues. Miranda Ottewell copyedited the manuscript and Kate Griggs guided it through production. From the start, Barbara Grossman championed the book with her characteristic enthusiasm; at every turn, she has been the ideal editor.

Among the friends whose counsel and spirits encouraged me in this project were Lyn and Ned Chase, Richard and Carolyn Culliton, Kate Ecker, Linda Feldman, Suzanne Freeman, Joan and Fred Gardiner, Laura Mayer, Susan Restler, Gail Winston, Charlotte Winton, and particularly Jonathan and Susan Galassi. In countless ways, members of my family, especially Penelope Saltzman, contributed. Katherine Hinckley corrected and expanded the French translations

and Elisabeth Motley did crucial work on the notes. An incalculable debt I owe to my sons Matthew and William Motley for their sustained good humor about the process of writing a book and to Warren Motley for making it possible.

October 20, 1997

CONTENTS

Photographs follow page 216.

Even the most perfect reproduction of a work of art is lacking in one element: its presence in time and space, its unique existence at the place where it happens to be. This unique existence of the work of art determined the history to which it was subject throughout the time of its existence. This includes the changes which it may have suffered in physical condition over the years as well as the various changes in its ownership. —Walter Benjamin,
"The Work of Art in the Age of Mechanical Reproduction," 1936

Portrait of Dr. Gachet
oil on canvas
26 × 22$^1/_2$ inches (66 × 57 cm)

PROVENANCE
1890 **Theo van Gogh** (1857–1891) Paris
1891 **Johanna van Gogh–Bonger** (1862–1925) Amsterdam
1897 **Ambroise Vollard** (1866–1938) Paris
1897 **Alice Ruben Faber** (1866–1939) Copenhagen
 Mogens Ballin (1871–1914) Copenhagen
1904 **Paul Cassirer** (1871–1926) Berlin
1904 **Harry Graf Kessler** (1868–1937) Weimar
1910 **Galerie Eugène Druet** (1868–1916) Paris
1911 **Städelsches Kunstinstitut und Städtische Galerie** Frankfurt, acquired by the director **Georg Swarzenski** (1876–1957) as a gift of Victor Mössinger
1937 **Reich Ministry for Public Enlightenment and Propaganda** Berlin (Confiscated, December 1937)
1938 **Hermann Göring** (1893–1946) Berlin
1938 **Franz Koenigs** (1881–1941) Amsterdam
1938 **Siegfried Kramarsky** (1893–1961) Amsterdam, New York Trust under the will of Siegfried Kramarsky
1990 **Ryoei Saito** (1920–1996) Tokyo

THE CANVAS

Elongated and spectral, the figure of an older man is seated at a table, painted red. He leans far to the left. His narrow head is propped upon a skeletal fist; his other hand lies, its fingers slightly spread, open on the table's edge. He is wearing a cream-colored cap and a dark blue jacket. More accurately, this jacket composes his torso, which is less three-dimensional substance than paint. Spread over almost half the canvas, the jacket's blue is the midnight of northern waters. Its turbulent surface of paint suggests the chop of the sea and the infinite, and also the glimmer of medieval stained-glass windows. Strokes of ocher and lime green model the contours of the man's narrow face. His fine features emerge from a network of thread-thin strokes of pigment darting across his forehead and his temples. He stares directly at us, his eyebrows arched, his gaze penetrating and sad.

In the foreground, two green flowering stalks rise from a water glass and veer off to the left like the figure behind them. Lying on the table, behind the flowers, are two yellow books, drawn with horizontal strokes of saturated lemon. On their spines the titles *Manette Salomon* and *Germinie Lacerteux* have been freely brushed in black.

The background echoes the color of the jacket, but in paler blues. The painter has left it vague—emptied of objects or perspective space. Close to the top of the canvas runs a horizontal line that seems to define a mountain ridge whose contour follows the silhouette of the man's shoulder and his sleeve. These mountains form a

broad strip of cobalt blue, a shade lighter than the coat but darker than the cerulean band that is the sky.

Nothing immediately signifies this man's profession or social class. Together the cap (which has the ghostly pallor of the face) and plain navy jacket might be a uniform or the costume of a public servant. Still, these garments give no exact sense of whether their wearer is a member of the bourgeoisie, a laborer, or a peasant. Similarly, the artist declines to document the particulars of light, atmosphere, or time of day. Neither has he worked the paint to differentiate between the textures of flesh, cloth, paper, glass, or flower petals. Still, he has painted his subject at a disarmingly close range, so that the figure barely fits into the canvas: his sleeves, the edges of the table, the books, and the water glass are all cut off by the frame. From the rapid, visible brush strokes and the briefly noted essentials of orange hair and green buttons comes the sense that the picture was painted quickly: a sketch made from life, a record of a visceral struggle to set down the facts of a live encounter.

Anchored at the table, the tilted man sits absolutely still. Yet nothing in the painting is at rest. The steep leftward angle of his body is countered by the sleeve and the hand in the lower right and also by the line of background hills climbing upward. A diagonal runs up the center of his blue coat, along the buttons, and sweeps through its lapel in a curve whose serpentine shape resembles the contour of a wave in a Japanese print, an arc of blue, frozen as it crests. Everything is freely drawn as though the artist was sketching with a paintbrush, informing each shape with the tormented spirit of his restive painted lines. Dark, flowing contours outline the large shapes. The sorrowing expression of the face is echoed in patterns of brush strokes that flow through the sea-colored jacket and the background. All the elements of the canvas—the man, the ink-toned coat, the empty background—submit to the extraordinary unifying architecture of oil paint.

The focus of the portrait—the dots of blue that are the sitter's eyes—is off center. His stark and skeptical gaze, directed once at the artist, and now at us, is one of both pain and recognition.

PROLOGUE

Sacred and Profane

Paintings are among other things fossils of economic life.
—Michael Baxandall

THE STORY OF *Portrait of Dr. Gachet* begins in May 1890, in a French village twenty-odd miles northwest of Paris. The subject of Vincent van Gogh's portrait is a sixty-one-year-old physician, Paul-Ferdinand Gachet. Only weeks before van Gogh painted the portrait, he had left the asylum of Saint-Paul-de-Mausole in the south of France and moved to the ancient walled town of Auvers-sur-Oise, seeking treatment for an inexplicable, intermittent illness diagnosed at the asylum as epilepsy. Gachet lived in Auvers and maintained a general practice in Paris. The artist began his study of the doctor on June 3 and completed the portrait in two to three days—a speed that belied the complex character of the canvas. Van Gogh worked out of doors, in an overgrown garden that partially encircled the doctor's house; he seated his subject at a garden table, his head resting on his hand, in the traditional pose of melancholy.

No more than a brief train ride from Paris, Auvers nonetheless boasted few citizens other than the doctor with whom the artist could discuss his painting. Relentlessly analytic about his art, van Gogh was the first to comment on the canvas. Immediately on finishing the picture, he described it in a letter to his brother Theo, an art dealer, hoping probably to persuade him of its significance (by

nature, a portrait is more difficult to sell than a landscape or a flower painting): "I am working at his portrait, the head with a white cap, very fair, very light, the hands also a light flesh tint, a blue frock coat and a cobalt blue background, leaning on a red table, on which are a yellow book and a foxglove plant with purple flowers. It has the same sentiment as the self-portrait I did when I left for this place." Later, in a letter to the artist Paul Gauguin (found among van Gogh's papers after his death), the artist explained the portrait's intent. "I have a portrait of Dr. Gachet," he wrote, "with the heart-broken expression of our time."

The climax of *Dr. Gachet*'s story takes place exactly one hundred years later, on May 15, 1990. On this balmy spring evening, in a windowless auction room at Christie's one floor above the hum of Manhattan's traffic, the painting by Vincent van Gogh, lot 21, was

Vincent van Gogh drew a sketch of *Portrait of Dr. Gachet* in a letter to his brother, Theo, in June 1890.

sold for $82.5 million, the highest price ever paid at auction for a work of art. This sum, reached in the course of five minutes of bidding, broke by $28 million the record set three years before by another van Gogh, *Irises*. Later the same week the painting's new owner, Ryoei Saito, a Japanese paper magnate, sent his agent to Sotheby's Impressionist sale, where he spent $78 million on Pierre-Auguste Renoir's *Au Moulin de la Galette*.

The auction of *Dr. Gachet* in the spring of 1990 marked the heyday of a great art-market boom. Speculators, many from Japan, had inflated the prices of Impressionist and Postimpressionist paintings, particularly those of the nineteenth-century Dutch artist, to unprecedented levels. That night, suspended momentarily at the front of a room jammed with art dealers from America, Europe, and Japan, the gold-framed portrait held up a mirror to the economic life of the 1980s, an era of high-flying stock markets, sudden wealth on a vast scale, and financial empires founded on debt. The portrait had been one of several Postimpressionist pictures owned by Siegfried Kramarsky, a German-Jewish banker who had emigrated to the United States in 1941. Off and on for five decades and then for most of the six years before it went on the block, the canvas had been exhibited in the galleries of the Metropolitan Museum of Art. It was one of many great paintings shipped to auction in the 1980s, lured to the market by the inflated prices and by the Reagan administration's 1986 tax code, which suddenly removed the incentives for American collectors to give their art to the nation's museums. *Gachet*'s sale—at a price far beyond the means of every American museum, with the possible exception of the J. Paul Getty museum in Malibu, California—was interpreted as a portent of Japan's fiscal might and the economic and cultural decline of the West.

Although well known to art historians, *Gachet* was not as familiar to the public as some other works by van Gogh—*Starry Night, Sunflowers, Van Gogh's Bedroom*, or *Self-Portrait with Bandaged Ear*. But as news of the auction sped around the globe by television broadcast, the painting became immediately renowned for its multimillion-dollar price tag. This notorious figure—shot skyward

by Japan's bubble economy—eclipsed for the moment the painting's meaning as an image, and the hundred-year history through which it had evolved into a record-breaking commodity.

Why this painting? Not preordained, *Gachet*'s record price resulted from a confluence of decisions and circumstances, some related solely to the particular economic situation in the spring of 1990 and to the ambitions and means of several tycoons who learned of the auction and placed their bids. But to a large degree the phenomenal market value of *Gachet* was bound up with its identity and its history as a celebrated work of art, its greatness ratified by a long-evolving consensus of artists, critics, dealers, collectors, and more recently, art historians. These connoisseurs and experts recognized the picture's aesthetic impact, its significance in the history of Western art, the ways it realized van Gogh's artistic aims and broke artistic ground. *Dr. Gachet* had held people in its thrall with its strange beauty and its appeal to the life of the mind. As a record of the human spirit and also a commodity, it possessed both sacred and profane aspects, seemingly at odds but inextricably and complexly linked—aspects not lost on its creator, perhaps the most spiritually driven of late-nineteenth-century artists, but also one who had worked for Europe's leading gallery for more than six years before devoting himself to painting.

The evolution of *Portrait of Dr. Gachet* into a modernist icon and art-market record had much to do as well with its origins in late-nineteenth-century France. While *Gachet* followed a singular path, its fate in the art market was emblematic of that of Impressionist and Postimpressionist paintings still remaining in private hands until the end of the twentieth century. By then most modern pictures of its caliber had found their way, either by gift or purchase, into museum collections, where their movement was confined to occasional shifts between galleries and the rare trip, often abroad, to other museums. Although an extreme case, the van Gogh portrait was one of many privately held modern paintings whose prices soared. These canvases shared similar backgrounds. They were created by the Impressionists—Edouard Manet, Claude Monet, Edgar Degas, Camille Pissarro—and the Postimpressionists—Paul

Cézanne, Paul Gauguin, Georges Seurat, and van Gogh—in the last three decades of the nineteenth century, or by iconoclasts like Henri Matisse or Pablo Picasso whose explosive entrances onto the Paris art scene took place before World War I. These artists relied upon the patronage of entrepreneurial art dealers such as Paul Durand-Ruel and Ambroise Vollard, whose commercial skills helped shape their success and fame.

This book will tell the story of *Portrait of Dr. Gachet*'s journey from a garden in a small French village to a warehouse outside Tokyo. It is a story of modernist art, economics, politics, and collectors; of dealers, taste, corruption, greed, and loss. First, it is the story of the extraordinary and melancholy painting itself. Created only weeks before the artist's suicide, *Gachet* was his last major portrait. It is also the story of the portrait's thirteen owners, the individuals through whose hands it passed: two affluent avant-garde artists, three dealers, a German collector, a museum director, a member of the Nazi elite, an Amsterdam banker, and a Jewish exile. Lastly, it is the story of the legend of van Gogh—invented almost immediately after his death—of the critical views of his work over time, and of the dramatic expansion of the market for modern art, a market that evolved with the rise of the upper middle classes and, simultaneously, of avant-garde painting.

Money spent on *Gachet* meant various things to the men and women who spent it. For some the painting was an object of passion, an ideal, a symbol of reform and revolution; for others, a product requiring promotion and, more recently, an emblem of national wealth and conventional material success. Over the course of one hundred years the canvas traveled from Paris to Amsterdam, Copenhagen, Berlin, Weimar, Paris, Frankfurt, Amsterdam, New York, and Tokyo. *Gachet*'s buyers acquired the painting for complicated reasons that reflected much about themselves and about the intellectual, spiritual, and even political preoccupations of the times. In some cases the purchase of the painting involved the pursuit of pleasure, coexisting often before World War I with cultural ambitions and on the eve of World War II with the demand for a portable asset.

On the night of its 1990 auction, however, as a turntable swung the canvas into view, no one thought about the painting's history, particularly the dark stretches when Hermann Göring exploited it to fund his appetite for expensive tapestries. On completing the picture, van Gogh expressed his hope that after a century the portrait would seem to viewers to be an "apparition." But could he have imagined that the portrait's ghostly quality would proceed from its momentary apparition on an auction stage, where it came and went like a flash of light?

Prices Paid for van Gogh's
Portrait of Dr. Gachet,
1897–1990

	PURCHASER	PRICE		EQUIVALENT IN U.S. DOLLARS	EQUIVALENT IN 1995 U.S. DOLLARS
1897	Ruben	300	French francs	$58	$1,056
1904	Cassirer[1]	1,238	marks	$293	$4,945
1904	Kessler[1]	1,689	marks	$399	$6,744
1910	Druet[2]	14,000	French francs	$2,703	$44,015
1911	Städtische Galerie, Frankfurt	20,000	French francs	$3,861	$62,879
1938	Koenigs[3]	4,000	pounds sterling	$20,000	$216,114
		266,400	sperrmarks	$33,300	$359,829
				$53,300	$575,943
1990	Saito	82,500,000	U.S. dollars	$82,500,000	$96,197,398

1. *Gachet* was sold with Maurice Denis's *Maternité à la Pomme*. This assumes *Gachet* accounted for half the sum paid for both pictures.
2. *Gachet* was sold with Paul Gauguin's *Manao tupapau*. This assumes *Gachet* accounted for half the 28,000 francs paid for both pictures.
3. *Gachet* was sold with van Gogh's *Daubigny's Garden* and Cézanne's *Bibémus Quarry*. This assumes *Gachet* accounted for one-third the sum (12,000 pounds and 800,000 reichsmarks, payable in sperrmarks or blocked marks) paid for the three pictures.

"THE HEARTBROKEN EXPRESSION OF OUR TIME"

1

Van Gogh:
Dealer, Preacher, and Painter,
1853–1886

To show the peasant figure in action, *that—I repeat—is what an essentially modern figure painting really does, it is the very essence of modern art, something neither the Greeks nor the Renaissance nor the old Dutch school have done.*
—Vincent van Gogh to Theo van Gogh, July 1885

VINCENT VAN GOGH arrived in Auvers-sur-Oise on May 20, 1890, hoping to find subjects for his pictures and a resolution to the physical and psychological problems that plagued him. Auvers was "set against a long ridge of rocks eaten into by stone quarries," and stretched along the Oise river. "Auvers is very beautiful," van Gogh wrote his brother Theo. "Among other things a lot of old thatched roofs, which are getting rare. . . . It is real country, characteristic and picturesque." Thirty years earlier, Charles-François Daubigny, a Barbizon painter whom van Gogh admired, had built a house in Auvers and lived there until his death in 1878. While the artist was optimistic that the doctor Paul-Ferdinand Gachet would diagnose his baffling illness, the landscape of Auvers promised to provide material for the ambitious painting program he was determined to pursue.

Van Gogh was thirty-seven. Whether the stay in his wearing illness was temporary, he could not tell, but he had reached a decisive point in his life as a painter. Although he had worked as an artist for only ten years, he had produced over six hundred canvases and

almost as many drawings, and recently he had begun to gain recognition for his art. Within the last year his paintings had appeared in exhibitions not only in Paris but in Brussels, and his work had won critical acclaim. Four months before, in a lengthy piece in the first issue of *Mercure de France*, the symbolist poet Georges-Albert Aurier had hailed him a "great painter" and a "not unworthy descendant of the old masters of Holland."

In the embryonic but expanding market for avant-garde art, van Gogh was exceptionally well positioned. First, his brother Theo was an art dealer who supported him with a steady income. The van Gogh brothers had been born into a family well connected in the art trade; three of their uncles were successful dealers whose galleries in Amsterdam, Rotterdam, and the Hague gave them vast influence in the Dutch art market. Through one of these uncles, the painter had been apprenticed at Goupil & Cie, a major international Paris gallery. Van Gogh had quit the gallery in 1876, but Theo, also an employee of Goupil's, had worked his way up to become manager of its Montmartre branch. There he handled the controversial art of the Impressionists. Although van Gogh had sold but one painting, a decade amounted to little time for an artist to establish himself, and he had as his patron and brother one of the most important avant-garde art dealers in Paris.

Six years' experience at Goupil's gave van Gogh a relatively sophisticated, sometimes jaded understanding of the art market, a topic frequently discussed in his letters. "Fortunately, it is very easy to sell nice polite pictures in a nice polite place to a nice polite gentleman, now that the great Albert [Goupil] has given us the recipe," he told Theo in June 1888. "Nothing," he rightly argued, "would help us to sell our canvases more than if they could gain general acceptance as decorations for middle-class houses. The way it used to be in Holland." The artist also understood the economics of art. He lectured his brother on what economists would call the "opportunity cost" Theo incurred by investing in pictures, pointing out he was forfeiting income by putting money into canvases by the still-obscure Paul Gauguin. (A former stockbroker, Gauguin had

quit the exchange after the market crashed in 1882.) Those pictures, van Gogh argued, "will be sold one day," but in the meantime, they "may freeze the interest on the purchase money invested for years to come."

Theo knew only too well the risks of speculating in the work of unknown painters. For years he generously contributed part of his substantial salary (some 7,000 francs a year plus commissions) to provide his brother with a stipend of 220 francs a month in exchange for his canvases. (At 2,660 francs a year, van Gogh's income was about a quarter of the annual earnings of a French doctor or lawyer—some 10,000 francs—but one and a half times the salary that the postman Joseph Roulin, the subject of four of the artist's portraits, used in Arles to support three children.) Willingly accepting Theo's donations, van Gogh characteristically refused to consider them charity. Instead he liked to think of their relationship as strictly professional; Theo's gifts, in his mind, were standard payments made by a dealer to an artist who in turn produced pictures. "Even if it should be your high pleasure to tear up my work," he wrote, "or maybe leave it peacefully alone, or if you should try to do something with it, I have no right to find fault with you. *But only if I am allowed to consider it a purchase on your part.*"

Theo's patronage had allowed van Gogh to develop as a painter, yet the artist nevertheless longed to release his brother from the constant financial demands it put upon him. Vincent stressed that he considered Theo his partner in a creative enterprise. "Though you are *indirectly* involved in painting, you are more productive than I am," he wrote in July 1888. "The more completely you are involved in dealing, the more of an artist you become." At the end of that same letter, he added, "I would be doing no more than my duty should I ever manage to pay back in kind the money you have laid out. And *in practice* that means doing portraits." By the time van Gogh reached Auvers, he was an accomplished if unconventional portraitist. When he made the decision to paint Dr. Gachet, a prominent figure in the village, he hoped he might attract commissions for other portraits. Thus what was arguably van Gogh's most

introspective and metaphysical portrait was born in part of practical and commercial considerations.

EARLY LIFE, 1853–1876

Vincent van Gogh was born into a middle-class family on March 30, 1853, in Groot-Zundert, a town in Brabant, in the south of the Netherlands, not far from the Belgian border—closer in fact to Antwerp than to Amsterdam. His father, Theodorus van Gogh, was a minister in the Dutch Reformed church. His mother, Anna Cornelia Carbentus, was the daughter of a bookbinder who had worked at the Dutch court in the Hague. Van Gogh received an excellent secondary education in local town schools, which gave him a good grounding in both French and English.

On July 30, 1869, at the age of sixteen, van Gogh began his apprenticeship at Goupil & Cie in the Hague, a gallery originally owned by his uncle Cent van Gogh. The Hague gallery occupied the first floor of a handsome nineteenth-century building on the Plaats, a fashionable square. Inside, it resembled a grand Victorian private house, its gloomy rooms stocked with heavy furniture and lined with dark paintings. A shrewd cosmopolitan businessman, Cent van Gogh developed a lucrative trade, dealing, it seems, primarily in contemporary Dutch art. In 1858 he had sold his business to Goupil's in exchange for a partnership in the French firm and moved to Paris. Goupil's had been founded in Paris in 1827 by Adolphe Goupil as a publisher of prints of both old master and contemporary paintings (many of them by now-forgotten artists). To obtain rights to produce engravings or lithographs from contemporary paintings, Goupil acquired stocks of canvases; eventually he began dealing in the pictures he had reproduced as prints. Through these prints and also photographs (photography being invented in the 1830s), Goupil's had advanced a mass market for art reproductions. By the 1860s the gallery had branches not only in the Hague but in Brussels, Berlin, London, and New York (later known as Knoedler).

If progressive in his international business practices, Adolphe Goupil was conventional in his taste. The gallery specialized in

expensive canvases by then-famous living artists who wielded influence as members of the French Academy and had made their reputations by winning prizes and medals at the Paris Salon, the annual (or biannual) juried exhibition of contemporary art. (Drawing thousands of visitors and generating commentary in the press, the Salon remained French art's most important exhibition until the 1880s.) Goupil's illustrious artists included William-Adolphe Bouguereau, Alexandre Cabanel, Jean-Louis-Ernest Meissonier, and Jean-Léon Gérôme, who happened to be Goupil's son-in-law. They considered themselves inheritors of the French tradition of history painting, brilliantly exemplified in the seventeenth century by Nicolas Poussin's somber epics of classical, biblical, and mythological history: *The Rape of the Sabines* and *The Death of Germanicus*. The French Academy set history painting at the pinnacle of the hierarchy of painting types, above landscapes, portraits, still lifes, and genre scenes (scenes of everyday life). Brandishing allegorical lessons of courage, honor, duty, and fate, history paintings theoretically served to instruct and inspire the public and to glorify the French state. In the mid-nineteenth century academic artists tended to paint precisely detailed literary and historical melodramas—Andromache, fighting enemy soldiers to keep an infant from certain death, or the arrest of Charlotte Corday. At the Salon of 1864, Meissonier exhibited a small panorama of Napoleon on horseback leading troops through the snow. Five years before, French critics reviewing the Salon had noted (only some with regret) the decline of history painting and the proliferation of genre scenes and landscapes.

But Adolphe Goupil, whose gallery thrived on academic art, ignored the increasingly popular landscape painters, including Camille Corot and members of the Barbizon school—Charles-François Daubigny, Theodore Rousseau, and Constant Troyon. Their seemingly traditional pictures, painted in the 1830s and 1840s, often on the edge of the forest of Fontainebleau, were innovative in that their creators had attempted to record faithfully the natural world by sketching out of doors, before completing the canvases in the studio. Praised by the critic Jules Castagnary for their "melancholy, elegance and a gloomy grandeur," the romantic Barbizon

landscapes sold well in Paris, Amsterdam, and New York. Ironically, this passion for images of the untouched French countryside, with wide vistas and ravishing skies, emerged as Europe was becoming increasingly industrialized, and the industrialists themselves bought many of the Barbizon pictures. "Nature was the desired realm," as art historian Robert Herbert wrote, "both the inner world of the untrammeled instinct and the outer world of field, forest, riverbank, or seashore."

Van Gogh was among those drawn to the Barbizon pictures. In 1874 he listed Corot and Rousseau as painters he particularly liked, and he began to voice his profound enthusiasm for the often-sentimental, sometimes politically charged scenes of peasants laboring in the fields by Jean-François Millet. (About Millet's *Angelus*, he wrote Theo, "That's magnificent, that's poetry.") After a few years at Goupil's, van Gogh was undoubtedly aware of the more radical currents in French painting, including the realism of Gustave Courbet, who at the 1850 Salon had riled conventional taste with *Burial at Ornans* and *The Stone Breakers*, canvases that portrayed villagers and manual laborers on a scale traditionally allotted to history painting. "Painting is an essentially *concrete* art," declared Courbet in 1861, "and can only consist of the representation of *real and existing* things." Van Gogh probably also knew of Edouard Manet, who in 1863 exhibited his *Déjeuner sur l'herbe*, a scene of contemporary life in which a nude woman is picnicking in the woods with two fully clothed men.

In the Hague, van Gogh, a hard-working employee, was put in charge of selling photographs, an increasingly significant part of the gallery's art-reproduction business. In June 1873 Goupil's management promoted him to a job in the London office. Meanwhile Cent van Gogh had secured a position for Theo (four years younger than Vincent) in Goupil's branch in Brussels; soon after Vincent left for England, Theo moved to the Hague. On May 15, 1875, Goupil's French owners, seemingly anxious to have their Dutch colleague's nephew under their supervision, brought van Gogh to the gallery's headquarters in Paris, at 2, place de l'Opéra. But in Paris van Gogh grew discontent with his situation and hostile toward the gallery,

devoting his free time to studying the Bible. On April 1, 1876, when he was twenty-three years old, he was fired.

BELGIUM AND THE NETHERLANDS, 1877–1886

On leaving the gallery, van Gogh seemed determined to follow his father and to serve in the Protestant church. He spent the next four years struggling to find steady employment as a minister. After stints of teaching, working in a bookstore, and studying theology, he succeeded in becoming an apprentice preacher in the Borinage, the desolate Belgian coal-mining district near the French border. When he failed to have his contract renewed, he insisted on continuing his grueling work with the miners; at the same time he began making numerous sketches and developing his skills as a draftsman.

By October 1880 van Gogh, now twenty-seven, had made the decision to become an artist and had enrolled in the Académie des Beaux-Arts in Brussels. In retrospect his seemingly wayward path from art dealer to minister to artist was something of a logical progression. Van Gogh treated painting as no less than a religious calling, while also producing pictures he hoped would find a market. For the next five years he painted in Belgium and the Netherlands (in the Hague, Antwerp, and the villages Etten and Nuenen, where his parents lived). From the start he often chose to depict working-class subjects (peasants, weavers, old "orphan men") whose bleak and bitter situation he captured in the emphatic, rough-hewn sweeping lines of his drawing style. His early works (from what would later be called the Dutch period) culminated in a painting of peasants seated at a dinner table, which he called *The Potato Eaters*. It was a monumental picture, dark, brooding, reverential, its figures awkwardly drawn in an exaggerated style that borders on caricature, forfeiting the dictates of naturalism to convey the metaphorical meaning of the family gathered at a meal. He himself explained his intent:

> The point is that I've tried to bring out the idea that these people eating potatoes by the light of their lamp have dug the earth with the self-same hands they are now putting into the

dish, and it thus suggests *manual labour* and—a meal honestly *earned.* I wanted to convey a picture of a way of life quite different from ours, from that of civilized people. So the last thing I would want is for people to admire or approve of it without knowing why.

2

Paris,

1886–1887

*In Antwerp, I did not even know what the impressionists were,
now I have seen them and though not being one of the club yet I
have much admired certain impressionists' pictures—Degas nude
figure—Claude Monet landscape.*

—Vincent van Gogh to H. M. Livens, an English painter, 1886

IN MARCH 1886 Vincent van Gogh joined Theo in Paris, where for
the first time he encountered the Impressionists, who in the six years
(1869 to 1876) during which he had been apprenticed to Goupil's
had revolutionized the theories and practice of landscape and figure
painting and established themselves as the most avant-garde artists in
Paris. The original group included not only Degas and Monet but
also Berthe Morisot, Camille Pissarro, Pierre-Auguste Renoir, and
Alfred Sisley. Their paintings broke with the ultra-detailed realism
of academic painting. They abandoned the studio for the freedom of
painting out of doors, aiming in visible, broken brush strokes to
capture fleeting effects of atmosphere and light. Instead of painting
traditional subjects from history and myth, they focused on con-
temporary life in Paris and its environs. They documented the
unstable, impersonal, evolving industrialized world and the beauty
of the endangered landscape. They painted streets, parks, cafés, the-
aters, railway stations enveloped in steam, and suburban haunts
where the bourgeoisie took their leisure. Mimicking the structure of
photographs and Japanese prints, their canvases seemed to catch

what was seen in a momentary glance. The novelty of their method was noted by the realist critic Edmond Duranty. In a review of the second Impressionist exhibition in 1876 he contrasted traditional landscapes, which he found so dark they seemed "like the depths of a fireplace," to these new paintings, in which "we feel an intoxication of light."

Even without Theo's presence, Paris was the logical destination for an ambitious painter beckoned by the extraordinary French painting tradition. The city had succeeded Rome as the art capital of Europe almost a century before, its architectural monuments and collections of painting and sculpture built up by the French kings and more recently Napoleon to glorify their reigns. In 1664, when Louis XIV's minister Jean-Baptiste Colbert reconstituted the Royal Academy of Painting and Sculpture, he had elevated the French state to be the leading patron of the visual arts. When in 1789 the Revolution abolished the monarchy and overturned the patronage system of the ancien régime, the new government nevertheless sought to maintain its role as influential sponsor of the visual arts. Throughout the nineteenth century a series of disparate governments continued commissioning and acquiring painting and sculpture, each administration taking for granted the capacity of a national school of art to benefit the state.

Descending from Courbet and the Barbizon landscapists, the "new painting" of Manet and the Impressionists emerged in the 1860s, during the Second Empire. France was still the most important power in continental Europe and England's chief rival. Under the emperor Napoleon III, railroads were built, manufacturing industries expanded, and the engineer Baron Georges Haussmann transformed Paris: ancient, crowded neighborhoods and slums were torn down and the poor were evicted to the suburbs to make way for a more brilliant, homogenized city mapped out with open boulevards, parks, and squares. With a new opera house, department stores, and 1.8 million citizens, Paris further consolidated its place as France's economic and cultural capital. As the middle classes grew, their uppermost segment—families with large commercial fortunes—composed a vital market for art.

When van Gogh arrived in 1886, France had been a republic (the Third Republic) for fifteen years. (Napoleon III's empire had ended with his quick defeat in the 1870 Franco-Prussian War.) Van Gogh was one of countless artists from all over Europe. As the art historian Kirk Varnedoe wrote,

> The liberal, business-minded opportunists who controlled the late-1870s and 1880s Republican government saw French culture—particularly the Realism they felt embodied their ideals of secular materialism and positivist science—as a kind of propaganda for the dispersion of their progress-oriented values. The diversity of exhibitions and the activity of the private art market made Paris an open laboratory that enticed artists from all over the world to come and study in an atmosphere of modern permissive liberalism unheard of in their native lands.

The Paris art world was in flux. Twelve years after the Impressionists had held their first exhibition, the group was breaking up, its members feuding. A new generation of painters, drawing on the style of the plein-air school, was making its own departures. A month after van Gogh arrived, the Impressionists began organizing their eighth and last exhibition, which opened on May 15. Paintings by the original members—including Degas, Pissarro, and Berthe Morisot—seemed familiar fare compared with Georges Seurat's *La Grande Jatte* (*Un Dimanche à la Grande Jatte*), a huge, tapestrylike painting of a crowd of Parisians on the banks of the Seine. This brilliant picture struck critics as shockingly modern in its "Egyptian" forms and apparently mechanistic system of tiny brush strokes of color. Seurat's "pointillist" method was also demonstrated by the paintings of Camille Pissarro, his son Lucien, and Paul Signac. In June the critic Félix Fénéon explained that these artists (soon labeled "neo-Impressionists") based their work on the technique of "optical mixture." Colors, he explained, "isolated on the canvas, recombine in the retina: we have, therefore, not a mixture of material colors (pigments), but . . . of differently colored rays of light."

Through Theo and at the studio of Fernand Cormon, van Gogh met not only Seurat and Signac but also Emile Bernard, Paul

Gauguin, Henri de Toulouse-Lautrec, and Louis Anquetin—artists who had absorbed the lessons of Impressionism and who were taking the already splintered movement in new "anti-Impressionist" directions. At age thirty-three, van Gogh had lost his stockiness, and his face was thin and angular. He had close-cropped reddish hair. Although certain aspects of his temperament and situation conform neatly to the myth of isolated genius, he was a contradictory character. Often selfish, stubborn, and argumentative, he was also outgoing and in the circle of Paris artists made many friends. To Bernard and Gauguin, among others, he proved a devoted and sympathetic companion. He had long since shed the citified suit required of an employee of Goupil's and dressed in rustic, working-class clothes. But the painters who spent time with him soon discovered a thinker fluent in English and French and an avid reader of Shakespeare, Thomas Carlyle, George Eliot, Victor Hugo, and the Goncourts. He was a "small, light-haired, and nervous person with lively eyes, a large forehead, and a chilly air about him," the critic Julien Leclercq recalled, "which made me think vaguely of the demeanor of Spinoza, concealing beneath a timid exterior a vehement activity of thought."

The encounter with the "new painting" in Paris redirected van Gogh's attention to color. He lightened his palette, and in the course of painting with Signac on the banks of the Seine outside the city, he experimented with applying paint in a uniform surface of brush strokes somewhat like the divisionist technique of the neo-Impressionists. "In impressionism I see the resurrection of Eugène Delacroix," he told Theo, "but the interpretations of it are so divergent and in a way so irreconcilable that it will not be impressionism which will give us the final doctrine." He recorded the view of rooftops seen from his Montmartre window, and in another canvas, the bleak suburban landscape (punctuated by a lamppost, with factory buildings marking the horizon). He painted some twenty-four self-portraits and ninety still lifes, mostly of flowers and fruit, but also of shoes and of books. He developed a style that took its cue from Japanese prints in its bold contours, flat shapes, and spatial arrangements that ignored traditional perspective. (He had started

collecting Japanese prints—*crepons,* or prints on crepe paper—in Antwerp, and now he also sold them for Siegfried Bing, a dealer in Asian art.) Theo believed in Vincent's work. "It is quite certain that he is an artist," he wrote their sister, "and while what he is doing now may sometimes not be beautiful, it is sure to be of use to him later on, and then it will perhaps be sublime, and it would be a shame if it were made impossible for him to go on studying. No matter how unpractical he may be, if he only proves himself he is sure to start selling one day."

At this point Theo, who had worked for Goupil's for six years, did not attempt to exhibit Vincent's canvases. By now Goupil's partners had ventured into Barbizon pictures, and they allowed Theo, as manager of the boulevard Montmartre branch, to promote more novel works of art than those they stocked at the main gallery. In 1884 Theo had taken a canvas on consignment from Camille Pissarro, and three years later he began spending substantial sums on Impressionist pictures. (That year Goupil's was renamed Boussod & Valadon & Cie after Léon Boussod and René Valadon became new partners.) In 1887 Theo purchased canvases by Pissarro and Sisley, as well as the ravishing *Woman with Chrysanthemums* by Degas, now in the Metropolitan Museum of Art. He also paid 20,000 francs for fourteen paintings by Monet. The profits from the Impressionists were still relatively small: the commission of 150 francs made off a 300-franc Renoir was only one-twentieth of the 3,000-franc fee earned by the gallery from a Cabanel portrait. The scholar John Rewald described Theo's activities:

> Little by little Theo thus turned the two small, low-ceilinged rooms on the mezzanine into a showroom for avant-garde pictures. The location was excellent; businessmen on their way to the stock exchange could drop in to see what was new, people strolling on the large boulevard might stop by, and anybody interested in art could combine a visit to the gallery with a tour at the nearby Hôtel Drouot where all the public sales took place.

In backing the Impressionists, Theo championed painters who not only overthrew aesthetic convention but reshaped the market for

contemporary art. With eight self-sponsored exhibitions, they had bypassed the Salon, taken control of the way their art was exhibited, and put their iconoclastic movement before the French public.

While they refused to stoop to academic convention or cater to popular taste, these entrepreneurial artists were not above commercial considerations. In 1874, at their first exhibition of 200-odd works, they had electric lights installed in the exhibition space at 35, boulevard des Capucines (formerly the studio of the photographer Nadar) so they could keep the show open until 10 P.M., in hopes of attracting viewers from the crowd attending performances at a neighboring theater. With admission priced at 1 franc, the Impressionists' first month-long show drew 3,500 visitors—less than the Salon's average weekday crowd of 4,000, but five years later the group attracted 16,000. The Impressionists were the most famous of several Paris art groups and societies that attempted to forge an identity and win recognition by showing together in alternative, unofficial exhibition spaces in the 1880s.

The path had been blazed two decades before, in 1855, when the Universal Exposition jury had rejected two of Gustave Courbet's paintings, and he had constructed an exhibition hall and filled it with fifty pictures. By midcentury the Salon had evolved into a "bazaar" (with an average of some 2,000 canvases in most of the exhibitions of the 1870s). "The perennial problem at the Salon—and the situation of 1859 was repeated during the next decade," the art historian Henri Loyrette noted, "was the great number of works both accepted and rejected." From the point of view of the artists—whether members of the establishment or the avant-garde—the state-sponsored exhibition had simply grown too large for their work to be adequately seen and to attract the attention of critics and dealers.

Even before the Impressionists held their first exhibition, the Paris dealer Paul Durand-Ruel had seen their iconoclastic work as an opportunity. An adventuresome connoisseur, shrewd entrepreneur, and speculator, he epitomized an increasingly important player in the art market. Durand-Ruel, as van Gogh put it, "bought pictures from Claude Monet in the days before anyone else had recognized

his individuality." He had purchased his first canvas from the artist in 1871 in London, where both had fled after the outbreak of the Franco-Prussian War. Within two years the dealer had spent 70,000 francs on works by the Impressionists; in 1876 the group held its second exhibition at his gallery. "For a long time, I have bought and greatly admired works by very original and skillful painters," the dealer wrote in 1885, "many of whom are men of genius, and I seek to make them known to collectors." Once the Impressionists became successful, he was seen as a model by other dealers of modernist art, including Theo van Gogh. Inheriting the business from his father, Jean-Marie Durand, who first sold stationery and art supplies, the younger Durand-Ruel could afford to invest in risky, unpopular Impressionist pictures by spending some of the substantial profits he had made off a near-monopoly interest (held with the dealer Hector-Henri Brame) in several Barbizon landscape painters whose prices soared in the 1860s when their pictures became popular with European and American business magnates and financiers. Durand-Ruel and Brame owned 140 pictures by Théodore Rousseau, having acquired 79 of his pictures at auction after his death for 70,000 francs. In one investment, Durand-Ruel sold Jean-François Millet's *Sheepfold by Moonlight* to John W. Wilson, an American collector in Brussels, for 40,000 francs, doubling the 20,000 francs he had spent on the painting only two months before. Durand-Ruel perceived that the Impressionists' brilliantly toned images of well-dressed men and women boating, dancing, and at the seashore would, like the idyllic vistas of the Barbizon painters, appeal to collectors.

In his field, Durand-Ruel was as influential as the artists he represented; he changed the marketing of contemporary art, according to the sociologist Harrison White, by shifting the attention of the public away from specific canvases to artists and the span of their work, in part by pioneering one-man shows like those he held for Monet, Renoir, Pissarro, and Sisley in 1883. Like his rival Georges Petit, Durand-Ruel drew clients to his gallery with relatively small exhibitions in elegant settings that stood, commentators observed, in sharp contrast to the overcrowded, haphazardly hung Salon. Durand-Ruel's struck one critic as "a truly private and intimate

space." (In his *Memoirs*, the dealer argued that in fact the gallery, which had several rooms, was too large: "One sees too many things at once, one hesitates.") To give the Impressionists both intellectual and monetary backing and to expand their audience, the dealer published illustrated catalogs and periodicals with texts that extolled and explained their work, and he often bid on their pictures when they came up at public auction.

Connoisseur that he was, Durand-Ruel was not above driving hard bargains. In 1881 Katherine Cassatt, mother of the American painter Mary Cassatt, complained about the dealer's practice of deliberately overstating prices on customs forms:

> Durand-Ruel is so used to "ways that are dark" as to bills of lading certificates that he seemed to think that any fuss about the matter was absurd but at the same time very tenacious of his standing with the American Consul here—One of the tricks I never heard of before is to make out the bill for pictures at double what they cost so that the dealer may show them to buyers who never suspect that he (the dealer) is willing to pay the extra duty in order to double his profits—

In the spring of 1886 Durand-Ruel held his first Impressionist exhibition in New York. Certain of his artists criticized the overseas venture, fretting that the dealer was spreading himself too thin. Four years before, the firm had been threatened with bankruptcy after the collapse of the Union Générale bank, one of whose directors was the gallery's major backer. In New York, on April 10, at the galleries of the American Art Association, the dealer opened a show of 264 Impressionist pictures. Adding 21 canvases, he moved the exhibition to the National Academy of Design, where the sugar magnate Henry Osborne (Harry) Havemeyer and his wife, Louisine Elder, bought Manet's *Salmon* for 15,000 francs. "Do not think that Americans are savages," the dealer wrote the artist Henri Fantin-Latour. "On the contrary they are less ignorant, less close-minded than our French collectors." In 1888 Durand-Ruel opened a Manhattan branch. Ultimately the dealer's geographic expansion would prove a brilliant strategy, as America's well-funded and unquenchable thirst for

French painting made it the largest and most lucrative market for the Impressionists.

But several Impressionists, who had established themselves sufficiently to attract the interest of other dealers, questioned their reliance upon their original backer; the group's eighth exhibition, in April 1886, was designed in part to underline the artists' independence. (Exhibiting at Galerie Georges Petit, Claude Monet refused to participate.) As the market for Impressionism was expanding, Durand-Ruel had competition from several dealers, among them, Theo van Gogh.

As an artist unknown to critics and the art public, van Gogh could not expect to have his paintings exhibited at Goupil's, but he gave canvases to several second-tier dealers, including Arsène Portier (who lived in his apartment building), and also to Julien-François Tanguy, the paint merchant and de facto dealer who ran a dilapidated shop on the rue Clauzel, between the van Goghs' apartment and Theo's gallery. Tanguy sold paint and canvas as well as finished pictures, which he obtained from van Gogh and other painters in exchange for art supplies. (In Paris van Gogh painted two portraits of Tanguy, their backgrounds decorated with Japanese prints.) Tanguy displayed van Gogh's canvases in his shop window. The artist's paintings also appeared in the lobby of the Théâtre Libre and at the offices of Félix Fénéon's *Revue indépendante*.

Around November or December 1887, after being in Paris for a year and a half, van Gogh organized an exhibition of his own work. The site was not a gallery but a restaurant—the Grand Bouillon-Restaurant du Chalet. (Sometime before, also at a café—Le Tambourin—he had put up a show of Japanese prints.) Now the former art dealer, fully cognizant of the progress of the Impressionists in the evolving market for contemporary art, presented himself and his colleagues (Bernard, Anquetin, Toulouse-Lautrec, and possibly others) as members of a new iconoclastic school of painting. Although reviewers ignored this makeshift exhibition, it later came to be seen as the launching of an "anti-Impressionist" movement whose leader was Vincent van Gogh.

3

Arles,

1888–1889

More and more it seems to me that the pictures which must be made so that painting would be wholly itself, and should raise itself to a height equivalent to the serene summits which the Greek sculptors, the German musicians, the writers of French novels reached, are beyond the power of an isolated individual; so they will probably be created by groups of men combining to execute an idea held in common.

—Vincent van Gogh to Emile Bernard, June 1888

IN FEBRUARY 1888 van Gogh left Paris for Arles. For more than a year he had set his mind on going to the south of France, "wishing," as he put it to Theo, "to see a different light, thinking that looking at nature under a bright sky might give us a better idea of the Japanese way of feeling and drawing." Van Gogh was not alone among vanguard European artists in wanting to abandon the city, which since midcentury had offered such rich subject matter for painters of the modern scene. In 1886 and 1888 Paul Gauguin had gravitated to Brittany in search of remote, rustic landscapes whose peasants represented an uncorrupted form of life endangered by industrialization. "I like Brittany," Gauguin wrote. "It is savage and primitive. The flat sound of my wooden clogs on the cobblestones, deep, hollow and powerful is the note I seek in my painting." In 1887 Gauguin visited

Martinique, an island in the French Antilles. Seeking a more exotic environment and primitive culture, he left in 1891 for Tahiti.

In Arles, inspired by the light and the countryside, van Gogh persisted in working from nature and fully developed his characteristic style with expressive brush strokes, flat planes of intense color, sweeping emphatic contour lines. "I spend my time in painting and drawing landscape or rather studies of color," he wrote the painter John Russell. Characteristically, he was an articulate explicator of his own method: "I exaggerate, sometimes I make changes in a motif; but for all that, I do not invent the whole picture; on the contrary, I find it all ready in nature, only it must be disentangled."

In May van Gogh moved into a room in the Café de la Gare, owned by Joseph-Michel and Marie Ginoux. The café's interior was the subject of the menacingly beautiful *Night Café*. "I have tried to express the terrible passions of humanity by means of the red and green," he wrote. "The room is blood red and dark yellow with a green billiard table in the middle; there are four citron yellow lamps with a glow of orange and green. Everywhere there is clash and contrast." Soon he managed to rent a house at 2, place Lamartine, which he hoped might serve as the center for the colony of artists he envisioned enticing to Arles. The landlord had the interior painted white, and van Gogh used one of the rooms as a studio before he moved to the "Yellow House" in September.

In Arles van Gogh, now at the height of his powers, painted over two hundred canvases, and over one hundred drawings and watercolors. Outdoors he painted the town and its outskirts: orchards, wheatfields, the public garden, and *Trinquetaille Bridge*, a study of steps leading to an iron bridge built in 1875. Indoors, he painted a canvas of the oddly proportioned room where he slept, attempting to convey his feeling of peace there, and designed to complement the dark mood of *Night Café*. Optimistic about persuading Gauguin to join him, he began a project to fill the Yellow House with paintings in a decorative cycle that served as a drawn-out experiment in color as it evoked the landscape and life of Provence. He often painted more than one version of a picture, first completing an *esquisse*, or

study, on the spot, then reworking the subject with a more elaborate color scheme in a *tableau* or *picture.*

In Arles van Gogh painted forty-six portraits—an extraordinary series of brilliantly toned, emblematic canvases. The Impressionists had radically changed the conventions of portraiture, ousting formal static poses and trading idealization for social and psychological realism. They tended to paint families and friends, caught at passing moments and framed by a particular private or public milieu designed to set them in the fabric of the modern world and to reveal the dynamics of their particular situation. "We want," argued the critic Edmond Duranty, "a back to reveal a temperament, an age, a social standing; a pair of hands to express a magistrate or a businessman; a gesture to disclose a whole set of feelings. The physiognomy will tell us that this man must be cold, orderly, and meticulous, while that man is the epitome of disorder and carelessness."

Van Gogh carefully chose the subjects of his portraits, searching for individuals who struck him as types, vivid characters who represented a certain social role, an idea, a feeling, or a moral value. The postman Joseph Roulin he saw as a "Socratic type," a "terrible republican, like old Tanguy," and a personification of the French Revolution. To evoke the abstract notions that he linked to these individuals, he became, in his words, an "arbitrary colorist." If his tonal schemes depended at first upon the hues he actually observed, they evolved from his own interpretation of the moods and ideas conveyed by certain pigments. When he painted peasant Patience Escalier, a "wild beast," he wanted to portray him as "terrible in the furnace of the height of harvest time, as surrounded by the whole Midi. Hence the orange colors flashing like lightning, vivid as red-hot iron, and hence the luminous tones of old gold in the shadows."

On October 23, 1888, Gauguin joined van Gogh in Arles. The collaboration between the two temperamental artists lasted nine weeks; at the end of an excessively rainy December, it deteriorated. Their later accounts differed about the progression of their disagreement, but one day after a heated argument, van Gogh, stricken by a still inexplicable attack, was found to have cut off a section of his own ear. Gauguin telegrammed Theo, who came immediately. He

and Gauguin then returned to Paris. Theo had recently become engaged to Johanna Gesina Bonger (the sister of his Dutch friend Andries Bonger), to whom he wrote, "there is little hope." But the artist recovered. Released from the hospital in January, he returned to the Yellow House, where he painted *Self-Portrait with Bandaged Ear*, a scrupulously mapped-out study of complementary colors, designed to prove to Theo and others that he was in full command of his powers. In February thirty citizens in Arles petitioned to have him imprisoned. A report by the police commissioner there referred to him as a "madman," potentially a "public danger," and advised detention "in a special asylum." In response the police forced the artist to return to the hospital, where he remained for two months. In April, Theo van Gogh and Johanna Bonger were married.

4

Saint-Rémy,
May 8, 1889–May 16, 1890

And in a picture I want to say something comforting as music is comforting. I want to paint men and women with that something of the eternal which the halo used to symbolize and which we seek to convey by the actual radiance and vibrancy of our coloring.
— Vincent van Gogh to Theo van Gogh, 1888

ON MAY 8, 1889, van Gogh entered the *"maison de santé,"* or private asylum, of Saint-Paul-de-Mausole, in the town of Saint-Remy-de-Provence, after learning that the police in Arles were planning to have him institutionalized elsewhere. In the asylum he again suffered episodes of illness. For a period of six weeks beginning in July he was incapable of leaving his room, and at one point he tried to eat oil paint. The head physician, Théophile-Zacharie-Auguste Peyron, diagnosed his condition as "acute mania with hallucinations of sight and hearing which have caused him to mutilate himself by cutting off his right ear," and later as epilepsy.

Desperate to understand his illness, van Gogh tended to blame himself but wanted to believe that Peyron, who had known someone else to have "injured his ear," would be able to help him. "I've noticed that others, too, hear sounds and strange voices during their attacks, as I did," he told Theo. "And that things seemed to change before their very eyes. And that lessened the horror with which I remembered my first attack." Four months later he was still battling

to regain his health. "During the attacks I feel cowardly in the face of the pain and suffering—more cowardly than is justified . . . in short, I am trying to recover, like someone who has meant to commit suicide, but then makes for the bank because he finds the water too cold."

Van Gogh had some reason to hope that the doctors would cure him. Certain French physicians had rejected the traditional primitive and brutal approach to treating the mentally ill, in the process advancing psychiatry as a profession and shaping the early study of the subconscious. In 1793, four years after the Revolution, one of these pioneers, Philippe Pinel, professor at the Ecole de Médicine de Paris and chief physician at the Salpêtrière (a Paris asylum for women) ordered inmates of the asylums unchained. Pinel advocated "moral medicine," directed at the mind and emotions, advising physicians first to approach patients with "gentleness" and "consoling words, the happy expedient (artifice) of reviving the hope of the lunatic and gaining his confidence." In the early years of the nineteenth century Jean-Etienne-Dominique Esquirol, Pinel's disciple, and others demanded an end to bleedings and purgings, which were standard treatment for mental illness.

Despite abundant speculation on the nature of van Gogh's extensive medical problems, they remain unresolved. As of 1990, physicians, psychologists, and others had published over 150 accounts hypothesizing on the diseases that afflicted him. The only primary sources on his condition are several medical reports from the asylum in Saint-Rémy and his letters. Although he was both stoic about his afflictions and reluctant to fully admit their extent to Theo, he sometimes described his symptoms. Whatever the physical causes of his disease, it was periodic in nature, causing seizures and hallucinations, at times leaving him incapable of venturing from his room and then also driving him to self-destructive acts.

But the artist's symptoms can be accounted for by various diseases and disorders, and all theories on the nature and causes of his mental and physical anguish will remain in the realm of speculation. Faced with a similar case, physicians in the late twentieth century would confirm their diagnoses by administering medications known

to work on specific disorders. Thus, a retrospective analysis of van Gogh's physical and mental afflictions can never be tested.

Most probably van Gogh suffered from several diseases—including a type of epilepsy and also manic depression. But possibly epilepsy alone and its unpredictable seizures caused him to descend into pathological states of depression. His unstable condition would have been aggravated by immoderate drinking of absinthe and by taking digitalis, apparently prescribed for epilepsy in the asylum. Although van Gogh seemed to accept Peyron's claim that he had epilepsy, he described himself as suffering from "melancholy," a term elastic enough to signify a mild depression or a severe pathological state.

Van Gogh's therapy at the asylum included doses of the sedative potassium bromide and baths, taken twice a week in one of eight tubs lining a desolate room. "The treatment of patients in this hospital is certainly easy," he wrote. "One could follow it even while traveling, for they do absolutely *nothing;* they leave them to vegetate in idleness and feed them with stale and slightly spoiled food." In December 1889 he attempted to ingest paints and to drink kerosene snatched from an attendant whose job was to fill the lamps.

Despite his illness, van Gogh continued to paint at the brilliant level he had achieved in Arles. During his first week in the asylum, in early May 1889, he painted still lifes of flowers, including a bank of purple irises. He began a series of cypresses and another of olive orchards. In *Starry Night* and *Starry Night over the Rhône*, he experimented with portraying landscapes cast in darkness. "In general people like the night effect (ie. *Starry Night*) and the sunflowers," Theo reported. "I have put one of the sunflower pieces in our dining room over the mantelpiece. It has the effect of a piece of cloth with satin and gold embroidery; it is magnificent."

Although far from Paris, van Gogh kept in touch with friends there. In the course of his two years in the south of France, he exhibited his work twice in the French capital at the Salon des Artistes Indépendants. (The Indépendants show was a large jury-less "salon" founded in 1884 that served as a showcase for the

neo-Impressionists.) To the Indépendants show in September 1889, Theo shrewdly sent *Starry Night* and *Irises*. In November Octave Maus, the head of the Belgian avant-garde group Les XX (Les Vingt, or the Twenty) invited the artist to show six paintings in the group's annual exhibition in Brussels.

A significant step in building a market for van Gogh's art was taken in January 1890, when the critic G.-Albert Aurier wrote a long, rhapsodic article, "The Isolated Ones: Vincent van Gogh," in the first issue of *Mercure de France*. Aurier was one of the band of literary symbolists who had announced their movement four years before with a manifesto published by Jean Moréas in *Le Figaro*. Ardent iconoclasts who looked to Charles Baudelaire as their forebear, the symbolists sought to break from the naturalism of Gustave Flaubert, Honoré de Balzac, and Emile Zola, who had dominated French literature for most of the century. In a piece on symbolist painters, Aurier articulated the disillusionment with and contempt for progress and positivism that propelled the new direction:

> After having proclaimed the omnipotence of scientific observa-
> tion and deduction for eighty years with childlike enthusiasm,
> and after asserting that for its lenses and scalpels there did not
> exist a single mystery, the nineteenth century at last seems to
> perceive that its efforts have been in vain and its boast puerile.
> Man is still walking about in the midst of the same enigmas, in
> the same formidable unknown.

"It is now time to react," he argued, "to chase away science." As he rejected naturalist literature, Aurier shunned realist art. Painting's conventional aim of mimicking nature, creating illusion and trompe l'oeil effects, was in the symbolists' view restrictive and mundane, and obstructed a more important spiritual purpose. While "the Impressionists study color . . . retaining the shackles of verisimilitude," Gauguin argued, "they neglect the mysterious centers of thought." The symbolists sought to shift the focus of art and literature to the realm of inner experience: as poets, they aimed to evoke ideas, feelings, sensations, and states of mind. Writers and artists, they believed, should summon an intangible, subjective reality, both

more true and more fundamental than that of the physical world. The goal of symbolist art was "to clothe the idea in a form perceptible to the senses."

While placing van Gogh in the tradition of Dutch realism, Aurier also claimed him as "almost always a symbolist." In van Gogh's brilliantly toned imagery, Aurier discovered the "profound, complex" art the symbolists had called for. In it the landscape had been transformed: "There are cypresses shooting up their nightmarish silhouettes of blackened flames . . . ," he wrote. "Rocks, lands, undergrowths, lawns, gardens, rivers that one would have said were sculpted from unknown minerals, polished, reflecting, iridescent, magical." In its overheated and suggestive language, Aurier's commentary was itself an exemplary piece of symbolist prose: "Vincent van Gogh in fact," he argued, "is not only a great painter, enthusiast of his art, of his palette, and of nature, he is also a dreamer, a fanatical believer, a devourer of beautiful utopias, living on ideas and dreams." What distinguished the "symbolism" that Aurier identified in the art of van Gogh and Gauguin was the way the artists attempted to use color, shape, and line to inscribe particular ideas and emotions into the fabric of the picture. But the term *symbolism* can also refer to a diverse group of nineteenth-century artists (including the French painters Pierre Puvis de Chavannes and Odilon Redon and the English Pre-Raphaelites) whose work had little stylistic resemblance to van Gogh's and Gauguin's, and whose pictures tended to depict not the tangible world but instead invented scenes of allegory, fantasy, and dream, often in intricately described detail.

Aurier also speculated on the market potential of van Gogh's works, on the chance that the "world of fashion would come to pay for his canvases—which is hardly likely—the prices of the small infamies of M. Meissonier." (A painting by Ernest Meissonier only 4 by 5 inches made $7,100 at the James H. Stebbins auction in 1889 in New York.) But he concluded that van Gogh was "at once too simple and too subtle for the contemporary bourgeois spirit. He will never be fully understood except by his brothers, the true artists."

Aurier's review singled van Gogh out from the multitude of new

painters and new styles. The poet's pronouncement would have great influence upon artists in France and elsewhere who were drawn to the symbolist credo. Van Gogh, however, refused to accept Aurier's label, apparently disliking formulaic distinctions between one style and another. "I do not see the use of so much sectarian spirit as we have seen these last years," he wrote, *"but I am afraid of the preposterousness of it."*

Van Gogh had a third attack in January 1890. The birth of a son to Theo and Johanna at the end of the month escalated the artist's anxiety about the future of his brother's patronage. A fourth attack in February lasted until April. Even before this relapse, van Gogh had concluded that the asylum and its volatile and depressed inmates only exacerbated his condition. He began a campaign to persuade his brother to let him leave and travel north, specifically to Paris, where he felt "almost certain" he would "get well quickly."

Skittish of the capital itself, van Gogh suggested he might stay with the Impressionist Camille Pissarro, who lived northwest of the city. Pissarro, in turn, advised that van Gogh arrange to consult the doctor Paul-Ferdinand Gachet, who lived in Auvers, "does painting in his spare moments," and "has been in contact with all the impressionists." Theo met with Gachet. The doctor struck him as "a man who understands things well." "Physically he is a little like you," he told his brother. "When I told him how your crises came about, he said to me that he didn't believe it had anything to do with madness, and that if it was what he thought he could guarantee your recovery . . ."

In spite of his suffering, van Gogh continued to paint, asking Theo to send him thirty-three tubes of paint—white, crimson lake, emerald green, orange, cobalt, malachite, chrome, and ultramarine. "What am I to say about these last two months," he wrote. "Things didn't go well at all. I am sadder and more wretched than I can say." As he saw it: "the main thing is to know the doctor, so that in case of an attack I do not fall into the hands of the police and get carried off to an asylum by force."

In May Theo delivered encouraging words after seeing ten of van Gogh's paintings together in the Indépendants exhibition:

"Your pictures are very well hung and make a good effect. Many people have come to ask me to convey their compliments to you. Gauguin said that your paintings are the chief attraction of the exhibition." Indeed, the usually egocentric Gauguin confirmed Theo's report. "For many artists you are the most remarkable part of the exhibit," he wrote van Gogh. "With subjects drawn from nature, you are the *only one who thinks.*" Three months before, in February, Theo had conveyed the news that Anna Boch, a painter in the Belgian group Les XX, the sister of Eugène Boch, an artist who befriended him in Arles, had bought a landscape, *Red Vineyard.* She had paid 400 francs—a respectable sum for an unestablished painter, comparable to what Seurat received for his landscapes.

Van Gogh was released from the asylum on May 16, 1890. In the hospital register, Peyron described him as "cured." For the moment his illness was in retreat. On Saturday, May 17, he arrived in Paris, where the 684-foot iron Eiffel Tower had been built for the Universal Exposition the year before. For the first time he met Johanna and the infant, Vincent Willem. Theo and Johanna's rue Lepic apartment was filled with his paintings—several on the walls, others piled up, some under a bed. He visited Tanguy's shop, where yet more canvases were stored in an attic room. But three days in Paris only added to the artist's anxiety. Theo, who had his own problems with his health, had been arguing with the managers of Boussod & Valadon and was debating whether to leave the firm and start his own gallery. On Tuesday, May 20, the artist boarded a train for Auvers. In the country village where Daubigny had lived, he hoped to continue his experiments in color and to elude his illness.

5

Auvers:
Paul-Ferdinand Gachet,
1890

I have seen Dr. Gachet, who gives me the impression of being rather eccentric, but his experience as a doctor must keep him balanced enough to combat the nervous trouble from which he certainly seems to me to be suffering at least as seriously as I. . . .

His house is full of black antiques, black, black, black, except for the impressionist pictures mentioned. The impression I got of him was not unfavorable. When he spoke of Belgium and the days of the old painters, his grief-hardened face grew smiling again and I really think that I shall go on being friends with him and that I shall do his portrait.

Then he said that I must work boldly on, and not think at all of what went wrong with me. —Vincent van Gogh

THUS VAN GOGH told Theo of his first meeting with Paul-Ferdinand Gachet on May 20, 1890, within hours of disembarking from the train that had brought him to Auvers from Paris. Soon the thirty-seven-year-old painter found a room in the Auberge Ravoux, a small inn facing the town hall, in the place de la Mairie. Already uncertainty and ambivalence had swept aside his high hopes of finding expert attention for his illness. On paper, however, Gachet appeared a logical choice to serve as the doctor in whom the artist would entrust his care. He seemed a sympathetic if idiosyncratic character who had some experience with patients suffering from nervous dis-

orders and who also had long-standing connections to the Paris avant-garde, beginning in the 1850s when he was a medical student and mixed with the circle of Gustave Courbet. He had been trained by the French medical establishment in Paris, then a center for the embryonic field of mental alienation as it was for modern art. Five years before, in 1885, Sigmund Freud had come to the French capital from Vienna specifically to study the techniques of Jean-Martin Charcot and to attend his lectures.

But in spite of Gachet's seemingly sound credentials, to van Gogh's profound disillusionment, the artist found a sixty-one-year-old physician, aging and out of touch, an amateur painter and printmaker who praised his canvases (including recent copies after Delacroix) but offered scant medical care, only a vague diagnosis, and no specific treatment beyond advising the artist to keep up his production. Paying more attention to van Gogh as an artist than as a patient, Gachet discounted the seriousness of his condition and assumed his problems were simply neuroses. Ill-equipped to diagnose and treat van Gogh's illness, he largely ignored it. Still, despite his shortcomings, Gachet was not unrepresentative of nineteenth-century medicine. Wherever van Gogh might have sought treatment, he had minimal chance of cure.

Although unconvinced by Gachet's counsel, van Gogh had little choice but to accept it. Born in Lille in 1828, Gachet had studied medicine at the University of Paris. Trained by Jean-Pierre Falret, a disciple of Jean-Etienne-Dominique Esquirol and a leading alienist of the day, Gachet had worked as a student at the Salpêtrière, the asylum for women, and at Bicêtre, an asylum for men. Failing to complete his training at the University of Paris, Gachet had transferred to the Montpellier school of medicine, France's second most prestigious medical school, where he earned a degree in 1858. There he wrote a thesis on the subject of melancholy or depression, "Etude sur la mélancolie." This treatise perpetuated the antiquated, romanticized notion that melancholy afflicted "all the great men, philosophers, tyrants, the great conspirators, the great criminals, the great poets, the great artists," and countless others, such as the "opium smoking Chinese":

Melancholy is an illness not only of a man, but of a people and it has marked periods of history. . . . The children of the present generation, sons of the empire and grandsons of the revolution, find themselves again plunged in doubt. Also this epoch is marked by numerous suicides.

The only quasi-scientific aspect of Gachet's study was an appendix of case histories of female melancholiacs whom he had observed in the Salpêtrière. After graduating, Gachet returned to Paris and opened an office at 9, rue Montholon, where according to his letterhead he specialized in "women's and children's diseases and invited the poor for free consultations." According to his son, he was a "physician for the Chemin de Fer du Nord," and he had been decorated for the service he gave administering to the victims of a train wreck.

In 1890 the widowed Gachet lived in Auvers with his daughter Marguerite, nineteen, and his son Paul, sixteen. Several days a week he commuted to an office in a dilapidated building in a working-class section of Paris. His idiosyncratic practice was shaped by his personality, his prejudice for homeopathic medicine, and his distaste for surgery. He seems to have borrowed freely from the tradition of alternative medicine, dispensing an "elixir of Dr. Gachet" to neighbors in the village. He had a long but solid face, a prominent nose, and orange hair that was rumored to be dyed with saffron. The blue jacket and white cap that he wore when he posed for van Gogh were his habitual summer costume. He was a "rabid Republican (the third French Republic was not twenty years old), Darwinist free thinker, and socialist." As an amateur artist, printmaker, and avid copyist he was not without ambitions for his own art. Later Johanna van Gogh, who seemed to like him, compared his etching studio to the workshop of a medieval alchemist. In 1891 he submitted several pieces to the Indépendants exhibition, signing his work with the name "P. van Ryssel."

Over the course of June, van Gogh crossed the village regularly to visit the doctor at his gloomy house, paint in the garden, and tolerate lengthy meals. For a few weeks Gachet's lackadaisical attitude

sat well enough with the artist, whose single-minded aim was to paint and whose respite from disease allowed him to discount Gachet's failings as a medic. He tried to reassure his siblings about his situation. If the "melancholy or anything else became too much for me to bear," he wrote Theo, Gachet "could easily do something to lessen its intensity." He is "something like another brother," he told Wilhelmina on June 3, "so alike are we physically and mentally, too." Then to Theo he reported, "M. Gachet says that he thinks it most improbable that it will return, and that things are going on quite well." Again, to Wilhelmina, van Gogh wrote, "I think that the doctor to whose care I am entrusted will absolutely leave me to my own devices, as if there were nothing the matter with me."

But van Gogh himself remained uncertain that he had escaped his illness. In only his second letter from Auvers, written on May 21, he debated whether or not he should in fact continue to work, requested twenty sheets of Ingres paper and other supplies, and voiced despair: "I can do nothing about my disease. I am suffering a little just now—the thing is that after that long seclusion, the days

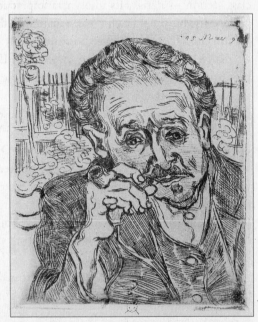

Vincent van Gogh, *Portrait of Dr. Gachet*, 1890. Gachet's printing press inspired van Gogh's only etching.

seem like weeks to me." Two days later, he jettisoned any belief he had in the doctor.

> I think we must not count on Dr. Gachet *at all*. First of all he is sicker than I am, I think, or shall we say just as much, so that's that. Now when one blind man leads another blind man, don't they both fall into the ditch?

At some point, presumably toward the end of May, van Gogh tried his hand at etching. In what Theo called a "drawing on metal," van Gogh sketched Gachet hatless and smoking a pipe, held in his raised right hand. Here he seems to map out the linear structure of the oil portrait, conveying a sense of anxious intensity in the doctor's crooked countenance and in the dynamic sweep and repetitive patterns of dark lines.

6

The Portrait of
Dr. Gachet

*I've done the portrait of M. Gachet with a melancholy expression,
which might well seem like a grimace to those who see it. And yet
I had to paint it like that to convey how much expression and pas-
sion there is in our present-day heads in comparison with the old
calm portraits, and how much longing and crying out. Sad but
gentle, yet clear and intelligent, that is how many portraits ought
to be done.* —Vincent van Gogh to Wilhelmina van Gogh,
June 11 or 12, 1890

THE IDEA of painting Gachet's portrait came to van Gogh Tuesday,
May 20, the day they met. But he waited at least twelve days before
starting to paint. The two or three days it took him to execute the
picture had been preceded by almost two weeks when he had time to
work out its concept and form. He prided himself on swiftness—he
could produce a finished canvas in a matter of days or even hours.
He compared his working method ("drawing as quick as lightning")
to a performance: "Sheer work and calculation, with one's mind
strained to the utmost, like an actor on the stage in a difficult part,
with a hundred things to think of at once in a single half hour."

Although painted quickly, the portrait drew on years of thought
and seemed the culmination of van Gogh's more than seventy por-
traits (thirty-seven of them self-portraits)—the genre that he told

Emile Bernard was "*the* thing of the future." To van Gogh's mind, portrait painting was his highest calling—an assignment with a moral purpose. At their finest, portraits conveyed the inexplicable, intangible, subjective being—what he called "something of the eternal." He summed up the achievement of the seventeenth-century Dutch painters Rembrandt and Frans Hals as "the painting of humanity, or rather of a whole republic by the simple means of portraiture."

By June 3 the artist had begun to paint Gachet in the garden beside the house, which was built against a cliff. From the street a steep row of stone steps rose to the front door. The garden was in bloom, and overrun, as the artist observed, with ducks and chickens. In the doctor's casual pose, the loose brushwork, the rich colors, and the sense of the seized moment, the portrait had its roots in the informal portraits the Impressionists painted of their families and friends (Manet's portrait of the poet Stéphane Mallarmé with a book or Degas's portrait of Manet listening to his wife play the piano). And yet the canvas excludes any hint of the heat of the sun, the ambiance of a summer day, the quotidian chaos that confronted him outside the doctor's residence. That van Gogh's portrait is far from a literal representation of Gachet's physical appearance is evident in a photograph of the doctor, who had a solid, even fleshy face, a large nose, and a stony, slightly puzzled expression. Photographic reproduction was never van Gogh's intent; in the Gachet portrait, he brought the methods of Impressionism in line with his symbolist preoccupations.

Van Gogh insisted on painting from nature; nature served as the stimulant to his imagination. This in turn was shaped over time by his encyclopedic mental inventory of art. The conception of the Gachet portrait came as much from van Gogh's dialogue with art history as from his perceptions of a man at a red table and the objects that happened to be in his line of sight as he stood in the garden. Like the postman Joseph Roulin, the peasant Patience Escalier, and others who posed for van Gogh, Gachet stirred the artist's memory and fired the particular ambitions he held for modern portrait

painting. The encounter with a doctor who had written a treatise on melancholy set off a chain of associations that he then laced together in constructing the painting.

Gachet's seemingly casual pose, his head propped on his hand, his elbow leaning on a table, was the classic pose of melancholy, found in countless earlier works of art and signaling the psychological state of depression. The melancholic pose appeared most famously in the 1514 print *Melencolia I* by the German master Albrecht Dürer. (Historians have traced the pose back to images from ancient Egypt.) For centuries artists employed the motif specifically to suggest the assumed link between genius and madness. Paul Cézanne would use it in *Boy with a Skull* and *The Smoker*, portraits he painted in the 1890s.

Specifically, van Gogh drew Gachet's melancholy pose from an 1839 portrait by Eugène Delacroix of the sixteenth-century Italian epic poet Torquato Tasso after he had been unjustly imprisoned for

Eugène Delacroix, *Tasso in the Hospital of St. Anna, Ferrara,* 1839. Delacroix's painting of the poet was one of the sources for *Portrait of Dr. Gachet.*

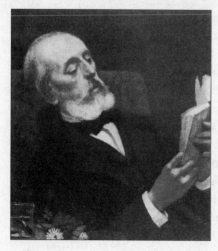

Pierre Puvis de Chavannes's conventional 1882 *Portrait of Eugène Benon* served as an inspiration for van Gogh's radical portrait of *Gachet*, painted in 1890.

insanity (*Tasso in the Hospital of St. Anna, Ferrara*). From the Delacroix, van Gogh also borrowed the painting's mood of desolation. Van Gogh chose his sources as he chose his subjects—for their emotional resonance. Two years earlier he had extolled Delacroix's mix of external and inward truth—"a *real* man ... with the thoughts, the soul of the model in it"—that he felt embodied the sublime in painted portraits. In letters, he referred at different times to the Tasso portrait. He thought of it in 1889 when he visited the museum in Montpellier and saw Delacroix's portrait of Alfred Bruyas, the patron of Gustave Courbet. He recalled it again in Auvers when Gachet mentioned that as a student in Montpellier he had actually met Bruyas. But van Gogh was also influenced by another portrait he passionately admired. This portrait, by the French mural painter Pierre Puvis de Chavannes, had nothing in common with Delacroix's tormented image of the Renaissance poet. It was more wistful verse than grand tragedy: "An old man reading a yellow novel, and beside him a rose and some water-color brushes in a glass of water." Indeed, van Gogh found the Puvis *Portrait of Eugène Benon* "consoling," as it presented "modern life as something bright in spite of its inevitable griefs."

Just as there was nothing accidental in Gachet's pose, neither were the yellow books and the foxglove random props that happened

to be on the garden table. Instead, they formed an allegorical still life. The foxglove, the source of the heart medicine digitalis, symbolized the doctor's profession. The yellow books, *Manette Salomon* and *Germinie Lacerteux*, were novels by Jules and Edmond de Goncourt. The books made explicit references to art and to psychological neuroses—themes of the painting. Written in 1867, *Manette Salomon* related the struggles of a band of artists living in midcentury Paris. *Germinie Lacerteux*, published in 1864, chronicled the descent of a working-class woman into alcoholism, insanity, tuberculosis, and eventually death. (Coincidentally, Germinie's decline paralleled one of the case studies made by Gachet at the Salpêtrière and documented in his thesis on melancholy.)

At the most literal level, *Portrait of Dr. Gachet* was a gesture of self-possession, a graphic realization of the contention van Gogh had spelled out in a letter to his distracted brother, that Gachet "certainly seems to me as ill and distraught as you or me." It spoke to van Gogh's rational understanding of his illness, his fears of the unresolved consequences of the doctor's failure to address his disease, and their momentary sympathy. It also demonstrated the lucidity of mind that he brought to the act of painting. In painting the portrait, van Gogh reversed the roles of patient and doctor and scrutinized Gachet as the patient afflicted by their shared disease. ("Melancholy" was thought among the medical profession of the time to be a form of neurasthenia or nervous collapse.) In representing Gachet's physiognomy as a map of his state of mind, van Gogh followed the practice of French physicians throughout the nineteenth century, who employed paintings, drawings, and photographs of lunatics as diagnostic tools. But Gachet's haunting countenance is not one of a madman; a rational being, he comprehends the nature of his own suffering.

In his portrait of Dr. Gachet, van Gogh created a portrait of the modern artist. The idea of identifying the task of a painter with the role of a physician had come to van Gogh earlier, in connection with the act of painting portraits. "I have made portraits of *a whole family,* that of the postman," he wrote Theo. "You know how I feel about this, how I feel in my element, and that it consoles me up to a cer-

tain point for not being a doctor." In the Gachet portrait van Gogh projected onto the doctor's image his own complicated double identity and perspective as both patient and artist, sufferer and healer. In linking his identity to that of the doctor, van Gogh suggests that the modern artist is not simply a tormented outsider but also a diagnostician of contemporary society, an analyst of its character, a critic of its injustices, diseases, and pathologies. Placing the yellow books at Gachet's elbow, he ties his mission to that of the Goncourts, who described themselves as "clinical writers of the nerves," and whose biting social realism captured the squalid and rapacious environment of industrialized Paris. Characteristically, he enlisted these "melancholy" writers into his imagined brotherhood of literary and artistic colleagues and compared the Goncourts' creative fraternal partnership to his bond with Theo. The preface of their novel *Cherie*, he wrote,

> tells the story of what the de Goncourts went through, and how at the end of their lives they were melancholy, yes, but felt sure of themselves, knowing that they had *accomplished* something, that their work would remain. What fellows they were! If we were more of one mind than we are now, if we could agree completely, why shouldn't we *do the same*.

The artist's disillusionment with society mirrored the crisis of faith in science and technology that followed the industrial revolution. The neurosis and anomie van Gogh evoked in *Gachet* was what he and many symbolists considered to be the shared condition of civilization at the end of the century. "Melancholy and pessimism" are the "diseases from which we civilized people suffer most," he wrote. The artist had not argued with Aurier's hyperbolic characterization of him as "a terrible and maddened genius, often sublime, sometimes grotesque, always close to the pathological." Rather, he accepted the symbolist poet's rhetoric as applicable to his circle. "The ideas he speaks of are not my property, for in general," he explained to Wilhelmina, "all the impressionists are like that, are under the same influence, and we are all more or less neurotic. This renders us very sensitive to colors and their particular

language, the effects of complementary colors, of their contrasts and harmony."

What was revolutionary in *Portrait of Dr. Gachet* was van Gogh's manner of painting. As radical as the graphic rip of the pigment was the way he worked form and color for decorative and symbolic purpose, and to lay bare a human psyche. The angst of the doctor's fixed and saddened gaze is embodied in the agitated skeins of paint. Nervous, fast-paced strokes, moving in parallel patterns, fill the canvas with electric anxiety that seems to travel directly from the doctor's brain. Van Gogh transcribed a sense of despair in the deep stained-glass tint of the jacket and the other tones of blue. He had explained the use of such blue when in Arles he painted *Portrait of Eugène Boch*. "Instead of painting the ordinary wall of the mean room," he told Theo, "I paint infinity."

What draws us to the portrait is that it is simultaneously representational and abstract—at once a convincing depiction of a man and an evocative schema of paint. "Two modes of portrayal are combined," writes the art historian Meyer Schapiro, "the probing of the features in their tiniest inflections, and the free creation of an expressive structure of lines, colours, and areas which convey a sensed mood of the person." Painted in 1890, the portrait reflected the moment at the end of the nineteenth century when vanguard painters in Paris (later labeled "Postimpressionists") sought in their paintings to restructure the surface appearances of figure, still life, and landscape according to their own visions, paving the way for abstract art. Modernity lay not in painted details of a transient contemporary world but in the emphatic subjectivity these artists conveyed in their imagery. Not coincidentally, in the year *Gachet* was painted, the twenty-year-old artist Maurice Denis exhorted, "It is well to remember that a picture—before being a battle horse, a nude woman or some anecdote—is essentially a plane surface covered with colours assembled in a certain order." Shortly after van Gogh described *Gachet* to Theo, he wrote Wilhelmina. Living in Holland and with no professional ties to the art world, she served as an untutored audience to whom he dared voice his lofty ambitions for portraiture.

What impassions me most—much, much more than all the rest of my métier—is the portrait, the modern portrait. I seek in it color, and surely I am not the only one to seek it in this direction. I *should like*—mind you, far be it from me to say that I shall be able to do it, although this is what I am aiming at—*I should like* to paint portraits which would appear after a century to the people living then as apparitions. By which I mean that I do not endeavor to achieve this by a photographic resemblance, but by means of our impassioned expressions— that is to say, using our knowledge of and our modern taste for color as a means of arriving at the expression and the intensification of the character. So the portrait of Dr. Gachet shows you a face the color of an overheated brick, and scorched by the sun, with reddish hair and a white cap, surrounded by a rustic scenery with a background of blue hills; his clothes are ultramarine—this brings out the face and makes it paler, notwithstanding the fact that it is brick-colored. His hands, the hands of an obstetrician, are paler than the face. Before him, lying on a red garden table, are yellow novels and a fox-glove flower of a somber purple hue.

My self-portrait is done in nearly the same way; the blue is the blue color of the sky in the late afternoon, and the clothes are a bright lilac.

His final observations on the *Gachet* were made to Gauguin. Earlier van Gogh had mocked *Christ in the Garden of Olives*, in which Gauguin had cast himself as the New Testament's redeemer, abandoned and betrayed against a desolate landscape. Calling it "that nightmare of a Christ," van Gogh argued that one could express anguish "without making direct reference to the actual Gethsemane." But now he compared his Gachet portrait to Gauguin's picture: "*If you like,* something like what you said of your *Christ in the Garden of Olives* not meant to be understood, but anyhow I follow you there." For van Gogh, left defenseless against the forces of his illness, the garden in Auvers was his own Gethsemane. The brilliance of *Portrait of Dr. Gachet* came from his ability to transfigure

mundane visual facts into a lyric of crisis and despair. But also he tempered the darkness with notes of red, yellow, white, struck against the dominant blue. That he himself could find any hope in his actual situation seems unlikely. Yet he found solace and transcendence in the act of painting itself. Gachet's order to keep up with his work failed as a practical prescription, but it answered the artist's metaphysical quest.

The first weekend in July the artist visited Paris, an excursion that only exacerbated his worries about his situation as Theo continued to debate whether he should make the long-sought break with Boussod & Valadon. "It is no small matter when for different reasons we are also made aware of the precariousness of our existence," van Gogh wrote to his brother around July 10. When van Gogh returned to Auvers, he fought with Gachet, reportedly over the doctor's carelessness in neglecting to properly frame a painting by Armand Guillaumin, one of the original Impressionists. But on July 23 van Gogh seemed to have gained perspective and to be determined to carry on. "I hope you found those gentlemen favorably disposed toward you," he said to Theo. "As far as I'm concerned, I am giving my canvases my undivided attention. I am trying to do as well as some painters I have greatly loved and admired."

Given his recent ability to manage his troubles, it came as a surprise when on July 27 the artist walked to the fields and shot himself with a revolver. He made his way back to the Auberge Ravoux, where the proprietor found him and called two local doctors, one being Gachet. The bullet had hit no vital organs, but they decided not to intervene. Gachet sent a note to Theo at the gallery in Paris: "At nine o'clock in the evening of today, Sunday, I was sent for by your brother Vincent, who wanted to see me at once. I went there and found him very ill. He has wounded himself." At some point Gachet also used the dying patient as a model for a sketch, somewhat reminiscent of those he made of the artist Charles Meryon when he was incarcerated at Charenton.

Theo arrived Monday, and van Gogh died at 1:30 A.M. the next day. On Wednesday the painters Emile Bernard, Lucien Pissarro,

and Charles Laval came from Paris with the color merchant Julien Tanguy and Theo's brother-in-law Andries Bonger. They carried the coffin through the narrow, crooked streets of the town up to a walled cemetery where van Gogh was to be buried. Across from the church, the cemetery bordered the fields so recently the subject of the artist's canvases.

NORTHERN

EUROPE AND THE

FIRST MODERNIST

COLLECTORS

*The International
Avant-Garde and
the Market*

7

Paris:
Theo van Gogh,
1891

I am now having an exhibition of Claude Monet at my house; it is very successful. It will not be long before the public will be asking for pictures of the new school for they certainly stir up the public mind. —Theo van Gogh to Vincent van Gogh, March 16, 1889

IN THE LATE SUMMER OF 1890, the fate of *Portrait of Dr. Gachet* was far from certain. The canvas was an obscure object worth at most a few hundred francs. It numbered among seventy-odd pictures painted in some seventy days by van Gogh in Auvers; his suicide in the town had turned these into something of a logistical problem. The paintings, scholars have assumed, were stashed somewhere in the inn across from the town hall. His small room could have held only a few pictures. A second, less complex, version of *Gachet*, painted apparently by van Gogh from the original, was given by the artist to the doctor himself. Gachet also received a self-portrait, *Church at Auvers*, and perhaps some two dozen other works from Theo, who reimbursed the physician with pictures.

Despair over his brother's suicide made Theo reluctant to inherit the artist's 600-some paintings. He told his mother,

One cannot write how grieved one is nor find any comfort. It is a grief that will last and which I certainly shall never forget as long as I live. . . . Life was such a burden to him; but now as

often happens, everybody is full of praise for his talents. . . .
Oh Mother! he was so my own, own brother.

At some point Theo had the Auvers paintings picked up and
delivered to Paris, storing them at Julien Tanguy's shop in the rue
Clauzel. In Paris, Theo already had possession of some 500 paintings
and 350 drawings produced by his brother during his four years in
France. (The artist had given away probably 50 pictures.)

Van Gogh's suicide stunned his friends and colleagues. "I was
very distressed to learn of the death of your brother Monsieur Vin-
cent," wrote Eugène Boch. "A great artist is dead." The letter of con-
dolence from the Belgian artist, who had known van Gogh in Arles,
was one of thirty-five received by members of the van Gogh family.
"His loss will be deeply felt by the younger generation," the Impres-
sionist Camille Pissarro told Theo. "You know what a friend he was
to me," wrote Henri de Toulouse-Lautrec.

The abrupt and violent end of van Gogh's difficult life prevented

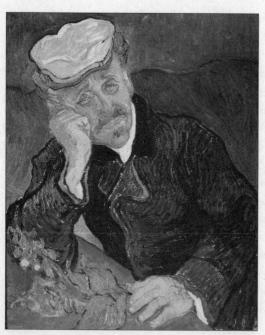

Vincent van Gogh,
*Portrait of Dr.
Gachet*, second
version. Presumably
the artist painted
this version from
the first to give to
Gachet.

Theo from taking any comfort in the knowledge that he had made it possible for his brother to paint. Haunted by the tragic conclusion to his brother's stay in Auvers, Theo now took steps to have van Gogh's art receive the recognition he believed it deserved. "Now there is in your canvases a vigor," he had written Vincent the year before;

> In the course of time they will become very beautiful by reason of the settling of the layers of paint, and they will undoubtedly be appreciated someday. When we see that the Pissarros, the Gauguins, the Renoirs, the Guillaumins do not sell, one ought to be almost glad of not having the public's favor, seeing that those who have it now will not have it forever, and it is quite possible that times will change very shortly.

Only a few weeks after van Gogh's death Theo boldly asked the Impressionist dealer Paul Durand-Ruel if he would hold an exhibition of the late artist's work at his gallery. "Yet not withstanding everything some canvases will find purchasers some day," van Gogh had written, only a few months earlier. Theo knew that an exhibition at the elegant and prestigious site, sponsored by a dealer famous for his success with the Barbizon school and the controversial Impressionists, would best promote his brother's cause. Theoretically, if the exhibition (accompanied by a catalog) met with critical acclaim, the dealer would hope to sell paintings to prominent private collectors, whose involvement in the art world would ensure the artist's continued exposure to other arbiters of contemporary taste.

"Durand-Ruel has absolutely refused to exhibit," Theo wrote Emile Bernard on September 18. "For the moment I can only try to hang as many as I can at home so that they are now on view for whoever shows the desire to become acquainted with my brother's work. In short, could you please give me a hand." With Bernard's help, Theo hung 350 paintings in his old apartment (recently he and Johanna had moved to another apartment in the same building) at 54, rue Lepic. Within weeks of van Gogh's death, *Portrait of Dr. Gachet* appeared in this makeshift retrospective. A checklist handwritten by Andries Bonger, Johanna's brother, served as the catalog. An insurance broker who had lived in Paris in the 1880s, Bonger was

a close friend of Emile Bernard; he was one of the first to buy the work of Paul Cézanne and later became a major collector of Odilon Redon. He assigned the number "251" to *Gachet*.

Theo was not alone in wanting his brother's work remembered and his paintings seen. In the spring of 1891 artists organized memorial exhibitions in Paris at the Salon des Indépendants, and in Brussels at the annual show of Les XX. About the ten paintings on view in Paris, the symbolist critic Octave Mirbeau wrote, "They appear very superior in intensity of vision, richness of expression, and in power of style, to all the surrounding ones." Emile Bernard took up his late friend's cause, arranging a one-man exhibition in 1892 at a new gallery run by Louis-Léon le Barc de Boutteville. Le Barc's gallery, as Albert Aurier put it, planned to "offer a permanent shelter to the young artists, the innovators, who are still opposed by the critics, disdained by the customers, and generally scoffed at by the dealers and the juries." But none of the van Gogh canvases sold.

Sadly, by this time van Gogh had lost his most persistent advocate. Even before the exhibition opened in the vacant rue Lepic apartment, Theo's health began to fail. His behavior became erratic; contemporary reports suggest he was suffering from kidney disease. In October 1890 he entered a Paris hospital; soon he was transferred to a psychiatric clinic in Passy, and the following month to an institution in Utrecht. Meanwhile most of his art collection remained in Paris in the care of Andries Bonger. Six months after van Gogh's death, on January 25, 1891, Theo died at the age of thirty-three. The death of the modernist dealer who grasped the nature of his brother's art dealt a blow to the prospects of van Gogh's paintings. For the moment the artist's canvases and drawings remained locked in an empty Paris apartment, gathering dust.

8

Amsterdam:
Johanna van Gogh–Bonger,
1891–1896

The letters have taken a large place in my life already, since the beginning of Theo's illness. The first lonely evening which I spent in our home after my return I took the package of letters. I knew that in them I should find him again.

—Johanna van Gogh–Bonger, letter to a friend

THEO'S ART COLLECTION now became the property of his widow, Johanna van Gogh–Bonger. When in the fall of 1890 her husband became sick, Johanna, now twenty-eight, had returned to Holland with him and their child (still under a year old). After Theo's death, she decided to remain there. "From various quarters she received the advice to 'clear off' the pictures," her son Vincent Willem van Gogh later wrote, "but she never thought of it." Indeed, preserving hundreds of paintings, which had minimal, if any, commercial value, was a large undertaking. Letters written to her sister from Paris suggest that Johanna did not share Theo's enthusiasm for avant-garde art. When dozens of van Gogh's canvases cluttered their Paris apartment, she had insisted they be removed to Julien Tanguy's shop, where the painter feared for their condition. But Johanna came to appreciate van Gogh's art, even if she never abandoned her somewhat conventional taste. (In 1912 she traded one of her Arles portraits, *La Mousmé*, to a Dutch art dealer for a still life of flowers by

Henri Fantin-Latour.) That among van Gogh's oeuvre there exist only three nudes (all owned by Emile Bernard) has led some scholars to speculate that Johanna might have disposed of others that he, like Degas and Toulouse-Lautrec, had painted in brothels.

Theo's death left Johanna in shock. Her comfortable and protected upbringing as the daughter (fifth child) of a Dutch insurance broker and her marriage to a member of the prosperous van Gogh family who had a promising career as an art dealer hardly prepared her for her bleak and lonely situation. Yet she was a woman of extraordinary conviction, determination, and energy. Before she married, she had studied English literature, worked briefly at the British Museum, and taught at two girls' schools in Holland. In her twenties, Johanna had a youthful, innocent, good-natured face, with slightly rounded features, and she wore her dark hair pulled severely back. Nothing about her appearance—from her high-collared dresses to a slightly anxious expression in her eyes—suggested her experience living for two years in Paris among painters in the French avant-garde.

By the fall of 1891 she had moved to a house in Bussum, a town fifteen miles from Amsterdam, where she supported herself and her son Vincent Willem by doing English translations and taking in boarders. On November 18, 1891, nine months after Theo's death, she wrote in her diary:

> Besides the care for the child he [Theo] left me yet another task, Vincent's work—to show it and to let it be appreciated as much as possible. All the treasures that Theo and Vincent collected—to preserve them inviolate for the child—that also is my task. I am not without an object in life, but I feel lonely and deserted.

With her mission set, Johanna made two decisions that would decisively shape the van Gogh legacy: to bring van Gogh's paintings to Holland, and to edit the letters (there were over six hundred) that the artist had written to Theo over the course of almost twenty years, including, most importantly, the decade when he worked as a painter. These two decisions revealed the grief-stricken Johanna's

pragmatic resolve to maintain control over her late brother-in-law's work. Whatever aesthetic doubts she may have had about the paintings, she followed Theo's example and became a singularly persistent champion of van Gogh's art.

Twice Emile Bernard tried to convince her to leave the paintings in Paris, where they would be accessible to artists and close to the center of the art market. But Johanna, who knew something of the art trade from Theo and could look to her father and her brother for business advice, wanted the paintings brought to the Netherlands. She seems to have taken some pictures already when she returned with Theo in the fall of 1890. By April 1891 Andries Bonger arranged to have some 270 paintings, including *Portrait of Dr. Gachet*, sent to Amsterdam. This shipment of twenty-seven packages (with at most 10 paintings in each) nearly emptied the French capital of the majority of the artist's extraordinary paintings. Deposited in his native land, van Gogh's work was thus relegated to a small country, but one that would appreciate his Dutch heritage and tended to prefer his dark, most traditional pictures. Still, in Paris, even after Theo's collection had gone, dozens of van Goghs remained—some that the artist had left with Tanguy and some that he had given away (to Bernard, Gauguin, Paul Signac, Camille and Lucien Pissarro, and others). Albert Aurier (who owned one of the versions of *Cypresses*) advised his sister to buy "a superb bargain, a *Bouquet of Flowers* by Vincent van Gogh . . . stranded at a bric-a-brac dealers" for some fifteen francs, then the equivalent of about three dollars.

Determined to carry on Theo's crusade on behalf of van Gogh, and needing money, Johanna sought to have the paintings exhibited in Holland, where through the art-dealing empire of the van Gogh family she had connections to Dutch artists and to the trade. Almost immediately her efforts met with success as local artists and dealers embraced van Gogh as a painter in the Dutch tradition. By February 1892 she reported being "busy all the time with the paintings." The proprietors of two traditional Dutch art galleries agreed to take pictures: "There are now finally ten paintings with Buffa in Amsterdam, twenty with Oldenzeel in Rotterdam," she wrote. (Oldenzeel was

originally owned by van Gogh's uncle, Hendrik van Gogh.) On March 3, 1892, she reported visiting an Amsterdam dealer: "I had taken along a little thing of Vincent's—but a very, very beautiful one. . . . now they want to have some on commission. What a triumph." In May Jan Toorop, a Dutch member of the Brussels art society Les XX, organized a retrospective of forty-five paintings and forty-four drawings at the Kunstkring (Art Circle) in the Hague. (The Kunstkring was one of many associations of artists and collectors that began to form in Holland in the mid-nineteenth century for the purpose of sponsoring exhibitions.) The following year, in 1893, the artist Richard Roland-Holst put together an even larger exhibition (eighty-seven paintings and twenty drawings) in Amsterdam, at the Kunstzaal Panorama. Still, few paintings were sold.

But Johanna's most significant contribution to van Gogh's legacy was her editing of the artist's correspondence, a project that seemed to offer solace for her loneliness. "In April, 1889, in our flat in the Cité Pigalle in Paris," she wrote, "I found in the bottom of a small desk a drawer full of letters from Vincent, and week after week I saw the soon familiar yellow envelopes with the characteristic hand-writing increase in number." Undoubtedly, Johanna's training in English literature alerted her to the extraordinary nature of these letters as a monologue on the artist's working method and his spiritual and aesthetic preoccupations, and as a primary source on the revolution in late-nineteenth-century painting. (In 1893 and 1895 Emile Bernard published excerpts from the letters in *Mercure de France*.) Her first task was to put the mostly undated correspondence in order. "Much time was necessary to decipher the letters and to arrange them," she later explained. "This was the more difficult because often the dates failed, and much careful thought was needed before these letters were fitted into their place." Even after she married a painter, Johan Cohen Gosschalk, in 1901, and two years later moved with him to an apartment in Amsterdam, Johanna continued to devote herself to this project. (Her second husband also had health problems, and died in 1912.) Finally, on the eve of World War I, she succeeded in having a "complete" edition of the letters (written in their original French and Dutch) published

in Holland, and also in Germany (in translation). At her death in 1925 Johanna was working on an English edition, which was published in 1928.

In her biographical essay on van Gogh, written as an introduction to the 1914 edition of the letters, Johanna minimized her role in his life and revealed almost nothing about herself. Steadfast and loyal, she gave no hint of the conflicted feelings she may have felt toward her problematical brother-in-law, whose death, as she said, left her husband's "frail health . . . broken." Several of her own letters to van Gogh reflect her generous spirit and a desire to understand him. On the subject of his suicide, she relayed only the bare-bones facts, skirting, as one scholar observed, the "elaborate questioning of motivation and questions of guilt and remorse." In a deliberate effort to present an untarnished image of the van Gogh family, she cut out passages of the artist's letters revealing that his father had attempted to have him institutionalized.

In her essay, Johanna's emotional bond to the memory of her husband and her brother-in-law precluded her objective judgment on certain aspects of their lives, and in many cases her romanticized viewpoint was accepted without question as the entire truth. For example, she sentimentalized Paul-Ferdinand Gachet, seeming to want to believe only the best about the feckless physician: "Dr. Gachet and his children continued to honor Vincent's memory," she wrote in 1914, "with rare piety, which became a form of worship, touching in its simplicity and sincerity." After Gachet's death in 1909, his son Paul sold several canvases but otherwise hoarded the art collection he inherited from his father. He refused to loan his paintings to museums and denied scholars access to them. In the 1930s he could be found in the Gachet house dressed in the same costume that his father wore in the portrait. Later, it was widely assumed that certain canvases from the Gachet collection were copies or pastiches made either by the doctor or by his son, who later tried to pass them off as originals. The taint of the Gachet legacy led certain scholars to question the second version of the Gachet portrait, which Paul and Marguerite Gachet gave to the Louvre in 1949, and other pictures from the family's collection.

THE VAN GOGH LEGEND

The image of the benevolent Gachet, as opposed to the careless, even neglectful physician, fit well into the tragic myth of van Gogh that began to develop immediately after his suicide. Commentators seemed unable to resist identifying van Gogh with the Romantic paradigm of the tormented painter, alienated from a society that misunderstood him. Using his illness and death to frame their interpretations of his life and his art, critics described van Gogh as a martyr whose suicide was the inevitable consequence of a life of struggle, poverty, and psychological pain. Following Aurier's lead, Octave Mirbeau lamented in 1891 that a "beautiful flame of genius had died." Van Gogh, he wrote, went to his death as "unknown and neglected" as he had "lived his unjust life." The French critic also characterized the artist as one who understood the "sadness, the unknown and the divine in the eyes of the poor, mad and sick men who were his brethren." In Holland, critics recalled Theo's part in the sad story: "Two tragedies were enacted for this art," wrote one commentator: that of "a sick genius who reaches for the moon like a child"; and that of "the loving brother who put his faith in that genius." Strikingly, although Georges Seurat's death in 1891 from diphtheria at the age of thirty-two was as sudden and premature as van Gogh's, it was never subject to interpretation, nor associated with his work.

Only three years after van Gogh died, the artist's tragic image was so well established in Holland that Richard Roland-Holst warned that "Van Gogh's art has become the illustration of the sad drama of his life." In a letter to a friend, Roland-Holst faulted Johanna for the emphasis she naturally placed upon the circumstances of her brother-in-law's story: "Mrs. van Gogh considers the best work that which is the most bombastic and the most sentimental—that which makes her cry the most; she forgets that her grief makes Vincent into a God."

But even if Johanna contributed to the construction of the van Gogh legend, she was not its primary author. Rather, the legend evolved from numerous commentaries, written by French, Dutch,

and later German critics, who tended to weld whatever information Johanna and other witnesses supplied into a parable of artistic martyrdom. Ironically, it was not van Gogh's obscurity but his central position in the Paris art world that caused the details of his life to become quickly known to artists and writers who tended to exploit them for melodrama.

From the beginning critics ignored any evidence that conflicted with a sanctified image of van Gogh. No one mentioned, for example, that the artist's illness had been intermittent, or that he had achieved recognition as a painter relatively quickly. Similarly, commentaries failed to cite the advantage he enjoyed over most of his colleagues by being born into a family in the art trade and by having a brother who earned enough money to support him. A fine education, a middle-class background, a family of wealthy dealers, and finally, experience working in a sophisticated, profitable international art gallery ill served van Gogh's image as self-taught outsider, tortured genius, and martyr to the philistines.

9

Copenhagen:
The Danish Secession,
1893

I have never seen a rolling, vibrating, light-drenched field presented in a more striking manner than in such pictures by van Gogh.
—Johan Rohde, 1892

IN 1893, three years after van Gogh's death, Johanna van Gogh received the first request to exhibit *Portrait of Dr. Gachet*. It came not from Paris but from Copenhagen, sent by a band of dissident artists who, inspired partly by the Impressionists, were staging their own exhibitions and seeking, as one critic put it, "to see the sun of the new art rise in Denmark." Calling itself the Frie Udstilling, or Free Exhibition, the group was headed by Johan Rohde, a painter and critic who had extraordinarily advanced taste. "Van Gogh is the greatest Dutch painter of this century," he wrote in 1892, "and in general, one of the great European trailblazers." On February 4, 1893, Rohde wrote to Johanna in French, asking to borrow "a small collection of the finest paintings of van Gogh—10 to 20 pieces." He was planning a special exhibition devoted to van Gogh and Paul Gauguin, both of whom were models to Copenhagen's art avant-garde. By pairing the two somewhat notorious artists (one a suicide, the other self-exiled to Tahiti), Rohde hoped to attract crowds to the Free Exhibition's show of contemporary Danish art, whose creators wanted to associate themselves with the French iconoclasts.

Copenhagen was a small city whose cultural fortunes had ebbed

and flowed along with the rate of artistic and intellectual exchange it maintained with the rest of Europe. Industrialization had restored to the Danish capital a degree of the extraordinary prosperity it had enjoyed in the eighteenth century as one of northern Europe's most important ports. Traditionally, Denmark's strongest ties had been to Germany, whose academies in Munich and Dresden (more prestigious than Copenhagen's academy) had lured Danish artists since the eighteenth century. But an abrupt end to the Danish-German alliance came in 1864, when the Danish defeat in the war against Otto von Bismarck's Prussia meant the loss of the province of Schleswig-Holstein as well as almost one-third of Denmark's population.

After this, Copenhagen's progressive artists looked to France for inspiration and training, spurred on in part by the humiliation suffered at the Universal Exposition of 1878 in Paris, when Danish art was dismissed as backward and provincial. ("Art vegetates in Denmark," as one French critic put it.) The following year, Denmark's Royal Academy of Fine Arts began offering classes in drawing from live models and in painting out of doors. In the 1880s some of the best Danish painters (Peder Severin Krøyer, Vilhelm Hammershøi, and Harald Slott-Møller) revealed the influence of French realism in their pictures of contemporary life. In the 1890s many Danish artists (again following the French) rejected realism for various forms of the new symbolism, some influenced particularly by van Gogh and Gauguin.

Johan Rohde had first heard about van Gogh through a friend, the Danish painter Christian Mourier-Petersen, who had known the Dutch artist in Arles. But Copenhagen artists also had a direct link to van Gogh and the Paris avant-garde through Paul Gauguin, whose wife, Mette Gad, was Danish.

The appearance of the Gachet portrait in Copenhagen in 1893, only three years after its creation, reflected the changing cultural landscape and the dissemination of the French avant-garde to central and northern Europe, whose cities produced their own vanguard movements in painting, sculpture, and decorative arts in the last decade of the century. Paris was no longer the sole source of radical painting. Those painters who had flocked to the French capital in

the 1870s and 1880s had absorbed the lessons of realism and Impressionism and taken these doctrines home, spreading the incendiary tenets of modernism to their native countries. By the turn of the century the European avant-garde formed a loose international network of artists, critics, dealers, and collectors, with multiple personal and professional ties. Perhaps ironically, this network depended on the mobility that came with Europe's unrelenting industrialization. At the time, northern Europe was connected by 87,000 miles of railroad track; in the twenty years since van Gogh had signed on as an apprentice at Goupil's gallery in the Hague, the railroad network had doubled.

Denmark's Free Exhibition group, founded in 1891, was one of the first of the artist exhibition societies, or Secessions, that emerged in the 1880s and 1890s in the cultural capitals of northern Europe and declared their independence from the art academies, which had become increasingly incapable of supporting growing populations of artists. The first Secession was the Belgian Les XX, founded in 1884. Others formed soon afterward—in Munich in 1892, in Vienna in 1897, and in Berlin in 1898. The Secessions were elite, self-selected collectives whose members insisted on showing their work on their own terms in small, carefully staged exhibitions designed to stamp their identities on the consciousness of the art public and to lure patrons from among the bourgeoisie, which formed the market for experimental art. While the Secession artists tended to cast themselves as aesthetic progressives, their disputes with the establishment generally had to do with the control of exhibitions and the economic conditions of the profession.

The Secessions played a crucial role in the reception of van Gogh, whose art they promoted in order to publicize and explain their own. Even before van Gogh's death, Les XX had exhibited his works in their annual show and published excerpts from Albert Aurier's article in their magazine *L'Art moderne*. In 1901 five of van Gogh's paintings appeared in an exhibition of the Berlin Secession; two years later others went on view in Munich and in Vienna. Among the Secessions, Vienna's offered the most unified and advanced aesthetic program, embodied in the languid art nouveau or

Jugendstil of the painters Gustav Klimt and Egon Schiele and the designer Josef Hoffmann. With Klimt's persuasion, in 1903 the Vienna Secession artists bought one of van Gogh's late panoramic landscapes, *Plain at Auvers*. To vanguard artists, Van Gogh "was the overpowering revelation," the British critic Roger Fry later explained. His example "destroyed in them the prestige of a culture which preached the doctrine that all real works of art were already enshrined in museums, and that the best that could be hoped for from the modern artist was the multiplication of skillful pastiches." The desire of these artists to champion van Gogh eventually helped fire the interest of dealers ready to back modernist art and of collectors, who often socialized in avant-garde circles.

Interestingly, van Gogh's art appealed first to the countries of northern Europe, where it had deep affinities to a collective visual heritage distinct from the classical tradition of Italy and France. The art historian Robert Rosenblum rightly characterized van Gogh as heir to the northern Romantics. "Again and again, his search for the supernatural in the natural, for the symbol in the fact," writes Rosenblum, "meant that he would duplicate, in most cases quite unconsciously, the imagery of much Northern Romantic art." In Belgium, Holland, Germany, and Scandinavia, artists and critics jumped to explain the significance of his work, label him as their own, and bring him back, as it were, to his place of origin.

When in 1892 the Free Exhibition leader Johan Rohde arrived in Paris, he carried a letter from Mette Gauguin to the painter Emile Schuffenecker. Seven years before, Mette had left France with her five children and moved back to Denmark, where she hoped more easily to support them. Joining her in Denmark, Gauguin tolerated Scandinavia for only six months. She remained, teaching French and trying to find a market for her husband's pictures. She lived above the café Bernina, a bohemian gathering place, where she mixed with Copenhagen's literary and artistic vanguard; her brother-in-law was Edvard Brandes, a founding editor of the radical paper *Politiken* (*Politics*); his brother, Georg Brandes, was an internationally renowned literary critic who was instrumental in publicizing the works

of Friedrich Nietzsche. Theo van Gogh's death had left Gauguin without a Paris dealer, and Schuffenecker had agreed to store his paintings while he was in Tahiti. Like Gauguin, Schuffenecker had been a stockbroker and had quit the Paris exchange to become a painter.

In Paris, Rohde visited Tanguy's "paltry" shop, where he discovered "excellent Provençal landscapes . . . and a strongly characterized but coarsely painted portrait of old man Tanguy." In search of other van Goghs, Rohde traveled from Paris to Holland. In the Hague he found the van Gogh exhibition at the Kunstkring. He himself could not afford any of the canvases, but for a Danish friend he bought a Saint-Rémy landscape (*Mountainous Landscape behind Saint-Paul's Hospital*). ("Mr. Rohde appears to be a highly cultivated man, though it is extremely awkward to talk to him, since he speaks German so poorly, seems deaf, moreover, and has a very weak voice," wrote a Dutch artist who met him there. "No one talked him into buying it [the picture], as has been known to happen.")

THE GAUGUIN AND VAN GOGH EXHIBITION

"Yes, that would be very beautiful," Johanna van Gogh replied to Rohde in February 1893, "a room with nothing but works of Gauguin and of Vincent and there is something touching that the two friends are reunited here by their work." Denmark, she sniped, was more receptive to modern art than Holland. Rohde had offered to pay the costs of both shipping and insurance, and suggested that van Gogh's pictures might find buyers in Copenhagen. To select canvases for the exhibition, Rohde asked Georg Seligmann, a Danish artist who happened to be living in Holland, to meet with Johanna. Seligmann at first objected to the notion that the Danish artists should be showing "foreign art." But he saw Johanna on February 26 and chose twenty paintings and four drawings ("The drawings I have gotten are his best. Superb, excellent," he wrote). Besides several landscapes, many from Arles, and flower pictures, the artist chose two portraits: one of the hospital attendant Trabuc; the other, *Portrait of Dr. Gachet*. "I would willingly have taken all his paintings

and drawings," Seligmann wrote, "but I suppose that would have been too much. What an extraordinarily fine artist he must have been." But the visit depressed him. "On Sunday I could clearly feel the mood of sadness which the husband's death had left in the house," he wrote. After helping Johanna set prices on the pictures, he told Rohde that if necessary she would also accept bids.

On March 25 a heavy snowfall covered Copenhagen, but 1,500 visitors filed into the Free Exhibition on its first day. "Various 'open-thinking' authors and journalists in the company of short-cropped ladies who indulged in vociferous enthusiasm," was how one newspaper described the crowd at the opening. Of the fifty-one works by Gauguin, ten were exotic images of Tahiti. Unfortunately, the twenty-two van Goghs were delayed in transit and arrived only on April first.

Predictably, the conservative papers attacked the pictures. "A kind of revolutionary hieroglyph painting which throws overboard all the capital that art has hoarded up for centuries," one critic blasted. But such denunciations were countered by the liberal press, whose critics employed the overheated language of Albert Aurier and, rejecting any conventional criteria, lauded van Gogh's art for its emotional pitch. "There burns a fanatical fire in the works of van Gogh," the poet Johannes Jørgensen wrote. "The man whose brush has painted these pictures is one whose sensibility seems stronger, stranger, and more profound than the normal run of men. Life dazzles him, drugs him, fills his soul until it well-nigh bursts." Another critic, in *Social-Demokraten*, argued that the "pictures are not just representations of reality, they are poems, fantasias, symphonies." A "frenzied riot of colour," he claimed, "rampages through his pictures with a clamour so insistent that it drove the artist to madness and suicide." Two critics singled out *Portrait of Dr. Gachet*. One explained it as "symbolist" portrait, in which instead of copying the appearance of his subject, the artist used it to convey an idea.

The artist has not been under obligation to paint Dr G the way he looks; so that each feature is a likeness. He has painted the melancholy in his character through a number of furrows

in his forehead and around the mouth, through giving the person a posture which conveys the most profound ennui, and through letting the blue eyes gaze out in space with an expression of exhaustion and resignation.

But despite critical praise, neither Mette Gauguin nor Johanna van Gogh could consider the exhibition a financial success. Gauguin had instructed his wife to set the prices of the Tahitian canvases high—at between 700 and 800 francs apiece. For *Manao tupapao* (*The Specter Watches over Her*), which Thadée Natanson, writing for *La Revue blanche*, called "The Olympia of Tahiti," he wanted at least 1,500 francs. "In general, the harmony is somber and frightening," Gauguin told Mette, "sounding on the eye like a funeral knell." Mette ended up selling several pieces, but each for only about 100 francs.

Johanna, on the other hand, refused to cut prices and sold only one drawing. For this, she received the relatively substantial sum of 200 francs. *Portrait of Dr. Gachet*, no. 71 in the exhibition catalog, was not for sale. Understandably, Johanna held on to the canvases with personal significance and sentimental value: the self-portraits, "*Yellow House*," *Van Gogh's Bedroom*, *Gauguin's Chair*, and a version of *Sunflowers*. But some of the paintings later recognized as van Gogh's most important—the beautiful *Rain: Behind the Hospital* and *Enclosed Field with a Peasant*—she sold. Soon she would change her mind about *Portrait of Dr. Gachet*.

10

Paris:

Ambroise Vollard,

1897

*Can you leave it as you had written me with this modification
that the* Black Shoes *be replaced by the* Portrait of Dr. Gachet?
— Ambroise Vollard to Johanna van Gogh, 1897

JULIEN TANGUY died in April 1894, and his shop was closed. Exactly
how many van Gogh canvases the honest but unreliable paint mer-
chant had sold remains a mystery, as he often failed to inform
Johanna van Gogh when someone bought a picture. Tanguy's death
effectively cut Johanna's commercial ties to the Paris market. Now,
seeking a more established agent, she got in touch with Paul
Durand-Ruel, who three years before had rejected Theo's request for
an exhibition of his late brother's work. This time the Impressionist
dealer agreed to take some paintings on consignment. Perhaps he
pitied the widow of his former rival. Also, van Gogh's reputation
had not faded. "The young people are full of admiration for . . . van
Gogh . . . ," the neo-Impressionist Paul Signac complained to his
diary. "And for Seurat," he added, "oblivion, silence."

In Paris, Johanna acknowledged, enthusiasm had not translated
into sales. "Until now the canvases that the late M. Tanguy sold for
me obtained only very modest prices; not more than 400 or 500
francs," she wrote the dealer, "whereas in Holland, I have sold a few
for 800 and 1,000 francs." In April 1894 Andries Bonger delivered

to Durand-Ruel ten of what seemed the most marketable van Gogh canvases—lush still lifes and landscapes.

On May 2 Durand-Ruel informed Johanna that someone had agreed to pay 550 francs for three of the paintings—two landscapes (*Poplars* and *Oranges in Bloom*) and a still life of lemons. Eager to sell, but wanting to salvage prices from complete collapse, Johanna countered: for 550 francs she would trade two canvases. Unfortunately the offer was rejected, and she heard nothing for six months. "We have not sold a single one of the paintings by M. Van Gogh," the gallery informed her. In February 1895 Durand-Ruel returned the pictures.

A year later, in March 1896, *Portrait of Dr. Gachet* went on exhibition twice in the Netherlands: first in Groningen, in a show organized by university students, and shortly after in Rotterdam, when that same exhibition moved to Oldenzeel's. At this point Johanna seemed willing to sell the portrait. While appreciating the attention of the Dutch dealers, she knew that to establish van Gogh as a modern artist required recognition in Paris.

The previous June, at an art auction at the Hôtel Drouot organized to raise money for Julien Tanguy's widow, two van Goghs came up for sale. As no one had stepped forward to bid up their prices, the dealer Eugène Blot spent only 100 francs on the *Factory at Asnières*, and a small *Pair of Shoes* went for no more than 30 francs. The buyer was Ambroise Vollard. Vollard had recently opened a gallery with an exhibition of Manet drawings, borrowed from the artist's widow. Although the Tanguy sale implied that in Paris a van Gogh market barely existed, eventually Johanna heard from the ambitious Vollard. The dealer had no doubt noted that the artist's modernist peers and successors had exhibited his work along with their own in exhibition societies, including the Indépendants in Paris, Les XX in Brussels, and the Free Exhibition in Copenhagen. Nevertheless, Vollard's interest in van Gogh came at a critical point.

Vollard's entrance into the Paris market in 1893 revealed a calculated, if idiosyncratic, approach. His gallery, three meters in width, was literally a stall, but strategically placed at 39, rue Laffitte,

down the street not only from Durand-Ruel at no. 16 but also from Bernheim-Jeune at no. 9. Since the early 1890s, the brothers Gaston Bernheim and Josse Bernheim (sons of Alexandre Bernheim, who had transferred his gallery from Brussels in 1873) had stocked Impressionist and Postimpressionist pictures. They specialized in works by the Nabi artists Pierre Bonnard, Edouard Vuillard, and Félix Vallotton, who in 1899 would marry the Bernheims' sister. Vollard purposefully located his gallery on the main thoroughfare of the market for modern art, only blocks from Goupil's headquarters and the Opéra. "A young man . . . has opened a small gallery in the rue Laffitte," Pissarro wrote his son Lucien:

> He shows nothing but pictures of the young. There are some very fine early Gauguins, two beautiful things by Guillaumin, as well as paintings by Sisley, Redon, Raffaëlli, de Groux. . . . he likes only our school of painting or works by artists whose talents have developed along similar lines. He is very enthusiastic and knows his job. He is already beginning to attract the attention of certain collectors who like to poke about.

Later, Pissarro's enthusiasm for the dealer waned. "Vollard, of this you can be sure, doesn't bother with anything he can't sell; reputation! the rest means nothing to him . . . he doesn't give a damn about the others . . . he wants names."

Self-interested or not, Vollard soon became the most important dealer of contemporary art in Paris. Difficult, sometimes tyrannical, he modeled his business on the gallery of Durand-Ruel, the gentlemanly speculator who was already renowned as a champion of neglected genius. Taking his cue from the Impressionists' dealer, Vollard portrayed himself as a courageous iconoclast and talent scout, a discriminating defender of unrecognized artists; to his patrons his aggressive pricing proved the validity of his aesthetic judgment and his ability to bet on art that would soar in value. In his memoirs (one of his vehicles of self-promotion), Vollard portrays himself as the ultimate art world insider, dropping the names of both artists and amateurs (private collectors) as he gives snapshots of his

life in the trade, while underscoring the theme that great art inevitably rises in value. He mocks a benighted collector who had passed up van Gogh's *Field of Poppies* (for 400 francs) to throw 15,000 francs away on an academic picture that twenty-five years later had no value. By then, he claims, the van Gogh was worth more than 300,000 francs. Like other great art dealers, Vollard melded his pervasive appetite for art with his skills as an entrepreneur. "I was hardly settled in the rue Laffitte when I began to dream of publishing fine prints," he wrote. "My idea was to obtain works from artists who were not printmakers by profession." He began publishing prints, albums, and illustrated books in 1896, encouraging his artists to experiment while extending their audience.

Shortly before writing Johanna van Gogh in 1895, Vollard gave Paul Cézanne, then fifty-six years old, his first one-man show, exhibiting some fifty of the artist's paintings, which he was forced to rotate in the tiny gallery. The Cézanne exhibition alone secured his reputation among progressive artists and later his place in history. Whether Vollard himself had extraordinary taste, he was clever enough to take the advice of artists. In the Cézanne show "there are exquisite things," wrote Pissarro; "*Still lifes* of irreproachable finish, *others very worked up* and yet left flat, still more beautiful than the others, landscapes, nudes and heads that are incomplete yet truly grandiose and so painterly, so supple." Although later the Bernheims attempted to woo Cézanne away from Vollard, he refused to abandon his first dealer. In 1899 Vollard commissioned Cézanne to paint his portrait. The dealer claimed the picture required 115 sittings, a figure he may have exaggerated so as to emphasize his close relationship with the master. The full-length portrait, considered a masterpiece, depicts Vollard in an ocher-toned suite, seated with a book in his lap. In the charcoal shadows subsuming the canvas, the artist conveyed the dealer's veiled and cryptic presence. Picasso also painted Vollard with the dealer's eyes closed, splintering his body into countless cubist planes.

In 1901, less than a decade after Vollard had started dealing in modern art, Maurice Denis acknowledged him as a pivotal figure in the Paris avant-garde by including him in a group portrait he called

Homage to Cézanne. In the painting Cézanne stands to the left, beside one of his still lifes, placed on an easel. Facing Cézanne are six of the Nabi artists (Pierre Bonnard, Paul Ranson, Ker-Xavier Roussel, Paul Sérusier, Edouard Vuillard, and André Mellerio) as well as the symbolist Odilon Redon and Denis's wife, Marthe. Behind the easel, but center stage, is the bearded Vollard, silent partner to the painters' creative enterprise, the middleman between modern artists and collectors. The Nabis, disciples of Gauguin who had established themselves as a new movement, now relied on Vollard to single them out as individuals, stake them to one-man shows, and support them with stipends in exchange for production. Above all, they depended upon the dealer to attract buyers who counted on his word, and believed in his ability to identify the taste of the future.

In France, dealers in contemporary art were a relatively recent phenomenon; they had grown up on the edges of a patronage system

Maurice Denis, *Homage to Cézanne*, 1900–1901. The painting depicts Cézanne and the Nabi artists; behind the easel stands the dealer Ambroise Vollard, who exhibited *Gachet* in Paris in 1896.

dominated by the academy, which had built artists' reputations through the Salon. Under the ancien régime, dealers originally dealt in old masters, negotiating international sales that moved works of art between the courts and the affluent households of Europe. When the chief patrons of art were the king, the aristocracy, and the *haute bourgeoisie* who mixed with the noble circles, artists generally worked directly for these patrons, who were considered their social superiors. Typically, artists were given specific commissions. Members of the French academy had studios in the Louvre Palace, and the public could wander in off the street. To guarantee their professional status and integrity, the academy forbade its members from actively engaging in commerce or employing promotional practices to sell their work. Because of this prohibition, artists left few records of what, if any, commercial transactions they made.

By the early eighteenth century, after the death of Louis XIV in 1715, artists found they could no longer depend exclusively upon income from their academic posts and commissions; increasingly they needed to market their works to private collectors. Even before Louis's death, Charles Le Brun, his court painter and the director of the Royal Academy, had churned out portraits to supplement his income from the crown.

In the seventeenth century, only in republican Holland did artists paint mostly for the open market. Although some Dutch painters preferred the certainty of producing for a single patron, Rembrandt in particular—as the art historian Svetlana Alpers argues—thrived on the freedom to paint for the market, and his distinctive, unfinished style, emphasizing the physical presence of paint, served to establish his identity among his commercial competitors.

By the eighteenth century, several of the Paris dealers seem to have bought and sold art made by contemporary painters. But according to art historian Andrew McClellan, dealers did not figure largely in the careers of French artists at the end of the monarchy; instead painters actively worked at self-promotion, seeking private commissions and getting printmakers to publish engravings after their own pictures.

Ironically, the French academy's success in creating a group of

professional artists and a large art public produced the conditions for the system's ultimate collapse. By 1863, the sociologist Harrison White estimates, some three thousand artists in Paris and one thousand more in the provinces were producing some two hundred thousand "reputable canvases" every decade. "Three hundred provincial museums there might be, government commissions for public works there might be," White wrote, "but the only possible paid destinations for the rising flood of canvases were the homes of the bourgeoisie." Under the aegis of the academy, with its rules and standards, artists had come to think of themselves as professionals; most also aspired to middle-class incomes, an economic goal typically encouraged by their own bourgeois origins. As the century progressed and the market grew increasingly competitive, the Salon, intended as a showcase of history painting, was increasingly filled with portraits, genre scenes, and landscapes, which appealed to potential buyers from the middle classes.

When the Impressionists and other avant-garde artists pursued their fortunes outside the academic system and aimed their paintings at the open market, their professional success hinged on critics, who explained their work, and dealers, who created a demand for it. As Courbet found a champion in Jules Champfleury, and Manet in Emile Zola, the Impressionists had several defenders, including Edmond Duranty, who brilliantly articulated the significance of their pictures. While in the mid-nineteenth century Adolphe Goupil and Jean-Marie Durand had profited by dealing in pictures by artists who had become famous at the Salon, later Paul Durand-Ruel (Jean's son) did not simply broker the Impressionists' pictures but publicized, validated, and made a market for their experimental work.

In 1896 Vollard moved to a larger shop at 6, rue Laffitte. The new gallery had brown walls, and none of the refinement and elegance that greeted clients at the galleries of his competitors Durand-Ruel and Bernheim-Jeune. "It did not look like a picture gallery," wrote Gertrude Stein, who went in 1904, wanting to buy a Cézanne. "Inside were a couple of canvases turned to the wall; in one corner

was a small pile of big and little canvases thrown pell-mell on top of one another, in the centre of the room stood a huge, dark man glooming. This was Vollard cheerful." The painter Maurice de Vlaminck reported that the paint was peeling and that two straw chairs and a single table piled with catalogs were the gallery's only furniture. Vollard's ramshackle decor amused and intrigued Stein and Vlaminck, as it undoubtedly intrigued the dealer's upper-middle-class clients. The gallery's eccentric character and offbeat ambience offered a perfect setting for the works of genius the dealer purveyed, and distanced him from the commercial aspect of his profession. In fact, Vollard was a master at courting wealthy aristocrats from America and Germany alike by initiating them into the inner sanctum of the Paris art world. At dinner parties held in the gallery's "cellar," his wealthy clients mixed with the Nabi artists, and sampled exotic "creole" food.

Eventually Vollard accumulated an extraordinary group of international clients, some of whom assembled historic modernist collections. Among the most important were Harry Havemeyer ("the sugar king," as Vollard put it), and his wife, Louisine, who would later endow the Metropolitan Museum of Art with one of the world's great Impressionist collections. Louisine was a friend of the artist Mary Cassatt, who advised her on collecting. "Vollard is a genius in his line," Cassatt told Louisine in 1913. "He seems to be able to sell *anything.*" In 1901, when Vollard overextended the business, Harry Havemeyer gave the dealer a loan that, according to Cassatt, staved off his financial collapse. Other major clients were the Russians Sergei Shchukin and Ivan Morosov, whose extravagant purchases (later confiscated by the Soviet state) gave the Hermitage Museum in Leningrad a trove of Postimpressionist canvases.

In photographs, Vollard appears a tall, burly, often scowling character whose suits were rumpled and whose dark complexion inspired the nickname of "black Lorenzo de Medici." Born July 3, 1866, the son of a French government official, he had grown up on Réunion, a colonial island off Madagascar. When at twenty-four he arrived in France, he intended to study law at the Ecole de Droit. Quickly, "the cramped streets of the Latin Quarter" distracted him.

He liked to sift through the secondhand booksellers' stalls along the Seine, where he found cheap drawings and prints. By 1893, after failing some of his exams, he had taken a job at an art gallery, Union Artistique, owned by Alphonse Dumas, a dilettante painter.

Once he grew knowledgeable about the market, Vollard saw the opportunity left by the death of Theo van Gogh. Prices for the Impressionists and their followers were rising. In March 1894, at an auction of the collection of the critic Théodore Duret, a Monet (*The White Turkeys*) sold for 12,000 francs. That May Durand-Ruel attached this 12,000-franc price to Monet's paintings of the Rouen Cathedral in an exhibition of fifty of the artist's pictures. The following year, 1895, officials at the French national museums (not without a fight) agreed to accept thirty-eight canvases from a collection bequeathed by the artist Gustave Caillebotte to the Musée du Luxembourg. But the state refused certain of the Caillebotte canvases, including three Cézannes. Vollard claimed his first Cézanne show to be an act of defiance against the Caillebotte rejections; one of the rejected Cézannes he set in the gallery's window.

From the start, Vollard insisted on buying low and on taking a profit on everything he handled, including risky canvases by Vincent van Gogh. He claimed he never negotiated prices, except upward. Indeed, if clients balked at a purchase, they rarely had a second chance. In the late 1930s he offered *Boy in the Red Waistcoat* and six other Cézanne watercolors to Knoedler's in New York for 5,000 francs apiece. When the gallery's directors hesitated, he turned around and sold all the paintings to the Berlin dealer Walter Feilchenfeldt. (All but *Boy in the Red Waistcoat*, Vollard had kept rolled up under a bed.) Vollard's freewheeling style required independence, which he retained until 1906, when the cost of a cache of 137 Cézannes forced him to join a syndicate.

Vollard had a reputation for being cheap and careless. Gauguin, who depended on him for funds in Tahiti, called the dealer "the most voracious kind of crocodile." The artist had agreed to turn over his entire output to the dealer in exchange for 300, then 350, francs a month, but Vollard often neglected to send the money. "Nothing to Vollard," Gauguin instructed, "except at fair prices; especially

since Vollard never makes an offer until he has already secured a client, and a 25 percent commission does not satisfy him. And it doesn't matter what one says to him; he doesn't give a damn as long as he is successful."

On May 9, 1895, Vollard wrote to Johanna van Gogh and asked to borrow ten paintings, preferably still lifes of flowers, for a van Gogh exhibition. Paris had not seen a show of the artist's work in four years. On June 7, Vollard again appealed to Johanna. The exhibition had opened three days before and he wanted pictures to supplement those he had obtained in France. Not until July 3 did Johanna send Vollard the ten pictures he had requested. Already, Vollard had made himself known as a source of the artist's paintings, acquiring them through connections to those (including Bernard, Gauguin, and the late Aurier) who had obtained them directly from the artist. To get hold of canvases given away by van Gogh in the south of France, he dispatched an agent, who bought the beautiful *Night Café* and several other pictures from M. and Mme Ginoux in Arles. Somehow, the Roulin family portraits also came into the dealer's possession. Reportedly, he let it be known that he could be relied upon to make markets for certain artists, including Cézanne, Gauguin, Armand Guillaumin, and van Gogh, with a standing offer to pay a flat 100 francs for any picture.

After dispatching the ten canvases to Paris, Johanna van Gogh heard nothing from Vollard for months. Meanwhile, Vollard held his first Cézanne show. Finally, in March 1896, nine months after Johanna had sent the pictures to Paris, Vollard informed her that he had sold a Paris-period painting: *Salle de Restaurant* (*Room of the Restaurant*). It had made a meager 180 francs, but he wanted to go further with van Gogh. He planned to come to Holland in two or three weeks to choose canvases that he thought might find buyers in Paris. But he never arrived. Four months later, in July, after having moved his gallery down the street to no. 6, he told Johanna that he wanted a group of paintings sometime before November, when he intended to open a second, larger van Gogh exhibition. Not until November 2 did he appear in Amsterdam. There he selected forty-

six canvases and ten drawings, which Johanna shipped to rue Laffitte. One of the canvases he chose was *Portrait of Dr. Gachet*.

As planned, the second of Vollard's van Gogh exhibitions opened in November 1896. For the first time since Theo's makeshift 1890 show in the apartment, the Gachet portrait was on view in the French capital; a French dealer had hung it in a gallery and offered it for sale. A relatively small picture of an old man, the painting was one of the cheaper canvases to be had at Vollard's, priced at 300 francs.

As both the owner of the van Goghs and the dealer were anxious to make the exhibition a financial success, they had set prices with a substantial spread: from a low of 180 francs to a high of 1,000 francs. At the top, there was only the dark, dazzling *Rhône at Night*. They considered two sunflower (*Soleils*) pictures—with backgrounds of blue and of green—almost as desirable, at 800 francs each. A number of other landscapes cost 600 francs: *Wheatfields*, *Storm Effect (Birds)*, *Along the Seine at Asnières*, *Along the Seine at Clichy*, and *La Grande Jatte*. *Gachet*'s 300-franc price they gave to four other pictures—*Landscape at Auvers*, *Yellow Books*, *Snow Scene*, and *Laundresses on the Bank of the Rhône*. Besides *Gachet* (no. 26 on a list written out by Johanna) Vollard had chosen two other portraits: a version of *L'Arlésienne* (400 francs) and a self-portrait that was not for sale. Set among van Gogh's late landscapes, the three portraits—of himself and of his friends Dr. Gachet and Mme Ginoux (both of whom he had painted in the pose of melancholy) must have created a dramatic effect.

Letters from Vollard to Johanna show that the dealer procrastinated. He took months to return the paintings. He wanted six pictures, but dragged out the negotiations, demanding to pay the minimum and trying to avoid risking his own money. On February 3, 1897, he informed her that he had changed his mind and wanted to replace one of the six pictures for another. "Madame," he began.

Excuse me for not having responded sooner to your letter. I will not delay sending back the canvases of van Gogh. The

newspapers—contrary to every hope—won't concern them-selves with this exhibition.

I am still negotiating with various people about the lot of paintings about which I had spoken to you. Can we leave things as you had written me with the following modification: that the *Souliers noirs* (*Black Shoes*) be replaced by the *Portrait of Dr. Gachet*?

He also mentioned a Renoir and a Pissarro picture that she had sent him and haggled about their prices, suggesting she reduce what she was asking by 25 percent.

Two weeks later he wrote again stalling for time, claiming to be "occupied for the moment with having reproductions made of one of the van Goghs." (He added, "It's an experiment which I believe will be very unusual. If it works, I'll send you one.") He wrote again on March 7, saying that negotiations were going well, but still failing to make a firm or precise offer for any of the fifty-four pictures in his possession.

Finally at the end of March Johanna heard from him again. His complaints included her inflexibility on the pricing of the Pissarro and the high cost of framing, an expense, he argued, that exceeded his fee. But he delivered a concrete offer for six canvases and ten drawings. The Gachet portrait was one of them. The price for six-teen works: 2,000 francs.

Paris the 29th of March 1897

Madame

Only today I put together your boxes of the paintings and drawings by van Gogh which I send you by slow mail. . . . The business concluded are these:

The three triptychs; the canvas in bad condition representing the washer women; the portrait of van Gogh; the portrait of Dr.

Gachet. And also 10 drawings selected among those which were not catalogued regarding price. Altogether 2000 francs.

le Pissarro 400
le Renoir 200
 2600 francs.

total *two thousand six hundred francs,* from which my commission of 10%, becomes then: *two thousand three hundred forty francs* which I will give you in a bank draft, at the time when you have informed me that you have received the paintings and drawings. . . . Do not doubt that this entire small commission (around 260 francs) only represents half only of my expenses for framing etc. etc. which comes close to *five hundred francs* . . . calculating that I have left this exhibition up for close to two months as much as I had the desire to do business. For the drawings you will find three with frames. I had framed them because I was hoping to sell them. I didn't want to take them apart. Salutations . . .

Vollard

Vollard seemed to assume that each of the six canvases cost 250 francs (for a total of 1,500 francs) and the ten drawings cost 50 francs apiece (for 500 francs); he then deducted his 10 percent. Based on these assumptions, *Gachet* cost the dealer about 225 francs. (This price was exactly 25 percent below the 300-franc price they had assigned the picture.) Still, Vollard had no qualms about driving a hard bargain with Theo van Gogh's widow. First, he had accepted the paintings only on consignment. (He may even have forced her to pay for shipping.) Later, when the dealer secured buyers for six of the pictures, he never revealed who they were or exactly what prices they had agreed to pay. Instead, he seems to have calculated a sum that he wanted to give for the six canvases, shaving it further by his "commission" of 10 percent. He had risked none of his own money, and she must have suspected that in the end his profit, though not

large, exceeded 10 percent. Despite Vollard's irritating terms, Johanna seems to have swallowed them.

Johanna was not paid quickly either. When Vollard's check finally arrived in Bussum, she found it had been drawn on a French bank and could not be cashed. Not until August 1897 did Johanna record Vollard's payment in hurried longhand on a page of an account book:

> Aug 97 bought by Vollard Paris, triptych, portrait of Dr. Gachet, and self portrait and drawing f [florins] 1120.

The sale of *Dr. Gachet* and five other van Gogh canvases ended transactions between Johanna van Gogh and Vollard. From his point of view, she insisted on setting prices at levels too high for the Paris market. When she refused to capitulate, he dropped the whole proposition. He continued to buy van Gogh paintings, but not from Johanna, and he never invested in large quantities of the artist's work, as he did with Cézanne.

Wary of being exploited, Johanna disliked Vollard's inexact way of working, and after their successful but protracted business, she wanted nothing more to do with him. Still, Vollard's two exhibitions bolstered the works of the late Dutch artist with commercial legitimacy. For the moment Vollard remained the Paris dealer to whom you went if you wanted a van Gogh. In the course of Johanna's brief and strained alliance with Vollard, she had cut whatever emotional ties she had to *Portrait of Dr. Gachet*, and he succeeded in selling it.

11

Copenhagen:

Alice Ruben,

1897–1904

[April] 30 Mme Faber first payment/Dr. Gachet 200
—Ambroise Vollard Account Book, 1897

IN THE SPRING OF 1897, as Ambroise Vollard was negotiating with Johanna van Gogh for a group of paintings, Alice Ruben visited his new gallery on rue Laffitte. Like the American collectors Louisine Havemeyer and later Gertrude Stein, she came to the legendary dealer seeking examples of the most up-to-date French art. There she saw *Portrait of Dr. Gachet* and made the decision to buy it.

According to the dealer's haphazardly kept account books, Alice Ruben bought *Gachet* on April 30, 1897, giving him a down payment of 200 francs. Presumably she agreed to the 300-franc price he had established with Johanna. (She may have paid more; Vollard's books only record her first payment.) At 300 francs, the painting cost $58 in 1897. (In 1995 dollars, this sum would be just over $1,000.) Those shopping in Paris for Postimpressionist art would have found the van Gogh picture to be relatively inexpensive—the price charged by Paul Durand-Ruel the year before for some of the cheaper pictures in his exhibition of Pierre Bonnard. Up until now, Vollard's price was speculation. But Alice Ruben established the portrait as a marketable commodity and gave it the beginning of a provenance.

Alice Ruben was a sometime artist and peripheral member of

Copenhagen's Free Exhibition group; she was also a collector and patron of several Danish artists, who were her friends. She had first encountered van Gogh's canvases at Copenhagen's *Gauguin and van Gogh* exhibition in 1893. She was then married to the art critic Emil Hannover, who wrote for the newspaper *Politiken*. On the subject of van Gogh, Hannover had written, "Together with Gauguin, the future will without doubt rank him as the one who offered the most courage and talent for the sake of artistic renewal at the end of the 19th century." The Hannovers had owned one of Gauguin's Brittany landscapes, which they bought from Mette Gauguin in 1893 and loaned to the *Gauguin and van Gogh* exhibition.

Now Alice Ruben was in Paris on a trip with her second husband, Poul Kuhn Faber, a physician for whom she had left Hannover four years before. In Paris, Alice and Poul Faber spent time in the galleries; they also visited Maurice Denis at his studio in Saint-Germain-en-Laye on the outskirts of the city. Alice had undoubtedly been introduced to the Nabi artist through Hannover, Johan Rohde, or another member of the Danish avant-garde. From Denis, Faber bought a chalk-toned painting of a mother and child (*Maternité à la pomme*, or *Madonna with an Apple*). In February 1897 Denis recorded the purchase in his notebook: "L'enfant nu [naked child] . . . Dr. Faber, Copenhagen." Alice Ruben and her new husband took both the Denis picture and *Portrait of Dr. Gachet* back to Denmark. At that point, in 1897, Copenhagen had in its private collections three van Gogh canvases, or more van Goghs than any other city besides Amsterdam and Paris. (According to descendants of the Ruben family, Alice's sister, Ella, owned a version of *L'Arlésienne*; one of these portraits of Mme Ginoux had also appeared in Vollard's exhibition.)

As a member of the upper bourgeoisie with a passion for radical painting, Alice Ruben resembled other clients of Ambroise Vollard who came to Paris scouting for art at the end of the nineteenth century. Born in 1866, Alice Ruben was the eldest of five children of Ida Coppel and Bernard Ruben, an entrepreneur, who had turned his family's cotton mill into one of the largest textile firms in Denmark. The Rubens were among Denmark's assimilated upper-middle-class

Jewish families, many of whom had intermarried with their Christian counterparts once Denmark granted equal citizenship rights to its Jewish population, in 1814. Alice grew up in a large house facing one of Copenhagen's parks, its spacious rooms filled with French furniture upholstered in silk. A country house, Bella Vista, overlooked the sound, north of Copenhagen. As a child she sat with other children and listened to Hans Christian Andersen reading his stories. Educated at home, she spoke French, German, English, and the Scandinavian languages.

Alice's efforts to become an artist, her relationships with Copenhagen's progressive painters, and her taste for Postimpressionist painting, particularly the introspective *Gachet*, suggest that she, like many privileged members of her generation, went beyond the comfortable materialism of her upbringing in search of less tangible forms of fulfillment. She was also something of a social rebel. Not only did she ignore contemporary middle-class mores by divorcing Hannover, but she felt compelled at one point to defy her father by openly supporting striking workers at one of his factories.

In Denmark, as in the rest of Europe, the patrons of art came from the expanding middle classes, particularly the most affluent. In the mid-nineteenth century, art collectors tended to be entrepreneurs who had amassed colossal fortunes from the building and financing of railroads, mining, textiles, chemicals, and other modern industries. In particular, those who bought avant-garde art, according to the art historian Albert Boime, were "later entrepreneurs who began to emancipate themselves from their aristocratic model and search for exotic styles to complement their budding individuality." The first collectors of Impressionist painting included bankers and industrialists as well as affluent professionals and civil servants. When the Impressionists were relatively inexpensive, artists also bought them.

As in France, entrepreneurs in Denmark supported the first generation of Danish avant-garde artists who in the 1870s had been inspired by French realist and Impressionist painting and broke away from the Royal Academy. The two most important collectors were Heinrich Hirschsprung and Wilhelm Hansen. Hirschsprung

inherited his family's tobacco firm and became friends with the plein-air painter Peder Severin Krøyer. (In 1902 Hirschsprung donated his collection to the Danish state, and a museum was constructed for it in Copenhagen. In 1918, Hansen installed his collection at Ordrupgaard, an estate on the outskirts of the city, which also became a public museum.)

As a member of the second generation of avant-garde collectors, Alice Ruben had paid for her van Gogh with inherited wealth. Educated in the humanities and lucky enough to have an independent income, she turned to the arts with abandon. (Similarly, the painter Anna Boch—the very first person to buy a van Gogh, and a member of Les XX—was the daughter of an industrialist whose affluence enabled her to buy contemporary art.) When Ruben had money to spend she used it to take art classes, and to pay for the services of a model. Her taste for the Postimpressionist art of Gauguin, van Gogh, and their followers was in keeping with the taste of Denmark's Free Exhibition artists. As they had reacted against the realist art of the generation before, she, as a collector, also turned to a painting that emphasized subjective experience. Like her ambitions to become an artist, her collecting expressed her allegiance to the antimaterial values of the symbolists.

At thirty, Alice had a handsome, open face with steady deep-brown eyes, a straight nose, and dark hair worn piled on her head like Edith Wharton, who was her contemporary. She was a spirited and independent woman. Her family considered her willful and temperamental, but her letters show her to be courageous in dealing with her chronic illnesses, which included tuberculosis and manic depression.

Alice Ruben had married Emil Hannover in 1887, when she was twenty-one. Hannover's father was an internationally famous research doctor, who had struggled to get a university appointment because he was Jewish. ("My family belonged to the most emancipated of the Jewish community, at a time when most Jews were still orthodox," wrote Hannover. "Once a year, at Yom Kippur, we visited the Synagogue in Krystalgade in order to show, as my father said, that we belonged to the community.") By this time Alice had

begun taking art lessons. Her income allowed the Hannovers to live in Paris in 1889—the period when coincidentally van Gogh was in the asylum at Saint-Rémy. The next year, they traveled to Italy. Close friends with Free Exhibition leader Johan Rohde, they knew many other vanguard Danish artists, including Peder Severin Krøyer, Vilhelm Hammershøi, Joakim Skovgaard, with whom Alice studied, and Agnes Slott-Møller, with whom she intimately corresponded. In 1892 Rohde had suggested to Hannover the idea of buying a van Gogh. "Our money situation is painfully bad at the moment," Hannover responded. "Consequently I shall naturally have to do without van Gogh besides a lot of other things." Although Alice received a substantial allowance from her parents, she observed that her income was uncertain because of their periodic displeasure with her behavior. ("When my parents take a sympathetic attitude towards me," she acknowledged, "I can count on an annual amount of 4000 kroner.") A prolific author of art books, Hannover later became the director of Copenhagen's Museum of Decorative Arts, and of the Hirschsprung Collection.

In the summer of 1892, while she was recuperating from tuberculosis at a sanatorium in Silkeborg, Jutland, Alice began an affair with Poul Kuhn Faber, who worked at the clinic. The following year, shortly after the *Gauguin and van Gogh* exhibition closed, she separated from Hannover. She and Faber were married on October 3, 1896.

Although no written record explains why Ruben bought *Portrait of Dr. Gachet*, she offered clues to her attachment to the picture in an extraordinary photograph. In the photograph, she lies against white pillows on a bare cot, covered with a dark blanket. She is wearing a white nightgown, and she stares at the camera with an uncertain smile. On close inspection, she appears to be pregnant. (Two months after Vollard had recorded her name in his account book, her son was born.) Beside her is a small bedside table, covered with checkered oilcloth of the kind often used in kitchens. Directly behind the bed is the Maurice Denis painting of the mother and child that Poul Faber had bought in France. And propped on her bedside table, leaning against the wall, still unframed (presumably,

that is the way Vollard, who complained of the costs of framing, sold it), is *Portrait of Dr. Gachet*. In front of the portrait someone has placed a book of poetry and a flowerpot with a single-stemmed plant—props arranged to imitate the still life in the picture.

This picture was the first reproduction of the Gachet portrait, but surely not meant for public consumption. Disarmingly informal, the photograph records the exclusive relationship between the collector and her picture, a graphic illustration of Walter Benjamin's observation that "ownership is the most intimate relation one can have to objects." On one level, Alice Ruben bought the painting as others of her means might have bought a piece of beautiful furniture. (Either would have required more money than her artist friends could possibly afford.) Yet she also embraced the painting as a talismanic possession. Having stopped in front of the dark and haunting painting in Vollard's gallery, she now put it beside her bed as she awaited the birth of her first child.

12

Copenhagen:
Mogens Ballin,
1897–1904

Sérusier tells me that Ballin and Clement are making great progress. Certainly they will make their mark.
—Paul Gauguin to Mette Gauguin, November 5, 1892

SOMETIME BEFORE 1904, Alice Ruben transferred *Portrait of Dr. Gachet* to Mogens Ballin, a painter and designer, who also took her painting of the mother and child by Maurice Denis. She may have sold it to him; possibly she gave it away, but most probably she asked him to serve as her agent in selling the two paintings she had bought seven years before in Paris. Ruben and Ballin (who was five years younger) were friends, their social backgrounds nearly identical. The son of a Jewish manufacturer, Ballin had even greater disdain for the well-upholstered world of his affluent upbringing than she did. More than a decade before, he had been one of the Copenhagen artists who had immersed himself in the symbolist painting of Paris and then returned to preach the new aesthetics in Denmark. Like Alice Ruben, Mogens Ballin was both an artist and a collector, his independent wealth allowing him to pursue his addiction to avant-garde art.

Born in 1871, Ballin was the only child of Hendrik Ballin, a magnate in the leather business, and Ida Levy, who came from a wealthy family of brewers. He arrived in Paris in 1891 at the age of twenty with an introduction to Gauguin from Mette, who had

tutored the Danish artist in French. Ballin was serious, intense, and prone to near-fanatical enthusiasms. He had dark eyes that stared sadly out through rimless glasses, black hair, and a black beard that aged his otherwise even-featured, youthful face. In a photograph taken in a garden in Italy, he is wearing a rumpled and ill-fitting suit. Ballin had seen van Gogh's work soon after arriving in France, one of the few to seek out the paintings in Theo van Gogh's apartment. In March 1891 Ballin guided a group of Danish friends who were in Paris to Tanguy's. There, for 300 francs, Fritz Bendix, a musician, bought *Undergrowth: A Corner in the Garden of Saint-Paul's Hospital*, a landscape filled with writhing greenery. When Bendix unveiled it to artists in Copenhagen, it caused a stir: "That rare kind of art," wrote the artist Ludvig Find, "where you are almost violently dragged right into the heart of the artist."

In Paris, through Gauguin, Ballin met the artists Jan Verkade and Paul Sérusier, who were members of the Nabis (a name that was derived from the Hebrew word for "prophet"). Soon after Gauguin departed for Tahiti on April 4, 1891, Ballin followed the two Nabis to Brittany, a region that, as Emile Bernard wrote, intoxicated painters at the end of the nineteenth century with its "incense, organ music, prayers, old stained glass windows, hieratic tapestries."

The Nabis had formed three years before in Paris, when Sérusier returned from Brittany and showed his friends from the Académie Julian a landscape whose radically flattened and simplified shapes demonstrated the "symbolist" style Gauguin had been developing in Pont-Aven. Sérusier called the picture *The Talisman*. "Thus we learned that each work of art was a transposition, a caricature," explained Maurice Denis, "the passionate equivalent of a sensation received." The original group of Nabis (Pierre Bonnard, Henri Ibels, René Piot, Paul Ranson, Ker-Xavier Roussel, and Edouard Vuillard) had expanded to include not only the Dutch Jan Verkade, but József Rippl-Ronai, who was Hungarian, and Félix Vallotton, who was Swiss. In December 1891 the Nabis exhibited their work at the gallery of Louis-Léon le Barc de Boutteville, who billed his artists as "Symbolists and Impressionists." Although some members of the alliance were drawn to mysticism and the occult, the finest

of their stylistically disparate paintings were the worldly images of Paris streets, parks, and interiors created by Bonnard and Vuillard, which seemed to descend directly from the Impressionists. After Gauguin's departure for Tahiti, the Nabis were among the most progressive artists in Paris.

In October 1891 when Ballin returned to Copenhagen, he brought his own boldly simplified, flat Nabi landscapes. These pictures impressed artists in Denmark as Sérusier's canvas had impressed his friends in France. On small, moody canvases, Ballin laid out segments of the countryside in wavy organic shapes. He favored rust and olive tones, so thinly applied that the paint surface sometimes looked as though it had been scraped. He had become a devoted symbolist, echoing Albert Aurier's observations about the art of Gauguin and van Gogh: "In the soul of the artist lives a picture of the ideal, the word," Ballin wrote about an exhibition of Verkade in Copenhagen, "the highest beauty of which also the greatest works of art are but a dim reflection."

During a second summer in Brittany Verkade converted to Catholicism, and Ballin began to study the Bible and to question the premises of modernist paintings, which he found "lack . . . the immovable foundation of religion." The "renaissance" which he and others were seeking in art, he concluded, depended upon "simplicity in the faith and that complete devotion which manifests itself in sacrifice." That fall in Italy, Ballin, raised as an Orthodox Jew, was also baptized a Catholic. After spending a year in Italy restoring frescoes, he returned to Copenhagen in 1898.

A year later Ballin founded a decorative arts workshop whose aim was to use "bronze, pewter, polished copper and other cheap metals" to make "lamps, chandeliers, belt buckles, combs, etc.": not "refined art" for "rich parvenus," as he put it, but "art for the people." Influenced by the ideas of William Morris, Ballin seemingly had found a way to direct his aesthetic idealism and creative impulses into an enterprise he imagined would have social benefit— producing finely designed objects in an understated style of art nouveau. Several of the Nabis had worked in various media, creating sets, costumes, programs, and posters for the theater. Charged with

visions of reform, they denied painting a privileged position among the visual arts. In the early 1890s, "a war cry went up from one studio to another," Jan Verkade later wrote.

No more easel painting! Down with useless furnishings! . . . The painter's work begins where architecture considers its work finished. The wall must remain a surface; it must be opened for the depiction of infinite horizons. There are no pictures, there are only decorations.

In 1896 Siegfried Bing, the dealer in Japanese art who had sold prints to van Gogh, expanded his gallery at 22, rue de Provence and opened La Maison de l'Art Nouveau, a shop designed to promote the new style of decorative art, which had abandoned eclectic historical styles and exploited organic forms. Bing commissioned Denis to create a room and Vuillard and Bonnard to design stained-glass windows, which he then had produced at the Tiffany studios in New York.

Ballin's move from the fine arts to the decorative arts paralleled that of Henry van de Velde, the Belgian neo-Impressionist and member of Les XX. In 1893 van de Velde launched an ambitious program of architecture and design, in which he aimed to strip decorative arts of frivolous ornament and elevate them to the aesthetic level of painting and sculpture. A resolute socialist, van de Velde also wanted to use industrial production to bring the best in modern design to a wide public. In 1895 he built a house in Uccle, outside Brussels, where he transformed the interior into a single unified space; every decorative element and piece of furniture (even the table settings) conformed to his austere form of art nouveau. As a brilliant theorist and practitioner who created rooms for Siegfried Bing, knew the Nabis, and later worked in Berlin and Weimar, van de Velde would play a pivotal role in the international network that created and promoted modernist art from the last decade of the century up until World War I. Through various means, van de Velde was one of the first to champion van Gogh. He bought one of the artist's drawings in 1894 and later acquired a painting. Early in the 1890s he edited an issue of a Belgian periodical that published excerpts from

the artist's letters. Finally, in their use of an expressive structural line, his paintings, prints, furniture, and interiors reflected the profound influence of the Dutch artist's style of drawing.

In 1904, when Mogens Ballin contemplated selling the Gachet portrait, he undoubtedly considered sending the picture to Paris. Vollard had kept his hand in the van Gogh trade, but the Dutch artist had no official dealer in Paris. Neither Durand-Ruel nor Bernheim-Jeune, the only other galleries likely to pursue van Gogh, had officially taken up his art. Seeing an opportunity, Gauguin's friend, the painter Emile Schuffenecker, and his brother Amedée (a wine merchant), as well as the critic Julien Leclercq, had purchased a number of van Goghs from Johanna, and they began to act informally as agents for the Dutch artist's work. In March 1901, in an effort to raise the artist's profile, Leclercq borrowed seventy-one pictures from various French dealers for an exhibition he organized at Bernheim-Jeune. The pictures came from Vollard, the Bernheims, Jos Hessel (their cousin), and Emile and Amedée Schuffenecker, as well as from the critic Octave Mirbeau and the artists Auguste Rodin and Camille Pissarro. In the catalog Leclercq revealed his intent to appeal to Paris collectors, calling van Gogh a member of "our French school of painting" whose fame was lagging behind the "incontestably glorious names" of "Monet, Degas, Renoir, Pissarro, Sisley" and also Cézanne. But the exhibition proved a commercial failure, and it discouraged the Bernheims from investing further in van Gogh. Then, in October 1901, Julien Leclercq unexpectedly died.

Three years later, Ballin knew that dozens of van Goghs remained in the storage bins of French dealers, and he sent the portrait to a city where he believed he had a better chance of selling it. That city was Berlin.

THE "OTHER" GERMANY

*Modern Art,
German Nationalism,
and the Making of
the Modern Museum*

13

Berlin:
Paul Cassirer,
1904

From the exhibitions at the Cassirer gallery each educated person in Berlin knew Max Liebermann, Manet, Monet, Degas, Renoir, Cézanne, and van Gogh at a time when the worth and fame of these great artists were still the secret of a few collectors and art historians in Paris and even fewer in England and America.
—Harry Kessler, in a eulogy for Paul Cassirer, 1926

SOMETIME IN the early months of 1904, Paul Cassirer took *Portrait of Dr. Gachet* on consignment from Mogens Ballin and placed the canvas in a small van Gogh exhibition at his Berlin gallery. The gallery was located on the ground floor of the dealer's house, at 35 Viktoriastrasse, a cosmopolitan street lined with large houses, grand hotels, and embassies and leading to the Tiergarten, Berlin's central park. Nearby were the shops of three other modern picture dealers— Fritz Gurlitt, Schulte, and Keller and Reiner. Designed by the Belgian architect Henry van de Velde, the interior of Cassirer's gallery was emphatically modern. The opulent grandeur of the Paris galleries of Paul Durand-Ruel and Georges Petit was eschewed in favor of an austere intellectual space, intended to appeal to collectors with decidedly progressive taste. The walls were a neutral gray; spare, elegant wainscoting lined the reading room. The more flamboyant gestures of art nouveau were confined to the whiplash pattern of a metal fire screen in the corner. Clients arranged to see the art at Cassirer's

by appointment. "As one leans against the long reading table, bent over an album of Bocklin prints or holding a volume of the Goncourts," wrote the poet Rainer Maria Rilke, "one is filled with contentment."

Eight years after Ambroise Vollard had sold *Gachet* in France, the painting was again in the hands of an ambitious dealer, passionately committed to modern art, a shrewd entrepreneur who hoped that van Gogh would find a market in Berlin. At age thirty-three, the prescient and combative Cassirer had staked himself in the front lines of a campaign to introduce van Gogh and French avant-garde art to the German public. He had opened his gallery with his cousin Bruno six years before, in 1898. Then, he wrote, "the word Impressionist was an insult and meant revolution." His task, the dealer explained, was "the promotion of a number of great artists who were virtually unknown in Germany."

Cassirer had discovered van Gogh at Julien Leclercq's Bernheim-Jeune retrospective in Paris in 1901; that spring he arranged to have five of the artist's canvases, including *Self-Portrait with Bandaged Ear*, shown at the May exhibition of the Berlin Secession. Seven months later, in December 1901, Cassirer held Germany's first substantial van Gogh exhibition, for which he borrowed nineteen canvases from Johanna van Gogh. Against the gray linen walls of the elegant gallery he set a version of *Sunflowers* and several landscapes, including the beautiful *Rain: Behind the Hospital*, to which he attached the highest price. "Ironic laughter and shoulder-shrugging" was the reaction of "a bewildered Berlin," according to the artist Lovis Corinth. But the critic Hans Rosenhagen saw a "highly original talent," and "the refinement of the neo-impressionists . . . combined . . . with the brute force of the Norwegians." Soon after, the sale of a single landscape, *Wheatfields behind Saint-Paul's Hospital*, for 1,500 marks to the collector Karl Ernst Osthaus suggested that the dealer not give up on van Gogh.

Now, three years later, on July 9, 1904, Cassirer sold his second van Gogh, *Portrait of Dr. Gachet*. The buyer was Count Harry Kessler, a friend and the director of the Grossherzogliches Museum für Kunst und Kunstgewerbe (Grand Ducal Museum of Arts and

Crafts) in Weimar; he bought the van Gogh for his private collection. Kessler was among the first German collectors of Post-impressionist art. Like Cassirer, Kessler was a restless and visible advocate of modernism, with numerous ties to France. Simultaneously, from Cassirer, he also acquired the Maurice Denis mother and child that Mogens Ballin had consigned to the dealer. For the two canvases, originally owned by Alice Ruben, Kessler paid Cassirer 3,000 Danish kroner, which the dealer translated into 3,378 German marks. More systematic in his accounting than his French colleague Ambroise Vollard, Cassirer kept track of the *Gachet* transactions in two black books where he recorded his "purchases" and "sales." There in neat script a gallery assistant numbered the van Gogh canvas "5957," and identified it simply as *Portrait of a Man* (*Herrenportrait*).

Graf Kessler Weimar
 5957 v. Gogh "Herrenportrait" [Portrait of a Man]
 5958 Denis kr. 3000
 a M.112,60 3378

Because the dealer had taken the pictures on consignment, when he recorded his sale to Kessler he simultaneously recorded his purchase from Ballin, to whom he paid 2,200 kroner, or 2,477 German marks. (He took a commission of 35 percent.) Assuming conservatively that *Gachet* was worth half the combined purchase price, or 1,689 marks, the van Gogh portrait cost the affluent Kessler approximately twice Germany's annual per capita income. The value of the portrait in terms of U.S. currency had jumped in seven years from $58 to about $400. It was now worth $6,744 in 1995 dollars.

Cassirer had various possible links to the Scandinavian avant-garde. The Norwegian symbolist Edvard Munch, for instance, had moved to Berlin in 1893 and joined a bohemian circle of predominantly Scandinavian writers (including August Strindberg) that gathered at the Zum Schwarzen Ferkel ("Black Piglet") café. It is possible that Kessler knew Mogens Ballin through the Nabis; he may have suggested that the Danish artist send the picture to Berlin. He even might have negotiated the sale of the two paintings himself,

ABOVE: 9 July 1904, "Mogens Ballin Copenhagen 5957 v. Gogh Herrenportrait," in Paul Cassirer's *Einkaufsbuch* (buying book). RIGHT: 9 July 1904, "Graf Kessler Weimar 5957 v. Gogh Herrenportrait," in Cassirer's *Verkaufsbuch* (sales book).

using Cassirer as the middleman. (This might explain why he paid Danish currency.) But it is more likely that Mogens Ballin decided to give Cassirer the van Gogh because he knew of the dealer's reputation and realized that Berlin was a rising market for modern art with ambitions to rival Paris.

In 1904 Berlin was Germany's largest city, twice the size of its

closest competitor, Hamburg. In the last decades of the century, it had experienced explosive growth; between 1870 and 1900 its population had more than doubled to 1.8 million. The German Empire had been founded in 1871, only three decades before, after Otto von Bismarck's victory in the Franco-Prussian War, and the new nation, an alliance of Prussia and twenty-four smaller sovereign states, remained culturally fragmented. Each of the German states (mostly hereditary monarchies) had its own constitution and laws. Berlin was the capital of both Prussia and the German Empire and was the nation's financial center, but it struggled for recognition as a city of art and culture. Despite three museums (built in the course of the nineteenth century by the Prussian kings) and its centuries-old art academy, Berlin was considered nouveau riche by some, and its frontier character was mocked by conservatives who nicknamed it "Chicago on the Spree." Indeed, it lacked the rich artistic traditions of Munich and Dresden, which since the eighteenth century had, along with Vienna, been the art capitals of central Europe. Munich and Dresden were each endowed with a magnificent collection and art academies that attracted students from abroad. Several of the smaller German cities (including Cologne, Düsseldorf, Frankfurt, and Weimar) also boasted museums, academies of art, communities of artists, and sometimes art dealers. In the second half of the nineteenth century, Munich had become the most important art market in central Europe.

By the century's end, however, Berlin was gaining ground. The economic vitality of the financial capital in Europe's most technically advanced and most dynamic industrialized nation had produced the conditions for a thriving market for modern art. "In the early twentieth century, a wind was blowing in Berlin," van de Velde later recalled, driving "away the fog lying over the limited, conceited and aging culture of the West." Opening their gallery in 1898, the Cassirers entered the Berlin art market in a boom period. Three years before, Berlin had only two art galleries. Two years later, in 1900, the Cassirers' was one of eight. By 1904, when the Gachet portrait arrived, the city was in the process of usurping Munich's place as Germany's primary market for contemporary art.

GERMANY'S VAN GOGH COLLECTORS

Paul Cassirer and Harry Kessler were among a small but visible group of dealers, collectors, critics, publishers, and museum directors who brought an international outlook to bear on exhibiting modernist French painting in Germany and on acquiring it for private and public collections. From influential positions at cultural institutions and periodicals, the Cassirer-Kessler circle promoted modernism on various fronts—staging exhibitions, writing articles, and buying paintings. They were disappointed, as one of them put it, that the German Empire had failed to produce an anticipated cultural renaissance. Judging contemporary German academic painting as insular and backward, they aspired to a renewal of the visual arts. To them, Impressionism and Postimpressionism represented the finest painting of their era and were heir to France's great tradition. A taste for French culture had a precedent among German intellectuals, some of whom had admired the Enlightenment traditions of France. Impressionism's insistent focus on contemporary life—in particular, on the haunts of the new urban classes and the picturesque suburbs where they spent their leisure—well suited the taste of the bourgeoisie now at the economic helm of German society. It was among these German collectors with a confident hunger for modernism that van Gogh found his most receptive audience in the first decade of the century.

These German collectors tended to be liberal, cosmopolitan intellectuals mostly from the upper bourgeoisie. Many were children of newly rich German manufacturers and bankers who had made fortunes in the extraordinarily rapid late-nineteenth-century transformation of an agrarian Germany into an industrial nation, which now challenged England in military and economic might. Their cultural internationalism descended from the global economic perspective of their parents. That generation's often technologically advanced business interests stretched across continental Europe and to America, where, for example, the Northern Pacific Railroad was funded by a German bank. With Europe's largest iron and steel industry pouring its products into railroads, ships, and armaments,

Germany had in the last three decades of the century taken France's place as the dominant nation on the European continent. By 1913 Germany's national income would rise to $12 billion, or double the income ($6 billion) of France.

When Cassirer sold *Gachet* to Kessler, Germany had seven van Goghs in its private collections. Kessler himself owned a landscape, *Plain at Auvers*. The other six were owned by three collectors, each of whom, like Kessler, were not only acquiring various pieces of modernist art but also playing multifaceted roles in German cultural politics. Karl Osthaus, who had bought the small landscape from Cassirer in 1901, was using his inheritance to build a private museum, the Folkwang Museum, in Hagen (later in Essen) to house his collection. Hugo von Tschudi, who owned *Rain* and another landscape, was a scholar of Renaissance art and the director of the Berlin Nationalgalerie. In 1897, the year that the French government had reluctantly agreed to accept Impressionist pictures from Gustave Caillebotte's estate for the Luxembourg Museum, Tschudi acquired for the Berlin museum not only Edouard Manet's *In the Conservatory* but also Cézanne's *Mill on the Couleuvre at Pontoise*, the first Cézanne ever purchased for a public collection. In 1899 Tschudi argued, as Peter Paret writes, that "the German public . . . is helpless before modern art; it must be given the opportunity to educate itself in museums and exhibitions." With Tschudi's bold acquisitions, the Nationalgalerie had examples of the new French painting a decade before the Metropolitan Museum of Art purchased its first Impressionist picture, Renoir's *Madame Charpentier and Her Children*. It is Tschudi "who infects them all," Mary Cassatt told Louisine Havemeyer in 1910, after hearing of Cézanne's success in Germany. At exactly the same time Kessler bought the Gachet portrait from Cassirer, Tschudi purchased Gauguin's *Martinique*, which the art dealer had also obtained in Copenhagen, from Mette Gauguin. The fourth van Gogh collector was the critic Julius Meier-Graefe. He had acquired a van Gogh portrait and one of the *Poet's Garden* series in Paris, where in the 1890s he owned Maison Moderne, a shop that sold art nouveau. In 1904, the year *Gachet* arrived in Germany, Meier-Graefe published his pioneering three-volume *Entwicklungs-*

geschichte der modernen Kunst (*History of the Development of Modern Art*). In it he devoted a chapter to van Gogh, praising the "excessive" artist as a revolutionary: "His work is the greatest possible contrast to the lazy art that seeks to preserve the status quo, and will merely decorate the house of the banal. He destroys it." Elsewhere he wrote, "Perhaps there has never been a man who, without being aware of it, penetrated so deeply into what we today recognize as artistic."

Meanwhile, van Gogh had already begun to have an influence upon German art. The first decisively modern German painting appeared in Dresden in 1905, when four architecture students—Fritz Bleyl, Erich Heckel, Karl Schmidt-Rottluff, and Ernst Ludwig Kirchner—formed a group they called Die Brücke (The Bridge). They lived and worked together in an abandoned butcher shop, producing paintings, drawings, and prints. Their communal enterprise resembled the kind of artistic fraternity envisioned by van Gogh. (Later Max Pechstein and Otto Müller also joined.) Immediately, critics recognized the influence of van Gogh in the Brücke artists' rough-hewn, exaggerated style, bold brush strokes, siren colors, and anguished imagery. Their woodcuts drew inspiration not only from medieval German prints but also from the boldly simplified and flattened prints of the Nabi Félix Vallotton and of Henry van de Velde. These earliest German expressionist paintings paralleled the riotously toned canvases that had appeared at the Salon d'Automne in Paris in 1905, paintings that had prompted a critic to call their creators the *fauves,* or "wild beasts." In the French canvases Henri Matisse, André Derain, and Maurice de Vlaminck used large blocks of Mediterranean color (high-keyed yellows, reds, and bright blues) to create lush and harmonious landscapes and figure paintings. Like the expressionists, the fauvist pictures reflected the color and drawing style of van Gogh. ("It is almost a year now since we saw the van Gogh exhibition," André Derain wrote in 1902, "and really, the memory of it haunts me ceaselessly.") One of Matisse's major paintings, which he called *The Joy of Life,* was an arcadian vision animated with nude figures dancing and playing music. In contrast, the German expressionist paintings of the same era tended to dwell on darker themes; often portraits and figure paintings suggested psycho-

logical anxiety and despair. In 1910 the Brücke artists moved from Dresden to Berlin.

THE KAISER'S OPPOSITION

Although in the first decade of the twentieth century van Gogh found his most enthusiastic public in Germany, there he also aroused the greatest antipathy and stirred controversy involving questions of nationalism and cultural identity as well as aesthetics. The political significance that modern art assumed in Germany at the end of the nineteenth century came to a large degree from the rigid stance taken against all its forms by the emperor Wilhelm II. "The rebellion of the 1890s and the first few years of this century against Wilhelminian art was in fact the beginning of the revolution," Harry Kessler later wrote. "The fragility of the imperial monarchy was felt and attacked much earlier in art and literature than in politics." By challenging the premises of German academic art, the new French painting was seen, by extension, to question the traditional ideals of the monarchy and even the authority of the emperor.

The kaiser was the grandson of Wilhelm I, the first leader of the German Empire, who ruled with his chancellor Otto von Bismarck until his death in 1888. His son Frederick III was terminally ill when he took the throne and survived only three months. Frederick's son William II became the German kaiser at the age of twenty-nine; two years later, in 1890, he forced Bismarck to resign. Although theoretically the emperor shared governing responsibilities with the Reichstag, or parliament (elected by universal male suffrage), in fact power remained largely in the hands of the emperor, his senior bureaucracy, the army (dominated by the nobility), and the new industrial and financial leaders. Some of the smaller courts also wielded considerable influence. The Reichstag had little real power over foreign policy, but it could sway domestic affairs and was a forum for debate.

Throughout his reign Wilhelm II was inept at dealing with the growing liberal and democratic opposition to his repressive regime,

seeking various legislative initiatives to weaken socialists, whom he characterized as dangerous and subversive. His verbal assaults on the working classes only alienated them from the more prosperous segments of German society. Despite the kaiser's resistance to democracy, his government added to the social security system installed by Bismarck as a measure of appeasement to the workers. In the 1912 election, the Social Democrats garnered some 4.25 million votes, making them the largest party in the Reichstag. "Even had war not come in 1914," as a pair of historians put it, "it is clear that the imperial Germany created by Bismarck was moving toward a constitutional crisis in which political democracy would be the issue."

Wilhelm II played an active role in the visual arts, motivated by a genuine interest as well as his convictions about the place they held in his state. Believing in the preeminence of the classical art of ancient Greece and Rome, he sought to perpetuate the principles traditionally preached by the "academy." In 1901, when he unveiled a row of monuments to his Hohenzollern ancestors that lined the Siegesallee, a boulevard in the Tiergarten, he outlined his high-minded and traditional vision of the function of art:

> The supreme task of our cultural effort is to foster our ideals. If we are and want to remain a model for other nations, our entire people must share in this effort, and if culture is to fulfill its task completely it must reach down to the lowest levels of the population. That can be done only if art holds out its hand to raise the people up, instead of descending into the gutter.

In his view, the finest and most worthwhile type of art was history painting, the sometimes vast canvases that depicted scenes of classical, biblical, and particularly national history. One of his favorite artists was the celebrated academic Anton von Werner, director of Berlin's Königliche Akademische Hochschule für die Bildenden Künste (Institute of Fine Arts), and chairman of the Verein Berliner Künstler (Berlin Art Society) as well as the Allgemeine Deutsche Kunstgenossenschaft, Germany's national art society. In his large canvas, *The Founding of the German Empire*, von Werner populated the scene, set in the Hall of Mirrors in Versailles,

with uniformed German officers victoriously waving their swords at Wilhelm I and Otto von Bismarck. In von Werner's pictures, "usually twelve to sixty uniformed, expressionless gentlemen stand around utterly dry and stiff," Kessler scoffed. But, Peter Paret has noted, the kaiser "upheld not only the aesthetic concerns of the dynasty, as he interpreted them, but also the taste and values of the majority." His "liking for uncomplicated renderings of realistically detailed landscapes, idealized nudes, and evocative historical scenes reflected the taste of large groups of middle and upper classes in German society, and at the same time bestowed a kind of sacral approval on it." Naturally, the kaiser's vision of the role of art as a handmaiden to his regime did not include experimental or radical styles of painting and sculpture.

The new French painting (starting with realism and Impressionism) and its German offshoots challenged the academic tradition not only in subject matter but in style. The Berlin Impressionist Max Liebermann summarized his disagreements with the academy with the quip, a "well-painted turnip is as beautiful as a well-painted Madonna." Not only did modernist pictures, so-called gutter art, ignore the technical rules of academic painting in their distortions of form and high-key colors, but they often confronted the public with unsettling imagery, pointing out aspects of an increasingly unstable world, raising issues of social injustice or suggesting, as van Gogh did in *Gachet*, alienation and psychological pain. That Impressionism came from a rival European power only made the new painting more threatening to the German public and in particular to the emperor anxious to claim Germany, still uncertain of its cultural identity, as a world power. From the start conservatives denounced Impressionism as a mindless recording of the visible world, and its supporters as victims of Parisian fashion willing to accept inferior examples of the French fad. (After the Franco-Prussian War, the defeated French fretted about the insidious influence the victorious Germans might have on Parisian art.)

The kaiser was among those who called for an art whose character was specifically German. In this he echoed the antimodernist tradition articulated by Julius Langbehn in his popular 1890 book

Rembrandt as Educator. Historians generally attribute ambitions for a "Germanic" art to the cultural insecurity of a society thrown forward into industrialization far faster than its neighbors. Germany's rapid transformation into a modern military and manufacturing giant produced massive dislocations of its population and altered the traditional rural way of life. In 1850 two-thirds of Germany's population lived in the countryside. Half a century later, two-thirds of the German public had gravitated to the expanding cities. The drastic social and economic shift bred contempt for capitalism among members of the middle classes, who blamed industrialization for tearing up the landscape, producing a mass of urban poor, and replacing the old social structures with a new hierarchy driven by money. As Germany adapted to the economic and technological demands of the twentieth century, there lingered a sometimes fanatical nostalgia for a rural way of life that had been only recently lost.

35 VIKTORIASTRASSE

Paul Cassirer had opened his Viktoriastrasse gallery with his cousin when both were in their mid-twenties. Neither had experience working in the art trade. The cousins came from an intellectually precocious generation of a prominent Jewish family that included Richard Cassirer, an eminent neurologist, and Ernst Cassirer, a philosopher associated with the Warburg Library in Hamburg and author of *The Philosophy of Symbolic Form* (1929) and other influential books. Along with the gallery, the cousins launched a publishing company whose books (including those by Henry van de Velde and the prestigious museum directors Hugo von Tschudi, Alfred Lichtwark, and Wilhelm von Bode) helped build the gallery's reputation. Initially the Cassirers' financial goal was to make both the gallery and the publishing business self-sufficient.

Born in 1871, Paul Cassirer was one of five children of Louis Cassirer, an engineer whose company produced high-quality cables laid for transatlantic telegraphy and other specialized technological uses. (Under the Nazi regime, Kabelwerke Dr. Cassirer & Co. was

taken over by Siemens.) Cassirer was highly energetic, decisive in his taste, and sometimes high-handed in the running of his business. He had elected to go into partnership with his cousin after some success as a writer in Munich, where in the 1890s he published two novels and worked for the satirical journal *Simplicissimus*. In his thirties, Cassirer had an unusual face, simultaneously boyish and middle-aged, with broad features, large eyes, and a skeptical gaze. He had a biting sense of humor. He was known for his "verbal brilliance" and "a speculative mind that never lost its playful, experimental quality." His willful and charismatic nature served him well in his often embattled position as an early broker for modernist art. The *Kunst und Künstler* editor Karl Scheffler described him as "one of the most audaciously unbiased men of his time."

From the start, the influence enjoyed by Paul and Bruno Cassirer in the German art market came from their singular alliance with the Berlin Secession, founded in 1898, the year the dealers opened their gallery. The Cassirers were not simply administrators but policy makers; they sat on the executive committee and helped select and hang the exhibitions. Their relationship with the Secession was unusual. By allying them to a prominent group and to the modernist cause, it gave them public roles in the art world outside the art trade. The Secession quickly gained the financial support of several Berlin collectors and possibly also Tschudi. Before its first exhibition, the group had raised enough money to construct a building with six exhibition rooms capable of holding over three hundred paintings and fifty sculptures. Officially, the Berlin Secession artists claimed not to "believe in a single sacred direction in art." Nevertheless, the group was associated with French Impressionism, since its president, Max Liebermann, and other influential members—Lovis Corinth, Walter Leistikow, and Max Slevogt—were influenced by the new French painting. The Cassirers had gained their positions at the Secession thanks largely to Liebermann, who was a mentor to both young men and also one of the first German collectors to purchase French Impressionist pictures.

At the Viktoriastrasse gallery, the Cassirers showed French Impressionist and Postimpressionist painting and contemporary

German art, particularly the work of Liebermann and the other leaders of the Berlin Secession. As when they paired Liebermann with Edgar Degas, the Cassirers underscored the stylistic ties between French and German art. Only five years after Vollard gave Cézanne his first one-man show, the Cassirers held the artist's first exhibition in Germany. (Their van Gogh exhibition came the following year.)

In 1901 the Cassirers' partnership dissolved. Paul kept the gallery and remained as secretary at the Secession. Bruno held the publishing business; in 1901 he founded *Kunst und Künstler*, a periodical that discussed art of all ages from a modernist perspective and whose lengthy, analytical essays provided the intellectual underpinnings for the reception of the avant-garde art stocked by the gallery. One issue in 1903, for example, included a forty-page review of the Impressionist exhibition at the 1903 Vienna Secession and excerpts from van Gogh's letters. In 1908 Paul Cassirer started his own publishing house (Paul Cassirer Verlag). Over the course of the next two decades the dealer published numerous art books, including the letters of Franz Marc and the ten-volume *Early Netherlandish Painting* by the art historian Max Friedländer. Under the imprint of the Pan Presse, Paul Cassirer also produced illustrated books and portfolios, which, like his cousin's publishing venture, advanced modernist graphics.

Paul Cassirer's success as a dealer depended upon his skills at forging strong ties to the French dealers—Durand-Ruel (with whom he negotiated an exclusive contract), Vollard, and the Bernheims—who supplied him with merchandise. He also won the confidence of Johanna van Gogh–Bonger. More patient than Vollard, Cassirer tolerated her high prices, thus ensuring himself access to the largest source of van Gogh's art. He shrewdly expanded the market for van Gogh and other modernist art by sending his exhibitions to dealers in other German cities. Once he began to make profits from the gallery, he used the sales of van Gogh and the Impressionists toward underwriting several contemporary artists on whose work the gallery eked out little if any money. Cassirer paid Ernst Barlach some 5,000 marks, before the dealer had sold any of the artist's sculptures.

As one of the commercial backers of the new French art, Cassirer quickly became a target of conservative critics, and in 1903 (a year

in which he exhibited Edvard Munch, Pierre Bonnard, Edouard Vuillard, Edgar Degas, and Claude Monet as well as the recently appreciated Spanish old masters Francisco de Goya and El Greco) a Catholic journal attacked the dealer with an unembarrassed anti-Semitism, which had surfaced after the 1878 stock-market crash.

> It is characteristic and significant that the transmitters of this type of art and its first critical heralds are—I don't want to say Jews, but rather, and this is the essential point—representatives of the specific Jewish spirit residing in the West End of Berlin. That many Germans join and follow them is not surprising. The zeal and activity of these people has suggestive power. And it brings concrete advantages. They have turned the Jew infested Berlin West End into an art market of the first magnitude, and they have learned how to take complete control of this market. The Cassirer gallery, which might as well be called "Liebermann Gallery," is nothing but a miniature version of the secession, whose affairs rest in clever "cashier" hands.

Cassirer ignored the attacks. In 1911, when he was again under fire, Cassirer responded,

> Why did I "put myself in the service of French art dealers?" . . . When twelve years ago my cousin and I tried to bring French art to Germany, no one thanked us for it, and it was difficult to earn enough to keep the enterprise going. Had I dealt with [German academic artists], making money would have been no problem. Why did I have to speculate with French paintings? . . . because I regard bringing French art to Germany as a cultural deed. But even that wasn't the real reason. Simply because I loved Manet; because I recognized Monet, Sisley, and Pissarro as powerful artists, because Degas was among the greatest masters, and Cézanne the bearer of a philosophy of life.

CASSIRER'S VAN GOGH EXHIBITIONS

After Paul Cassirer sold *Gachet* in July 1904, he continued to persevere with van Gogh. Late in 1904 he organized a small exhibition,

but failed to sell any of the nine canvases. But the following year, when both Amsterdam's Stedelijk (City) Museum and the Indépendants in Paris held van Gogh retrospectives, efforts on behalf of the artist finally paid off. "I would like to further intensify the circulation of van Gogh's art," he wrote Johanna, "and try to sell more works at higher prices." Now, of the thirty canvases he borrowed, he sold ten. (For these he paid 15,000 marks, or 1,500 apiece.) Tschudi acquired three: two landscapes and a version of *Sunflowers*. This was an expensive canvas, costing the museum director 3,200 marks, or close to the 3,378-mark price Kessler had paid only the year before for *Gachet* and the Denis mother and child together. Four other paintings went to Berlin collectors. Encouraged, Cassirer put together a large exhibition with fifty-four van Goghs (mostly from Johanna), which ran at the gallery's branch in Hamburg in September and October 1905 and went on to Dresden, Berlin, and Vienna. Generally, Cassirer preferred small exhibitions, believing that collectors only get confused and indecisive when presented with too wide a choice. But in Hamburg, Cassirer sold four pictures. Then in Berlin Tschudi once again bought two landscapes, including the gray-toned *Trinquetaille Bridge*. Altogether in 1905, Cassirer sold twenty van Goghs. Two years later he asked Johanna to "appoint" him "sole agent for Germany," but she refused. Nevertheless, in October 1908 she loaned him seventy-five paintings for yet another exhibition in Berlin. In three years, Cassirer more than doubled prices: *Roses* and *Vase of Irises* each sold in March 1908 for 9,000 marks, or slightly more than $1,500, to the bankers Robert von Mendelssohn and Fritz Oppenheim.

In 1911 Cassirer signed a contract to publish the German translation of van Gogh's letters and was certain enough in the van Gogh market he had helped build in Germany to buy eleven canvases on his own account. His campaign to establish van Gogh culminated shortly before World War I, when he displayed 151 of the Dutch artist's works; almost half—54 paintings and 13 drawings—came from German and Austrian collectors.

By the outbreak of World War I, Germany's appetite for van Gogh had endowed it with the most extensive collections of his

work outside of the Netherlands. There the van Gogh family collection—now somewhat smaller—remained, and Helene Kröller, a wealthy student of art, had acquired over twenty-five of the artist's works. She would accumulate the second largest van Gogh collection, later housed in a museum in the town of Otterlo. In 1938 she gave the collection to the Netherlands, and the museum became the Rijksmuseum Kröller-Müller.

In 1904, *Portrait of Dr. Gachet* was the seventh van Gogh acquired by a German collector; only a decade later the portrait was one of 120 van Gogh canvases and 36 drawings in German private and public collections. The playwright Carl Sternheim owned ten pictures, including a self-portrait, a version of *L'Arlésienne*, and a *Garden with Weeping Tree*. In Paris there were now only about 30 van Goghs, in Switzerland 12, and in the rest of Europe (Austria, Russia, and Scandinavia) some 20. When in 1912 Albert C. Barnes, the pharmaceutical magnate, acquired a version (some think the very best) of *Portrait of Joseph Roulin*, he became the first American to buy a van Gogh. The following year, the American public saw the artist's work for the first time at the Armory Show in New York. At that point American collectors had acquired only four van Goghs. By then, more than a decade had passed since Paul Cassirer had ventured to introduce the Dutch artist's provocative canvases to Berlin.

14

Weimar:
Harry Kessler,
1904–1908

Sometimes he appeared German, sometimes English, sometimes French, so European was his character. In truth the arts were his home. For he reacted to everything artistic with a stormlike swiftness; even in music, of which he was an ardent enthusiast, he was . . . always first to make a discovery.

—Novelist Annette Kolb, from an obituary for
Harry Kessler (d. November 30, 1937)

FROM PAUL CASSIRER'S gallery in Berlin, Count Harry Kessler took *Portrait of Dr. Gachet* to his house on Cranachstrasse in Weimar. There he installed the painting in a small, exclusive enclave of Postimpressionist, neo-Impressionist, and Nabi art. Designed by Henry van de Velde, the interior of the house was itself a manifesto of modernism, a sanctuary molded by Kessler's avant-garde sensibility and accommodating his immoderate appetite for vanguard art and design. Van de Velde's style of art nouveau—in which ornamentation was stripped away to reveal an object's structure—flowed through a series of rooms where Kessler worked and entertained. Tables, chairs, bookcases, desks—all were shaped to fit the harmonious space. The furniture was relatively small and stood on thin, slightly curving legs. Straw matting covered the floors. Van de Velde's style captured, in Kessler's words, "the long, elegant movement of lines now remarkably bursting forth everywhere, not simply in iron

construction, in mighty suspension bridges, in machines, racing yachts, automobiles, but also in private life, in skirts, in the cut of dress coats, in women's tailor-made clothing."

Photographs show that Kessler filled his living room, dining room, and study with his collection of art. On the walls were paintings by Renoir, Cézanne, and Bonnard, each set in a simple frame of painted wood. Bronzes by Aristide Maillol and Renoir stood about on pedestals, bookshelves, and the corner of the collector's desk. By 1898 Kessler had bought paintings by Cézanne, Renoir, Bonnard, Vuillard, and Maurice Denis. He traveled regularly to Paris, where his mother lived and where he befriended many of the Nabi artists, whose work he patronized. From Vollard in 1901 he acquired Gauguin's great *Manao tupapao* (*The Specter Watches over Her*), the "Olympia of Tahiti," which the artist had exhibited in the Copenhagen *Gauguin and Van Gogh* exhibition in 1893. Where possible, paintings were literally woven into the physical structure of the

Harry Kessler's house in Weimar (here, ca. 1910), designed by Henry van de Velde (with a mural by Maurice Denis), was the setting for van Gogh's portrait from 1904 to 1908.

room. A Maurice Denis mural of nymphs running in a forest, for instance, was mounted into the paneling of the dining room wall.

In its fusing of radical painting, sculpture, and design, *Gachet*'s new residence well suited a collector who promoted modernism not only through his patronage of contemporary art but through his exhibition program at Weimar's museum and his writings, which included an article on neo-Impressionism published in 1903. The interior of Kessler's house also spoke to the way the museum director integrated the collecting of art into both his professional and private life and to his conviction that art expressed the achievement of a nation. "The modern state concerns itself with art," he wrote. "The state owns galleries, organizes exhibits, builds and rewards. And these matters are not 'minor,' as politicians like to claim, issues that should not disturb the course of 'grand' policy. On the contrary, they are the ultimate reasons for politics. In the final analysis," he concluded, the goal of politics is "to guard and smooth the way for the highest, most varied, and broadest development of a people—that is, for its ideal, intellectual and artistic gifts." Yet paradoxically Kessler's vast vision for the "renewal of German culture" was manifest in a private house that was itself a metaphor for retreat and alienation, an aesthetic refuge from the blight caused by the advance of industrialization.

Here, in a space "pervaded," according to van de Velde, with "the spirit of aesthetic perfection," Kessler immersed himself in art and introduced *Gachet* to an audience of artists, writers, intellectuals, statesmen, and others who wielded influence in German cultural and political affairs. In few places would the painting have had such finely tuned social and cultural exposure. Kessler enjoyed a steady stream of guests: the museum directors Hugo von Tschudi, Gustave Pauli, and Alfred Lichtwark; the painters Max Liebermann, Edvard Munch (who lived for a time in Weimar), Max Beckmann, the producer Max Reinhardt and set designer Edward Gordon Craig; the industrialist Eberhard von Bodenhausen, who financed van de Velde's Brussels workshop. Among Kessler's friends was Walther Rathenau, son of the founder of Allgemeine Elektrizitätsgesellschaft (AEG), one of the country's two large electrical firms. Rathenau

would serve as foreign minister in the postwar Weimar Republic, and Kessler would write his biography. Another one of Kessler's closest friends was the Austrian poet Hugo von Hofmannsthal, with whom he later collaborated on the libretto to Richard Strauss's opera *Der Rosenkavalier*. Hofmannsthal was one of the first German writers to articulate the appeal van Gogh had for Kessler and his circle. In 1901 the poet wrote a fictional account of seeing the artist's paintings and finding a "world of revelations." How, Hofmannsthal's narrator asks, "can I even begin to tell you how this language reached my soul, revealed to me an enormous justification for the strangest, seemingly most unresolvable conflicts of my inner depths . . ." For many of Kessler's visitors, the encounter with *Gachet* and *Plain at Auvers* would be their first with van Gogh. Kessler's friend Helene von Nostitz recalled in her memoirs seeing the portrait over the piano; as was not uncommon, she mistook it for a self-portrait.

Although he was admired, some felt Kessler and his circle carried their aesthetics too far. "All took place in a ceremony," van de Velde recalled, "in which a false word, a false gesture would have ruined the atmosphere like an insult whose perpetrator subjects himself to the disdain of all." Maurice Denis, a devout Catholic, recoiled from an environment he thought decadent: "Cosmopolitanism, boredom, immorality, the need for new sensations. . . . What effort they make to be true Hellenes! From the cult of Maillol to the dances of . . . Isadora Duncan and the contortions of Ruth St. Denis."

The internationalism that characterized the early German collectors of modern art can be attributed in the case of Harry Kessler to his German and Anglo-Irish heritage, his upbringing and education abroad. Moreover, Kessler adopted cosmopolitanism as a guiding principle of life. He believed, as art historian Beatrice von Bismarck observed, that "art and intellectual matters cannot be confined to a strictly national context, but require border-crossing and an international vantage point to thrive." Kessler disagreed with the kaiser's call for Germanic art. "Our native land is the present," he wrote in 1905. "We must accept the culture and life of our times in all their complexity and national mix. A strictly national art is actually an

uprooting, an attempt to cultivate art in unnatural isolation." From the start he had ambitions to become a diplomat, a profession well suited to his aristocratic background and international heritage and education, as well as to his intellectual passions.

Kessler was born in Paris in 1868, the son of Adolf Kessler, a Hamburg banker, and Alice Blosse-Lynch, the daughter of an Irish explorer, who gave her son his English first name. Working as a financier in Paris after the 1871 Franco-Prussian War, Adolf Kessler had accumulated a massive fortune, exploiting the investment opportunities that arose as France's reparation payments poured into Germany's bank accounts. In recognition of Adolf Kessler's contribution to the nation's booming industrial empire, Kaiser Wilhelm I awarded him the rank of count. The beautiful Alice Kessler was also friendly with the kaiser. Although she did not meet him until after Harry's birth, rumors that the kaiser was his father plagued Harry throughout his life. In a photograph taken when he was a boy, Kessler is dressed like a prince, in a black velvet and pleated-silk suit. He poses with his hand on his hip.

After spending his early childhood in France, Kessler was educated in England and Germany. When he was twelve his parents sent him to St. George's, a boarding school in Ascot, but he completed secondary school in Hamburg. He studied law at the universities of both Bonn and Leipzig. After passing the state legal exam and taking a world tour, which began with a transatlantic voyage on the *Normandie* from Paris to New York, Kessler in 1892 joined the Third Guard Lancers, an elite regiment of Prussian guards whose ranks were chosen from the nobility. Prussia deliberately kept its army relatively small, as a result of its unwillingness to commission more officers from the lower ranks of the middle classes. Through brief mandatory service, the government enlisted a loyal upper-middle-class and aristocratic officer corps. On completing his military service in 1893, Kessler tried to join the foreign service, a bastion of the old aristocracy that he could not crack.

Moving to Berlin in 1894, Kessler worked as a legal secretary in Spandau, a job he disliked. There he began to write articles (the first on the French symbolist poet Henri de Régnier) for the art nouveau journal *Pan*. He had an apartment in Berlin and traveled incessantly,

spending a lot of time both in London and in Paris, where he frequently visited Vollard's gallery. His customarily frantic pace is obvious from his diary. In the weeks before he bought the Gachet portrait, for instance, he made entries from Weimar, Dresden, Berlin, and Hamburg. His wealth, social position, and restless independence of mind allowed him to fashion his own role as a modernist advocate and art patron—a role he quickly assumed in Berlin. In September 1895, when the sponsors of *Pan* fired Julius Meier-Graefe as editor (for publishing what they thought was a scandalous Toulouse-Lautrec print of a Parisian chorus girl in a flamboyant hat), Kessler became a member of the newly composed editorial board. He also gave the magazine financial backing. That year Adolf Kessler died, leaving his son substantial sums of money. Kessler's work for *Pan* from 1895 to 1899 kept him in touch with artists, writers, art critics, museum directors, and art dealers in both Germany and France. He met Edvard Munch and the bohemians who gathered at Zum Schwarzen Ferkel. In 1902 the Berlin Nationalgalerie director Hugo von Tschudi took him to Maurice Denis's Saint-German-en-Laye studio and to meet Vuillard in Paris. Vollard introduced him to Pierre Bonnard and the sculptor Aristide Maillol, both of whom he would photograph in their studios.

By then Kessler already owned Georges Seurat's masterpiece *Les Poseuses* (*The Models*). "From Vollard for 1200 francs!" he noted triumphantly in his diary on December 30, 1897. As the painting was more than $2^1/_2$ meters wide and wouldn't fit any of the walls in his apartment, he had van de Velde design a special wooden frame, in which the canvas was mounted like a scroll and only part of it was visible at any one time.

At the age of thirty, Kessler was thin and blandly handsome, with fair coloring, a high forehead, sharp cheekbones, and an aquiline nose. "Kessler had perfect poise and natural, understated elegance," van de Velde wrote, and "penetrating, gleaming eyes." Yet even with van de Velde, who considered him a close friend, he maintained his distance. His high-strung sophistication is obvious in a full-length portrait (now in the Berlin Nationalgalerie) painted in 1906 by Edvard Munch; here the slim figure of the count, dressed

in a dark blue suit and wide-brimmed straw hat, is outlined against a background of yellow.

Just as Kessler's personal attachment to both England and France complicated his German identity, so too within German society his position was neither fixed nor absolute. He was born into the new upper middle class, whose success in business and finance had transformed the nation into an industrial power; but he was also a member of the new German nobility, which along with the traditional aristocracy still dominated both the government and the military in 1910. (The old aristocracy consisted of families whose ancestors were princes in the Holy Roman Empire and other landed gentry who held lands in the east.) As a Prussian officer in the increasingly militaristic society forged under Kaiser Wilhelm II, he possessed coveted social and political connections. But as a collector and museum director who bought and exhibited the new French art, he publicly allied himself with the German cultural dissidents. Close to the seats of power, he was also detached. With his opposing loyalties, Kessler embodied the tensions and conflict between the old order of the Kaiserreich, with its conservative ruling elite, and the new order of the bourgeoisie, whose aesthetic iconoclasm and liberal politics sometimes embraced modern art. On an individual level, Kessler experienced some of the social and political clashes now unsettling Germany itself. Later Kessler was nicknamed "the Red Count," an appellation that exaggerated his socialist sympathies. That he was a homosexual, although not openly so, also set him on the periphery of the traditional social establishment, a perpetual outsider gazing in.

Kessler exploited his insider-outsider vantage point in what would be his most lasting work—his diary. In a commentary widely quoted by scholars as a primary source of history, Kessler proved himself a brilliant witness. From 1880, when he was twelve, until his death as an exile in 1937, he kept a running commentary on his life on 15,000 pages covered with tiny, almost illegible script, into which he wove observations on history, politics, art, and national identity. The diary is stored in the German National Literary

Archives in Marbach am Neckar; excerpts were published in English in 1971, in a volume called *In the Twenties*.

Kessler came to Weimar in 1903, as the director of the Grossherzogliches Museum für Kunst und Kunstgewerbe. He had taken this job only after being discouraged in his attempts throughout the 1890s to get a post with the foreign service. In 1902 he had met with Prince Lichnowsky, later German ambassador to England, with whom he discussed the possibility of a job in London. He was turned down; "Too many people are against it," Lichnowsky acknowledged. Immediately afterward Kessler agreed to take the Weimar museum job. He owed his appointment in part to Elisabeth Förster-Nietzsche, the philosopher's sister, who lived in Weimar, where she maintained the Nietzsche archives. Since 1900 Kessler had been working with her on producing a luxury edition of *Thus Spoke Zarathustra*; he had commissioned van de Velde to illustrate the book with 100 woodcuts. In 1901 Kessler had used his influence to persuade the grand duke of Sachsen-Weimar-Eisenach to appoint van de Velde the director of Weimar's Kunstgewerbeschule (School of Arts and Crafts). "A kind of art laboratory in the service of industry will be established, that will work on the artistic problems facing industry," Kessler argued, "and offer solutions for exploitation, exactly as the chemical laboratories [did] with their artificial indigo or Bremer burners." At the school, van de Velde taught workshops and developed designs that were given to Weimar's artisans and manufacturers to produce; he also designed new buildings for the Kunstgewerbeschule, and for the Kunstschule (Art Academy).

Kessler bought *Gachet* the year after he became the museum director. With van de Velde as his partner in the "new Weimar," Kessler strived to turn the small capital of the Duchy of Sachsen-Weimar-Eisenach, a town of 30,000, into a center of modern culture and to resurrect the brilliance of the period when it was the residence of Johann Wolfgang von Goethe and Friedrich von Schiller, the two giants of German literature. Furthering the cause of the avant-garde meant, he wrote, to "gradually build up a real *public* what Germany

otherwise lacks." To this end, his monthly exhibitions introduced the public to the Impressionists (Manet, Monet, Renoir), the Post-impressionists (Gauguin, Cézanne), and the neo-Impressionists (Paul Signac, Henri-Edmond Cross, Théo van Rysselberghe), as well as to set and costume designs by Edward Gordon Craig and to the expressionist canvases of Emil Nolde and Wassily Kandinsky.

With the support of the grand duke Wilhelm Ernst and particularly the grand duchess Caroline, Kessler made headway in his mission to advance Weimar. In 1903 the town was the site of a meeting where Kessler and representatives from the various secessions helped organize the Deutscher Künstlerbund (German Artists Union), a nationwide society of artists (both modernist and traditional) who wanted a voice in the selection of art for the Saint Louis International Exposition. "Personalities whom I don't even know, Druet, Denis-Cochin, Octave Mirbeau, have let me know that they wish to get in touch with us," Kessler told van de Velde. "I see that today we already have the same strong backing in England and France that we possess in Germany. We hold the world of art in our hands. Above all we must not lose the wonderful, pivotal point that is Weimar."

But in 1906 the conservatives in Weimar decided Kessler's projects had gone far enough. (The grand duchess Caroline had died of pneumonia suddenly in 1905.) The backlash came when the museum exhibited watercolors by Auguste Rodin, whose depictions of female nudes were thought to be indecent. Problematically, the celebrated French sculptor had scribbled a dedication to the grand duke (who happened to be hunting in India) on one of the offensive drawings. "It is the impudence of the foreigner to offer such things to our high lord," charged a local artist, "and irresponsible of the committee to display these disgusting drawings and tolerate such an exhibition." Away in London when the exhibition opened, Kessler withdrew the sketch with the dedication and challenged one of his enemies at the court to a duel. "He [the Grand Duke] had made up his mind to get rid of Kessler without a hearing," van de Velde wrote. The Prussian ambassador to Weimar reported the scandal to the kaiser. On June 13, Kessler resigned. "The prestige of the Grand Duke is completely *our* work," he complained to Eberhard von

Bodenhausen. "It will not survive us. On the other hand, I strongly hope to maintain and strengthen our *circle,* and Weimar as its center," he wrote. "That shall be my only revenge."

Elsewhere, the conservative opposition had gained ground. In 1908 Hugo von Tschudi, who had openly defied the kaiser with his acquisitions for the Nationalgalerie, finally succumbed to pressure and resigned as the museum's director. (A controversy had erupted when Tschudi had committed the museum to making acquisitions for which he hadn't yet secured funding.) Tschudi went on to become director of the Bayerische Staatsgemäldesammlungen (Bavarian State Galleries) in Munich, where he continued his buying of the new French art.

Although Kessler's ties to the museum had been severed, he continued to live in Weimar, in various ways kept up his support of contemporary German and French artists, and began writing a book on Impressionism. "I would like also, if only in my own modest way," Kessler told Hofmannsthal, "to produce something myself. I have neglected this far too much and would like to catch up now." In 1908 he traveled to Greece with the sculptor Aristide Maillol and Hofmannsthal. In 1909 Kessler began working with the poet on a libretto, which became *Der Rosenkavalier.* In 1912 he again collaborated with Hofmannsthal on the scenario for *The Legend of Joseph,* a ballet composed by Richard Strauss and choreographed by Sergey Diaghilev, which opened at the Paris Opéra on May 14, 1914. Meanwhile Kessler founded a publishing company, the Cranach Press, to produce luxury editions of classic texts, including Virgil's *Eclogues,* with woodcuts by Maillol, and *Hamlet,* illustrated by Craig.

EUGÈNE DRUET, 1908–1910

A private collector, Harry Kessler was also a trader of pictures. In January 1908, three and a half years after he bought *Portrait of Dr. Gachet* in Berlin, he put it back on the market in Paris. (Perhaps he hoped that France might provide a degree of anonymity and avoid speculation about his reasons for selling a number of pictures.) Kessler sent the picture to Eugène Druet.

Druet wanted *Gachet* for an exhibition that he had planned to run in competition with a van Gogh retrospective being organized by the critic Félix Fénéon at Bernheim-Jeune. Fénéon had borrowed one hundred of the Dutch artist's paintings from Johanna van Gogh–Bonger, in hopes of igniting French demand for his work. In Paris *Gachet* could be seen by collectors from Europe and America who flocked to the French capital, assuming it to be the best market for modernist art. Fénéon told Karl Osthaus that while the gallery constantly sent paintings to exhibitions in Germany, German collectors still liked to go to Paris to buy.

Eugène Druet had opened a "sumptuous store" in the faubourg Saint-Honoré five years before. Recently he had made a substantial investment in van Gogh, purchasing several paintings from Johanna. An entrepreneur, Druet had started out as the owner of a restaurant. By 1899 he was employed by Auguste Rodin as a photographer to document his works of sculpture. Druet got his first taste of the art trade when in 1900 he managed the Rodin pavilion at the Universal Exposition, where he sold his photographs as souvenirs. His work as an art photographer introduced him to many collectors. (At Druet's death, reportedly some 15,000 negatives from his studio went to the Louvre.) As a dealer, Druet specialized in the Postimpressionists, whose art Kessler collected. His artists included Paul Signac and the Belgian neo-Impressionists (Théo van Rysselberghe, Maximilien Luce, Ker-Xavier Roussel, Henri-Edmond Cross, and Eugène and Anna Boch), as well as the Nabis (Pierre Bonnard, Edouard Vuillard, Maurice Denis, and Paul Sérusier).

In Paris, much had changed in the eleven years since Ambroise Vollard had exhibited van Gogh's late portrait. Cézanne had died in 1906. That year Bernheim-Jeune held an exhibition of seventy-nine of the artist's watercolors, many of which had never been on public view. In October the Salon d'Automne held a memorial exhibition with fifty-six Cézannes as well as photographs by Druet of the painter's studio. Art in France was advancing at an accelerating pace. The year before, the fauves—Henri Matisse, André Derain, and Maurice Vlaminck—had burst on the scene at the Salon d'Automne. Already, Vollard had given Matisse his first one-man show.

In 1906 the dealer acquired twenty canvases by Pablo Picasso. By then Gertrude Stein, Sergei Shchukin, and other collectors demonstrated a taste for his work. In 1907 Picasso completed his masterpiece *Les Demoiselles d'Avignon*. Soon he and Georges Braque would begin working in their complex, earth-toned "analytical" cubist style, painting landscapes and still lifes that were almost interchangeable and that broke their subjects into multiple intersecting planes. Around this time, Braque made his first collage. In 1908 Bernheim-Jeune gave Matisse a contract guaranteeing him a steady income in exchange for a supply of his brilliantly toned paintings. Two years later Matisse would board a train for Moscow to install his murals *Dance* and *Music* in Shchukin's palace.

The demand for fauve and cubist painting had the effect of elevating prices of the art of the Postimpressionists, whose pictures were now several decades old. Cézanne, Gauguin, Seurat, and van Gogh were now modernist masters. Among them, Cézanne had the greatest reputation, largely because he was seen as the forefather of cubism. Not only had a new generation of artists grabbed public attention, but there were new dealers for the younger painters. The most important was Daniel-Henry Kahnweiler, who opened a gallery in 1907 and the next year bought forty Picassos. Starting in 1912 Kahnweiler promised stipends to Braque, Picasso, Derain, and Fernand Léger in exchange for their work.

Also, French collectors had begun to speculate on these recent paintings. In January 1908 a syndicate of collectors ("La Peau de l'Ours") headed by André Level, a businessman and friend of Gaston and Josse Bernheim, spent 1,000 francs on Picasso's *Family of Saltimbanques*. The syndicate, formed specifically to invest in modern art, ultimately would purchase eighty-eight paintings and fifty-six drawings. The rise in Postimpressionist prices was evident when in March 1908 Kessler sold his Maurice Denis mother and child (bought in 1904 with *Dr. Gachet*), and the relatively minor Nabi canvas went for 10,000 francs, or ten times the price of the Picasso *Saltimbanques*, a major work.

Intriguingly, Picasso's early success, like van Gogh's, depended primarily upon his popularity in Germany. According to John

Richardson, he was "the hero of the modern movement" in Europe and America because of "the success of Kahnweiler's *Ostpolitik:* his strategy of getting progressive young dealers like himself to put on exhibitions in Germany and thus establish a constituency and a market for his artists outside France." But Richardson noted that "built into the success of this strategy was a dangerous side effect. The more acclaim cubism generated in Germany, the more hostility it generated in France." Cassirer was not among the German dealers who promoted Picasso: Alfred Flechtheim in Düsseldorf, Hugo Perls in Berlin, and Justin Thannhauser in Munich.

In his 1908 van Gogh show, Druet exhibited thirty-five pictures; twelve were portraits, including self-portraits and *Gachet*. Five of the pictures came from his own inventory. The remainder he had taken on consignment from nine dealers and collectors. Emile Schuffenecker loaned eight canvases, including an *Arlésienne* and one of the two versions of *Daubigny's Garden*. Druet's exhibition ran twelve days (January 6 to 18, 1908); he failed to sell a single painting. That the Bernheims fared only slightly better with their landmark retrospective suggested that French interest in the Dutch artist was at best erratic. But the Bernheim-Jeune exhibition spawned exhibitions in four German cities, so the group of paintings broke up. Twenty-three went to Cassirer's in Berlin; seventy-one were split between Brakl's Moderne Kunsthandlung and the Kunstsalon W. Zimmermann in Munich. These pictures were then reassembled and went on view first in Dresden and then at the Kunstverein (Art Society) in Frankfurt.

When Druet closed his van Gogh exhibition, it seems that *Portrait of Dr. Gachet* did not return to Weimar. Remaining in the possession of Harry Kessler, the canvas appears to have stayed on at the gallery in Paris, where Kessler left it on consignment. Two years later, in February 1910, Druet, presumably confident now he would find a client for the portrait, bought it himself. Simultaneously, the dealer purchased from Kessler the Tahitian Gauguin, *Manao tupapao* (*The Specter Watches over Her*). For the pair Druet paid Kessler 28,000 francs, or $5,400. It is safe to assume that he gave the paintings equal weight, which would set *Gachet*'s price at 14,000

francs, or about $2,700. From Kessler's point of view, he had made a substantial profit ($2,300) on the painting that he bought six years before for 1,689 marks, or about $400. In terms of 1995 dollars, *Gachet*'s price had risen from less than $6,744 in 1904 to some $44,015 in 1910.

Kessler's immediate reason for selling *Gachet* was to pay his bill from Druet, which stood at 8,000 francs. Specifically, he applied the collective proceeds from the Gauguin and the van Gogh toward a large and beautiful screen by Pierre Bonnard, for which Druet was charging 22,000 francs. A ravishing decorative piece covered with elegant figures, the Bonnard fit perfectly into his Weimar house. In great demand on the Paris market, the screen was more than half again as expensive as the more cerebral *Gachet*.

Kessler constantly shifted the pieces in his collection, buying and selling as his taste changed. Still passionate about the new French art, Kessler seemed to possess no sentimental attachment to his van Gogh portrait. At first, in fact, he seemed at best ambivalent about the artist's achievement. About one of the versions of *Olive Orchard* he wrote in 1890: "Violet trees in a red field beneath a yellow sky, . . . trees looking like a battle of demented serpents." Some thirty years later he reacted more positively: "There is brutality and an almost insane loathing of nature in every brushstroke by van Gogh. Yet the overall effect is always delicate, fresh, and attractive. The brutality of the brush-stroke dissolves into a luminous gentle harmony. That is nature, and van Gogh is perhaps the only painter whose canvases show it like that."

LONDON: MANET AND THE POSTIMPRESSIONISTS, 1910

Druet had no immediate luck selling the Gachet portrait. But in the summer of 1910 Roger Fry arrived at the gallery, scouting for examples of the new French painting that he could put in a major exhibition he was planning to open in London in the fall. Fry, in his mid-forties, was a painter, a critic, and a leading figure in the Bloomsbury circle. He had established himself as an expert on quattrocento and High Renaissance

art; later his fluent and persuasive writings on Cézanne and other modernists would help build their reputations in England and America. Earlier in 1910 he had resigned as adviser to the Department of Paintings at New York's Metropolitan Museum of Art. In 1907 he had persuaded the board to purchase for 84,000 francs (around $20,000) Renoir's *Madame Charpentier and Her Children*, the museum's first Impressionist painting. (That purchase alone had almost cost him his job.) Druet gladly agreed to let Fry take thirty-three paintings for his London show, one of them *Portrait of Dr. Gachet*.

Fry called the exhibition *Manet and the Post-Impressionists*, and it opened on November 8, 1910. Virginia Woolf, in her biography of Fry, described the British response:

> The public in 1910 was thrown into paroxysms of rage and laughter. They went from Cézanne to Gauguin and from Gauguin to van Gogh, they went from Picasso to Signac, and from Derain to Friesz, and they were infuriated. The pictures were a joke, and a joke at their expense.

Fry exhibited 155 paintings and 50-some drawings, as well as 20 bronzes and pieces of pottery. The 22 paintings by van Gogh were unintelligible to the art critic of the *Daily Express*. He laughed at *Dr. Gachet*, judging it as a likeness to be "a mean revenge on a cherished enemy":

> It is astonishing to find that van Gogh's raging golden sea against a royal blue sky, a vermilion paint-pot upset in the foreground, represents a cornfield with black-birds; and only on retreating to the far side of the gallery do you find that the vermilion splotches might—this is a suggestion, not a statement of fact—be roads. No wonder Dr. Gachet, next door, looks horribly seasick.

Compared to German opponents of modernism, the British press, however outraged, still carried on in a lighthearted tone when mocking and denouncing what they saw as incomprehensible and worthless works of art. While recoiling from the new French painting, English critics never framed the aesthetic discussion in terms of

nationalism and foreign threat. Seeing van Gogh as little more than a subject for ridicule, England had no use for *Gachet*. Still, the exhibition's title put the term "Post-Impressionism" into common usage. Failing in his efforts to market the portrait in London, the entrepreneurial Druet welcomed it back to France, where it would not remain long. Learning that the van Gogh was about to return to Germany, Roger Fry chided the British:

> Those who remember the outcry which Van Gogh's portrait of Dr. Gachet caused last year at the Post-Impressionist Exhibition will learn with some surprise that Dr. Swarzenski has had the courage to buy it for the Städel Institute at Frankfort, where it will take its place beside the masterpieces of Dutch and Italian art. We in England shall probably wait twenty years and then complain that there are no more van Goghs to be had except at the price of a Rembrandt.

15

Frankfurt:
The Old Master Museum
and the New Portrait,
1911–1919

*Seated behind a table and leaning on his right arm you can see the
subject in a buttoned Prussian blue coat. His left hand sits on
the edge of the table. The table occupies the lower left corner of the
picture . . . his lips are emptied of blood, and his skin color is
pale . . . on the table there are 2 yellow books, in the foreground—
intersected by the painting's edge—stands a glass of water with a
foxglove. In the background, he uses an even lighter Prussian blue,
which seems to wave because of green highlights . . . a triple-
differentiated blue surrounds the pale yellow of his head.*

—*Inventarbuch* (registrar's book), Städelsches Kunstinstitut, 1912

"I WILL SEND OFF today at full speed the painting of Dr Gachet," the
art dealer Eugène Druet wrote Georg Swarzenski on February 20,
1911. Swarzenski was a scholar of medieval art and the director of
Frankfurt's Städelsches Kunstinstitut (Städel Art Institute), a mu-
seum widely renowned for its collection of old master pictures. He
had come across the Gachet portrait first at Harry Kessler's house in
Weimar. He may have encountered the picture again at Roger Fry's
notorious 1910 *Manet and the Post-Impressionists* exhibition in
London. Finally, he had seen it at the Galerie Druet in Paris.

In 1911 *Gachet* cost 20,000 French francs, or about $3,900. The
dealer Druet knew that the German museum wanted only already

"recognized" works of art, and he charged almost 50 percent more than the 14,000 francs he had paid Harry Kessler for the painting the year before, a price that no doubt both buyer and seller wanted kept secret. While its funds were limited, the museum was in some ways less price-sensitive than a private collector. In the fourteen years since 1897, when Vollard had sold the painting for 300 francs, its price had jumped by a factor of 60. Still, in the context of the thriving market for Impressionist and Postimpressionist painting, Swarzenski's new acquisition was relatively inexpensive. The year before, Fritz Wichert, director of the Kunsthalle in Mannheim, spent 100,000 marks (some $25,000) for Manet's large *Execution of the Emperor Maximilian*. "You can't touch a Cézanne for under $3,000 and that for a small landscape," the American artist William Glackens wrote in 1912. On December 10 of that year, at the Paris auction of the estate of Edgar Degas's friend Henri Rouart, Louisine Havemeyer anonymously purchased Degas's *Dancers Practicing at the Barre* for 478,500 francs, or $95,700—a record sum that raised the price of this Impressionist picture to the level of old master paintings. Indeed, Degas's *Dancers* cost more than the 336,000 marks (some $84,000) that the Städel had spent recently on Rembrandt's 1636 *Blinding of Samson*. As the price for the work of a living artist, the record for this Degas stood unbroken for decades.

Swarzenski traveled frequently to Paris. There at Druet's gallery, from among canvases of the neo-Impressionists and the Nabis, the late van Gogh portrait confronted him with a radically modern painting whose metaphysical cast matched his aesthetic sensibility and whose centuries-old theme touched upon his intellectual preoccupations as a medievalist. In the melancholy canvas, he recognized the means to advance his quiet revolutionary plan to bring modern art to the city of Frankfurt. By acquiring *Gachet*, the first Postimpressionist canvas to enter the Städel's collection, Swarzenski knew he would immediately throw the traditional German museum into the controversy over the new French painting and set in motion the process of transforming the Städel from a distinguished but remote collection of old master paintings into a modern museum of art.

But as the painting would change the museum, equally the museum would change the painting. By acquiring the van Gogh portrait, Swarzenski revealed his judgment as an expert that the canvas, now only twenty years old, was a masterpiece worthy to be hung in the company of Albrecht Dürer, Hans Holbein, Rogier van der Weyden, and Rembrandt. Winning over an art historian and finding a place in the pantheon of old masters was a significant step in the process of recognition of van Gogh's work that had begun with the attention of artists, critics, and dealers. The museum's embrace lifted the painting above the intrigue of the marketplace, but somewhat ironically left no doubt as to its commercial value.

Swarzenski's acquisition of the Gachet portrait for the Frankfurt museum signaled the acceptance of the most advanced of the new French painting by the German art establishment. In 1911, more than a decade had passed since Hugo von Tschudi had angered Wilhelm II with his purchase of Manet and Cézanne for the Berlin Nationalgalerie. In central Europe, Impressionism was no longer an unknown novelty displayed at the Secessions and by a few dealers. The champions of the new French painting had taken their cause beyond Munich and Berlin to other German cities. Swarzenski was one of many German museum directors (including Ludwig Justi in Berlin, Fritz Wichert in Mannheim, and Gustav Pauli in Bremen) who followed Tschudi's footsteps and assembled collections of modern art in close to twenty German cities before World War I.

FRANKFURT

In 1911 Frankfurt was Germany's seventh-largest city, with a population of 370,000. Its prosperous economy was bolstered by industrialization and its growing chemical industry. "The whole appearance of the city," Karl Baedeker declared in his 1911 guidebook *The Rhine*, "betokens the generally diffused well-being of its inhabitants." Strategically located on the Main River, an eastern tributary of the Rhine, the city had for centuries served as a center of trade connecting the northern Rhineland and the south, a role advanced

in 1888 with the completion of the towering Hauptbahnhof (Main Train Station), whose triple ninety-three-foot glass-and-iron barrel vaults made it one of the largest stations in Europe. Frankfurt's situation as a commercial crossroads had spawned a tradition of trade fairs, which began in the thirteenth century. In the eighteenth century the poet Johann Wolfgang von Goethe had written that Frankfurt's inhabitants lived "in a frenzy of making money and spending it." Frankfurt had been the home of Meyer Amschel Rothschild, the founder of the banking dynasty, who lived in the city's Jewish ghetto and in 1811 was instrumental in winning equal rights for the city's Jewish population. (Although pushed by his alliance with the French toward following the 1804 Code Napoléon and giving Frankfurt citizens equal rights, Karl von Dalberg, Frankfurt's grand duke, had extracted 410,000 gulden from the Jewish community before he agreed to grant the rights.) For fifty-one years starting in 1815, Frankfurt had been one of the four free cities that, along with thirty-five princely states, formed the German confederation, and the city prided itself on its liberal democratic traditions. At its Paulskirche, the first German National Assembly had gathered in 1848, attempting to bring about a unified German democracy; without political power, its efforts for political reform inevitably failed. After the unification of the German states under Prussia in 1866, Berlin supplanted Frankfurt as a financial center; nevertheless, the sale of Frankfurt's banking assets to larger Prussian institutions enriched many of the city's financiers, some of whom spent money on art. At the start of the twentieth century, the city's progressive character came in part from its affluent bourgeoisie, an alliance of Protestants and assimilated Jews. Frankfurt's Jewish population (estimated to be some 25,000) was second in size among German cities only to Berlin's. But the modern-minded character of the city was rooted in its past. At the center of Frankfurt stood a section of some two thousand narrow timbered houses and winding cobbled streets that dated back to the twelfth century. The Gothic Altstadt (Old Town) reminded the contemporary city of its eight-hundred-year-old foundations, which rested in the shops, guildhalls, and dwellings of artisans, tradesmen, and merchants.

THE STÄDEL

Frankfurt's first art museum, the Städelsches Kunstinstitut was founded in 1817 as a private foundation by Johann Friedrich Städel, a banker and merchant whose bequest enabled his collection of some five hundred Dutch, Flemish, and German paintings, assembled in the last three decades of the eighteenth century, to form the nucleus of a public museum. The refined and cerebral character of both the Städel's building and its holdings of art was shaped by the museum's origins as the collection of a visionary citizen who lived in a self-governing German city run by its middle classes. At the start of the twentieth century, despite its now-extensive array of European painting, the Frankfurt museum retained the feeling of a private collection—with single fine, sometimes extraordinary, examples of the works of the great European artists: Rembrandt, Lucas Cranach, Jan Vermeer (*The Astronomer*), Fra Angelico, Giovanni Bellini, Jacopo da Pontormo, Claude Lorrain, and Nicolas Poussin.

The Städel was one of Europe's Enlightenment-inspired public collections, founded at the beginning of the nineteenth century following the opening of the French national museum in the Louvre. (In Paris, since 1750 an exhibition of art had been on view in the Luxembourg Palace two days a week; plans were laid to open galleries in the Louvre Palace when the Revolution began.) In 1793, four years after the Revolution, the painter Jacques-Louis David and the Committee of Public Safety transformed the palace of the Bourbons (a royal residence since the fifteenth century) into a public gallery of art, granting the French citizens access to the royal collections of antiquities, paintings, sculpture, furniture, and other decorative arts, which now theoretically were theirs. The vast Paris museum with its magnificent holdings became a grand symbol of French democracy and of the aspirations of the modern state. (After his European campaigns, Napoleon added works of Greek and Roman art, as well as Italian, Flemish, and Dutch pictures, raked from conquered territories; many pieces were returned after his defeat.) In the first decades of the nineteenth century, other European countries sought to express their nationalistic aspirations

by creating their own collections of art: the Rijksmuseum (State Museum) was founded in Amsterdam in 1817, the Altes (Old) Museum in Berlin in 1823, and the National Gallery in London in 1838.

The course of European politics was written out on the map of the continent's art museums. Following its history as a nation ruled by an absolute monarchy located in Paris, France concentrated its treasures in a single museum near its governmental seat. By contrast the German nation, united only in 1871, had several cultural capitals, each boasting internationally recognized museums. Germany's two most celebrated collections of old master paintings were Munich's Alte Pinakothek and Dresden's Gemäldegalerie (Painting Gallery), both of which originated as "princely collections" formed respectively by the Bavarian ruling family (the Wittelsbachs) and by the Electors of Saxony. In Berlin the Prussian kings had built a complex of museums on Museum Island, most of whose collections of paintings, sculpture, and archaeological treasures came from the royal family, the Hohenzollerns: the Altes Museum, the Neues Museum, the Kaiser Friedrich Museum, and the Nationalgalerie (opened in 1876 to hold nineteenth-century art). The first German museum designed specifically for "contemporary" nineteenth-century art was Munich's Neue Pinakothek, which opened in 1853. As a private foundation, the Städel differed from these German "princely collections," which had become public museums, owned and operated by the governments of their respective cities or states.

Johann Friedrich Städel shared with the founders of larger European public museums the ambition to assemble an extraordinary collection, one that he naturally hoped would make Frankfurt a hub not only of commerce and banking but also of culture. But Städel carried no nationalistic agenda for his museum, nor did he hope to amass an encyclopedia of world treasures on the scale of the Louvre. Instead, with a limited pool of wealth, the eighteenth-century connoisseur sought out fine pieces of western European art that he could have at reasonable prices. His collection spoke to the banker's well-developed taste, personal drive, and business acumen. Städel was emblematic of Frankfurt's cultivated, entrepreneurial

bourgeoisie, upon whose philanthropy the city relied to fund its civic institutions—including a hospital, a science institute, an opera house, and in 1914 the university, named for Johann Wolfgang von Goethe. Not much is known about Städel's private life. A marble bust reveals a thin face with sharp features. He installed his collection in a large house where he lived alone and where it was seen by Goethe. His finest pieces were old master drawings (he had over two thousand), some of which he bought from Paris dealers the year the Louvre was opened. Later, as a public collection, the Städel evolved along lines drawn by professional connoisseurs who had limited resources rather than by princes backed by a state treasury. Städel's bequest gave the museum's curators the freedom to develop the collection, buying and selling as they saw fit, allowing the museum to move with the taste and intellectual currents of the times. This freedom reflected the advancing professionalization of the field of art history.

In 1876 the Städel moved into a graceful neo-Renaissance building, whose sandstone facade ran (and still runs) for two blocks along the left bank of the Main River, in Sachsenhausen, from where it looked out at the center of the city. Designed by Oscar Sommer, the new building took architectural inspiration not from the extravagant Baroque palaces of the absolute monarchs but rather from the residences of Florentine bankers, renowned patrons of the visual arts. On the ground floor of the museum's two-tiered facade, arched windows were cut into massive stone walls; the more delicate and complicated upper tier consisted of windows separated by clusters of Ionic columns. Above the entrance stood statues of the German masters Albrecht Dürer and Hans Holbein, monuments that reflected a burst of nationalistic fervor following victory in the Franco-Prussian War. With its historical references, the museum's architecture spoke to its role as a secular temple of art (designed to instruct and inspire) and to the city's cultural ambitions. A grand building designed to accommodate the art public, it preceded the neo-Baroque opera house (1880) and the vast vaulted railroad station (1883–1888), Frankfurt's two other monuments to the industrial age. At the same moment that the directors of the Städel

oversaw the construction of a "new" museum, their counterparts in Boston, Chicago, and New York were founding the first major art museums in North America: the Museum of Fine Arts, Boston (1871), the Art Institute of Chicago (1879), and the Metropolitan Museum of Art (1870).

Inside, although an ornate marble double staircase ascended from the lobby to the second floor, the galleries were relatively spartan, designed expressly as a backdrop for works of art. The collection was composed only of painting, sculpture, drawings, and prints, reflecting Städel's allegiance to the eighteenth-century hierarchy of visual arts that placed these fine arts above all forms of decorative (or applied) art. Following the lead of the French museums, the art was laid out chronologically according to schools. To the left of the central rotunda hung Netherlandish and German pictures; to the right, old masters from Italy and Spain.

Still, it was evident to anyone strolling through the museum that the Städel was German. In a prominent place, not far from the front door, hung J. H. W. Tischbein's much-reproduced romantic portrait *Goethe in the Roman Campagna*, a reminder of the country's great literary tradition and of Frankfurt's significance as his birthplace. Besides five rooms of nineteenth-century German art, five more were devoted to the art of Frankfurt, and a large gallery was filled with pictures by the Rome-based German religious painters, the Nazarenes.

At the heart of the Städel's collection was its northern Renaissance art, a group of pictures painted in the fifteenth and sixteenth centuries in Germany, the Netherlands, and France, many of them acquired in the early nineteenth century by the artist-connoisseur Johann David Passavant, who served as the museum's director. Paintings of breathtaking virtuosity, several hung in an unadorned corner gallery on the museum's second floor: three paintings by Robert Campin, a *Madonna* by Petrus Christus, a *Virgin with Saints* by Rogier van der Weyden (once in the Medici collection), a *Portrait of a Man* by Hans Memling, and the *Lucca Madonna* by Jan van Eyck. In the *Lucca Madonna*, for example, the fifteenth-century artist conveyed the miraculous phenomenon of the mother and child

through his extraordinary rendering of three-dimensional form and detail—in cascades of crimson drapery and the edge of a half-filled carafe touched by a glimmer of light. Meanwhile, the Städel's steadily expanding collections of drawings (17,000) and prints (63,000) were among the finest in Germany.

When Swarzenski arrived in 1906, the Städel had no more than two Impressionist pictures, and the museum was locked in a battle with the city over the question of whether or not to accept modern art in its galleries. A forward-thinking banker, Ludwig Pfungst, had left 10 million marks to establish a public museum for the works of living painters, and the mayor, Franz Adickes, wanted this museum to become part of the Städel. Although new to the city, Swarzenski used his authority as an expert and his skills at diplomacy to persuade the conservative museum board (its membership drawn from old-line Frankfurt families) to take on the new public museum of modern art. Funded by the city, Frankfurt's newly created Städtische Galerie ("Municipal Gallery") was housed in the Städel and served in practice as the museum's department of modern and contemporary art. With the possibility of buying the "last still-living masters of French painting of the nineteenth century," Swarzenski told Frankfurt's mayor, "we will make a modern gallery of the first order."

From the start, Swarzenski had considered acquiring examples of the new French painting, yet he needed time for his appreciation of modernism to evolve. Nevertheless, as a connoisseur of medieval art, which rarely conformed to the dictates of classicism and the High Renaissance, his taste ran to the unconventional. Medieval art has "a new unprecedented and unrepeatable beauty," he later wrote, "independent of and in opposition to conventional reality." Correspondence flew back and forth between Frankfurt and Paul Cassirer in Berlin, E. Arnold in Dresden, and Paul Durand-Ruel, Ambroise Vollard, and Paul Rosenberg in Paris. The dealers offered the museum director pictures by Edgar Degas, Edouard Manet, Claude Monet, and Auguste Renoir—and by Pierre Bonnard, Henri-Edmond Cross, and Maurice Denis. Félix Fénéon sent him a Toulouse-Lautrec and a Gauguin on approval, but he decided against both. He did acquire two small Renoirs and a brilliant Monet, *Le Déjeuner*, a monumental

scene of a family dinner table redolent of bourgeois life in nineteenth-century Paris. He also purchased a dark, Dutch-period van Gogh landscape. The modern French pictures and the shadowy van Gogh (*La Chaumière*) he placed together in a corner room with landscapes from the Barbizon school.

Swarzenski's choice of *Portrait of Dr. Gachet* as his modernist battleground was the choice of an art historian. The picture was now twenty years old. Yet by the standards of the Städel, its paint was barely dry. Even compared with the Impressionists' scenes of contemporary life painted in the 1870s and 1880s (two and three decades ago), the portrait, with its distorted figure and writhing lines, seemed radically modern. But Swarzenski recognized instantly that the "anarchist" van Gogh, in this portrait, had drawn on tradition. As a subject, melancholy had particular significance for Germany, as the greatest portrayer of that psychic state was the German Renaissance master Albrecht Dürer (1471–1528). Erwin Panofsky's later interpretation of Dürer's 1514 engraving *Melencolia I* as a "subjective confession" and "spiritual self-portrait" could equally apply to the Gachet portrait. Despite its origins in a village in France, van Gogh's introspective portrait, Swarzenski could see, followed in the northern Romantic tradition, whose nineteenth-century artists (including Caspar David Friedrich and Philipp Otto Runge) painted self-portraits less concerned with style than with questions of identity and existence.

This metaphysical thread ran through the tradition of German art and had recently surfaced in the expressionist art now being produced in Munich, Dresden, and Berlin. Wassily Kandinsky began in 1910 to paint completely abstract canvases, pictures emptied of identifiable images from the empirical world and instead filled with stray lines and clouds of color, which he described as scenes of apocalypse. (In 1911 in Munich, Kandinsky and Franz Marc founded Der Blaue Reiter [Blue Rider], an association of international artists united by their attachment to Kandinsky's radical aesthetic principles. Artists, he felt, should not slavishly follow rules of form, or struggle to imitate a particular style; instead, works of art—whether representational or abstract—must express their creators' emotions

and spirit, driven by what he called the "principle of inner necessity.") Already critics were pointing out that van Gogh had served as inspiration for the intense colors and distorted forms appearing in certain contemporary German paintings; the art historian Wilhelm Worringer described expressionism as "a great new direction deriving from van Gogh."

At that point Swarzenski would not have dared hint to the museum's staid board of directors that in the future they would find expressionist art in the Städel, but he was moving in this direction. Impressionist in color, expressionist in line, *Gachet* would serve his new collection as a critical link in the chain of recent art history between nineteenth-century French painting and twentieth-century German art. Placed in a gallery of the museum, the portrait would help the director defend and explain the new—and, to some, dissonant and unnerving—art by emphasizing its fundamental connections to the old.

What Swarzenski also realized was that this dark and difficult van Gogh portrait found resonance in the Städel itself, a museum whose dimly lit rooms were filled with religious images and many of whose most ravishing works of art represented states of suffering and pain: Rembrandt's *Blinding of Samson*; Robert Campin's *Thief on the Cross*; and Stephan Lochner's *Martyrdom of the Apostles*, an altarpiece with six panels depicting in delicate detail six saints in the hands of their torturers.

Max Beckmann, *Portrait of Georg Swarzenski*, 1921.

GEORG SWARZENSKI

Born in Dresden in 1876, the son of a Jewish merchant, Swarzenski had made his own way from an obscure, middle-class family to take charge of one of Germany's major museums in 1906 at the age of only thirty. He was driven to learn and took advantage of the opportunities in German society to attain rank through education. He was trained first as a lawyer, on the insistence of his father, then prepared himself for a career in the history of art at the universities of Heidelberg, and of Freiburg, Berlin, Munich, Vienna, and Leipzig, along the way also studying archeology and the history of music. ("A German student . . . spends one semester here and another there," Erwin Panofsky explained in 1955, "until he has found a teacher under whose direction he wishes to prepare his doctoral thesis [there are no bachelor's and master's degrees in German universities] and who accepts him so to speak, as a personal pupil.") A dissertation (published in 1901) under the medievalist Adolph Goldschmidt on tenth- and eleventh-century Regensburg illuminated manuscripts earned him a doctorate in 1900 and established his credentials as a scholar. As an assistant to Julius Lessing, director of the Kunstgewerbe museum in Berlin, he honed his skills as a connoisseur, experienced at discriminating true from false at a time when art history was less systematic and scientific and depended more on the expert's eye. (That he thought of himself as a connoisseur is evident in an official photograph, in which he is posed contemplating a bronze statue.) While in Berlin, he found the art world in a state of change. Paul Cassirer was exhibiting Manet, Degas, Cézanne, and van Gogh. Hugo von Tschudi was buying Impressionist and Postimpressionist paintings for the Nationalgalerie, deposing from the museum's walls many of the nationalistic history paintings. In 1904 Wilhelm von Bode, director general of the Royal Prussian Museums, opened the Kaiser Friedrich Museum, a collection devoted exclusively to the arts of the Renaissance and whose innovative installation mixed paintings and decorative arts to evoke the ambiance of the period. Swarzenski came to Frankfurt with hopes of weeding out and improving the city's collections, knowing that

ultimately as a museum director he would be judged on his acquisitions. Ambitious for the Städel to rival the best museums in Europe, he had come to believe it necessary to acquire the modernist paintings of France.

At the age of thirty, the scholarly Swarzenski looked considerably older. He had a high, bald forehead that, along with a neatly clipped goatee, lengthened his otherwise round face. His most striking aspect was a rapierlike gaze that shot through the rimless pince-nez he habitually wore. He was short and stocky. His thick hands struck one contemporary as more like a worker's than an intellectual's, and his voice was extraordinarily deep. Dressing with a Prussian correctness, he wore dark, heavy suits, starched shirts with high collars, and elegant striped neckties. As time went on, his formal clothes and tense, upright bearing made him seem increasingly old-fashioned. A chain smoker, he was rarely without a cigarette.

Frankfurt seemed the ideal home for the ambitious and brilliant scholar. Temperamentally, he was both timid and bold. With justification, he had great confidence in his intellect and professional achievements. (A bibliography of his works lists over ninety articles and books.) At the Städel he acted decisively; yet at times he was cautious and conservative. Judging in 1905 that Frankfurt lacked a representative collection of sculpture, Swarzenski decided to create one, acquiring in only two years over 350 pieces of sculpture, from both Europe and Asia. These he installed in the Liebieghaus, a turreted mansion a few blocks from the Städel, in effect giving the museum a department of sculpture. With an equal sense of certainty, soon after becoming director of the Städel he banished from the museum the plaster casts of Greek and Roman sculpture that filled half of the ground floor. Such casts (in the absence of originals) were considered necessary to art museums in the early nineteenth century, when ancient sculpture and paintings of the High Renaissance still were deemed to epitomize an absolute canon of beauty.

As the director of a major German museum, Swarzenski was an extraordinary but not unique example of Germany's educated bourgeoisie—the Bildungsbürgertum—a class of lawyers, journalists, doctors, and professors that distinguished itself by intellectual

and cultural achievement. In the elevated position of museum director he was accepted, along with countless other assimilated Jews in business and the professions, as a member of Frankfurt's liberal upper middle class. After his first wife, Ella Pertz-Wilcynska, died in 1913, Swarzenski married Marie Mössinger and joined one of old Frankfurt's prosperous Protestant families, attaining a social status commensurate with his professional rank.

THE VINNEN PROTEST

Despite the acquisition of van Gogh paintings by several German public collections, the purchase of a van Gogh by a public collection still had the power to stir politically charged debate. Earlier in 1911 Gustav Pauli, the director of the Kunsthalle in Bremen, acquired van Gogh's *Field of Poppies* from Paul Cassirer for 30,000 marks (about $8,000). The purchase provoked Carl Vinnen, an obscure landscape painter who had once been a member of the Berlin Secession, to issue *Ein Protest deutscher Künstler* (*A Protest of German Artists*). This was a bitter, inflammatory manifesto that accused art dealers of conspiring to foist overpriced French art on the unwitting German public, putting at risk the national interest and character, not to mention its working artists.

> In view of the great invasion of French art which for the past few years occurred in the so-called progressive art centers of Germany, it seems to me a necessity of German artists to raise a warning, without being deterred by the objection that their only motivation is envy. . . . Speculation has taken hold. . . . German and French art dealers work hand in glove, and under the guise of supporting art, flood Germany with great masses of French pictures. . . . On the whole we are granted only leftovers, only those paintings not bought by the French themselves or by the great American princes of finance.

The *Protest* included a list of the names of 140 supporters—most of them artists but also conservative museum directors and critics. While demonstrating how German conservatives persistently framed

the issue of modern art as a question of national destiny, it failed to slow the "invasion" of French art.

Swarzenski publicly responded to Vinnen's *Protest* with a ringing affirmation of Impressionism. In the *Frankfurter Zeitung* he argued that 3,000 marks spent on a van Gogh amounted to nothing compared with what museums typically spent on Italian or Dutch primitives or certain nineteenth-century German pictures.

> There is no doubt about the French painting of the nineteenth century. The painters created masterpieces of the highest order, in which the world and its appearance are recreated in a new and perfect way. . . . It is a matter of course that every museum being aware of its cultural mission would like to call these works its own.

Still, to avoid possible public controversy, Swarzenski asked Victor Mössinger—a businessman and city councillor for cultural affairs, who would later become his father-in-law—who had donated landscapes by Sisley and Monet to the Städel, to purchase the van Gogh and then give it to the museum. In this way, the museum director avoided the technical problem that his funds for contemporary art could only be spent on the work of living artists. (Later, he wrote to Karl Osthaus that he hoped to acquire a Cézanne "in the same way.") More importantly, he sidestepped accusations that the museum had squandered funds better spent on more certainly established works of art.

But in the culturally ambitious Frankfurt, the appearance of *Portrait of Dr. Gachet* produced no immediate public outcry. To support the purchase, Swarzenski could count on a substantial group of collectors who had been buying French art for a decade: they included the art dealers Ernst and Martin Flersheim, *Frankfurter Zeitung* publisher Heinrich Simon, and the leather-manufacturing magnate Robert von Hirsch, who in 1912 bought van Gogh's *Shepherdess (after Millet)*. All the new and interesting movements began with these Frankfurt collectors, according to the art historian Beatrice von Bismarck. As soon as they started to buy Impressionist paintings, they also exhibited them. She calculated that these collec-

tors owned eight van Goghs, and pictures by the Impressionists, as well as by Gauguin, Cézanne, Seurat, Bonnard, and the fauves— Vlaminck, Othon Friesz, Matisse, and Derain. Swarzenski was both a friend and artistic advisor to many of these collectors, sponsors not only of the Kunstverein (Art Society), but also the Museumsverein, an association of "friends" (started by Leopold Sonnemann, *Frankfurter Zeitung* founder), a major source of funding for Städel acquisitions. (The Kunstverein was one of many art societies, composed of collectors and sometimes artists, that formed in German cities in the mid-nineteenth century to exhibit and support contemporary painting and sculpture.) In June 1908 Frankfurt's Kunstverein had brought Félix Fénéon's landmark van Gogh exhibition (82 paintings and 16 drawings) from Paris. Two years later, the society presented a smaller exhibition of van Goghs (49 paintings and 6 drawings). That was followed the next month by an exhibition of 35 of the artist's drawings at the "modern" gallery of a dealer named Marie Held.

In 1912, as if to deliver Frankfurt's answer to the Vinnen *Protest*, the Kunstverein celebrated the art of nineteenth-century France with an exhibition that began with Jean-Baptiste-Camille Corot and ended with van Gogh. In discussing the French art, the critic Carl Gebhard argued that the Dutch artist was in fact more Germanic than French. "If it is the nature of the Germanic spirit to give external shape to inner visions," he wrote, "if it is for this reason that the German has become the philosopher, the poet and musician, has become Kant, and Schopenhauer, Goethe, and Kleist, Beethoven and Wagner, this same spirit has also brought forth van Gogh the painter whose work led to the triumph of the Germanic spirit." In this vein, he celebrated the newly acquired *Portrait of Dr. Gachet*: "It is superfluous to speak about the outer form of this painting, about the suggestive power of the features, the powerful form of the head, the eyes which repeat the dominating colors, and are set in the head like two deep lakes between the mountains." Gebhard concluded, "Here, we see the emergence of something of the greatest depth and of true substance."

That same year, Wassily Kandinsky and Franz Marc published the image of *Gachet* (the second version) in their "*Blaue Reiter*"

Almanac, juxtaposed to a Japanese print of a juggler with a monkey on his shoulder, to illustrate their theory that art of every culture springs from the universal force they called "inner necessity."

That indeed van Gogh had secured a place in Germany as the preeminent modernist was made clear also in 1912 at the Sonderbund (Special League) exhibition in Cologne (originally organized by the Düsseldorf Sonderbund Westdeutscher Kunstfreunde und Künstler). In this vast international array of 577 works by 160 artists, the first five galleries were filled with 125 works by the now-famous Dutch artist. By comparison, his contemporaries Cézanne and Gauguin were each represented by 20-odd works. There were also 16 Picassos. The Sonderbund became the model for the 1913 Armory Show in Manhattan, in which the Association of American Painters and Sculptors displayed 1,300 paintings and pieces of sculpture (one-third from abroad). In response to Paul Cassirer's 1914 retrospective celebrating van Gogh, the critic Julius Meier-Graefe declared van Gogh "the Christ of modern art. He created for many, suffered for still more. If he is or can become its savior will depend on the faith of his disciples."

THE STÄDTISCHE GALERIE

As the cornerstone of a museum that combined both old masters and modern art, the *Gachet* signaled a shift in the vision of a museum. No longer was it primarily a storehouse of objects, whose mission was to teach the history of art; instead, in Swarzenski's words, the museum should be "like a concert hall," its primary purpose "to transmit artistic experience as perfectly and directly as possible." He had moved beyond the Enlightenment notion of the art museum designed to inform the public about the progress of civilization and to inspire an identification with the cultural achievements of the past. The capability of photography to provide reproductions of works of art had made it possible to study the history of art from illustrated texts; one consequence of the new technology was that those who ran art museums now could rethink the nature of the museum's didactic role. They could concentrate on the museum's

unique capability: to offer an encounter with original works of art. Swarzenski's writings on the subject of the museum reflected his schooling in the German idealist tradition, which assumed that there was nothing higher than the life of the mind. "The peculiar nature of the museum," he wrote, "lies in the fact that it does not directly further systematic understanding or the impulse to knowledge and education, but rather ethical consciousness and spiritual inventiveness." As a scholar of medieval art, he believed that to really understand the art of the past demanded knowledge of history and artistic tradition, and naturally, he followed the accepted practice of organizing the museum's collection according to schools and in historical sequence. But in shaping the experience of viewers as they walked through the museum, he sought to create what he called "constant intensification," by setting up provocative correspondences between pieces from different cultures or periods that had thematic or stylistic links. In his purchases, he sought out such correspondences. When for example in 1934 he bought a thirteenth-century Florentine panel painting of Saint John in the pose of melancholy, he found a picture whose content and style seemed to prefigure van Gogh's *Gachet* by six centuries. Rather than having the museum deliver accepted truths, Swarzenski reconfigured the collection in order to enhance the visitors' aesthetic experience, to train their senses, and to make them think. In a period when modern artists redirected their ambitions away from duplicating objective appearance and aimed rather at using painting and sculpture to express their own particular vision and experience, art's shift toward subjectivity pulled the museum along with it.

WORLD WAR I

On August 3, 1914, Germany declared war on France; on the following day England declared war on Germany. Communication within the international art world immediately ceased. (Cassirer's connections to the Paris dealers and to Johanna van Gogh were abruptly severed.) In the years just before the conflict began, there had been a frenzy of buying in many fields. In 1913 old master

painting prices climbed to new highs. The dealer Joseph Duveen sold a Raphael *Madonna* to the American P. A. B. Widener for 116,500 pounds, or over $567,000. Soon after, the Benois family traded a Leonardo da Vinci painting for some 310,000 pounds to Nicholas II of Russia. Shortly, these extravagances would seem like emblems of a lost era.

Swarzenski presumably supported the war effort. Most artists and intellectuals associated with the Berlin Secession, Peter Paret wrote, also backed Germany's position: "At least during the opening stage of the war, these people believed that Germany had been forced to take up arms. They trusted the army and its leaders and accepted the need for sacrifice; they were shocked by Allied propaganda that represented Germans as barbarians; they became aware of the horrors of war between industrialized societies and felt free to express their sense of the apparently unending tragedy, without regarding these reactions as tantamount to criticism of the government and the high command."

Throughout the protracted conflict, *Portrait of Dr. Gachet* remained safely inside the Städel, hundreds of miles from the fighting, which took place in Belgium and France. Swarzenski, now forty, received an induction notice but managed not to serve; instead he tried to keep the museum going. Plans had already been drawn up for a new wing to house the museum's collection of modern art. By the outbreak of the war, Swarzenski had acquired over thirty Impressionist and Postimpressionist paintings. In 1915 ground was broken. But within months construction came to a halt. The museum remained open, but visiting hours were cut. Soon, most of the museum's guards and maintenance men as well as the curatorial staff left for the front. (By 1916 Germany extended the draft to cover the male population between the ages of sixteen and sixty.) In the course of the war, 13 million men, or almost 20 percent of Germany's population, would serve in the German army. Designed to survive for centuries, the museum remained basically untouched by the distant battle. The impact on individual lives, however, was immediately visible.

The all-encompassing war did not spare members of the

German art world. Forty-two when the war began, Paul Cassirer enlisted. Already suffering from a heart condition, he nevertheless served as a courier in Belgium, where he earned an Iron Cross. Meanwhile, he published a book of poems by members of his army corps, illustrated with sketches by the expressionist Max Beckmann. He also published *Kriegszeit* (*Wartime*), a journal, which carried lithographs along with poems and texts taken from official government statements. In 1915, because of his heart condition, Cassirer was demobilized. Back in Berlin, he began to publish *Der Bildermann*, a periodical that made clear the realities of mass-scale warfare. ("The strain of war had taught us to look horror calmly in the face," he wrote, "but it has also reawakened our longing for higher and purer things.") Possibly in retaliation for his publication, his medical discharge was rescinded; he was inducted, arrested, and threatened with a court-martial; then, fortunately, he was released. Through Kessler, he obtained an appointment as a German cultural representative in Switzerland, where he remained until 1918.

For Harry Kessler, trained as a Prussian officer, the declaration of war seemed to offer a release from his frustrations and failures in writing for the opera and ballet. At the age of forty-six, he enlisted as a liaison officer. Experiencing a nervous breakdown, he was transferred from the front. From Switzerland, he served as a cultural attaché to a mission for the Prussian foreign ministry, assigned to use his connections to France to pursue possible avenues to peace.

Max Beckmann, thirty, was one of many artists (including Franz Marc and August Macke) who headed for the front. He went not without enthusiasm to serve as a medical orderly, and in April he wrote that he was learning "all the moods and possibilities of the War." But after months ministering to soldiers in the field and living in a building whose basement served as a morgue, Beckmann suffered a breakdown. In 1915 he was discharged and he moved to Frankfurt. By the end of 1915 German public enthusiasm for the war had faded. The following year German casualties on the western front rose to 1.2 million. Meanwhile the civilian population suffered from shortages of food; this, in turn, left them susceptible to disease. In Frankfurt Beckmann resumed painting. Stricken by the war

experience, Beckmann turned from painting contemporary life and instead took his subjects from the Bible. In 1916 he started to work on a large (twenty square feet in size) *Descent from the Cross*, a standard New Testament subject that depicts the moment when guards haul down from the cross the body of Jesus. Beckmann portrayed the deposition as a frightening and grotesque scene, acted out in a compressed, confused space, dominated by a towering, ghostly, skeletal corpse, its arms outstretched, frozen in the position of the cross. Two women crouch in the foreground and avert their eyes. All participants have a deathly pallor. Soon after Beckmann finished the canvas in 1917, Georg Swarzenski hung it in the Städel. By then, he and Beckmann had become friends. Those who came to the museum for escape instead confronted what Julius Meier-Graefe described as a portrait of a nation, its "rotten flesh . . . burned away so that its spirit might come to its senses." The Beckmann picture broke the silence of the galleries with a scream of pain. It condemned not only the slaughter taking place in Belgium and France but specifically Germany's role in it. By transforming a benign religious subject into social critique, the German expressionist painting was in full concert with *Portrait of Dr. Gachet*. In 1919 the museum director bought the Beckmann canvas for the permanent collection.

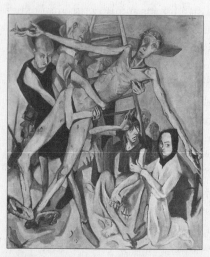

Max Beckmann, *The Descent from the Cross*, 1917. Frankfurt's Städtische Galerie acquired the painting shortly after World War I.

16

Frankfurt:
Museum Masterpiece,
1920–1933

*But then, the great burning, revolution should have followed.
And it did not. . . . And then the agony of the war begins to seem
meaningless, the collapse of the European world appears to be
completely sealed.*
 —Benno Reifenberg, art critic for the *Frankfurter Zeitung*, 1921

IN GERMANY, World War I launched a series of political, economic,
and social crises that rocked the nation for more than a decade. The
armistice was signed November 11, 1918, after 10 million Euro-
pean soldiers had been killed (115,000 Americans also died—
49,000 in combat and the remainder succumbing to disease). In
all, the German dead would amount to 2 million; over 800,000 of
these were soldiers younger than twenty-five. "Among the dead was
the promise and flower of Europe's youth," wrote Fritz Stern. "The
potential leaders of the 1920s and 1930s had been decimated, as
thousands of men of recognized talent died alongside others whose
talents and genius would remain undiscovered forever." Long after
the fighting ended, the deep and devastating imprint of the war
could be detected in the social, political, and economic issues with
which Germany wrestled throughout the decade. Meanwhile
expressionism and other avant-garde movements, born under the
Empire, bridling often against imperial opposition, flourished
under the new republic. In the course of the 1920s, modernist

art entered many German public collections and gained a wider audience.

Two days before the armistice, Kaiser Wilhelm II abdicated. "Revolution has won the day in Berlin," Harry Kessler wrote on November 9, 1918. The Empire was replaced by a republic, founded in Weimar on July 31, 1919. The Germans desperately hoped that the new democratic government would be able to negotiate a reasonable peace settlement with the Allies, who were demanding reparations of 50 billion gold marks. But the Allies had little sympathy for the plight of the new German government. From the start the Weimar Republic was resented by its citizens for being saddled with the Versailles Treaty and with the burden of the debt. The reparation payments (calculated in 1921 by the Allies to be some 132 billion gold marks) on top of the government's deficit spending (begun to finance the war) caused dramatic inflation. Against other currencies, the German mark collapsed. In January 1921, the mark traded at 64 to the dollar; by October 1923 it had fallen to a rate of 25 billion to the dollar. (One could, Malcolm Cowley wrote, "gamble in Munich for high stakes, win half the fortune of a Czechoslovakian profiteer, then, if you could not spend your winnings for champagne and Picasso, you might give them day after tomorrow to a beggar and not be thanked.") The inflation impoverished much of the middle class. Stringent economic measures taken by the government, in addition to a reduction in the reparations, brought recovery in 1924 and a period of prosperity that lasted through 1929.

In the course of fourteen years, however, the Weimar Republic had seventeen different administrations; it was forced to contend with a lack of support from the extreme right and left but also from liberals. The art dealer Paul Cassirer, after backing the revolution, grew disillusioned and characterized the new political system as "nothing but a great swindle." At first the Social Democrats, the moderates who formed the largest party in the Reichstag, were in charge; in January 1919 they suppressed an uprising headed by the Spartacists, Karl Liebknecht and Rosa Luxemburg, both of whom were killed. The chaotic politics of the Weimar Republic left many intellectuals, including Georg Swarzenski, politically uncommitted

and at sea. A liberal, he remained unaffiliated with any political party. Reportedly, on one election day he went to the polls, hesitated, circled the block more than once, and returned home, incapable of casting his vote.

Among the acts of violence that plagued the Republic was the assassination in 1922 of foreign minister Walther Rathenau (Kessler's friend) by right-wing nationalists. The following year, Adolf Hitler, a member of the National Socialist German Workers' Party (in German, Nationalsozialistische Deutsche Arbeiterpartei, or NSDAP)—the Nazi party—attempted with his private band of storm troopers, or "brownshirts," to stage a rebellion (the "Beer Hall Putsch") in Munich; he was arrested and imprisoned. Sentenced to five years, he served only nine months, in which he dictated the first volume of *Mein Kampf* (*My Struggle*), which was published in 1925.

With the overthrow of the Empire, conservatives in the cultural bureaucracies of the Republic and its individual member states who had been on the defensive since the beginning of the century lost further influence. In Berlin the government turned the Kronprinzenpalais (Palace of the Crown Prince) into an art gallery for French Impressionist, Postimpressionist, and German expressionist art. The Preussische Akademie der Künste (Prussian Academy of Art) elected Max Liebermann as its president. Expressionist painters took influential teaching posts; Oskar Kokoschka joined the faculty of the Dresden academy. Max Beckmann became a professor at the Städelschule in Frankfurt.

The most influential development in the visual arts was the founding of the Bauhaus by the thirty-six-year-old architect Walter Gropius. Gropius launched the school in 1919, in the town of Weimar—when the new republican government was drawing up its constitution—by combining Henry van de Velde's Weimar Kunstgewerbeschule and the Kunstschule. Because he was Belgian, van de Velde had left Germany during the war, but the Bauhaus program reflected the art nouveau designer's desire to eliminate the distinctions between artist and craftsman and to employ technology to revolutionize design for the mass market. "Together let us conceive and create a new building of the future," wrote Gropius, "which will

embrace architecture and sculpture and painting in one unity and which will rise one day toward heaven from the hands of a million workers like the crystal symbol of a new faith." The painters Josef Albers, Wassily Kandinsky, Paul Klee, and Oskar Schlemmer were among the school's original staff.

In Frankfurt, as soon as the war ended, Georg Swarzenski ordered construction on the modern galleries of the Städel to resume. The museum's new wing opened in 1923, giving its nineteenth- and twentieth-century paintings as much space as the old masters. There Swarzenski hung *Portrait of Dr. Gachet*. He placed the late van Gogh portrait not in a large room of Impressionist paintings but among the German artists, in a sequence that began with Hans Thoma and proceeded to Max Beckmann, an installation designed to emphasize the Dutch artist's profound influence on expressionist painting. Beside the van Gogh portrait he placed Oskar Kokoschka's brooding 1911 portrait of Hermann Schwarzwald, an Austrian banker. Except for the face and hands, a white streak of collar, and a red necktie, the Kokoschka portrait was almost completely enveloped in tones of smoke and brown; its charred existential atmosphere echoed the neighboring *Gachet*.

Throughout the 1920s, Germany's museum directors bought quantities of expressionist pictures. Swarzenski filled the Städel's modern galleries with dozens of twentieth-century paintings, drawings, and prints, which caught his historically grounded eye. Although he shied from pure abstraction and from social commentary, he bought numerous works by the German expressionists, portraits or figure paintings by Paula Modersohn-Becker, Lovis Corinth, Carl Hofer, and Ernst Ludwig Kirchner; landscapes by Christian Rohlfs, Oskar Kokoschka, and Erich Heckel; and a still life by Karl Schmidt-Rottluff. In 1919, the year he bought Beckmann's *Descent from the Cross*, he had acquired another biting condemnation of the war in Kirchner's *Self-Portrait as a Soldier* (1914), in which the artist appears in his military uniform, holding up his partially amputated right arm. Swarzenski continued to favor Beckmann, and from the artist the museum director purchased still lifes, portraits, and several paintings of the city. Swarzenski's acquisitions of expressionist pictures

revealed his preference for early examples of the movement. Indeed, after the war, expressionism lost its original fire. Die Brücke, which the Dresden artists Fritz Bleyl, Heckel, Schmidt-Rottluff, and Kirchner had formed in 1905, had long since disbanded. Similarly, Wassily Kandinsky and Franz Marc's Blaue Reiter movement ended with the war: because of his Russian citizenship, Kandinsky was forced to leave Germany, and Marc, thirty-six, and August Macke, twenty-seven, who were soldiers, were killed. "In its beginnings expressionism was an exceedingly revolutionary movement with socially disruptive overtones, particularly erotic ones," wrote art historian Peter Selz. "This was in the post-Victorian era. But in the 'twenties many of the free-thinking notions of the expressionist painters were accepted, if not approved of, by most of the well-to-do bourgeoisie."

Swarzenski also acquired several important French pieces, including a late Tahitian Gauguin (*Marquesan Man in a Red Cape*), a Matisse still life with a blue background (a 1917 gift from Robert von Hirsch), and another still life by the cubist Georges Braque. In 1924 Picasso's dealer Paul Rosenberg gave the museum the artist's *Head of a Woman*, painted two years before. In June 1931 the new acquisitions were assembled with scores of pieces from private collections in *Vom Abbild zum Sinnbald* (*From Representation to Symbol*), an exhibition of two hundred works that Fritz Wichert, director of Frankfurt's Städelschule, put together at the Städel to clarify modernism as a progressive history, which began with early Impressionism and was carried to contemporary German art. Included were images by George Grosz and Otto Dix, who had launched the Neue Sachlichkeit (New Objectivity) movement, a "new realism bearing a socialist flavor." Their work offered scathing critiques of German society, reflecting in harsh, sometimes grotesque imagery the cataclysm of the war; Dix's etching *The Bombing of Lens* documented the sort of horror the war had visited upon innocent citizens, whom he shows scattering in a bombed-out street as a warplane flies overhead. Similarly Beckmann's lithograph *Beggars* portrayed veterans on crutches and wooden legs, the maimed survivors who frequented Germany's thoroughfares.

During the course of the Weimar period, Swarzenski extended

his influence as a cultural figure in Frankfurt. In 1922 he master-minded a controversial swap with the history museum, which gave the Städel a huge altarpiece by Hans Holbein and a painting of Saint Laurence by Matthias Grünewald. In 1928 Frankfurt named Swarzenski, then fifty-seven, general director of the Frankfurt municipal museums, a post created specifically for him. He now headed not only the Städel and the Städtische Galerie but also the Historisches Museum (Museum of History) and the Kunstgewerbe-Museum (Museum of Arts and Crafts). He was also a full professor of art history at the University of Frankfurt. He lived in the city's fashionable West End and enjoyed the company of Frankfurt's collectors and intelligentsia.

At the end of the decade Frankfurt's museum housed a collection of old masters and modern paintings at the center of a city that boasted active collectors, dealers, and artists. Frankfurt's thriving intellectual community was fed not only by the new university, which opened in 1914, but by the Institut für Sozialforschung (Institute for Social Research), founded in 1924. This was a center of Marxist sociology whose associates (including Max Horkheimer, Theodor Adorno, Erich Fromm, Herbert Marcuse, and Walter Benjamin) came to be known as the Frankfurt school. In less than a decade its library held 60,000 volumes.

In 1931 the achievement of contemporary German artists was celebrated in New York with the exhibition *Modern German Painting and Sculpture*, held by Alfred H. Barr Jr. at the Museum of Modern Art. (Only two years before, Barr had launched New York's first modernist museum with an exhibition of works by the four canonical Postimpressionists: Cézanne, Gauguin, Seurat, and van Gogh.) In the catalog of the German show, Barr listed fifty German museums whose avant-garde collections had stocked his exhibition. Germany's museum directors, he wrote, "have the courage, foresight and knowledge to buy works by the most advanced artists long before public opinion forces them to do so." He added:

Even in small towns the museums have their figures by Kolbe or Barlach, their paintings by Heckel, Hofer, or Beckmann, their

watercolors by Klee and Nolde. Larger cities have special galleries devoted to modern art with special catalogs, which list, in the case of Dresden for instance, over 700 19th and 20th-century works (exclusive of prints) in the case of Hamburg 1,577, and Essen 774. Berlin and Munich have entirely separate institutions devoted to modern art *since* Impressionism.

Yet Germany's museums had not been immune to the country's economic troubles. At the start of the 1930s the only museum with funds enough to buy van Gogh was the Berlin Nationalgalerie. In 1931 the director Ludwig Justi purchased one of the two versions of *Daubigny's Garden*, a landscape of flower beds, and a self-portrait. Together they cost 240,000 marks. Critics not only accused Justi of paying too much but questioned the authenticity of *Daubigny's Garden* because it lacked the black cat that van Gogh had described as being in the foreground of the painting. To defend himself, Justi argued that for the Berlin museum he had acquired paintings by only two foreign artists, Munch and van Gogh, and they were "the two great Germanic masters of the modern age."

By then van Gogh was widely known in Europe. In 1921 the critic Julius Meier-Graefe, whose early-twentieth-century writings had alerted German collectors to the significance of van Gogh's art, published a melodramatic biography of the artist, entitled simply *Vincent*. Based on van Gogh's letters and also reports of those (including Gachet) who had known the artist, the book spoke to the disillusionment that gripped Germany following the war and that was manifest in other histories of "oversized heroes." In the context of the postwar period, the "sacrifice" of van Gogh ("an artist and the greatest of our time") paralleled the sacrifice made by millions of Germans to the expansionist ambitions of their rulers. "Something of van Gogh's destiny sublimates and oppresses all the intellects of our time," he wrote. "Every person who is now struggling with life feels something of his tension." But Meier-Graefe had lost his optimism about art's capacity to trigger social reform: "Certainly the occasions for despair have not lessened since his death. The crack in the world, which none saw more clearly than Vincent . . . has widened to a

chasm and the artists, the last protection in the world, have given up." Meier-Graefe's biography sold well and put the artist into a category of popular hero from which it would prove difficult to escape.

The van Gogh literature swelled with the publication not only of biographies, memoirs, and novels but of medical studies. The idea that van Gogh's madness was a crucial component of his genius produced an extensive body of psychological literature that was based on speculation about his condition. In 1922 the psychiatrist Karl Jaspers, professor at Heidelberg University, analyzed the artist as suffering from schizophrenia whose effects he claimed to see in his work. (From 1889 "the paintings have an inadequate effect; details appear by chance.") Ten years later the psychologist Françoise Minkowska, arguing that van Gogh was epileptic, saw *Portrait of Dr. Gachet* as proof of his "post-psychotic" state. She read the "serpentine line" that runs along the border of the physician's coat as an indication of the derangement of the painter's mind, "far from the relative calm found in the portrait of *Père Tanguy*; one now feels oneself drawn by an irresistible force, as had been the artist himself."

But with the rise of the popular mythology about van Gogh came the simultaneous decline in his reputation among certain art historians, notably the influential Roger Fry, who had included *Gachet* and many other pictures in the 1910 London exhibition *Manet and the Post-Impressionists*. Fry now dismissed the Dutch artist as no more than an "illustrator," who played only a peripheral role in the evolution of modernism. Fry, the formalist who insisted on judging art purely on abstract visual principles, paradoxically seemed to accept the view of those who interpreted van Gogh's works as strictly biographical. "The agitation of his own mental state—he was at this time in the asylum at St. Rémy—has by now become the real theme of his art," wrote Fry. "His vision of nature is distorted into a reflection of that inner condition." He concluded, "It is well, perhaps, at this moment, to recall with gratitude what van Gogh's saintly self-immolation accomplished for us, for, to tell the truth, his work visibly declines in importance. . . . Van Gogh staked all on the first shock of his attack, and as we recover from that we look in vain for further revelations."

Fry's scorn did nothing to dampen the continuing enthusiasm of the Dutch for their most influential artist since Rembrandt. In 1928 van Gogh scholarship advanced with the publication of a four-volume catalogue raisonné (*L'oeuvre de Vincent van Gogh*), an annotated list of van Gogh's complete work written by the dealer Jacob Baart de la Faille. Although riddled with errors, the catalog was nevertheless a pioneering work that for the first time offered a near-complete account of the artist's development.

With van Gogh's ascending fame, the prices of his pictures continued to rise, and the market was also increasingly subject to corruption. In 1928, when the Cassirer gallery staged a large van Gogh exhibition in Berlin, one of the gallery's directors discovered several of the canvases to be fakes. In the course of the ensuing "Wacker scandal," thirty-three van Goghs in circulation were declared forgeries; the Berlin dealer Otto Wacker was convicted of fraud, and Meier-Graefe, who had authenticated some of the pictures, was among several art world figures whose reputations were damaged. In 1930 de la Faille published *Les Faux van Gogh*, in which he declared that not only the Wacker pictures (included in the original catalogue raisonné) but more than a hundred other "van Goghs" were fakes.

Despite the widespread acceptance of modernism throughout the Republic, those who opposed it had not vanished. ("While not all Expressionists loved Weimar [the Republic]," wrote Peter Gay, "the enemies of Weimar hated all Expressionists.") In 1925, after right-wing parties won elections in the state of Thuringia, funding for the Bauhaus was cut and the school moved from Weimar to Dessau. Four years later Wilhelm Frick, a Nazi party member, became Thuringia's minister of the interior. Soon a crafts organization headed by the Nazi architect Paul Schultze-Naumburg occupied the Weimar building that had housed Bauhaus. (Schultze-Naumburg had condemned modernism in his 1928 book *Kunst und Rasse* [*Art and Race*], in which he juxtaposed photographs of deformed faces with expressionist pictures.) To the east of Weimar, antimodernists were also gaining ground. In Chemnitz, for instance, the director of

the Kunsthütte worried in 1925 about the repercussions of staging a *Neue Sachlichkeit* exhibition. (His acquisitions had recently been denounced as "Bolshevism in art.") When he borrowed the *Neue Sachlichkeit* show from the Mannheim Kunsthalle, he asked if the curator there had no objections if he revised the catalog text in order to make it less controversial. "Everything now is affected by political conditions," the Chemnitz director wrote, "and [there are those who] want to kill everything that does not please them. This includes Expressionism of course, especially my purchases by Schmitt-Rottluff, Kirchner and Heckel."

In 1929 German unemployment had climbed to 2 million when the New York stock market crashed, triggering a worldwide depression. The effects were felt acutely in Germany and helped the cause of political conservatives. In 1927 the National Socialists (the Nazis) held only 12 seats in the German parliament; three years later, winning 6 million votes, they took 107 seats. (By December 1930, unemployment had jumped to 4.4 million.) "The whole afternoon and evening great Nazi masses demonstrated," wrote Harry Kessler in Berlin when the Reichstag opened in October. "And, during the afternoon in the Leipzigerstrasse, smashed the windows of the department stores of Wertheim, Gruenfeld, etc. In the evening, in the Potsdamer Platz, crowds . . . shouted *'Deutschland erwache!'* (Germany awake!), *'Juda verrecke!'* (Judah die!), *'Heil! Heil!'* and were continually dispersed by the *Schupo* (police), patrolling in vans and on horses."

MODERN ART

AND

THE THIRD REICH

*Propaganda,
Confiscation,
and Export*

17

Frankfurt:

"Degenerate Art,"

1933–1938

*The name of Frankfurt and that of its Gallery achieved glory
because of the presence of the picture—glory which carried across
the ocean because the picture was in demand for major exhibitions
countless times. The most experienced art experts of every nation
agree with the judgement that this picture of Dr. Gachet ranks
with the most important works of modern painting.*
—Max Brück, editor of the *Frankfurter Zeitung*,
to the lord mayor of Frankfurt, December 1937

IN THE SPRING OF 1933, only weeks after Adolf Hitler fastened his
grip on Germany, Georg Swarzenski removed *Portrait of Dr. Gachet*
from its second-floor gallery in the Städelsches Kunstinstitut and
locked the canvas in a room under the museum's roof. There too he
stashed dozens of German expressionist pictures. The circumspect
museum director never recorded what went through his mind as he
hid the celebrated van Gogh portrait; he only later referred to the
Nazi period as a time of "turmoil, mystification, and madness."

In early 1933 Adolf Hitler and the National Socialist German
Workers' Party had taken control of Germany with characteristic
ruthlessness and speed. Hitler had become chancellor of Germany
on January 30, an event partly engineered by the Nazis intimidating
a populace devastated by the depression, which had brought levels of
unemployment to over 30 percent. Hitler blamed the burning of the
Reichstag building (on February 27) on the Communists, predicted

a revolution, and persuaded the eighty-five-year-old president Paul
von Hindenburg to declare an emergency and suspend civil rights.

Harry Kessler, then sixty-five, with typical sharp-sightedness,
observed the Nazi regime from Berlin:

> Göring has immediately declared the entire Communist Party
> guilty of the crime and the SPD as being at least suspect. He
> has seized this heaven-sent uniquely favorable opportunity to
> have the whole Communist Reichstag Party membership as
> well as hundreds or even thousands of Communists all over
> Germany arrested and to prohibit publication of the entire
> Communist Press for four weeks and the Social Democratic
> Press for a fortnight. There appear to be no limits set to the
> continuation of arrests, prohibitions, house searches, and clo-
> sure of Party offices. The operation proceeds to the tune of
> blood-thirsty speeches by Göring which savor strongly of
> "Stop-Thief!"

By dampening the press and attacking opposition parties, the
National Socialists took 43.9 percent of the vote in parliamentary
elections held on March 5; the following week they gained a
majority in the communal elections. Before the end of the month
Hermann Göring had employed his police to arrest the remaining
opposition members of the Reichstag. With the opposition cowed,
the Nazi-controlled parliament used the so-called Enabling Act to
give Adolf Hitler four years of dictatorial power. "Simultaneously
with the purification of our public life, the government of the Reich
will undertake a thorough moral purging," Hitler declared in March
1933. "The entire educational system, the theater, the cinema, litera-
ture, press and broadcasting will be used as a means to that end."

By then, or not long afterward, Swarzenski had emptied the
Städel's galleries of modern art. Later his assistant, Oswald Goetz,
explained the pragmatic response to the fanatic cultural policies of
Hitler's regime.

> We learned that van Gogh belonged to a large group of degen-
> erate artists, that his paintings were a danger to the morale of

the people. In order to avoid clashes with the Nazi commissar assigned to the Institute [Städel], and the party proletarians, we decided to remove the endangered pictures from the galleries and to wait for better days. They did not come. In a small room under the roof of the museum building, separated from public galleries, I assembled some sixty to seventy paintings of "degenerate" art. Among them were the German expressionists, the French cubists, Beckmann, Kokoschka, Corinth (after his first stroke!), Klee, Chagall, Picasso, Braque, Munch, even Matisse, and of course, van Gogh's Dr. Gachet. I kept the key to this "horror chamber" in my drawer and it was always a kind of ceremony when I had the privilege to show them secretly to those who did not surrender to the Nazi doctrine. But it was a humiliating enterprise—my private discussions with Dr. Gachet were not encouraging at all.

From the start, the Nazis sought complete control over the production and exhibition of visual art that they saw as an instrument of propaganda, exploitable for political and criminal purposes. On March 12, 1933, Hitler established the Reichsministerium für Volksaufklärung und Propaganda (Reich Ministry for Public Enlightenment and Propaganda) and appointed as its director Dr. Joseph Goebbels. Goebbels had been head of Nazi party propaganda since 1928. He had proved himself instrumental in the election victory by blanketing the airwaves with Hitler's speeches. As minister of propaganda, his mandate was to put German culture into ideological step with Nazi party ideology. The Nazis called the process *Gleichschaltung,* or "putting into the same gear," a term that the historian Gordon Craig rightly describes as "so cryptic and impersonal that it conveys no sense of the injustice, the terror and the bloodshed that it embraced."

"Politics is an art," Goebbels stated, "perhaps the most elevated art and the greatest that exists, and we—who give form to modern German politics—feel ourselves like artists to whom has been entrusted the high responsibility, beginning with the brute masses, of forming the solid and complete image of the people."

In September 1933 Goebbels cemented his control over the visual arts, music, theater, book publishing, film, the press, and broadcasting by establishing the Reichskulturkammer (Reich Chamber of Culture), a bureaucracy that ran parallel to the Propaganda Ministry. He demanded that German artists, writers, musicians, filmmakers, and radio commentators, among others, join the Reichskulturkammer in order to work; simultaneously he refused membership to those whose politics or work Hitler and other Nazi ideologues found intolerable. (In 1935 Jews were also refused membership.) Within the Reichskulturkammer, the Chamber of Visual Arts was assigned to supervise not only the production of fine arts but also art exhibitions and the market.

The Nazis drew upon the long-standing antimodernist sentiment that had shadowed the support of avant-garde art in Germany since the beginning of the century; they espoused a fanatical contempt for the avant-garde, which their bureaucracy translated into public policy and practice. Nazi ideologues condemned as "degenerate" all varieties of French and German modernism—cubist, fauvist, and expressionist painting and sculpture. Particularly intolerable to the Nazi credo was the social criticism of George Grosz and Otto Dix, who had so scathingly delineated the bloodbath of World War I and its legacy in images of maimed and wounded soldiers. The term "degenerate art" had originated with the 1890 book *Entartung* (*Degeneration*), a five-hundred-page diatribe by Max Nordau, who happened to be Jewish and who enlisted pseudo-scientific theory to contend that "degenerates are not always criminals, prostitutes, anarchists, and pronounced lunatics; they are often authors and artists." Hitler, who was for a time an aspiring art student in Vienna and in 1907 had failed to get into the city's art academy, assailed modern art. "The people regard this art as the outcome of an impudent and unashamed arrogance," he claimed, "or of a simply shocking lack of skill; it felt that this art-stammer—these achievements which might have been produced by untalented children of from eight to ten years old—could never be valued as an expression of our own times or of the German future."

The Nazis swept their indictment of modernism ("it was for the

select few—the art intellectual and the art market") into their broad
political attack on the Weimar democracy and culture, as well as
on Marxists, Bolsheviks, Communists, socialists, and the Jews—a
minority (some 564,000 in Germany's 1925 population of 62 mil-
lion) singled out by the Nazis' anti-Semitism as an enemy. "Under
no circumstances," Hitler stated in 1933, "will we allow the repre-
sentatives of the decadence that lies behind us suddenly to re-
emerge." But at first Swarzenski and others in the art world had
difficulty gauging exactly how the officials of the Third Reich would
proceed. The museum director, a self-assured intellectual, tended to
dismiss the Nazi rhetoric as irrational and ridiculously extreme; he
assumed the political situation would improve. Less than three
months after Hitler took office, the museum director would find out
firsthand about Nazi tactics.

SACKED

On March 13 Göring replaced Frankfurt's socialist mayor with a
loyal Nazi party member—Friedrich Krebs. Within weeks Swarzen-
ski was informed he was to be immediately suspended. On April 27
Krebs reported to his superior, the Nazi party administrator in
Wiesbaden, explaining his decision to force Swarzenski to take a
leave of absence: "Georg Swarzenski, General Director of the Städel
Museum, is a Jew." Later, in other correspondence, Krebs began
referring to the art historian by the name "Georg Israel Swarzenski."
(The Nazis added the name "Israel" to the names of Jewish men, and
"Sarah" to the names of Jewish women to indicate their status as
non-Aryans.) In July Krebs informed the regional president that
Swarzenski had "retired." Dismissed as general director, Swarzenski
lost his position at the Museum of History, the Museum of Arts and
Crafts, and the Städtische Galerie. He was also fired as a tenured
professor at the University of Frankfurt, along with one-third of the
faculty. Yet Swarzenski held on to his job as director of the Städel,
over which, as it was a private foundation, the Nazis technically had
no jurisdiction. A Nazi newspaper detailed Swarzenski's cultural
crimes: "The good property of the Städel was decomposed with a lot

of foreign racial and cultural bolshevist concoctions." He had also forgotten to acquire contemporary works "that would testify to their origins in the Frankfurt mother earth."

Swarzenski was not alone. When the Nazis came to power, they ousted some twenty directors and curators from museums in Berlin, Cologne, Hamburg, Halle, Hannover, Lübeck, Mannheim, and Munich, as well as in other cities. Many had bought and championed modern art; some were Jews; in certain cases the new regime simply threw out the old staff to install its own people. Among the casualties were Gustav Hartlaub at the Kunsthalle in Mannheim and Ludwig Justi at the Nationalgalerie in Berlin. (Justi refused to leave the museum, forcing officials to transfer him to the library, where he remained until he reached retirement age.) Justi's successor, Alois Schardt, evacuated the modern art to the museum's top floor, but he was also fired. Fritz Wichert, Hartlaub's predecessor at the Mannheim Kunsthalle, was suspended as director of the Städelschule, from which Max Beckmann was also discharged. (A room of Beckmann's paintings at the Berlin Nationalgalerie was permanently closed.)

The legal grounds to dismiss Swarzenski came from the Nazis' notorious "Professional Civil Service Restoration Act," issued April 7, 1933, which ordered the expulsion of Jews and other politically troublesome individuals from their jobs in the government bureaucracy, and in publicly funded universities and museums. On April 11 Hermann Göring closed the Bauhaus in Berlin. Various members of the Prussian Academy—including the expressionists Karl Schmidt-Rottluff, Käthe Kollwitz, and Ernst Ludwig Kirchner—resigned, some under duress, others in protest. Max Liebermann gave up the presidency in 1932.

Despite pressure, Swarzenski stubbornly refused to relinquish his post at the Städel, where he had worked for thirty years. Krebs had already purged the museum's five-member board and replaced it with Nazi colleagues. Robert von Hirsch, who had been one of the museum's trustees, had bargained with Göring to let him emigrate and take his art collection (assembled with Swarzenski's help) with him; the price Göring extracted was a masterpiece by Lucas Cranach, the reichsmarschall's favorite artist. In 1933 von Hirsch

left Frankfurt for Switzerland. But his friend Georg Swarzenski was disinclined to go. Like many assimilated Jews, Swarzenski resisted leaving the country whose culture he had embraced. At fifty-seven, he felt he had too much to lose; he had little money and was too old to start again. His son Hanns, also a medievalist, was working at the Institute for Advanced Study in Princeton. But the United States, still in the grip of the depression, offered few prospects for an older German art historian. At the same time, Swarzenski assumed that he could rely on influential friends to help him; these included the wine importer Otto Henkell, whose daughter Annalies was married to Joachim von Ribbentrop, Hitler's foreign policy adviser and from 1938 his foreign minister. As many did, he misconstrued the danger of the situation. At that point, the Nazis had banished Jews from civil service and refused to allow Jewish students to attend institutions of higher education. In 1935 the Nuremberg laws stripped German Jews of citizenship (which required Aryan blood). Still, many Germans accepted the propaganda that the concentration camps, first constructed in 1933, were only for criminals.

Strangely, Swarzenski found a protector in the Oberbürgermeister (Lord Mayor) Friedrich Krebs. A lawyer and judge, Krebs was an *alter Kämpfer*, or one of the old fighters, of the Nazi party, who had made a reputation in the 1920s as an attorney, defending many Nazi party members charged with committing violent crimes against Communists and others. Krebs was bald and heavyset. In full regalia—with a swastika-emblazoned armband and high black boots—he looked like a caricature of a Nazi official. He had moved fast to transform Frankfurt into a Nazi city, overseeing the closing of some five hundred Jewish businesses by the end of 1933. He had proved himself a rabid antimodernist, as an original member of the Frankfurt chapter of the Kampfbund für Deutsche Kultur (Combat League for German Culture). The league's mission was to promote Nazi-approved art and to attack all forms of modernism. Under Krebs, the Kampfbund succeeded in disrupting performances of Kurt Weill's *Dreigroschenoper* (*Threepenny Opera*).

Nevertheless the Frankfurt mayor decided to let Swarzenski stay, concluding that as the head of a museum of old master paintings, he

could cause no real harm. What's more, sustaining Frankfurt's museum of art and its university (which at one point the Nazis threatened to close) served Krebs's own political interests, as mayor of a city whose status and vitality depended in part upon these well-respected institutions, which had been funded largely by Jewish philanthropy.

With such beneficent gestures Krebs deliberately tried to distinguish himself from the hard-line "Gauleiter," Jakob Sprenger, in Wiesbaden, above him in the Nazi chain of command and his rival for influence in the city. That Krebs, jockeying for position in the Nazi hierarchy, allowed Swarzenski to remain in office at the Städel revealed the ambiguity, inconsistency, and moments of moderation that marked the first confusing years of National Socialism, when leaders were consolidating their power and policies were often driven forward by competing bureaucrats. Extremists wanting to get rid of Swarzenski encouraged Krebs to form a commission (of artists and architects and Alfred Wolters, the new director of the Städtische Galerie) to investigate his competence as director of the Städel. Swarzenski was called before the investigative commission, which

Friedrich Krebs, Frankfurt's National Socialist lord mayor. He protested *Gachet*'s confiscation by the Propaganda Ministry in 1937.

accused him of being a "cultural bolshevik" and "foreign racist," who had bought too many paintings by Max Beckmann. Swarzenski seized the opportunity to make an emotional statement in support of Beckmann. After failing to find sufficient incriminating evidence, the commission was disbanded. With Krebs's tacit permission, the museum director held on.

Similarly, Joseph Goebbels's own taste for certain German expressionist art offered a glimmer of hope that despite party rhetoric the Nazi government would tolerate certain forms of avant-garde art. When the architect Albert Speer hung watercolors by Emil Nolde in Goebbels's new residence, the propaganda minister had no objections. He also vocally supported the Nationalsozialstischer Deutscher Studentenbund, the Nazi student group that had organized several exhibitions of expressionist art. And in a speech he gave in May 1933 he called the Neue Sachlichkeit movement "the German art of the next decade."

Goebbels's chief rival for control of the arts was Alfred Rosenberg, a fanatic antimodernist and founder of the Kampfbund whom Hitler elevated to the party post of supervisor of ideological training and education in 1934, perhaps to help foil the power of the propaganda minister. Rosenberg was the author of *Der Mythus des 20. Jahrhunderts* (*The Myth of the Twentieth Century*), a best-selling Nazi ideological text. ("The myth is the Myth of the Blood, which under the sign of the Swastika, released the world Revolution," the publisher explained.) Goebbels also had competition from Bernhard Rust, Reich minister for science, education, and public instruction, assigned to oversee the administration of Germany's museums and art academies. "Talked to [the art dealer] Alfred Flechtheim," Harry Kessler noted in his diary on July 15, 1933; "Diametrically opposed trends exist among the Nazis. One supports modern art, including Barlach and Nolde; the other, under the leadership of Schultze-Naumburg, wants to exterminate it." Goebbels, Rust, and Rosenberg "not only battled one another for jurisdiction over the administration of the arts," wrote Jonathan Petropoulos in *Art as Politics in the Third Reich*, "but they were forced to contend with a

variety of other ministers: Himmler and Göring, for example, who used their respective positions atop the police and economic bureaucracies as a means of encroachment. The regional leaders, most notably the Gauleiters and later the reichskommissars [rulers of the territories occupied during the war], also constituted a source of competition." By splintering responsibility, Hitler attempted to maintain a balance of power among subordinates, who constantly called upon him to step in and settle disputes, thus allowing him constantly to reassert his own authority. Ultimately, "it took four years to 'refine' the Nazi art criteria," writes Lynn Nicholas in *The Rape of Europa*. "In the end what was tolerated was whatever Hitler liked, and whatever was most useful to the government from the point of view of propaganda."

In the summer of 1935 Swarzenski was visiting Paul Rosenberg's gallery in Paris when he met Alfred Barr, the director of the Museum of Modern Art in New York. Barr was one of the few Americans aware of Swarzenski's situation. Two years before, he had traveled in Germany and seen firsthand the results of the Nazis' repressive art policies. Later, in a series of four articles, he described the shocking situation. "One of the great German scholars, Prof. Zwarzenski [sic], formerly General Director of the Frankfort museums, has been demoted," he wrote, and "in Frankfort certain galleries of modern German art are simply locked." But embarrassingly, in America Barr's accounts were so controversial that in 1934 he was able to publish only one, in Lincoln Kirstein's *Hound and Horn*. At Paul Rosenberg's gallery, Barr told Swarzenski of his plans to organize a van Gogh retrospective and asked the German director if he might borrow *Portrait of Dr. Gachet*—in his words, "van Gogh's greatest portrait." Back in New York, Barr received word from Swarzenski that he had applied to the "ministry in Berlin" for permission to loan the painting. ("The government has issued a new regulation about lending of works of art which arrived at the same time as your request," he wrote. "This has unquestionably complicated matters and I am not certain whether we shall receive permission.") In September Swarzenski informed Barr that the loan was not possible.

Undeterred, Barr tried to approach the Nazi ministry directly through an American in Berlin. What happened next remains unclear, but the painting stayed in Frankfurt.

On November 2, 1935, three weeks after the opening of Barr's van Gogh retrospective at the Museum of Modern Art, a telegram of only five lines was delivered to Alfred Wolters, the director of the Städtische Galerie in Frankfurt, from the Reich Ministry of Propaganda in Berlin. "By order of the Reich Chancellery [Reichskanzlei]," it began, "I request a photograph of the following picture sent by express mail to the Director of the Reich Propaganda Ministry—Van Gogh Portrait Dr. Gachet." It was signed "Reich Ministry of Propaganda, on the authority of the Minister," and by an official named "Keudell." The "Minister," of course, was Goebbels.

On that same day the Propaganda Ministry, in separate telegrams, also demanded photographs of two of the museum's finest and most valuable Impressionist paintings: Auguste Renoir's *Garden Breakfast*, and Edouard Manet's *Game of Croquet*. Both had been bought by Swarzenski before the war.

Without delay, Alfred Wolters dutifully dispatched photographs of *Gachet* to Berlin. What exactly officials at the Propaganda Ministry had in mind for the portrait was not clear, as van Gogh had long been celebrated as a "Germanic" artist and was not necessarily anathema to the Nazi ideologues. In fact one Nazi critic, Wilhelm Schramm, had even absurdly claimed that the Dutch artist had anticipated the National Socialist state. "Much of the power that was only to take political effect in Germany over a generation later," he wrote, "first became apparent in the pictures of the Fleming, van Gogh." Even as Schramm sniped at "Jewish literati and art dealers," he celebrated in van Gogh "the noble barbarism on which the necessary renewal of all Nordic peoples depends."

On December 17, six weeks after he had sent the photographs, Wolters heard again from Berlin, this time from Bernhard Rust. Rust's sudden intervention suggests an attempt to prevent the Propaganda Ministry from dictating policy for museums officially under his charge. He made three requests. First, were there any objections to the sale of the three paintings whose photographs had been sent to

the Propaganda Ministry? Second, would Wolters propose other objects in the museum's collection that the government could sell for high prices? Finally, he urged the museum director to name artworks—particularly Impressionist paintings—in private collections that would also serve the government's purposes.

On the following day, December 18, the worried Alfred Wolters appealed to his immediate superior at Frankfurt's Department of Cultural Affairs. Born into an affluent upper-class family, Wolters was neither by nature nor by upbringing a fighter. But now Wolters, presumably coached by Swarzenski, did not hesitate to resist Rust's demands. Originally a friend of Swarzenski's son Hanns, Wolters had spent his entire career working for the Städel director. In 1933, after Swarzenski was removed from his job as director of the Städtische Galerie, Wolters took over. He felt loyal to his old boss and, as Swarzenski remained at the Städel, continued to work closely with him. In a letter stamped "confidential," he informed the Frankfurt official (whose name was Keller) that Goebbels had demanded photographs of a Manet, a Renoir, and the van Gogh portrait— three of the museum's most valuable modern pictures. The Reich, he explained, was considering their sale, and he adamantly opposed it. These pictures, he argued, were widely recognized as masterpieces and were irreplaceable. Because of Frankfurt's long-term ties to nineteenth-century French painting, they had particular significance to the city and its cultural traditions. Their loss, he claimed, would damage the prestige of the Frankfurt museum. Finally, Wolters brought up a legal technicality: the portrait of Dr. Gachet by van Gogh (to whom he pointedly referred as a *Nordic* artist) had not been purchased with city funds but had been a gift to Frankfurt from Victor Mössinger, a private citizen. Alternatively, Wolters offered up two representative late-nineteenth-century pictures—one by the Nabi Maurice Denis, the other by the neo-Impressionist Henri-Edmond Cross. As for works in private collections suitable for sale, Wolters claimed he knew of none.

Persuaded by Wolters's plea, the Frankfurt official Keller conveyed it—sometimes verbatim—only a day later, on December 19, in a letter to the mayor. (He sent a copy of his letter to Wolters.)

That same day Friedrich Krebs, vocal opponent of modernism, nevertheless put his own name on virtually the same letter and sent it to Bernhard Rust in Berlin. More brazen than Wolters in his arguments, Krebs advised against the sale of any of Frankfurt's works of modern art.

This plan to sell Impressionist paintings came, according to Lynn Nicholas, from Karl Haberstock, an art dealer, Nazi party member, and relentless maneuverer, who claimed to have a collector from Paris interested in buying a number of works for 5 million marks. But it was resisted by Eberhard Hanfstaengl, director of the Berlin Nationalgalerie, and was stopped by an official at Rust's ministry. According to Nicholas, this official refused to permit museum officials to sell objects that "would be an 'irreplaceable loss to public collections' or which had been donated or whose resale was forbidden on 'legal or moral grounds.' " At that point, the policy was inchoate. "When the matter was actually presented to Hitler," Nicholas wrote, "he rejected any such dealings."

THE "DEGENERATE ART" EXHIBITION

In 1936 the Nazis hosted the Olympic games and before an international audience purposefully sought to disguise their extremism. Nevertheless, by now Hitler had made it clear he would not tolerate modernism in any form, and the opportunistic Goebbels fell in line. On November 26, the propaganda minister prohibited art criticism; the press, according to the Nazis, was largely to blame for modernism's success. Days later, on December 1, Goebbels appointed Adolf Ziegler, a Nazi party member and favorite painter of the führer, as president of the Reich Chamber of Visual Arts, one of the seven departments of the Chamber of Culture.

In June 1937 Goebbels stepped up his attacks on modern art, with the announcement of an exhibition, *Entartete Kunst* (*Degenerate Art*), to open in Munich that summer. ("Pitiful examples of cultural Bolshevism have been submitted to me," Goebbels wrote in his diary on June 4. "But I shall now intervene. . . .") On June 30 he issued a decree that empowered Adolf Ziegler "to select and secure

for an exhibition, works of German degenerate art since 1910, both paintings and sculpture, which are now in collections owned by the German Reich, individual regions, or local communities."

The propaganda minister appointed a commission to assist Ziegler in selecting pieces for the Munich show. Its members were active contributors to the Nazi cause: the Nazi-appointed Folkwang Museum director Klaus von Baudissin; art teacher Walter Hansen (who would help install the show); Propaganda poster artist Hans Schweitzer; and Wolfgang Willrich, author of *The Cleansing of the Temple of Art*, a book that partly inspired the *Degenerate Art* show. Ziegler and his commission arrived at the Städel on July 7. ("By putting the paintings aside, we had hoped they would escape the Party's attention," wrote Goetz. "However, the confiscation of the degenerate and bolshevik works of art took place under the control of treacherous experts who proceeded with the help of the printed catalogues.") Ziegler's commission quickly combed through the collection of the Städtische Galerie which Swarzenski and Goetz had locked in the room under the roof. For the exhibition they selected fifteen paintings and works of sculpture, and over one hundred prints. They took both Pablo Picasso's *Head of a Woman* and Oskar Kokoschka's brooding *Hermann Schwarzwald*, which had been hanging in the gallery beside *Gachet*. (These pieces did not fit the definition of "degenerate art" as given by Goebbels's decree, since neither Picasso nor Kokoschka was German.) The commission members worked extraordinarily fast, giving their orders and moving on. Perhaps Wolters managed to keep the *Gachet* (also not technically "degenerate art") out of Ziegler's sight. It had been a year and a half since he had sent photographs of the painting and a letter protesting its possible sale to Berlin. He had as yet to receive a response.

In the first two weeks of July, Ziegler, Baudissen, Hansen, Schweitzer, and Willrich examined the modern collections of thirty-two museums in twenty-eight German cities, including Berlin, Chemnitz, Cologne, Dresden, Düsseldorf, Essen, Hamburg, Hannover, Königsberg (now Kaliningrad), Leipzig, Lübeck, Mannheim, Munich, Stuttgart, Ulm, and Weimar. In only fourteen days, they had issued instructions to the museum staffs to ship five thousand

works of art to Munich. Some commission members questioned whether works by August Macke and Franz Marc, casualties of World War I, should be seized, but Ziegler overruled them. (Marc's paintings appeared in the Munich show but were removed when the exhibition traveled to Berlin.)

The *Degenerate Art* exhibition opened on July 19, 1937. Into six rooms in an old exhibition hall, the organizers had packed 650 works of art. Labels, alternately serious and sarcastic, scribbled directly on the walls like graffiti, carried the Nazis' chilling message. "Madness becomes method" ran across a wall in Room 5. "Crazy at any price," accompanied watercolors by Kandinsky, who was identified as a "teacher at the Communist Bauhaus in Dessau until 1933." The commentary emphasized that museum officials had wasted public money for these acquisitions ("paid for by the taxes of the German working people"). Blame was laid on critics, curators, and historians: "At least as culturally pernicious as the work of incompetent, malignant, or sick 'artists' is the irresponsibility of those literary pimps, tenured museums directors and experts who have foisted this

Max Beckmann's *Descent from the Cross* (confiscated from Frankfurt's Städtische Galerie) on display in the *Entartete Kunst* (*Degenerate Art*) exhibition, Munich, 1937.

perversity on the people and would still cheerfully offer it as art today."

Displayed in the chaotic array of images were eleven paintings acquired by Swarzenski for the Städel. On the west wall of Room 1, a room designated for religious subjects, was Beckmann's great *Descent from the Cross*, in a row of canvases packed so closely together that their frames touched. Marc Chagall's *Winter* was in a room of "Jewish artists." In Room 4 Kirchner's *Artist's Wife* had the label "5,000 marks in 1919." Scattered about were the other eight Frankfurt pictures, including Heinrich Campendonk's *Mountain Goats*, Marc's *Forest Interior with Bird*, Carl Hofer's *Two Friends*, and Kokoschka's *Monte Carlo*.

Inverting the traditional idea of an art exhibition, Goebbels presented art that the Nazis avowedly despised. Wanting to generate public contempt for the pieces on view, he pointed to them as outlaw objects, racially unacceptable and politically subversive ("Jewish-Bolshevist") to be not revered but reviled. By systematically rounding up modernist paintings and sculpture, the Nazis demonstrated their ability to banish works that failed to conform to their totalitarian ideology. "How deeply the perverse Jewish spirit has penetrated German cultural life is shown in the frightening and horrifying forms of the 'Exhibition of Degenerate Art,' in Munich," Goebbels declared in a speech in November 1937.

To complement *Degenerate Art*, Goebbels staged the *Grosse Deutsche Kunstausstellung* (*Great German Art Exhibition*) in the recently constructed Haus der Deutschen Kunst: six hundred pieces of official Nazi art, technically proficient works of painting and sculpture intended to illustrate Nazi racial theories, and to celebrate and appeal to the *Volk*, or the people. Landscapes predominated, interspersed with scenes of peasants and families, soldiers, and other specimens of the Aryan race, including Ziegler's awkward nudes. In one picture Hitler was portrayed as a knight, dressed in armor and riding on a horse. At the exhibit's opening, the führer spoke:

From now on—of that you can be certain—all those mutually supporting and thereby sustaining cliques of chatterers, dilet-

tantes, and art forgers will be picked up and liquidated. For all we care those prehistoric Stone-Age culture-barbarians and art stutterers can return to the caves of their ancestors and there can apply their primitive international scratchings.

Paul Rave, a curator at the Berlin Nationalgalerie, described the horrifying spectacle.

With every sentence Hitler's manner of speaking became more agitated. He seethed with rage . . . saliva flowed from his mouth . . . so that even his own entourage stared at him with horror. Was it a madman who twisted convulsively, waved his hands in the air, and drummed with his fists . . . ?

Shortly after, Max Beckmann fled Germany for Amsterdam.

The *Degenerate Art* show, according to government statistics, drew over 2 million people during its four-month run in Munich, far more than the Great German Art exhibition, which attracted only 400,000 viewers. (On a four-year tour of eleven German and Austrian cities, including Frankfurt, *Degenerate Art* attracted 1 million more.) The official figures suggest that Goebbels had succeeded in drawing a mass audience to a propaganda event. Yet the tally of visitors fails to distinguish the motives and reactions of the crowd, or to account for those who came to see work they liked and admired. "Many visitors to the 'degenerate' art exhibition have been foreign tourists, especially American and British," the *New York Times* reported a few weeks after the show opened, "but included also are many German art students to whom this exhibit is presumably their last opportunity to study modern art." The artist Hannah Höch, who visited the exhibition twice in September, described the viewers as serious and subdued. "The most important works of the Post–World War I period are represented here. After the public outcry, it is astonishing how well behaved the public is. Many faces are closed and also quite a lot of opposition can be detected. Scarcely a word is spoken."

On July 27, 1937, Goebbels issued a second, far more comprehensive order instructing Ziegler to "impound 'all those products of

the age of decadence'. . . . still held by all the museums, galleries, and collections whether owned by the Reich, the individual regions or the local communities." The commission returned to the Städel on August 25. This time they seized 77 paintings (including 10 Beckmanns and the blue fauve still life by Henri Matisse donated by von Hirsch), and 3 pieces of sculpture, as well as over 572 drawings and prints. Oswald Goetz reported,

> My "horror chamber" was emptied, with a few exceptions among which was the Dr. Gachet. The van Goghs in Cologne, Essen, Munich and the *Jardin de Daubigny* which L. Justi had bought for the National Gallery in Berlin, had been confiscated; why Dr. Gachet had escaped the Argus-eyes of the brigands, none of us knew.

In the end, Goebbels dismantled the collection of twentieth-century art built by Georg Swarzenski over the previous three decades, setting the Städel back to where it was at the beginning of the century—a museum of old master paintings and nineteenth-century landscapes that only hinted at the revolution to come. In the wake of the commission, the staff of the Städel began to type. Assistants and secretaries hammered out a number of lists, each with multiple carbons, and each documenting every piece of modern art that the Propaganda Ministry had removed. These lists were deposited in various files and archives about the museum, evidence of the 100-some paintings and 600 drawings and prints formerly in the museum's possession.

By October 1937 Ziegler's efficient commission had taken into custody the modern art of 102 German museums. They had shipped some 17,000 pieces—5,000 paintings and pieces of sculpture, and 12,000 works of graphic art—to a warehouse on Köpenickerstrasse in Berlin.

On December 1, 1937, one of Adolf Ziegler's agents arrived at the Städtische Galerie and met with Alfred Wolters; he explained that the Propaganda Ministry now wanted five more Frankfurt paint-

ings: three relatively minor canvases, a Tahitian Gauguin (*Marquesan Man in a Red Cape*), and van Gogh's *Portrait of Dr. Gachet*.

Stalling for time, Wolters requested that the Propaganda Ministry deliver written confirmation of the new request. Meanwhile he responded to the ministry's inquiry about the values of the pictures. He set the value of the *Gachet* at 350,000 reichsmarks.

That same day, Wolters received Ziegler's written order: "Send the five paintings that had been requested," it read, by "the authority of the Führer." At the top of the list was the *Portrait of Dr. Gachet* ("1. van Gogh '*Bildnis Dr. Gachet*,' 350,000 reichsmarks"). The order instructed the museum to have the pictures delivered to the "Knauer Agency, Station Kolonnenstrasse, Berlin." It was signed by a Ziegler deputy, Rolf Hetsch.

Wolters dragged his feet. He would send the pictures only after he obtained permission from Frankfurt's lord mayor, he told the Propaganda Ministry. But his tactics were ineffectual, and the delay amounted to only a few days. Oswald Goetz removed the *Gachet* from its hiding place.

> Our carpenter made a box. Since van Gogh had used one of Pere Tanguy's cheap canvases, I was very much afraid the painting would be damaged in transit. So I had some precautionary measures taken. When everything was prepared the carpenter called me. The job had been neatly done; the painting was lying, well padded, with its face up. As the carpenter drew an oil cloth over the picture the blue eyes of Gachet looked reproachfully at me. There was a funeral atmosphere.

On December 8 Max Brück, editor of the *Frankfurter Zeitung*, boldly wrote a letter to the mayor. "Visitors to the Municipal Gallery have called our attention to the fact that the picture of Dr. Gachet . . . is no longer in the collection."

On the following day, in an unsigned editorial in the *Frankfurter Zeitung*, titled "Dr. Gachet," the critic Benno Reifenberg mourned the loss of the portrait. He made no mention of the fact

that the painting had disappeared; instead, he interpreted the picture's meaning to Germans who had acquiesced to the Nazi terror. In the doctor's sorrow-laden gaze, which, he explained, suggested an understanding of van Gogh's fate, Reifenberg saw the unspoken understanding that passed between humanists, who were now isolated, alienated, and endangered in the Nazi nation. The portrait's dark mood expressed the despair the critic felt under the tyranny of National Socialism. With a sense of approaching doom, he drew a parallel between van Gogh's suicide and the fate of the German nation:

> Anyone far away who thinks of the *Portrait of Dr. Gachet* and hence of the Städel where this van Gogh work has become the most prized possession, anyone who remembers this physician's face has found comfort. Anyone to whom the force of good reveals itself as the inalienable sign of humanity. We today, those of us who are willing, respond to this portrait in such a direct manner that it astonishes us to learn that it was painted half a century ago, that is to say in those weeks in which the painter. . . . was destined to die. . . . [Van Gogh and Gachet] understood each other. Perhaps that is why a lot of things didn't need to be said. In a letter to Gauguin (which was later found unfinished among van Gogh's papers), the painter notes: "after hesitating two or three times, my friend Dr. Gachet suddenly said: how difficult it is to be simple." The portrait, van Gogh's last, gives evidence that great simplicity can be achieved even in our times. The portrait was painted on July 4, 1890; on July 29 the painter took his life. . . .
>
> Now and then, in the wrist of the right hand, for instance, silence becomes exhaustion. It is not the kind of exhaustion which follows work, it is . . . the exhaustion of knowledge acquired after a long period of brooding and pondering.
>
> But all the lines and colors lead to the face . . . on whose features the spirit has engraved shadows. . . . A sense of astonishment has remained, forming a strong arc on his eyelids. His eyes look straight ahead and beyond the painter. They dominate every motion which stirs up the painting. These eyes are

deep and simultaneously as transparent as a lake; the calmness of a noble man emanates from them.

In that same letter to Gauguin, van Gogh characterized Dr. Gachet: "His face has the melancholy expression of our time." It is precisely this expression that the painter's admirable strength has preserved and from the pain and sorrow of the past later generations can thankfully find relief for their own confusion.

Reifenberg's eloquent indictment of the Nazi regime was one of the only public acts of protest made against the Propaganda Ministry's confiscations of modernist art.

On a Saturday not long after the editorial was published, Georg Swarzenski was with friends at lunch when members of the Gestapo appeared at the door of his house and asked him to come to their headquarters. (Earlier, a *Gaupropagandaleiter*, or local Nazi official, had noticed that the *Verfallsprodukt* ["decay-product"] was still in office and pressured the Städel board to force him to resign.) Swarzenski explained the situation to Marie and left with the armed men. She returned to the guests and made excuses. At the Gestapo headquarters, an officer instructed Swarzenski to sit down, then laid a pistol on the desk in front of him and proceeded to interrogate the museum director about the editorial. Although he denied having anything to do with it, he was held overnight. ("Coming home from the headquarters of the Gestapo, Swarzenski was more indignant than ever before, and after this experience, renewed his efforts to emigrate to the United States," Goetz wrote.) Wolters, who boldly wrote to the department of cultural affairs that he was in complete agreement with the editorial, was also called in and questioned. Ordered to appear at the Propaganda Ministry in Berlin, Reifenberg refused to identify who had informed him of the van Gogh's confiscation.

In the weeks following the removal of *Gachet*, the Städel board finally forced Swarzenski to resign. Even then, the sixty-two-year-old medievalist refused to abandon Frankfurt. In April 1938 the Nazis issued a decree forcing Jews to report their assets worth over

5,000 reichsmarks. Two months later the government stepped up the "Aryanization" of Jewish businesses; soon doctors and lawyers were given deadlines by which their practices must be closed. Swarzenski worried about emigrating when he was allowed to take only his personal possessions, and 10 percent of his money. Later, his friend Litschan Volhard recalled sometimes seeing the former museum director sitting alone at a table at the restaurant in Frankfurt's Hauptbahnhof (Main Train Station). He seemed to know that his time was up. But there he lingered, savoring a drink, bidding farewell to his beloved city.

Only days after the Reifenberg editorial was published, Johanna Mössinger, Marie Swarzenski's mother, wrote Alfred Wolters to ask about *Portrait of Dr. Gachet*—the gift of her late husband, which, she had heard, had been removed from the Städel museum's galleries. If this were indeed the case, she said, she "respectfully requested the return of the painting." By now Frau Mössinger, who had entertained her family at Christmas parties in a large house near the old Opera, was living in much reduced circumstances. The inflation of the 1920s had severely cut her inheritance, and the depression had left her relatively poor. At first she had rented out one room, then an entire floor of her house. Eventually, she sold the house and moved to a small apartment.

Despite the threat implicit in the Gestapo interrogations, Krebs did not abandon the fight to get back *Dr. Gachet*. Two months after the picture's confiscation, Frankfurt's Department of Cultural Affairs responded to a request to gather information about the painting to prepare the mayor for a conference about it in Berlin. This lengthy memo was intended as ammunition in the mayor's naive and protracted attempt to appeal to the rationality and good faith of his superiors in the Nazi hierarchy.

On January 13, 1938, Goebbels took Hitler to the Köpenickerstrasse warehouse so that the führer could inspect the thousands of detested examples of "degenerate art." "The result is devastating," Goebbels wrote in his diary. "Not a single picture finds favor. . . . Some of them we intend to exchange for decent masters abroad."

Meanwhile, Friedrich Krebs attempted to placate Johanna

Mössinger. On January 14, he informed her simply that the painting had been sent to the Chamber of Visual Arts, explaining that he could give no definitive answer until its destiny was decided in Berlin. By mid-February 1938, Rolf Hetsch at the Propaganda Ministry's Chamber of Visual Arts gave Wolters only the news that the Gachet portrait had arrived "undamaged" in Berlin. Hetsch deliberately kept the museum director in the dark. He undoubtedly knew that Propaganda officials had deposited the portrait in the warehouse on Köpenickerstrasse, now stocked with thousands of works of art. There someone assigned *Gachet* an inventory number: no. 15,677.

18

Berlin:
Hermann Göring and
Foreign Currency,
1938

It seemed to me to be a relatively simple matter in former days. It used to be called plundering. It was up to the party in question to carry off what had been conquered. But today things have become more humane. In spite of that, I intend to plunder and to do it thoroughly. —Hermann Göring, in a speech to Reichskommissars for the Occupied Areas, 1942

IN EARLY MAY 1938 Josef (Sepp) Angerer, a Berlin antiques dealer, appeared one day at Friedrich Krebs's office in Frankfurt. Angerer's firm, Quantmeyer & Eicke, at Kronenstrasse 61–63, specialized in rugs, tapestries, and decorative sculpture. Under the Nazi regime the dealer had thrived, as his most important client was Hermann Göring. Angerer's tactics matched those of his chief patron. When the year before a Munich art dealer was reluctant to sell rare French and Belgian tapestries, Angerer threatened to use the Gestapo to change his mind.

Angerer identified himself to Krebs as an agent for the Berlin officer responsible for disposing of the "degenerate art" that had been confiscated from the German museums; he wanted to discuss *Portrait of Dr. Gachet*. He had come to Frankfurt, he explained, to warn the mayor to stop his protests against the sale of the van Gogh. The picture, Angerer argued, had been in Berlin for a "long time" (in fact, five months), and now it should be sold. The startled Krebs

was uncertain about Angerer's authority. Mindful of his responsibilities to Frankfurt, he refused to capitulate.

"I explained to Mr. Angerer," Krebs later wrote, that "the city was not allowed to sell the painting because it was given as a gift to the Städtische Galerie." Angerer returned to Berlin, where he reported Krebs's resistance to his Nazi superiors. Meanwhile the mayor prepared for a trip to Sofia.

Only days later, on May 10, before he left for Bulgaria, Krebs received a telephone call from Hermann Göring. In the course of the conversation the reichsmarschall ordered the mayor to cease his efforts to prevent the sale of *Portrait of Dr. Gachet*. He gave three reasons to justify the immediate disposal of the painting, which Krebs wrote down:

1. *Portrait of Dr. Gachet* is decidedly a question of degenerate art.
2. Shortly, the Reich will issue a law that will provide for uncompensated confiscation of such questionable works of art.
3. The führer wants these sales to take place because the foreign currency obtained in this way is more useful than pictures of the type in question.

Surprisingly, even under severe pressure, Friedrich Krebs, the loyal Nazi party member, seems to have clung to a legal argument and stood his ground. Secure in his antimodernist record, the mayor refused to accede immediately to Göring's demands. Rather, the recalcitrant Krebs maintained that various legal issues involving the painting, given to Frankfurt in 1911, needed to be settled before the picture could be sold. There were, for instance, questions of title, the donor's rights, and the city's obligations. Göring replied that Frankfurt must make an immediate decision, and hung up.

In the spring of 1938 Hermann Göring was as influential as any of Hitler's senior officials; his power was perhaps at its peak. He was head of both the Luftwaffe and the Four-Year Plan, which gave him considerable authority over the German economy. He was also Prussian minister-president and minister of the interior, which gave

him some influence over the police. Overweight, addicted to morphine (taken originally as a painkiller, after he was wounded in the Beer Hall Putsch), grotesque in his appearance and tastes, Göring was nevertheless a relatively popular figure compared to other members of the Nazi elite. The public seemed to admire his record as a World War I fighter pilot; they liked his common touch and his sense of humor, and tolerated his very obvious frailties.

Later Göring made his reputation as one of history's most rapacious art thieves, rivaled among the Nazi elite only by Hitler. He used the Nazi territorial expansion in Austria and Czechoslovakia, Poland, the Netherlands, and France as an opportunity to amass a colossal collection of art. Operating in the style of a grandee, Göring flaunted his wealth, power, and prestige by obtaining eight residences and stocking them with great numbers of paintings, tapestries, and pieces of sculpture. A Berlin palace behind the Leipziger Platz renovated by Göring in 1933 reflected his taste. It was a "tangled warren of small dark rooms with stained-glass windows and heavy velvet hangings, cluttered with massive Renaissance furniture," recalled Albert Speer. "There was a kind of chapel presided over by the swastika, and the new symbol had also been reiterated on ceilings, walls, and floors throughout the house."

Josef Angerer was one of nine agents who bought and sold art for Göring while the Nazi's power was on the ascent. After the fall of France in June 1940, Angerer raced to Paris so as to have first pick of the French treasures. In 1940 and 1941 Göring visited Paris twenty times, each time stopping in at the Jeu de Paume, to peruse the art collections stolen by the ERR, the Einsatzstab Reichsleiter Rosenberg (Special Staff of Reichsleiter Rosenberg). Hitler had given the Paris-based organization, headed by "Kampfbund" founder and Nazi ideologist Alfred Rosenberg, the mandate to confiscate art from the collections of French Jews. According to an OSS (Office of Strategic Services) report, Angerer "acted as intermediary in passing to Göring photographs of objects acquired by" the ERR, and the dealer "boasted of bringing books, furniture, and art objects from the collections of the Rothschild palace [probably Maurice de Rothschild] back to Germany for Göring." Göring acquired in bulk. The

pieces he selected for himself were packed and shipped by train to Carinhall, his Nordic hunting lodge outside Berlin, named for his late first wife, Carin von Fock, a Swedish aristocrat. In certain rooms canvases were stacked in three and four tiers to the ceiling. "Many examples of the best Italian and old German masters were placed side by side with daubs by modern German painters," wrote American envoy Sumner Welles in 1940. He appears to have had in his possession a van Gogh, *Langlois Bridge* (from a French private collection); presumably he intended to trade it for something more to his taste. Even after the disastrous failure of the 1940 Battle of Britain, when Göring was stripped of political power, the pace of his art acquisitions hardly slackened; he constantly enlarged this monument to his greed and criminality. At the end of the war, OSS officers estimated that Göring's collection consisted of 1,375 paintings, 250 pieces of sculpture, and 168 tapestries (which in the 1920s were among the most expensive pieces on the market). After the war, Walter Andreas Hofer, director of the reichsmarschall's collection, testified that Göring's spending on art ultimately amounted to 100 million reichsmarks.

Only Hitler outdid Göring; at the end of the war his collection included some 5,000 pieces. In 1939 Hitler appointed Hans Posse (director of the Gemäldegalerie in Dresden) as head of a project to collect art for the museum (the Führermuseum) he planned to build in Linz, the Austrian city where he had spent some of his childhood. Encouraged by the wealth of plunder available to him from conquered territories, as well as the assets designated for Sonderauftrag Linz (Special Project Linz), Posse envisioned gathering a collection that would survey the history of European art. He made his first acquisitions in Austria, annexed by Germany in 1938, selecting paintings, rare books, and coins owned by the Rothschilds; there he quickly obtained some 324 pictures that had been in Jewish collections. Hitler's agents pressured the Czernin family into selling Jan Vermeer's *Artist in His Studio*, long on display in their gallery in Vienna, for 1.65 million reichsmarks, or $640,000, a sum considerably less than the $1 million Andrew Mellon had supposedly offered for the picture some years before. "Quite apart from what [Hitler]

stole," wrote Janet Flanner, "his purchases during the first five years of the war—he lacked time and heart for art during the last, losing nine months—totaled 163,975,000 reichsmarks, the equivalent of $65,590,000, the greatest individual outlay for beauty ever recorded, especially for a man who knew and cared nothing about it."

KREBS FIGHTS FOR THE VAN GOGH

Before leaving for Bulgaria, Friedrich Krebs turned the *Gachet* problem over to his deputy, Kremmer. The mayor explained that they needed to call a meeting of city councillors to decide whether or not he should approve the reichsmarschall's proposal to sell *Portrait of Dr. Gachet*. Meanwhile, he wanted the Department of Cultural Affairs to study the exact terms under which Victor Mössinger had donated the picture to the museum. Were there, for instance, any restrictions on his 1911 gift? With the situation unresolved, the mayor left for his trip. The next day, the city councillors met; not surprisingly they concluded that Frankfurt had no choice but to cease attempting to block the *Gachet* sale. After the meeting, Kremmer drafted a statement addressed to Hermann Göring, in which he stated that Frankfurt had agreed to release the picture; it would be sent when he obtained approval from his superiors in Wiesbaden. The letter was typed and ready for the mail when Krebs called from Sofia. Informed of the decision of the city councillors, the mayor immediately overruled them. He ordered Kremmer not to send the letter. Instead, he insisted that his deputy consult the cultural administrators, who should have all the relevant facts about the painting on his desk by the following day. The city attorneys must be ready to prepare him to plead the city's case in Berlin. He wanted certain questions answered: again, he asked, had Victor Mössinger placed any limitations on the gift? If so, were they binding? Also, what rights, if any, did Johanna Mössinger have to the picture? If the government decided to sell the painting, did she, for instance, have any say in its disposition?

The lawyers went to work. A quick investigation found that while the city possessed clear title to the van Gogh portrait, Johanna

Mössinger claimed that her late husband's gift required that the city keep *Portrait of Dr. Gachet* on public view in the Städtische Galerie at all times. A few days later, on May 20, 1938, the lawyers gave Krebs a more thorough review of Frankfurt's rights and obligations to the departed van Gogh, and the potential liabilities the city would face if it were sold. In the lawyers' opinion, by giving the portrait to the gallery, not the city itself, Mössinger clearly indicated his intention to have the canvas on permanent display. If Frankfurt ignored the wishes of the picture's donor, the city would run the risk of being liable to the heirs, who could demand to have the picture back. Armed with this legal opinion, Krebs kept up the fight. On May 23 he wrote to his superiors in Wiesbaden. Adopting the tone of deferential public servant, he struggled to appeal to any sense of fairness they might possess. At this point he employed Johanna Mössinger's plight as a central point in his plea. Perhaps, he thought, a member of the Nazi hierarchy would be more open to the problems of a widow than to those of the city's modern museum. Asking his superiors to consider the widow's rights even above those of the city, he suggested that if the painting were sold, Mössinger should at the very least receive some compensation. Frankfurt, he concluded, could not "in good conscience" sell *Portrait of Dr. Gachet*.

Four days later, on May 27, Krebs heard again from Johanna Mössinger. She politely demanded to have the painting back. In his response, Krebs lied, claiming he as yet had received no news about the painting.

Frustrated in his own attempts to learn through official channels what Göring and Goebbels had done with Frankfurt's property, Krebs turned to another member of the Nazi elite, Philipp Prinz von Hessen, minister-president of Hessen-Nassau. Philipp was married to Princess Mafalda of Savoy, daughter of the Italian king Victor Emmanuel III, and he worked as an agent who acquired art in Italy for the museum in Linz. Krebs wrote to the prince on May 30, 1938. Explaining the *Gachet* case, the mayor asked him to intercede with Göring. In return, he promised that the Städel would gladly compensate the Reichsministry with a work of Greek sculpture.

NO. 15,677

On May 31, 1938, the Nazis issued a law retroactively legalizing their wholesale confiscations of "degenerate art" from Germany's museums; the law also absolved the state of any obligation to compensate the public for the lost collections. Now Goebbels wrestled with the problem of what to do with the thousands of objects of "degenerate art" that filled the Köpenickerstrasse warehouse. In June 1938 he created the Kommission zur Verwertung der Produkte Entartete Kunst (Commission for the Disposal of Products of Degenerate Art), headed by Franz Hofmann at the Propaganda Ministry. "Paintings from the degenerate art action will now be offered on the international art market," Goebbels wrote in his diary, on July 28, 1938. "In so doing we hope at least to make some money from this garbage." But problematically for the propaganda minister, the art market had collapsed with the depression; moreover, the sheer number of German expressionist pieces suddenly available for sale would inevitably cause a glut. At first the disposal commission decided to let four art dealers—Karl Buchholz, Ferdinand Möller, Bernhard Boehmer, and Hildebrand Gurlitt—handle the problem, giving them permission to take what they wanted in exchange for minimal sums of foreign currency.

Officials at the Ministry of Propaganda opened a special Reichsbank account: the Sonderkonto Entartete Kunst or "Special Account EK," into which the proceeds from the "degenerate art" sales were supposed to go. Ultimately these proceeds were to be turned over to Bernhard Rust, who wanted them to go to the German museums, particularly those upon which the confiscations had inflicted the most severe financial loss. The Special Account EK was under the supervision of Walther Funk, the economics minister, who was supposed to channel funds to the appropriate places.

But months before the disposal commission convened in November, *Portrait of Dr. Gachet* had already been sold. On May 10, when Göring pressured Friedrich Krebs on the telephone to capitulate on the sale of the painting, he was asking for consent after the fact; by then he had circumvented the Nazis' official "degenerate art"

apparatus and arranged to sell the canvas through his own dealer, Josef (Sepp) Angerer. The transaction involved not only *Gachet* but two other Postimpressionist masterpieces taken from German museum collections: Cézanne's *Bibémus Quarry* (from the Folkwang Museum in Essen) and van Gogh's *Daubigny's Garden* (from the Nationalgalerie in Berlin). *Quarry* was a canvas almost a yard long, of a rocky, tree-covered landscape in molten ochers, blues, and greens. Cézanne painted it in 1895, and Karl Ernst Osthaus had bought it from Ambroise Vollard for his museum in 1906. *Daubigny's Garden* (the version without the black cat) was the controversial purchase made by Ludwig Justi for the Berlin museum only seven years before.

RIGHT: Paul Cézanne's *Bibémus Quarry*, ca. 1895. BELOW: Vincent van Gogh's *Daubigny's Garden*, 1890. Confiscated from German museums, both canvases were purchased along with *Gachet* by Franz Koenigs in May 1938.

The buyer of the two van Goghs and the Cézanne was Franz Koenigs, a German banker and collector who lived in Amsterdam. In a letter dated May 18, Koenigs confirmed that he would purchase the three paintings: for 12,000 English pounds in cash and 800,000 reichsmarks (to be paid later in sperrmarks).

Franz Koenigs was a partner in the Berlin bank Delbrück Schickler & Co., and also in his own Amsterdam investment firm, Rhodius-Koenigs Handel-Maatschappij. In the art world, Koenigs was widely renowned for his collection of old master drawings, considered by many to be the finest private collection of drawings in Europe.

The British currency that Koenigs offered Göring was then worth $60,000. But he also forced the reichsmarshall to take sperrmarks, a restricted currency that could be spent only inside Germany and was useless elsewhere to the international banker. The sperrmarks would come from Rhodius-Koenigs's account at Delbrück Schickler in Berlin; their value, difficult to calculate, was roughly equivalent to $100,000. Altogether, Koenigs paid British and German currencies that amounted to some $160,000. Later Angerer recalled that Koenigs had paid some 500,000 RM (or the equivalent then of $200,000) for the three paintings. Theoretically, as a third of the total, the Gachet portrait cost some $53,000. In 1995 dollars the price Koenigs paid for the three pictures was about $1.7 million, and thus for *Gachet* some $575,000.

Franz Koenigs seemed to attach one condition to the sale: that the Nazi government release one of his paintings—the great Mathias Grünewald *Crucifixion*—from those works of art forbidden to leave the country. However, it appears from two diagonal lines drawn across the sentence about the Grünewald painting that someone struck this reference from the letter. (Later Koenigs's heirs sold the Grünewald to the Samuel H. Krebs Foundation, which gave it to the National Gallery of Art in Washington, D.C.) Koenigs specified the exact time and place that *Portrait of Dr. Gachet* would be sold, asking if Angerer would arrange to bring the three paintings to the San Regis Hotel, at 19, rue Jean Goujon, in Paris, at 9 A.M. on May 21, which was a Saturday.

Three days after he wrote the letter, Koenigs presumably picked

up the three magnificent paintings in Paris; Göring's agent took 12,000 pounds in cash. The less desirable "blocked" marks would come later.

Göring's responsibilities as director of the Four-Year Plan included regulating foreign exchange. But in the *Gachet* transaction he ignored the government's rigid restrictions on currency. From the start, Göring attempted to give Angerer's dealings the gloss of legitimacy in order to obtain the approval of the economics minister, with whom he competed for influence. To maintain a semblance of consistency, Göring's foreign exchange department was compelled to report, explain, and justify his transaction. The sale of *Dr. Gachet*, *Daubigny's Garden*, and *Quarry* to Koenigs set off a stream of reports, memos, accountings, and repeated attempts to document and reconcile pieces of the transaction and the movement of art and currency. The abundant paperwork reflected a twisted persistence in feigning legitimacy for his seizure and sale of the pictures. Careless with financial records, Göring never fully accounted for these art purchases, and what accounting there was came long after the fact.

TAPESTRIES AND ACCOUNTS

As soon as Sepp Angerer got his hands on Koenigs's funds, he took 10,500 of the 12,000 pounds, and on May 21 he bought three eighteenth-century Gobelin tapestries, at a cost of 6,200 pounds, from F. Stern-Drey, an antiques dealer in Brussels. The tapestries were decorated with scenes of the "Hunt of Maximilian," based on cartoons by Barnaert van Orley. From Stern-Drey he also bought three minor tapestries for less than 1,600 pounds. (The Maximilian tapestries went to Carinhall, and the less expensive tapestries ended up in the Reich chancellery building.) Angerer also acquired a Lucas Cranach painting, *Nymph at a Spring*. (Later, Göring indicated that the Cranach had been purchased for his personal collection and that he would pay for it himself. By the end of the war, Göring's collection would boast fifty Cranachs.) Angerer gave the remaining 1,500 pounds to Göring, who used them immediately to pay the Berlin dealer Karl Haberstock to cover part of a balance of 7,960 pounds,

already spent by the Nazi dealer on seven minor old master paintings; these included a mythological scene by Sir Anthony Van Dyck and views of Vienna, Pyrna, and Dresden by Bernardo Belotto. Haberstock was the Berlin dealer behind the original scheme to sell objects from the museum collections that Hitler had derailed in 1935. To make up the difference he still owed Haberstock, Göring (through an assistant named Neumann) asked the directors of the Reichsbank to transfer funds from the "degenerate art" account at the Midland Bank in London to Haberstock's account at the West End branch of a Swiss bank. (He promised to repay this loan by the end of the month.) Meanwhile, Angerer spent 400,000 lire on ten eighteenth-century Flemish tapestries (six of them for Hitler), assuming he would be reimbursed with sperrmarks that Koenigs still owed for his three pictures. Göring's purchases for Hitler, Jonathan Petropoulos noted, not only served as a gesture of loyalty but "provided a suitably complex business deal with which to camouflage his own machinations." Angerer went so far as to ask an official at the economics ministry to allow Koenigs's bank, Delbrück Schickler, to release the 800,000 sperrmarks directly to him. On June 15 he billed the Prussian State Ministry 287,000 reichsmarks for the tapestries.

That *Portrait of Dr. Gachet* had actually left Germany was known by very few—Koenigs, Angerer, Göring, Goebbels, and several bureaucrats responsible for foreign currency. Rather than applying *Gachet's* foreign currency proceeds toward securing raw materials for the state, Göring diverted them toward his own art-collecting schemes. In this, Göring seems to have had the tacit agreement of Hitler and of the pragmatic Goebbels, who was saddled with the problem of diminishing the stockpile of "degenerate art," and probably hoped that Göring's international business connections might help him solve it. Unlike Economics Minister Walther Funk, Goebbels was no stickler for accounting; he simply overlooked the fact that Göring might be diverting some of the proceeds away from the state to expand his collection. In the end the confiscation of the van Gogh portrait was only tangentially related to the confiscation of "degenerate art." Indeed, since 1935, when the Propaganda Ministry first requested that the Städtische Galerie send

photographs of the painting to Berlin, the dealer Haberstock and various Nazi officials had singled out Frankfurt's brilliant van Gogh as a marketable commodity. Somewhere along the way (either before or after *Gachet* was ordered delivered to Berlin) Göring took charge of the readily exploitable canvas and used it to pay for tapestries and paintings that he otherwise couldn't afford.

Göring helped himself to ten other paintings confiscated from German museums, hoping to market them abroad. Nine came from the Berlin Nationalgalerie: *Wheatfields* and *Young Lovers* by van Gogh; Franz Marc's *Three Deer* and *Tower of the Blue Horses* (one of his masterpieces); *The Embrace, Encounter by the Sea, Melancholy,* and *Snow Shovelers* by Edvard Munch; and *The Harbor*, a landscape, by Paul Signac. Another Franz Marc, *Deer in the Forest,* had been taken from the museum in Halle.

On June 29, 1938, over a month after Koenigs picked up the two van Goghs and the Cézanne in Paris, he still had not paid the 800,000 sperrmarks. Meanwhile, Angerer informed the office of the Four-Year Plan that Koenigs had been promised he could purchase another of the confiscated paintings—which one, he didn't say. He claimed that "appropriate German authorities" refused to release it. Angerer wanted to offer the collector two additional paintings; he said he intended to send someone to Holland to negotiate the sale. But the transaction seems to have fallen through. On July 19, 1938, Koenigs paid the remaining 800,000 sperrmarks for the van Gogh to the Prussian State Ministry.

Coincidentally, that same day, the dogged Friedrich Krebs had arranged to meet with Heinrich Hoffmann, from the disposal commission, in his office at the Ministry of Propaganda; the Frankfurt mayor hoped finally to learn what had happened to *Gachet*. Hoffmann revealed only that the portrait had in fact already been sold. When the following month Johanna Mössinger again politely inquired about the portrait, the mayor once again put her off. Pretending he still had no information, he promised to inform her when he learned of a final decision. Krebs wanted to avoid revealing the truth. But presumably he informed various city officials about the painting's sale, and sometime in the summer the news reached

Swarzenski, who passed it on to his mother-in-law. Yet she wrote again on November 12. Krebs acknowledged that the painting had been confiscated but said he couldn't tell her what the authorities had decided to do with the picture.

In September 1938 Georg and Marie Swarzenski finally fled their beloved Frankfurt. Of his possessions, he took with him several paintings by Max Beckmann and some 10,000 marks. On September 19, from the Hôtel des Rois in Basel, he wrote to Paul Sachs, director of Harvard's Fogg Art Museum, informing him that he had left Germany the week before. By October the Swarzenskis were in London. Only weeks later, on the night of November 9 (Kristallnacht), gangs set fire to Frankfurt's synagogues and smashed the windows of stores owned by Jews. (Of Frankfurt's Jewish population of some 29,000, 11,000 would be deported to concentration camps; the other 18,000 would manage to leave; but how many of those who went to other parts of Europe ultimately escaped and how many were deported is not known.)

On January 24, 1940, the secretary of the Prussian State Ministry informed the Städel curators that the führer had decreed that museums not be compensated for their losses of "degenerate art"; but by order of Reichsmarschall Göring, the Städel would receive 150,000 reichsmarks for *Gachet*, valued by Wolters three years before at 350,000 reichsmarks. (The petty Angerer had advised against reimbursing Frankfurt, as its officials had caused so much trouble.) The *Gachet* matter technically ended ten months later, when on October 10, 1941, Frankfurt received the payment. Göring also paid 100,000 reichsmarks to the Folkwang Museum, and 150,000 RM to the Nationalgalerie. Six of the thirteen paintings he took from the Köpenickerstrasse warehouse were never accounted for. (One of the van Goghs turned out to be a fake.) Although Frankfurt's lawyers had originally argued Johanna Mössinger deserved some compensation if the van Gogh were sold, on February 29, 1940, city officials issued an opinion that she was owed nothing.

In the end, the disposal commission had only meager success. After six months of operation, the commission decided that many works should simply be destroyed. On March 20, 1939, over 1,004

paintings and pieces of sculpture, as well as 3,825 watercolors, drawings, and prints, were secretly set on fire as part of a drill at the headquarters of the Berlin Fire Department. According to notes taken at a meeting of the commission on December 11, 1941, "degenerate art" sales had brought some 1 million reichsmarks, or about $400,000. The 12,000 pounds that Franz Koenigs had paid to Hermann Göring for two van Goghs and a Cézanne landscape never appeared in the official tally.

In 1912, after Georg Swarzenski acquired *Gachet* for the Städel, the museum's registrar officially recorded the "Gift of City Councillor Victor Mössinger" in a large black leather book, one of a set in which the record of the museum's collection was kept. Written in delicate script, the entry, entitled *Porträt Dr. Gachet*, runs across thirteen lines at the bottom of two pages. It describes the painting with thoughtful precision. It begins, "Seated behind a table and leaning on his right arm you can see the subject in a buttoned, Prussian blue coat." It goes on to mention the yellow books, the water glass, the flowers, and the "triple-differentiated blue" that "surrounds the pale yellow of his head." In 1938, across the thirteen-line entry two diagonal ruled lines were carefully drawn; in the margin someone wrote the word "confiscated."

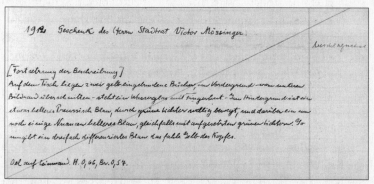

A portion of the *Gachet* entry ("1912 Gift of City Councillor Victor Mössinger") in the registrar's book of the Städelsches Kunstinstitut, Frankfurt. After the Nazi Propaganda Ministry confiscated *Gachet* in 1937, lines were drawn through the entry.

19

Amsterdam:
Passage to Exile—
Franz Koenigs and
Siegfried Kramarsky,
1938–1940

In May 1938 Franz Koenigs telephoned Walter Feilchenfeldt at the Cassirer gallery in Amsterdam. The fifty-seven-year-old German banker was known to leading art dealers in Europe, and he had been a Cassirer client since the 1920s. He spoke frequently to Feilchenfeldt, from whom he had acquired some of his most beautiful Degas drawings and Cézanne watercolors. It was Koenigs's custom to leave his office at the end of the day and walk down the street to the gallery, where Feilchenfeldt would show him the pieces that had recently arrived. Sometimes the collector would stay for supper. But this particular telephone call was extraordinary, and more than fifty years later the dealer's wife, Marianne Feilchenfeldt, remembered it. Koenigs told Feilchenfeldt that at the antique shop of Quantmeyer & Eicke in Berlin he had just seen three modernist pictures that had been in the collections of German museums: Paul Cézanne's *Quarry* and Vincent van Gogh's *Daubigny's Garden* and *Portrait of Dr. Gachet*. Koenigs asked Feilchenfeldt if he would be interested in buying them.

Feilchenfeldt, age forty-three, was one of the directors of the Cassirer gallery. He was an expert in both Cézanne and van Gogh (he had organized a major exhibition of the Dutch artist in 1928), but he was outraged by Koenigs's call. He explained to his client that he wanted to have nothing to do with the pictures. The dealer had left Germany five years before, in 1933, soon after Hitler had come to power; he had closed Cassirer's headquarters in Berlin and

transferred the business to its branch in Amsterdam. The decision to leave his native Germany came after he witnessed Nazi recruits march into an art auction and summarily shut it down without encountering resistance. In Feilchenfeldt's view, the three pieces of confiscated "degenerate art" were stolen property, rightfully owned by the Folkwang Museum in Essen, the Berlin Nationalgalerie, and Frankfurt's Städel. Even though the government of the Third Reich had seized these pictures from public collections and thus theoretically from the German people, rather than from private citizens, Feilchenfeldt considered the confiscation and sale of "degenerate art" illegal. The foreign currency proceeds generated by the pictures, he believed, would go toward the manufacture of German munitions. As the Nazis had no legitimate claim to these canvases, he assumed that eventually the German museums would demand restitution, and whoever owned them would be forced to give them back.

In the spring of 1938, as Europeans trained their eyes on Germany and tried to fathom Hitler's plans, there was little time to ponder the decision of whether or not to buy paintings recently confiscated by the Nazi Propaganda Ministry from the German museums. Although many who lived in France, Belgium, and the Netherlands rationalized that they would be safe in western Europe, the German chancellor had already launched his drive for territory. In March the Nazis had annexed Austria, and their bureaucracy implemented a campaign of terror against the Jewish population. "Hundreds of Jews, men and women, were picked off the streets and put to work cleaning public latrines and the toilets of the barracks where the S.A. and the S.S. were quartered," wrote William Shirer. "Tens of thousands more were jailed." SS officers helped themselves to the collections of wealthy Viennese Jews, "safeguarding" them in the Kunsthistorisches Museum and elsewhere. Those Jews who managed to get exit visas (from Adolf Eichmann's Office of Jewish Emigration) paid with their property.

Despite Feilchenfeldt's objections, Koenigs asked if he could send the pictures to Cassirer's, explaining that he thought that Siegfried Kramarsky, a German banker who had lived in Holland since the early 1920s, would want to buy them. Feilchenfeldt agreed,

and Koenigs arranged to have the paintings sent to Amsterdam. It was Koenigs's characteristically quick-witted decision to buy three of the finest modern canvases to be confiscated by the Third Reich that caused the Gachet portrait to slip secretly out of Germany. As a financier and a collector of art, he recognized immediately not only the aesthetic significance of the Postimpressionist pictures but also their value as fungible assets whose worth would only rise as Germany threatened the political stability of Europe. *Portrait of Dr. Gachet*, which Göring had seized so he might buy tapestries, was now a commodity one of whose precious attributes was that it could be rolled up and hidden in a suitcase. The famous canvas was a negotiable note exchangeable for hard currency, and in certain circumstances even safe passage; it had particular appeal to Jews and others in Europe who might suddenly become refugees. In a period of economic and political upheaval, well-established works of art possessed value offered also by gold and jewelry (often small enough to be easily hidden). The drawings collector was pragmatic; he could argue that by removing confiscated pictures from Germany, he defied the Nazis' aesthetic dogma and rescued works of art from an uncertain future under the German's antimodernist cultural program. The three celebrated museum pictures offered not only a certain investment but the possibility to assist a Jewish friend whose property and well-being were increasingly at risk.

Franz Koenigs and Siegfried Kramarsky had little, if anything, in common in social background, but they had by now a complicated business relationship and friendship. It began in the early 1920s, when both had moved from Germany to Amsterdam, seeking business opportunities in Holland, where the economic environment was more stable than in Germany, whose economy had been devastated by the catastrophic inflation. As financiers, Koenigs and Kramarsky shared an appetite for risk taking and speculating; at various times each made and lost large quantities of money. When Koenigs bought *Gachet*, he owed Kramarsky's bank a substantial sum (apparently more than 1 million guilders). It is likely that Koenigs discussed the paintings with Kramarsky before he bought them. Kramarsky may or may not have committed himself to taking

them sight unseen from Koenigs. Most probably, Koenigs used the three Postimpressionist pictures to pay off part of his debt. The details of the deal that transferred the van Gogh from Koenigs to Kramarsky were known, it seems, only to the two bankers, who had no desire to publicize them. Koenigs may have held the van Gogh portrait for months, perhaps weeks, or probably only days. In economic straits, he appears not to have had the financial capability to prevent the van Gogh from slipping through his fingers.

Portrait of Dr. Gachet arrived at the Cassirer gallery most probably in May 1938. Four months later, on September 17, Helmuth Lütjens, who like Feilchenfeldt was a director of Cassirer's and who served informally as the curator of Koenigs's art collection, officially documented the painting in the gallery's inventory by writing the title "Gachet" along with "Quarry" and "Daubigny's Garden" in an account book where he kept track of works of art that clients had left there for safekeeping. He listed the owner of the three pictures as "Lisser & Rosenkranz," Siegfried Kramarsky's bank. By then Kramarsky had taken the pictures. But he may never have hung them in his house. Storing the paintings at Cassirer's, he kept them in limbo as he struggled to decide if and when to flee Amsterdam. The whereabouts of Frankfurt's portrait was known only to Koenigs, Kramarsky, the Feilchenfeldts, Lütjens, Grete Ring (the third Cassirer director), and presumably their circle of associates. The van Gogh had already spent four years in hiding.

KOENIGS

In the *Gachet* transaction, Franz Koenigs played the go-between, a role he often took as a high-born, anti-Nazi German financier. Koenigs had been born in 1881 to an affluent Rhineland banking family with ties to industry, particularly textile manufacturing. He grew up in a large house in the center of Cologne and was educated by tutors. After briefly studying law in Munich, he began a peripatetic career in business and banking. In his twenties, he was apprenticed in a German textile mill and employed at a Paris bank, a London jute trading firm, and a Rumanian oil company, where he

served as president. In 1913, when he was thirty-two, he became a director of Delbrück Schickler, a major private Berlin bank in which his family had a stake. Delbrück operated like an American investment bank, raising venture capital, issuing credit to businesses, and trading stocks, bonds, commodities, and currencies. It managed both its own assets and outside capital. Its investments in certain corporations were large enough to give it a controlling interest, and Koenigs sat on several corporate boards. In 1923, when Berlin businesses were crippled by German inflation, Koenigs and a cousin went to Amsterdam and launched Rhodius-Koenigs Handel-Maatschappij, a firm that specialized in currency and commodity trading. He remained on the Delbrück board.

That Franz Koenigs arranged to purchase the Gachet portrait in Berlin, picked it up in Paris, and carried it to Amsterdam was a matter of course in the banker's schedule. He chose to live at a pace more typical of the late twentieth century than of the 1930s. Constitutionally impatient, he traveled around Europe by railroad and later by plane. His friends remember him as always rushing off to the station, leaving barely enough time to make a train. He scoffed that most people wasted half their lives waiting on station platforms. To those he considered his friends, Koenigs could be generous to a fault.

Leopold, Count von Kalckreuth, *Portrait of Franz Koenigs*, 1906.

According to Hermann Josef Abs, his assistant in Amsterdam and later the chairman of Deutsche Bank, Koenigs too often based investment decisions more on relationships rather than financial analysis. Koenigs was now in his late fifties, a tall, intense, energetic man of vast charm and volatile moods. He had a formidable memory that served his ambitions in business and art collecting. His handsome, animated face, with its straight nose, high forehead, and piercing gaze, suggested his adventuresome temperament. He had been married since 1913 to Anna Herzogin von Kalckreuth, daughter of Leopold von Kalckreuth, a Munich Secession artist who came from a German landed noble family. She had met Franz Koenigs when his father commissioned Kalckreuth to paint the family's portraits.

THE DRAWINGS COLLECTION

In 1921, when he was forty, Koenigs began to collect old master and modern drawings. Twelve years later he had acquired 2,671 drawings—a group that systematically covered the major schools of European art, from the early Renaissance to the late nineteenth century. This accelerated pace reflected not only Koenigs's character but also the opportunities to buy art afforded by the financial turbulence of the 1920s, which forced many large collections onto the market and allowed those with funds to buy in quantity. In 1929, for instance, Koenigs bought 250 drawings from the Swiss collector Julius W. Böhler, who was in bankruptcy. In 1923 Koenigs made one of his most spectacular purchases, acquiring at auction the Gabburri albums, bound books containing 500 drawings by the Italian High Renaissance master Fra Bartolommeo. Over the next three years he acquired close to 700 drawings.

Koenigs had old master drawings from the Italian, French, and German schools—drawings by Albrecht Dürer (17), Jacopo Tintoretto (40), Rembrandt (35, plus 48 by Rembrandt's school), Rubens (42), Antoine Watteau (31), Jean-Honoré Fragonard (38), and Giovanni Battista Tiepolo (50). He also had a fabulous group of nineteenth-century French drawings: 26 by Eugène Delacroix, 24 by Honoré Daumier, 21 by Edgar Degas, 13 by Edouard Manet, and

22 by Henri de Toulouse-Lautrec. He stored the drawings in a room lined with wooden chests of drawers in his house in Florapark, a residential area of Haarlem, some fourteen miles west of Amsterdam. There he and Anna lived with their six children. For visitors who wanted to see them, he would lay drawings out on a billiard table. Meanwhile he also purchased old master paintings.

"The most profound enchantment for the collector," wrote Walter Benjamin, "is the locking of individual items within a magic circle in which they are fixed as the final thrill, the thrill of acquisition passes over them. Everything remembered and thought, everything conscious, becomes the pedestal, the frame, the base, the lock of his property." But Koenigs's passion for collecting also undoubtedly turned on the satisfaction of possessing a level of expertise rivaled only by professionals in the field. In the 1920s the field of old master drawings was esoteric and relatively treacherous, as many pieces had scant documentation to prove their authenticity. As a buyer, he depended ultimately on his knowledge of art history and his eye; these he used to judge images whose subtlety demanded he discern shades of difference. One of his beautiful modern drawings was a red chalk sketch by Toulouse-Lautrec of a young prostitute lying on a bed, sleeping, a delicately rendered image, at once weightless and laden with grief.

Koenigs bought the Lautrec in 1929, the year his financial fortunes suddenly reversed, following the October crash of the New York stock market, which brought on a worldwide depression. The German banking crisis of 1931 led to large losses to Koenigs's firm. The blow to the banker's own finances was evident in the sudden drop in his art acquisitions. In 1931 he bought only nineteen drawings; over the next two next years, he acquired none. Because he had poured his assets into his drawings collection, a relatively illiquid investment, Koenigs had few other resources on which to depend when his financial situation deteriorated. Instead of selling his drawings, he decided to borrow a large sum from Lisser & Rosenkranz, Siegfried Kramarsky's bank. Kramarsky and his partner, Salo Flörsheim, specialized in venture capital and various forms of arbitrage, including the trading of currencies and securities. (Money could be

made exploiting the price spreads between markets in different countries.) The specific sum and credit terms of Koenigs's loan from Lisser & Rosenkranz are matters of speculation. But to secure the loan, Koenigs put up part of his drawings collection as collateral. (Later it was claimed that he had spent some 4.5 million guilders on the collection.) The collector insisted that the drawings not be placed in a bank vault but instead be stored at the Boymans Museum in Rotterdam, where curators would know how to care for fragile sheets of paper. For the moment he had lost control of what had become his life's work. In 1935, the year his collection went to the Boymans, Koenigs began a second collection of some two hundred drawings, acquired mostly from Walter Feilchenfeldt; these he hid from creditors in his apartment in Berlin.

KRAMARSKY

Now the tables were turned; ten years before, according to Hermann Abs, Kramarsky had been in Koenigs's debt. The reason that Kramarsky had moved to Holland, Abs said, was that in Hamburg Lisser & Rosenkranz had gone into bankruptcy. To restart the firm in Amsterdam, Kramarsky had borrowed from Koenigs. (Abs claimed that Kramarsky was the only banker he had ever known who after filing for bankruptcy later repaid creditors in full.)

Kramarsky had been born in Lübeck on April 14, 1893. His father died when he was ten, and he went with his brother Felix to live in an orphanage. Working as a laundress, his mother could not afford to house, feed, and clothe her five children. (Her daughters remained at home.) Whatever formal education he managed to obtain ended when at fourteen he was apprenticed to a dry goods company, which dispatched him to provincial towns to sell fabrics and ribbons. In 1916, at the age of twenty-three, he went to work for Rosenkranz & Co. (later Lisser & Rosenkranz) in Hamburg. Through his employer Franz Lisser he met Lola Popper, who had been hired as a tutor for Lisser's children. Lisser told Lola that Kramarsky was a clever young man and encouraged them to marry.

Lola had been born Violet Else Ingeborg Popper in 1896, the

daughter of Karl Popper, a coal broker, and Alma Flies. She enjoyed a comfortable middle-class childhood in Hamburg. A fine secondary school education and some university courses had given her a fair grounding in literature and art. But her life was shattered by World War I, during which not only her father but her twin brother was killed. When she met Kramarsky after the war, she was helping her mother make ends meet by maintaining what was left of the coal business. Lola was serious and intense. She had dark hair, dark eyes, and strong, striking features. Her father's death and the concomitant sudden end of the family's economic security seems to have hardened her ambition. Kramarsky could not impress Lola with his social credentials or his education, but he earned a good salary. His confident, joking, charming, easygoing manner must have appealed to her. He was also handsome, with a long forehead, sharp features, deep-set eyes, olive skin, and black hair. When they were married in

Siegfried and Lola Kramarsky. They acquired *Gachet* from Koenigs shortly before World War II.

1921, Lola was twenty-five. She could barely afford to buy new shoes for the wedding.

Lola Kramarsky's determination to maintain a position as a respected member of the European bourgeoisie seems to have evolved with age and her alliance to Kramarsky. Not long after their marriage, Lisser retired and sold the firm to Kramarsky and Flörsheim. In 1922 the Kramarskys' first child, Sonja, was born; Bernard was born the following year, and Hans Werner (later called Wynn) three years later.

In 1923 the Kramarskys moved to Amsterdam. There Lisser & Rosenkranz flourished. When the three Kramarsky children were old enough to notice, they lived in a large three-story brick house on Prins Hendriklaan, within walking distance of the Rijksmuseum. Lola ran a strict household; her children were brought up by governesses, and their lives rarely intersected with her own. When the young Kramarskys stayed in fancy hotels with their parents, they would envy the American kids who ate with the grown-ups and had their own spending money. Once they could afford it, the Kramarskys gave to Jewish philanthropic causes and acquired art and antiques, decorating the house with French wallpaper, eighteenth-century French furniture, and Meissen porcelain.

Franz Koenigs became one of Lola and Siegfried Kramarsky's closest friends. Together they traveled around Europe, visiting vineyards in France and attending auctions in Paris and London. Kramarsky had bought art before he moved to Amsterdam, but under Koenigs's tutelage the Kramarskys expanded their collecting. They acquired seventeenth-century Dutch landscapes, Watteau drawings, and Rubens oil sketches. By the 1920s Impressionist and Postimpressionist pictures had joined French furniture as popular art objects for mainstream collectors in Europe and America. It was Lola who liked Impressionist paintings and persuaded Siegfried to buy them. In 1932, at a Paris auction conducted by Walter Feilchenfeldt, Kramarsky bought van Gogh's *Trinquetaille Bridge*, the gray-toned landscape of the Arles iron bridge that Hugo von Tschudi had purchased from Cassirer in 1905. He paid 361,000 French francs.

As German Jews living in Amsterdam, the Kramarskys were

acutely aware of the measures the Nazis had taken to drive Jews from business and the professions, strip them of legal rights, and take their property. In the first five years of Nazi rule, between 1933 and 1938, some 270,000 Jews (out of a Jewish population of 525,000) fled Germany. Refugees poured into Amsterdam. But Kristallnacht—November 9, 1938, when gangs torched 191 synagogues, smashed the windows of 7,500 businesses, murdered 91 people, and sent 20,000 others to concentration camps—marked a new level of barbarity in the Nazis' treatment of Germany's Jewish population. To pay for the destruction, Göring fined the Jews 1 billion reichsmarks and issued a "Decree on the Elimination of the Jews from German Economic Life," which banished them from the last remaining fields of work that were available. From then on the Nazis freely seized Jewish property, decreeing such confiscation legal. "All sorts of ingenious schemes were devised to hide, sell, or export possessions," wrote Lynn Nicholas, "but by now, for most, it was much too late." Meanwhile the "Aryanization" of businesses had forced Jews to sell out their enterprises at deflated prices, then pay a 25 percent Flight Capital Tax, leaving them often with only a small fraction of their assets. By January 1939 Hitler had clarified that he would tolerate no moderation in his policies, declaring to the Reichstag, "If international Jewish financiers in and outside Europe should succeed in plunging the nations once more into a world war, the result will not be the Bolshevising of the earth, and thus the victory of Jewry, but the annihilation of the Jewish race in Europe."

Later Sonja Kramarsky recalled the late 1930s as the "difficult years" when her parents devoted much of their time and abundant resources to the refugee cause. Siegfried raised money for the Jewish Refugee Committee, which used rooms in Lisser & Rosenkranz for offices. Both Kramarsky and Salo Flörsheim were described as "unfailing in finding new ways for raising money," and "always prepared to advance money." On the first floor of the Kramarsky house volunteers spent long hours trying to find shelter and jobs for the immigrants. Regularly the Kramarskys' chauffeured car was dispatched to the German border to pick people up. Lola worked for the Refugee Committee and for the Amsterdam office of Youth

Aliyah, whose mission was to train Jewish teenagers to live in Palestine. Learning that a large group of children was about to arrive in Amsterdam, she and a friend obtained the use of an abandoned seventeenth-century building that had been used as an orphanage, which they had to quickly fix up. Lola Kramarsky, who enjoyed a houseful of servants, now worked on her hands and knees scrubbing the orphanage floor.

Franz Koenigs also assisted refugees; he exploited his multiple connections to the German industrial and banking establishment to help certain Jews secretly extract money and assets from Germany and avoid the devastating flight tax. For one friend, Käthe Oppenheimer, Koenigs arranged for "Rhineland industrialists" to swap assets held in foreign accounts with funds she had in German banks. Koenigs's schemes to circumvent the Nazi financial restrictions on Jewish wealth put him at risk with the German authorities. One day Käthe Oppenheimer was supposed to meet the banker for lunch, but he never appeared; that night he came to her apartment and told her he had been held at the Reichsbank all day while Nazi officials interrogated him about his financial dealings.

THE FISCHER AUCTION

In September 1938 in Munich, the ministers of Britain and France accepted Hitler's taking of the Sudetenland from Czechoslovakia, in an agreement that stated this would be the last of Germany's irredentist claims. In March 1939 Hitler broke this agreement by seizing the rest of Czechoslovakia. The following month, an advertisement appeared in *Art News* magazine announcing an auction of "Paintings and Sculpture by Modern Masters from German Museums," organized by the Galerie Fischer in Lucerne, Switzerland, to be held at the Grand Hotel National on June 30. In a bold attempt to generate some profits from the confiscated "degenerate art," Goebbels's disposal commission had arranged to auction 125 of the most marketable pieces confiscated from the museums. The auctioneer Theodor Fischer (who coincidentally had worked in the 1920s at Cassirer's in Berlin) put the highest presale esti-

mate (250,000 Swiss francs, or some $58,000) on a van Gogh, a self-portrait with a brilliant pale green background and dedicated to Gauguin, which Hugo von Tschudi had bought in 1906, and which had been confiscated on March 27, 1938 from the Neue Staatsgalerie, Munich.

For the auction, the disposal commission had selected eleven works from the collection of the Frankfurt Städtische Galerie for the sale, including Gauguin's *Marquesan Man with a Red Cape*, Kokoschka's *Hermann Schwarzwald*, the Matisse still life, and Picasso's *Head of a Woman*. After the van Gogh, the paintings expected to bring the highest prices were two Picassos: *The Absinthe Drinker* (73,500 Swiss francs) and *Acrobat and Young Harlequin* (105,000 Swiss francs).

The Lucerne auction was a highly controversial event; many dealers from Europe and America decided to boycott the sale. Prices were generally depressed. Walter and Marianne Feilchenfeldt went to observe. *Art News* editor Alfred Frankfurter, bidding for Maurice Wertheim, a New York financier, bought the van Gogh self-portrait for just over 200,000 Swiss francs (175,000 SF plus a 15 percent commission) or some $46,500 (a price close to the $53,000 Koenigs had paid for *Gachet* the year before). Wertheim bequeathed the painting to the Fogg Art Museum at Harvard University. In the end, the Fischer sale generated 570,904 Swiss francs, or some $132,000.

Alfred Barr, director of the Museum of Modern Art, shunned the auction, but in August he announced that he had already purchased five pieces of "degenerate art," including Max Beckmann's *Descent from the Cross*, from Frankfurt. "The only good thing about the exile of such fine works of art," Barr told the *New York Times*, "is the consequent enrichment of other lands where cultural freedom still exists." He emphasized that he had not dealt directly with the government of the Third Reich but had bought his new acquisitions from the dealer Curt Valentin, who had opened a branch of the Buchholz Gallery in New York. In 1940 Charles Kuhn, director of Harvard's Germanic Museum (later called the Busch-Reisinger) bought two of the museum's most important modern pictures from

Valentin: Erich Heckel's triptych *To the Convalescent Woman* and Max Beckmann's *Self-Portrait in Tuxedo*, which cost only $600. "I'd appreciate it if you would not tell too many people what price you have paid for this picture," Valentin told Kuhn.

During the summer of 1939, as Germany geared up its war machine, the rest of Europe struggled to prepare for attack. On August 23, the day after news came of the pending German-Soviet nonaggression pact, the National Gallery in London closed; soon the Rijksmuseum (which hid its finest pictures in safe corners of the building) and the Louvre were also shut. Immediately, curators at the Paris museum proceeded with evacuation plans. They pulled paintings from walls, lifted pieces of sculpture from their pedestals, and packed these pieces in crates, which were loaded onto trucks that headed to various chateaux in the south of France. By then too, the art of the London museums was journeying by train to Scotland. As caravans holding the great Paris collections moved out into the French countryside, Europe's other great museums were cleared, leaving their galleries vacant. Among the indelible photographs of the period is the image of the grand gallery at the Louvre, its walls stripped, its floor strewn with empty frames. Another picture documents a crew in the process of guiding the marble *Winged Victory of Samothrace*, encased in a wooden frame, down a railroad of wooden planks laid on the museum's staircase. In private houses, the same process was taking place on a smaller scale as thousands of objects disappeared from view, their owners attempting to protect precious possessions first from bombs and then from theft. "The exodus continued everywhere until October," wrote Lynn Nicholas, "as lesser collections followed the masterpieces."

At that point Siegfried Kramarsky made the decision to remove part of his collection from Amsterdam to the United States; he instructed Helmuth Lütjens to send *Portrait of Dr. Gachet*, as well as *Daubigny's Garden* and *The Quarry*, through a French shipping firm, Chenou, to London. Lütjens arranged to have the pictures picked up on August 14, 1939. From London, they went on to New York. Soon after, the dealer Raphael Rosenberg sent other pieces in the

Kramarskys' collection, including *Trinquetaille Bridge*, from Amsterdam to his cousin Eric Stiebel, who was operating the family's art gallery out of a small apartment in Manhattan.

On September 1, German troops invaded Poland; France and England declared war on Hitler, and the "phony war" began. On November 11, 1939, the Kramarskys were visiting the Hague when they noticed cars being packed outside the British consulate; they raced back to Amsterdam, where they received word that the invasion of the Netherlands was to begin that night. (A telephone call from a friend delivered the agreed-upon warning: "It's going to rain tonight.") Kramarsky packed a case with gold boxes and coins; that night he, Lola, and the children (who were told they could bring one suitcase each) boarded the only ship leaving Amsterdam—the *Jan Pieterszoon Coen*, which was headed for the Dutch East Indies. The Kramarskys got off in Lisbon, hoping to book passage to North America. From Lisbon they arranged to send the boys (thirteen and fifteen), both born in Holland and carrying American visas, on to New York where they would stay with an aunt. Because Siegfried, Lola, and Sonja Kramarsky had German passports and only Canadian visas, they were forced to wait. (The inadequate American quotas for German immigrants had been filled.) As it turned out, the Germans postponed the invasion of the Lowlands. Kramarsky's partner, Salo Flörsheim, had remained in Amsterdam, where he wrapped up the business of Lisser & Rosenkranz, which was in liquidation. Nine days after the aborted German attack, the artist Max Beckmann calmly drafted a letter to a friend: "I'm writing this during a blackout in Amsterdam, to the harmonious concert of wailing sirens."

THE SALE OF THE DRAWINGS

Now that Kramarsky had left Holland and war seemed imminent, Koenigs could wait no longer to repay his debt to Lisser & Rosenkranz. Lacking adequate funds, he was forced to raise the money. As early as the fall of 1939 he began to try to sell his drawing collection, letting it be known that the drawings were for sale. (At

some point, Saemy Rosenberg informed Paul Sachs at Harvard's Fogg Art Museum that they might be available.) His hope was that the drawings would be acquired by the Boymans Museum in Rotterdam, where they were on loan; then at least they would be in a public collection and remain permanently in Holland. In February 1939 the German banker had become a Dutch citizen. Because the museum itself did not have sufficient funds to acquire the collection, Dirk Hannema, the director, immediately turned to two Rotterdam collectors, Daniel G. van Beuningen and Willem van der Vorm. Van Beuningen was a Rotterdam ship owner and agent for two German coal companies; he was also a collector of old master paintings. But neither collector leapt at the chance to buy the Koenigs collection. No doubt they realized that they had the luxury to wait. On March 13, 1940, Hannema explained Koenigs's now pressing situation to van der Vorm:

> Today Koenigs had telephoned me and announced that within fourteen days his collection will be transported to Lisbon. A longer delay is not possible, because the bank where his collection is given as collateral is in liquidation. Mr. Koenigs assured me, though, that he will undertake everything possible to keep the collection here. As you know, in 1935 the collection was insured for 4.5 million guilders, which is about what Mr. Koenigs has spent on it over the years. It is now being offered for 2.2 million guilders. At first, the important nineteenth-century French drawings were not included, but now they are. Two drawings by Dürer and Grünewald, which are at the moment in America, also belong to it. My evaluation could be called low. I would apply another standard for eventual sale of only a part of the collection. It would be a disaster if it [the collection] were to leave Rotterdam for good.

The museum director also sent an almost identical letter to van Beuningen on March 21. But still the collectors failed to make offers. On April 2 Koenigs informed the directors of the Boymans Museum that his drawings collection was now the "full and free property" of Lisser & Rosenkranz. That same day representatives of

the bank told Hannema that they planned to have their shipping agent pick the drawings up sometime that week.

On April 8 Hannema again wrote van Beuningen. By then the shipping magnate had offered to buy the Koenigs collection (not only drawings but also some of the collector's paintings) for 1 million guilders. (Kramarsky and Flörsheim seem to have rejected this price.) Now the museum director tried to persuade van Beuningen to stick to his offer. Koenigs's drawings, he argued, constituted the most important private collection of its kind, one that would be impossible to reassemble. To reduce the drawings' cost, Hannema suggested that van Beuningen sell certain of the Koenigs paintings. On April 9 van Beuningen made another offer—presumably again 1 million guilders; for that sum, he would take all the drawings, three paintings by Hieronymus Bosch, and nine by Peter Paul Rubens. The offer, Hannema wrote, stood until 10 P.M. that night. "This new offer, under the circumstances, is more than good," he advised the bankers, "and I am convinced that you would not easily get a better offer elsewhere." Shrewdly he added that the packing of the collection would be completed Monday. As of Tuesday, it would be ready to be picked up. He reminded them of the dangers of moving such fragile sheets of paper: "As any transport causes risks and especially old drawings would appreciably lose value if they were to be affected by moisture, the most important sheets will be covered with tissue paper."

Within hours, the principals of Lisser & Rosenkranz accepted van Beuningen's offer. Their decision to take only 1 million guilders for the drawings, which a Boymans Museum inventory valued at more than 1.8 million, as well as the twelve paintings reflected their desperate need to remove their assets from Holland. Fears that they might be prevented from exporting such a collection undoubtedly encouraged them to take cash.

In his correspondence, never for a moment did Koenigs flinch or reveal a glimpse of the pain that the loss of his collection had inflicted. To the Boymans Museum, he showed gratitude. Days later he wrote the opportunistic Hannema that he was giving the museum two Carpaccio drawings to fill what he saw as a gap in its Venetian

holdings—a gesture of appreciation that the drawings would remain in Holland.

On April 9 the Nazis invaded Denmark and Norway, and on May 10 German planes began their raids on Holland; in five days the Nazis had taken control of the country. Within weeks the Germans installed their own government and ordered the arrest of German Jews who had come to Holland after 1933. Following the rapacious pattern they had established in Austria, the Nazis immediately began to rake through the Dutch art collections.

A month after Germany's conquest of Holland, Hans Posse, director of Hitler's "Special Project Linz," arrived at the Boymans Museum, accompanied by Lukas Peterich, van Beuningen's German son-in-law and a member of the Nazi party. They came to scrutinize the Koenigs drawing collection. On October 14 Posse reported to Hitler's secretary, Martin Bormann, that "in principle, the Führer agreed to the acquisition" of "one of the most famous collections of old master drawings, containing 24 drawings by Dürer, 40 by Rembrandt, etc." The price for part of the collection was 1.5 million guilders, Posse reported. By now Dirk Hannema had joined the new German government's Dutch Chamber of Culture as supervisor of museums in the Netherlands. On December 3, 1940, Posse bought 527 of the Koenigs drawings—most of them by German artists—for 1.4 million guilders, obtaining less than a quarter of the collection for almost 50 percent more than van Beuningen had paid for all of it. Such financial windfalls occurred, as the victorious Nazi leaders arrived flush with money and ready to compete among themselves for the patrimony of the nations of Europe. "In 1940 it was not yet known that for many it would be a question of life and death, and few comprehended the totality of Nazi purification ideology. At this early date, compromises of all sorts seemed possible," Lynn Nicholas wrote in *The Rape of Europa*, "and while one hoped for escape or liberation, there was no reason to forgo the enormous profits to be made at the expense of the enemy. Nowhere would these be greater than in the art trade, and nowhere was the survival of the otherwise doomed more possible than through the satisfaction of the collector's fever by which the Nazi leadership was possessed." Soon after, van

Beuningen donated the remaining 2,200-odd drawings to the Dutch National Collection at the Boymans Museum Foundation; in 1958 the museum became the Boymans–van Beuningen Museum.

Göring waited only days after the capitulation of Holland to survey the booty. For 700,000 guilders he also got his hands on paintings formerly owned by Koenigs, which he bought in a convoluted transaction with Alois Miedl, a Nazi businessman who had lived in Amsterdam since 1932 and was an art agent for Göring. In 1941 Miedl took over the assets of Lisser & Rosenkranz.

In September 1940 the persistent Frankfurt mayor Friedrich Krebs visited Franz Koenigs in Amsterdam on the pretext of wanting to buy an old master picture. From Koenigs, Krebs learned that "the van Gogh together with a Cézanne and one other painting had been sold for $110,000 and were in America." But Koenigs for some reason gave Krebs the hope that "it would perhaps be possible" to get the painting back for "$60,000."

Eight months later, on May 6, 1941, Franz Koenigs was killed. He had arrived late at the station in Cologne, and fell trying to jump onto a moving train. From the start, friends speculated that Koenigs had been murdered by the Nazis. While Koenigs had been depressed over the death of his son, who had been fighting in the Spanish Civil War, those who knew him well said he would never take his own life. Frightened by possible repercussions that the family might face in occupied Holland from claims that Koenigs's death was anything but an accident—the result of his insistence on never losing a minute waiting idly on a station platform, and a split-second loss of footing—Anna Koenigs–von Kalckreuth let it lie. By May 26, 1941, the 527 drawings from the Koenigs collection that Posse had purchased for Hitler had reached the Gemäldegalerie in Dresden; there they were to be stored until the Führermuseum in Linz could be built.

Vincent van Gogh,
Self-Portrait, Arles, 1888.
Van Gogh dedicated this
painting to Paul Gauguin;
the inscription reads,
"à mon ami Paul G."

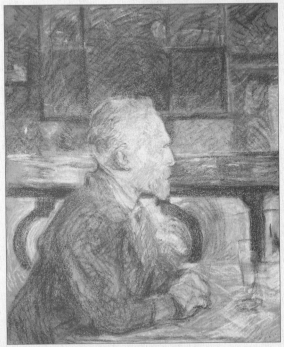

Henri de
Toulouse-Lautrec,
*Portrait of Vincent
van Gogh*. Lautrec
drew this pastel
in a Paris café,
probably early
in 1887.

LEFT: Dr. Paul-Ferdinand Gachet, photographed ca. 1890. In May 1890, van Gogh left a French asylum and moved to Auvers-sur-Oise, near Paris, hoping to get treatment from Gachet. In June he painted the doctor's portrait.

BELOW: Theo van Gogh, ca. 1886–1887. Vincent's brother was a Paris art dealer. After the artist's suicide in 1890, Theo inherited *Gachet* with hundreds of other canvases; six months later, Theo himself died.

Johanna Gesina van Gogh–Bonger with Vincent Willem in 1890. In less than a year, van Gogh's sister-in-law would become a widow and the owner of *Gachet*.

LEFT: Ambroise Vollard (*Portrait d'Ambroise Vollard*), photographed by Brassaï (Gyula Halász) in 1932 or 1933. In 1896, Vollard borrowed the Gachet portrait for a van Gogh exhibition held at his Paris gallery, and the next year he succeeded in selling it.

BELOW: Paul Cézanne, *Portrait of Ambroise Vollard*, 1899. In November 1895, Vollard gave Cézanne his first one-man exhibition.

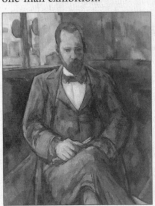

ABOVE: Alice Ruben, with *Portrait of Dr. Gachet* and Maurice Denis's *Maternité à la Pomme*, in 1897. Ruben, *Gachet*'s first owner, was an affluent Danish art student; she bought the portrait from Vollard in Paris, then took it back to Copenhagen.

RIGHT: Félix Vallotton, *Mogens Ballin and Marguerite d'Auchamp*, Paris, 1899. In 1904, when the Gachet portrait left Denmark, Ballin brokered its sale; by then, he may have been its owner.

LEFT: Paul Cassirer, ca. 1910. The Berlin art dealer first exhibited van Gogh's canvases in 1901. In 1904, he bought *Gachet* from Mogens Ballin in Copenhagen for 1,238 marks ($293).

BELOW: Edvard Munch, *Harry Graf Kessler*, 1906. Patron of avant-garde art and design, Kessler purchased *Portrait of Dr. Gachet* for his own collection in 1904 and paid 1,689 marks ($399).

BELOW: Pierre Bonnard, *Portrait of Eugène Druet*, ca. 1912. Druet, originally an art photographer, exhibited the Gachet portrait at his gallery in Paris in 1908; two years later he purchased it for approximately 14,000 French francs ($2,703).

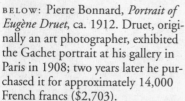

Georg Swarzenski, director of the Städelsches Kunstinstitut und Städtische Galerie, in 1912. One of the pioneering German museum directors who bought modernist painting before World War I, he acquired *Portrait of Dr. Gachet* in 1911. Its price: 20,000 French francs ($3,861).

The Städelsches Kunstinstitut, Frankfurt am Main. Designed by Oskar Sommer, the "old master" museum was built in 1878. Its transformation into a modern museum began in 1911 when it acquired *Portrait of Dr. Gachet*.

BELOW: Hermann Göring visiting art dealers in Amsterdam in June 1940, a month after the Nazis invaded the Netherlands. Two years earlier, the reichsmarschall had sold *Gachet* and two other paintings confiscated from German museums to obtain foreign currency.

ABOVE: "Degenerate art" confiscated by the Nazi Ministry of Propaganda, stored at Schloss Niederschönhausen in Berlin. On the easel is van Gogh's *Self-Portrait* (from Munich's Neue Staatsgalerie); below, Pablo Picasso's *Head of a Woman* (from Frankfurt's Städtische Galerie). On the wall to the left is Gauguin's *Marquesan Man in a Red Cape*, also from Frankfurt.

BELOW: Van Gogh's *Self-Portrait*, confiscated from the Staatsgalerie in Munich, being sold at the Galerie Fischer auction of "degenerate art" in Lucerne, June 1939. At 175,000 Swiss francs, the painting brought the highest price of the auction.

Franz Koenigs, photographed by Marianne Breslauer, Amsterdam, 1937. A German banker living in Amsterdam, he amassed one of Europe's great drawing collections. In 1938 in Paris, he secretly bought *Gachet*.

The Kramarskys, owners of *Gachet*, with their friends Chaim Weizmann, future president of Israel, and his wife, Vera, crossing the Atlantic aboard the *Rex* in January 1940. Anticipating the Nazis' invasion of Holland, the Kramarskys had fled Amsterdam the previous November. From left: Siegfried Kramarsky, Vera Weizmann, Sonja Kramarsky, Chaim Weizmann, Lola Kramarsky.

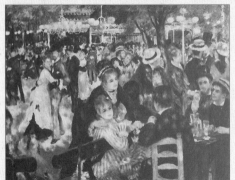

Pierre-Auguste Renoir, *Au Moulin de la Galette*, 1876. In January 1990, Sotheby's announced that it would auction the Renoir in May in New York, and estimated the painting would bring between $40 million and $50 million.

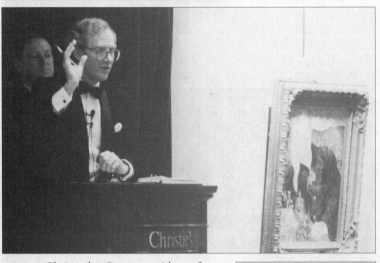

ABOVE: Christopher Burge, president of Christie's, auctioning van Gogh's *Portrait of Dr. Gachet* in New York on May 15, 1990. At $82.5 million, the painting became the most expensive work of art sold at public auction.

RIGHT: Ryoei Saito was the buyer of *Portrait of Dr. Gachet* at Christie's; the same week, at Sotheby's, the Japanese paper magnate bought Renoir's *Au Moulin de la Galette* for $78 million. For the next six years, he kept both late-nineteenth-century masterpieces locked in a Tokyo warehouse. Saito died in March 1996.

POSTWAR

NEW YORK

20

New York:
Refugee, 1941

On my explorations through the Metropolitan Museum . . . I visited a loan exhibition of French paintings on the second floor. Suddenly among the Impressionists I saw the cobalt blue of Dr. Gachet. I went close since I thought it was an optical illusion. It seemed to be the Frankfurt picture, or was it the other version which I had never seen? No, there were the purple foxgloves of our version. To be sure, I touched an ornament of the frame which we had once mended. It was the Frankfurt Gachet. I looked again at the old man who had kept his sad smile and heard him grumbling "vanitas vanitatum," et omnia vanitas. —Oswald Goetz

OSWALD GOETZ thus described his encounter with the van Gogh portrait early in 1941. The former assistant to Georg Swarzenski had escaped from Frankfurt in the fall of 1938 and made his way to the United States. He had last seen the portrait at the Städel in December 1937, when he had packed it up, prepared it for shipping to the Propaganda Ministry in Berlin, and bid it farewell. Word of Franz Koenigs's purchase had not reached him. The bittersweet encounter between Goetz and the lost portrait ("lent anonymously" to the museum) was not as improbable as it might have seemed. Both the refugee museum official and the refugee picture were part of the migration of art objects and art world figures from Europe following Germany's seizure of Poland and Czechoslovakia, its invasion

of the Low Countries and France, and Hitler's persecution of Jews. As the art historian Colin Eisler noted, a number of exiled curators were "reunited in America with exported art that they had purchased first in Germany and then again in America for museums of their employ."

The canvas had arrived in New York in the fall of 1939 without fanfare: a box of well-insured freight, it immediately went into storage. The first documentary evidence of its being in the United States was an appraisal list written in longhand by the art dealer Saemy Rosenberg, probably shortly after he himself came to New York in 1940. A German Jewish refugee, Rosenberg, like the Kramarskys, had fled Amsterdam; from there he went to England, where he was detained as an enemy alien before coming to the United States. At the top of the inventory, Rosenberg listed the three pictures Kramarsky had obtained from Franz Koenigs. The dealer assigned the highest value ($45,000) to *Portrait of Dr. Gachet*, a sum only slightly higher than that for van Gogh's *Daubigny's Garden* ($40,000) but three times that of the Cézanne *Quarry*, which he thought worth only $15,000. At some point in 1940, the portrait was stored at Duveen Brothers, the old master painting gallery, at 720 Fifth Avenue.

America welcomed the van Gogh portrait more readily than it welcomed its owners. Unable to obtain American visas, Siegfried, Lola, and Sonja Kramarsky were forced to wait in Portugal until January 1940 before they booked passage to New York. When they finally docked there, they could only stay overnight before heading to Montreal, where they would again wait for permission to move permanently to the United States. Franklin Roosevelt had resisted efforts by Jewish groups to raise quotas for Jews entering America. The United States offered asylum to only 157,000 German Jews between 1933 and 1944; in 1938 only 18,000 were admitted. Finally in May 1941 the Kramarskys obtained the permission of the U.S. government to enter America and moved to New York. That month they learned that Franz Koenigs had been killed; meanwhile they were desperately trying to rescue Lola's mother, Alma Popper, who had remained behind in Amsterdam.

Of the exiles from Nazi-occupied Europe who came to America,

only a fraction were art collectors and art professionals, yet they left a decisive imprint upon the American art world. New York's ascendance as an international capital of modern art coincided with the transfer to America of French and German modernist painting and sculpture, and of those Europeans who created, bought, brokered, and wrote about avant-garde art—many of whom arrived in the middle of their professional lives. With *Gachet* came not only the Kramarskys but also the scholar who had acquired the portrait in 1911 for Frankfurt's Städtische Galerie. Georg Swarzenski was one of the art historians who expanded the American field as a result of what his colleague Erwin Panofsky sardonically called the "providential synchronism between the rise of Fascism and Nazism in Europe and the spontaneous efflorescence of the history of art in the United States." Art historians were part of a larger intellectual migration from which countless fields of American higher education profited. From Germany, exiled artists and architects included Josef Albers, Marcel Breuer, Lyonel Feininger, Walter Gropius, George Grosz, Wassily Kandinsky, Ludwig Mies van der Rohe, and László Moholy-Nagy. From France the refugees included Marc Chagall, Fernand Léger, Jacques Lipchitz, Piet Mondrian, and the surrealists André Breton, Max Ernst, and Yves Tanguy.

As the center of modern art shifted to New York, so too did the art market, which moved with the French dealers, including Georges Wildenstein, Paul Rosenberg, and Germain Seligmann. Both Rosenberg (whose artists included Picasso, Braque, Matisse, and Léger) and Wildenstein saw immediately the opportunity to promote van Gogh; during the war, each held a van Gogh exhibition at which he displayed the newly arrived *Gachet*. The Wildenstein show, which opened in 1943, had over eighty works, including *Irises* and fourteen pictures from the van Gogh family collection that happened to be in the United States when war broke out. Running simultaneously with the Wildenstein show was an exhibition entitled *Artists in Exile* at the gallery of Pierre Matisse (son of the artist), where fourteen refugees showed their work. Through Paul Rosenberg, the Museum of Modern Art acquired its first van Gogh in 1941, the ravishing *Starry Night*.

By 1937 the German dealers Karl Nierendorf and Curt Valentin also established new galleries in New York, bringing with them German expressionist art that, like *Gachet*, had recently been in the collections of German museums. Valentin's Buchholz Gallery was a branch of the Berlin gallery of Karl Buchholz, one of the dealers who had access to the stocks of confiscated "degenerate art."

As the financial and cultural capital of the United States, the center of the American art world and its art market, New York was the logical destination for many of these artists, collectors, dealers, and art historians who had been driven from Europe. In New York, the refugee art professionals found extraordinary museums: the Metropolitan Museum of Art, the Museum of Modern Art, the Frick Collection, the Whitney Museum of American Art, and the Solomon R. Guggenheim Collection of Non-Objective Art. These collections were reflections of the city's economic success and of America's passionate and competitive relationship with European culture. As soon as Americans amassed sufficient wealth to buy art, many immediately looked back across the Atlantic and applied themselves to the task of catching up, in the accumulation first of objects and second of knowledge. In an upwardly mobile society, where hierarchies were quickly established but based on achievement and money, the acquisition of fine arts went hand in hand with social ascent. As one of the United States' richest cities, New York was also its most international. The art historian Erwin Panofsky, who began teaching in New York in the 1930s, recalled the scene that greeted him:

> Countless exhibitions and endless discussion, privately financed research projects, started today and abandoned tomorrow; lectures delivered not only in the seats of learning but also in the homes of the wealthy, the audience arriving in twelve-cylinder Cadillacs, seasoned Rolls-Royces, Pierce-Arrows, and Locomobiles.

The collections of the Metropolitan alone now rivaled not only those of the Hermitage in Leningrad but also of the Louvre. It had been founded in 1870, not from a private collection but as the vision

of a band of civic-minded businessmen, who dreamed of building "a more or less complete collection of objects illustrative of the history of art." Early in the century Roger Fry, then a consultant to the museum, had complained that the collection was deficient in everything but "sentimental and anecdotal" nineteenth-century art; indeed at that point it couldn't compete with any of the major European collections, including the Städel's. But by World War I, thanks largely to the collecting practices and leadership of J. P. Morgan, its president, the museum curators had gone far in filling major gaps. In the 1920s, when the American economy boomed, the Metropolitan received numerous gifts, including most significantly the bequest (some 1,972 objects) of Louisine Havemeyer and her heirs, who gave the museum a collection of nineteenth-century French painting surpassed only by the French government's collections in Paris. Not long before the arrival of the refugees, New York's early neglect of Postimpressionism and twentieth-century art had been redressed with the opening of the Museum of Modern Art in 1929, founded by three women collectors, Lillie P. Bliss, Abby Aldrich Rockefeller, and Mary Sullivan. In the decade since its opening, the energetic Alfred Barr had organized brilliant exhibitions that introduced the American public to various vanguard movements, including Postimpressionism—in *Cézanne, Gauguin, Seurat, van Gogh*, 1929; *Cubism and Abstract Art*, 1936; and *Fantastic Art, Dada, Surrealism*, 1936—and also to major artists, including Matisse in 1931, van Gogh in 1935, and Picasso in 1939.

FROM DAVID TO TOULOUSE-LAUTREC

It was at the Metropolitan that the refugee art historian Oswald Goetz rediscovered *Portrait of Dr. Gachet*. Their reunion took place at an exhibition that was itself a byproduct of the war. In 1939 René Huyghe, curator at the Louvre, had sent a group of some seventy paintings and seventy drawings from French public collections on a tour of South American cities. When the tour ended, French museum officials decided that their pictures were "safer on this side of the Atlantic" because of "the heavy risks of ocean transportation

in wartime." In May 1940 Germany had invaded France, and by June 22 the French had surrendered. The Third Republic rapidly collapsed, and World War I hero Philippe Pétain, who signed the armistice with Germany, led a new collaborationist government headquartered in Vichy. From South America the French art went first to San Francisco before arriving at the Metropolitan, where Harry B. Wehle, curator of paintings, organized an exhibition that he called *French Painting: From David to Toulouse-Lautrec*. Wehle supplemented the French museum pictures with loans from collections in North America, including *Gachet*. From Duveen's gallery, the portrait was delivered to the Metropolitan. The Kramarskys were still in Montreal.

The French painting show opened on February 6, 1941. In the catalog introduction, Wehle took the opportunity to lament the fate of France:

> At a time when the world hangs in breathless suspense and free nations are invaded and subjugated, when vision is blurred and emotions inflamed by the smoke and dust of war, when bureaus of enlightenment purvey misleading propaganda, at such a time it should be edifying, at least in some degree, to reconsider one full century of the art, and thus of the essential spirit, of the nation which is for the present more painfully distracted and humiliated than any other.

By September 1940 the Nazis' ERR (Einstazstab Reichsleiter Rosenberg) had set up its Paris office and had launched its systematic confiscation of art from the collections of French Jews, including those of the Rothschilds, the Wildensteins, and the Seligmanns.

At the Metropolitan, the Kramarskys' celebrated van Gogh made its first public appearance in eight years. But few besides Oswald Goetz recognized the painting, an image unfamiliar to the American public. Even Wehle seemed not to know which picture it was. "This one," he wrote in the exhibition catalog, "is presumably the second version," and not the one in Frankfurt. By consulting the 1928 de la Faille catalogue raisonné, he could have learned that the Frankfurt picture differed markedly from the second version, which was still in the collection of Paul Gachet. Undoubtedly Wehle, like

other Americans, was preoccupied with more pressing issues, including the question of whether or not the United States should go to war, but as a museum curator he was certainly aware of the Nazi Propaganda Ministry's confiscation of "degenerate art." He could have learned of the confiscation from colleagues (including Alfred Barr) or read about it the press. In August 1937 the *New York Times* reported that Göring had "issued a decree ordering a sweeping cleanup of all German art museums and other public art exhibitions in line with the principles laid down by Hitler." In July 1939 the *Times* also described the Fischer auction in Lucerne, reporting that a van Gogh self-portrait had been sold. Perhaps because the acquisition of works of "degenerate art" was controversial, the curator lacked incentive to learn the picture's identity. For their part, the Kramarskys may have hesitated to broadcast the painting's history, fearful perhaps that some in America might disapprove of the purchase of a van Gogh confiscated by the government of the Third Reich. When in January 1942 Paul Rosenberg exhibited *Gachet* in his show *Van Gogh Masterpieces*, the catalog listed the previous owners of the picture but omitted the Städtische Galerie. Yet the dealer undoubtedly knew that the picture had been in the Frankfurt museum. (It was in Rosenberg's Paris gallery that in 1935 Alfred Barr and Georg Swarzenski had discussed *Gachet.*) From that point on, the part of the painting's history that involved its confiscation by the Nazi propaganda ministry and its sale was forgotten.

THE KRAMARSKYS

Once in New York, in the spring of 1941, Siegfried and Lola Kramarsky rented and then bought an apartment on Central Park West, overlooking the 840-acre park. Here they hung their extraordinary Postimpressionist canvases: Cézanne's *Quarry* and three van Goghs—*Daubigny's Garden*, *Trinquetaille Bridge*, and *Portrait of Dr. Gachet*, one of the larger private van Gogh collections in New York. (In 1953 the Kramarskys would acquire a van Gogh still life, *Pair of Shoes*, painted against a tile floor.) These modernist pictures were installed in an apartment where the Kramarskys attempted to pre-

serve the old world interior of their house in Amsterdam. Lola filled the living room with elegant eighteenth-century French furniture brought from Europe. The floors were covered with Aubusson and Persian rugs; on shelves were porcelain teapots, vases, and figurines made in Dresden and Meissen. Casting a soft light was a lamp converted from a Chinese vase. In keeping with the decor were old master pictures, drawings by Antoine Watteau, oil sketches by Peter Paul Rubens, and a number of Dutch landscapes.

Siegfried Kramarsky had an office at 40 Wall Street, but he did not attempt to work as a financier, convinced that American banking regulations were too restrictive. With an engineer from Holland, he bought a pharmaceutical firm in New Jersey, but the factory failed. As she had in Amsterdam, Lola in 1942 threw herself into the effort to rescue Jews still trapped in Europe. At the invitation of Gisela Warburg, who had run the Berlin office of Youth Aliyah and was now in New York, she went to work full-time as a volunteer, applying her considerable energy and organizational skills. "These years . . . of global war, of Hitler's persecution meant horror and strain and tension to every one of us," she later wrote. "To be able to detach oneself from the day-in, day-out, general and personal worries, one had to be dedicated to and work for something in which one believed, in a good and great cause." By this time the situation of Jews in Europe was ever more desperate. A law passed in October 1941 prevented emigration from German-controlled territories. (On December 7 the Japanese attacked Pearl Harbor, and the United States entered the war.) In December at the Wannsee Conference in Berlin, Reinhard Heydrich, head of the SS, discussed the administration of the "final solution," ordered several months earlier by Hitler. In July 1942 the deportation of Dutch Jews to Auschwitz began. (Deportations from Poland, Germany, and France had started already in February.) In Amsterdam, Kramarsky's partner, Salo Flörsheim, had officially "retired" from Lisser & Rosenkranz in September 1940. By then the assets had been taken over by Alois Miedl, the German businessman who ingratiated himself with Göring (to whom he sold some of Koenigs's paintings). Flörsheim, who had become a Dutch citizen, was arrested and taken to a con-

centration camp. (Miraculously, he survived.) By the end of the war the Nazis had deported 105,000 Jews from the Netherlands. Lola's mother was among those deported; she perished at Bergen-Belsen.

SWARZENSKI

Only weeks after Georg and Marie Swarzenski reluctantly left Frankfurt in September 1938, they were staying at a hotel in New York. By February 1939, thanks to the influential Paul Sachs, director of Harvard's Fogg Art Museum, the Boston Museum of Fine Arts offered the former museum director, now sixty-one, a job as a fellow for research in sculpture and medieval art, a humble post he gladly took. Sachs had already hired Jakob Rosenberg (Saemy's brother), who had worked at the Kaiser Friedrich Museum in Berlin, as curator of prints at the Fogg and professor of seventeenth-century Dutch and Flemish art. Paul Sachs had an exceptional mix of social and academic connections. A collector, he had started his career as an investment banker at his family's firm, Goldman Sachs & Co, in New York, deciding to change professions and moving in 1915 to Harvard as an instructor in art history. Rosenberg and Swarzenski were among the few German art historians to find employment at American museums. Erwin Panofsky explained that "the immigrants were either added to the staffs of college or university departments . . . (museums were, for understandable but somewhat delicate reasons, not equally eager to welcome them . . .)." Those delicate reasons generally boiled down to an unstated anti-Semitism.

In 1933 the Nazis had purged some 250 art historians from their jobs in universities and museums; these mostly Jewish scholars had made up about one-quarter of the art history professionals employed in Germany, where the discipline had originated in the early nineteenth century. An estimated 130 art historians found refuge in the United States, including Alexander Dorner, Julius Held, Horst W. Janson, Adolf Katzenellenbogen, Ernst Kitzinger, Richard Krautheimer, Ernst Kris, Alfred Neumeyer, John Rewald, Charles de Tolnay, and Rudolf Wittkower. This influx of German scholars brought an internationalism and rigor to a field whose American

practitioners often failed to differentiate their discipline from art appreciation and connoisseurship. "By the early 1930s, after a decade of brilliant contributions, art history in America remained sporadic and provincial," wrote John Coolidge. "It was the task of the refugees from Germany to establish it as a unified discipline and to bring it abreast of continental practice." Janson's *History of Art* became the standard text in countless college survey courses. In *The History of Impressionism* (1946) and *Post-Impressionism* (1955), John Rewald made the first comprehensive studies of these modern movements. Rewald had traveled to Auvers and interviewed Gachet's reclusive son, who helped him pin down the precise details of the doctor's appearance, including "the blue alpaca redingote or overcoat" and "white cap with a leather visor" he wore in summer.

The most influential of the exiled scholars was Erwin Panofsky, a prolific author, who taught first at New York University's Institute of Fine Arts and, after 1935, worked at the Institute for Advanced Study in Princeton. Panofsky's well-written and vastly learned books—including *The Life and Art of Albrecht Dürer* (1943), *Early Netherlandish Painting* (1953), and *Meaning in the Visual Arts* (1955)—strengthened the foundation of American art history by translating quantities of German scholarship into English. But Panofsky also revolutionized American art historical practice with his "iconographical" method, which reoriented scholarship away from aesthetics and style and toward subject matter and intellectual history. "For it is obvious," he wrote, "that historians of philosophy or sculpture are concerned with books and statues not in so far as these books and sculptures exist materially, but in so far as they have a meaning. And it is equally obvious that this meaning can only be apprehended by re-producing, and thereby quite literally, 'realizing,' the thoughts that are expressed in the books and the artistic conceptions that manifest themselves in the statues."

At the Boston Museum of Fine Arts, Georg Swarzenski was employed in a position below the level of curator. Yet he devoted himself to laying the foundation for what became the third largest collection of medieval art in America. (His son Hanns became a

research fellow in Boston's European paintings department in 1948 and eventually the curator of European decorative arts.) Characteristically, in building the museum's collection of medieval enamels Swarzenski focused not on amassing a comprehensive group but on acquiring beautiful and unusual pieces. In 1940 he raised Boston's awareness of medieval art by organizing *Arts of the Middle Ages, 1000–1400,* one of the first major exhibitions on the subject in America. Quietly publishing articles on his acquisitions in the museum bulletin and other scholarly journals, Swarzenski remained an obscure figure in the United States. Even in Boston, only a handful of the small community of art scholars had any idea who he was.

The war had severed Swarzenski's ties to Europe, and he had lost track of his friend Max Beckmann, who had remained in Amsterdam. Finally in 1946 the dealer Curt Valentin sent him photographs of paintings Beckmann had made in Holland, and he learned that the painter had survived. "This was exciting news!" Swarzenski wrote. "He is really alive, has continued painting, and, in spite of the Nazi invasion . . . it is absolutely his, Beckmann's painting!" That year Valentin exhibited these Beckmanns at the Buchholz Gallery. In 1947 Beckmann embarked for the United States, taking a teaching job in Saint Louis, and two years later the painter moved to New York.

Neither the museum director nor the artist ever returned to Frankfurt. Understandably Swarzenski, who traveled in Europe after the war, stayed away. Frankfurt was now a city without a history; the Jewish population so instrumental in shaping its character as a financial and cultural center was gone. Frankfurt's skyline, once busy with stepped roofs, Gothic church spires, chimneys, and bell towers, had disappeared. Photographs from 1945 show a dark landscape of empty lots, piled with ashes and punctuated by the scorched skeletons of buildings. According to city statisticians, the city had been leveled to 12 million cubic feet of rubble. Eighteen Allied air attacks had killed 5,559 citizens. By March 1945 the population of 500,000 in 1933 had dropped by almost half as men were drafted into the army and families fled to the countryside. Firebombs had demol-

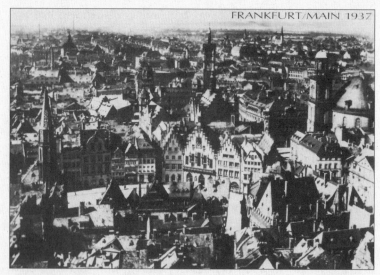

ABOVE: Frankfurt am Main, 1937. BELOW: Frankfurt am Main, 1947. American bombing leveled most of the central city, including the medieval buildings in the "old town."

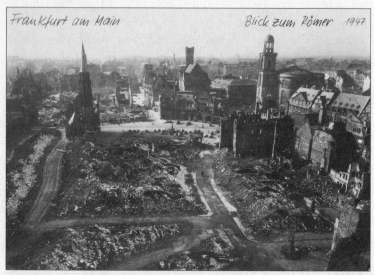

ished 50 percent of the 176,000 houses and apartments, and the majority of commercial buildings; the opera house was destroyed, as were most of the thirteenth-century buildings of the old city. Miraculously, however, the glass-and-iron vault of the grand Hauptbahnhof remained standing. The Städelsche Kunstinstitut had also survived, but had suffered severe damage. Allied bomber pilots aiming at a gun tower that German soldiers had carelessly placed on the museum's roof had blown out the ornate central marble staircase and leveled the ends of the building.

In 1950, five years after the war, Swarzenski was reunited with Max Beckmann in New York. The artist had been asked to do a portrait of the former museum director to illustrate a volume of essays, edited by Oswald Goetz, written in honor of his seventy-fifth birthday. (The contributors included Panofsky and Bernard Berenson.) The portrait was a charcoal sketch, drawn straight on, a haunting image of a man who is no longer young. Swarzenski's eyes stare unflinchingly through the rims of his glasses, the rings of charcoal creating hollows of darkness. In late December, only weeks after he finished the drawing, Beckmann, at sixty-six, was stricken by a fatal heart attack as he walked on Central Park West. Seven years later, after suffering a stroke, Swarzenski himself died. He was buried at Mount Auburn Cemetery in Cambridge, after an Epis-

Max Beckmann drew this *Portrait of Georg Swarzenski* (1950) when both artist and art historian were living in the United States.

copal ceremony at the chapel. If in America he ever saw *Portrait of Dr. Gachet*, the circumspect scholar left no record of it. Nor did the German medievalist express his thoughts on the recent wrenching history in which the fate of its acquisition as a refugee closely paralleled his own. In 1985 the curator of drawings at the Städel acquired Beckmann's portrait of Swarzenski for the Frankfurt museum's collection.

21

"Exactly How Great
a Painter Was He?"
1950s–1970s

*When he painted his portrait of Dr. Gachet with what he called
"the heartbroken expression of our time," Vincent struck a chord
that still resounds in contemporary feeling. A period that idolizes
Dostoevsky and makes a prophet out of Kafka will continue to
react to such intense emotions stretched to the breaking point. . . .
Van Gogh's moral austerity, his grim acceptance of reality and
responsibility for action, constitute an almost classical case study
for Existentialism. . . .*

*How can one explain the vast hordes of war survivors who
stood in patient queues at Paris and London, eager to catch even a
glimpse of his work? . . . Part of his continuing appeal may lie in
his unique ability to suggest those tensions and dislocations under
which man lives today.*
 —Daniel Catton Rich

THUS DANIEL CATTON RICH interpreted *Portrait of Dr. Gachet* for
an American audience in 1949, four years after Germany had surren-
dered. The director of the Art Institute of Chicago had borrowed the
painting from the Kramarskys for a van Gogh retrospective, opening
at the Metropolitan and going on to Chicago. To Rich, *Gachet* was a
psychological portrait of the artist (psychology being a relatively new
and popular lens for seeing the world). In its tormented imagery, he
believed, the viewers would find a reflection of the collective angst
suddenly felt in the new era of the cold war. The euphoria of the

Allied victory had vanished with surprising swiftness in response to Stalin's launch of the Berlin blockade in June 1948 and the Soviets' testing of the atomic bomb, which began the following year.

By now van Gogh was probably the most well known artist in America. In 1929 the pioneering Alfred Barr had selected the Dutch painter as one of the four Postimpressionists, with Cézanne, Gauguin, and Seurat, who were the subject of the inaugural exhibition at the Museum of Modern Art. Two years before, Houghton Mifflin had published the first English edition (in two volumes) of the artist's letters, following it with *Further Letters* in 1929. More instrumental than Barr to heightening the artist's fame was Irving Stone, who in 1934, during the depths of the depression, published *Lust for Life*, a novel based on the artist's biography that became a bestseller. Barr organized the first American van Gogh retrospective at the Museum of Modern Art the following year. The exhibition promised to reveal works never seen before in the United States: Barr borrowed thirty paintings and thirty-five drawings from the Kröller-Müller collection in Otterlo, and thirteen paintings and six drawings from Vincent Willem van Gogh's collection in Amsterdam. (The artist's nephew had inherited the collection of his mother, Johanna, who had died in 1925. He kept it at his house in Laren, storing most of the pictures in an unheated room, until 1930, when he loaned the collection to Amsterdam's Stedelijk Museum.) But Barr also obtained twenty-three paintings and nineteen drawings from six American museums (in Chicago, Detroit, Kansas City, Toledo, Buffalo, and Washington), and from twenty American collectors. In the United States both public and private collections now had magnificent examples of the artist's work, including *Van Gogh's Bedroom*, *La Berceuse*, a *Sunflowers*, the haunting *Night Café*, *L'Arlésienne*, *Roses*, *Landscape near Saint-Rémy*, *Olive Trees*, and *The Drinkers (after Daumier)*. Various American museums had clamored for Barr's show, and from New York it traveled to Boston, Philadelphia, Cleveland, and San Francisco. In these five cities the exhibition attracted 878,709 visitors. "The people came as though the museum was exhibiting the Sistine Chapel," observed Harold Edgell, the Boston museum's director. Critics were enthusiastic. A writer at the

New Yorker called the show "the most thorough, the most exemplary, and the most stimulating exhibition of modern art" yet held at the New York museum. Later the critic Alfred Frankfurter assessed what Barr had achieved:

> [It] will be remembered as probably the outstanding artistic success of the 'thirties, if not indeed of the history of American museums until then. Hundreds of thousands of visitors taxed the handicapped facilities of the museum building, department stores along Fifth Avenue arranged Van Gogh windows (inaugurating a timely use of art for advertising that of course has been repeated many times since), and a daily newspaper went so far as to offer Van Gogh reproductions as premiums in a circulation-promotion stunt.

But Frankfurter observed that the exhibition's ability to draw crowds depended upon the popularity of Irving Stone's book (translated into nine languages), which he found impossible to read "because of the vulgar melodrama of the dialogue." (About *Sunflowers*, for example, Stone has a chatty Gachet tell Theo, "These canvases alone, Monsieur, will make your brother immortal.")

In postwar America the van Gogh legend flourished. By the 1950s Americans across the continent had the opportunity to see the Dutch artist's canvases in the original. Since World War I, American cities had constructed over two hundred new art museums. Washington's National Gallery had opened in 1941, founded with a gift from Andrew Mellon. In 1949, the year of the Metropolitan's van Gogh retrospective, the museum finally bought its first examples of the artist's canvases: one of the *Cypresses* landscapes and a small *Sunflowers* still life. Over the next fifteen years, private collectors (encouraged by the U.S. tax code) donated six more: *Olive Pickers*, *First Steps (after Millet)*, *Vase of Irises*, *Flowering Orchard*, *Oleanders*, and *L'Arlésienne*. In 1951 the Kramarskys loaned their portrait to a van Gogh exhibition at Houston's new Contemporary Arts Museum. To a Texas curator, van Gogh's "tragic life" offered a "significant lesson for our time," a lesson "of making an effort toward

sympathetic understanding of contemporary artists who are struggling today." To the Houston press, van Gogh signaled money. One newspaper reported that the exhibition was insured for $1.5 million; *Gachet*, it estimated, was worth around $200,000. (In 1935 Barr had set the insurance value of the paintings in his van Gogh show at $40,000 each.) Even a sportswriter devoted a column to the show. Dr. Gachet, he wrote, is a "sad guy at his saddest [who] looks like Rusty Russel, the S. Mich. coach, right after the Texas game last fall." In the summer of 1957 the van Gogh portrait traveled to Los Angeles for an exhibition at the Municipal Art Gallery, organized by Wildenstein.

Two years before, MGM had begun shooting the movie version of *Lust for Life*. The studio had bought the rights to the novel for $120,000 in 1946, but MGM executives had rejected several screenplays. Then the 1953 success of *Moulin Rouge*, a John Huston movie about Henri de Toulouse-Lautrec, spurred the studio to proceed. Vincente Minnelli was chosen as director. Among his credits were *Meet Me in St. Louis* (1944), *Father of the Bride* (1950), and *The Bad and the Beautiful* (1952). Wanting the movie to be as accurate as possible, Minnelli hired the art historian John Rewald as a consultant and shot much of the film on location in Belgium and France, where the film crew even visited Dr. Gachet's garden. (The scene of the portrait being painted was filmed in a Hollywood studio.) Photographers were sent to various collections to take pictures of canvases, images later put on film. The movie (which starred Kirk Douglas as van Gogh and Anthony Quinn as Gauguin) had its American premiere at the Metropolitan Museum in September 1956. For his performance, Quinn won an Academy Award for best supporting actor.

Americans had grown accustomed to the idea of the avant-garde. Soon after the war a band of radical painters known as the abstract expressionists or Action Painters congregated in New York, their mural-scale, iconoclastic, generally abstract canvases for the first time bringing attention to American painting abroad. Among the group's members were Arshile Gorky, Willem de Kooning, Adolph Gottlieb, Robert Motherwell, Jackson Pollock, and Mark Rothko. "The main premises of Western art much to our surprise have at last migrated to the United States," the critic Clement Greenberg wrote, "along with

the center of gravity of industrial production and political power."
He contrasted these "new talents so full of energy and content"
with the legendary cubists—Picasso, Braque, Léger—whose work,
he claimed, had "declined." Pollock, the group's most prominent
figure, made mural-scale "drip-paintings" covered with free-form
lacings of paint by pouring pigment directly onto the canvas, which
he had laid out on the floor. In 1949 *Life* magazine made Pollock
and his method famous by publishing photographs of the artist
splashing paint onto canvases in his studio. The following year the
Museum of Modern Art spent $2,350 to acquire Pollock's *Number 1*. Eleven years later, in 1961, a Pollock reportedly sold for
more than $100,000. "The completeness with which Pollock
appears to have exemplified the syndrome of the *artiste maudit*,"
wrote Greenberg, "has invested his legend with a resonance like that
of van Gogh's."

Although at this moment Greenberg failed to acknowledge it,
the success of the van Gogh legend in America's mass market culture
unsettled art professionals, himself included. As had happened in
Europe in the 1920s, the rise of the van Gogh mythology brought a
decline in the artist's reputation with critics and art historians. In
1949 Daniel Catton Rich had worried that "the artist was in danger
of disappearing altogether, his paintings and drawings turned into
mere illustrations for popular biography." Nevertheless, even Rich
and his colleagues saw van Gogh's life as "a high moral religious
drama," and seemed not to dispute the premise that van Gogh's
paintings were graphic depictions of his troubled psyche. "He was
drawn especially to objects in strain," wrote the art historian Meyer
Schapiro in 1955, "to landscapes, unstable, obstructed and con-
vulsed; to a cataclysmic world of stormy movements and upheavals,
nature suffering or disturbed." Assuming the paintings to be psycho-
logical illustrations led certain critics to question van Gogh's ability
as a painter. "Is there craft competence, did van Gogh have a profes-
sional command of his art?" asked Clement Greenberg. "Or was it
his derangement that made him the painter that he was?" When
reviewing Wildenstein's 1943 show, he asked, "Exactly how great a
painter was he?" He added that "the problem is made no easier by

this exhibition, in which the complete masterpieces are too few and far between." *Gachet* was one of the sixty-five works on exhibition, but it did not impress him enough to merit mention.

By then Greenberg was the leader of the formalist school of criticism, which dominated the field of modernism in the postwar period. Following Roger Fry, the formalists had pushed van Gogh to the periphery of the history of modernism, where Cézanne held center stage. The formalists regarded the history of art as a history of style; modernism in their eyes was the evolution of Paris-based, anti-academic painting, from the realism of Courbet and Manet to the abstraction of the cubists. With his notorious *Olympia*, modeled on Titian's *Venus of Urbino*, shown at the Salon of 1865, Manet had riled both the Paris critics and the public, who recognized the nude that takes up most of the canvas as a Parisian courtesan. But despite the radical nature of such modernist subject matter, the formalists paid scant attention to it. The contemporary life that was the subject of many Impressionist paintings was accepted by commentators at face value. The painter's choice of a street, a cabaret, a group of ballet dancers, fields and flowers, friends and family members, was interpreted as significant mostly because it flew in the face of academic convention. By rejecting traditional heroic or moralizing subject matter, artists seemed, to the formalists, to be rejecting the significance of subject matter itself. The art historian Linda Nochlin assessed the formalists' bias: "In its most simplistic formulation, the whole point of the Modernist effort, from Manet on, was to rid art of its encumbering subject matter, leaving the production of meaning—understood always as an outmoded emphasis on moralism or story telling—to Academism and outer darkness."

In the formalists' view, Manet's most profound contribution to modernism was his style, in particular his flat way of applying pigment, which was seen as self-consciously marking the canvas as two-dimensional and propelling painting away from photographic illusion and toward abstraction. After Manet the Impressionists further underscored the medium's two-dimensional aspect, using broken brush strokes to create tapestry-like surfaces of paint. Because van Gogh made it clear that he invested his subject matter (starting

with *The Potato Eaters*) with symbolic significance or "meaning," and because his free-flowing gestural style seemed driven by emotional rather than aesthetic issues, he attracted the attention of relatively few American art historians in the heyday of formalism. In 1971 New York held its first van Gogh retrospective in twenty-four years; it took place at neither the Metropolitan Museum nor the Museum of Modern Art, but at the Brooklyn Museum. During the 1970s *Gachet* was on public exhibition only once, in a small, innovative exhibition (with nine van Goghs) at the Metropolitan organized by the curator Charles Moffett, *Van Gogh as Critic and Self-Critic*.

THE ART MARKET

Whatever doubts the critics had about van Gogh in the postwar period, the prices of his pictures rose with his public popularity. Through the 1950s and 1960s New York's galleries, now more numerous than those in Paris, continued to keep the Dutch Postimpressionist in the public eye. The United States had 7 percent of the world's population, produced 50 percent of its manufacturing output, and enjoyed 42 percent of its income; Americans could more than ever afford their appetite for late-nineteenth-century French art. This market was relatively small and dominated by a handful of galleries, including Knoedler's, Wildenstein's (again headquartered in Paris), and Paul Rosenberg's. These dealers had stocks of Impressionist pictures, which they typically picked up from private collections or from auctions in London and on the Continent. In the late 1950s Wildenstein's New York inventory reportedly contained some 2,000 paintings. The gallery's owners "aimed always to have at least 20 by Auguste Renoir and 10 works each by Paul Cézanne, Paul Gauguin and Vincent van Gogh." Wildenstein marketed Impressionism and Postimpressionism primarily by presenting benefit exhibitions and thereby catering to the aesthetic and philanthropic interests of its clients. For at least twenty years after the war the gallery clung to this same formula, borrowing Kramarsky's *Gachet* three times: in 1948 for *Six Masters of Post-Impressionism*, in 1955 for *Vincent van Gogh*, and in 1965 for

Olympia's Progeny: French Impressionist and Post-Impressionist Paintings. The gallery played down the commercial aspect of its business by using these exhibitions to raise funds for charitable causes, whose benefactors were often Wildenstein clients and lenders to the shows.

London, however, remained the center of the auction market through the 1960s. There Christie's (founded in 1766) and Sotheby's (founded by the bookseller Samuel Baker in 1744) competed. Their auctions served largely as the wholesale market where dealers could circulate often second-rate merchandise to others in the trade. Even in the 1960s, dealers could buy paintings at auction in Europe and sell them to collectors in America who were not aware of what the pictures had recently cost. Auction catalogs provided little information beyond the bare-bones facts: the artist's name, the object's title and dimensions; for major lots the catalogs gave the provenance and listed the exhibitions and publications in which the work had appeared. Collectors bought at auctions at Parke-Bernet Galleries, New York's major auction house, and at Sotheby's and Christie's, but generally not without the advice of a dealer. Even among the audience attending a public sale, only insiders could determine which pieces actually sold. Each auction lot carried (and still carries) a secret reserve, a price below which an owner refused to sell. If the reserve was not reached, technically the seller "bought back" his own property. Traditionally, on a given lot, even if the auctioneer found not a single bid, he would nevertheless go through the motions, calling out numbers "from the chandelier," so as not to stop the momentum of a sale. Although after each sale the London auction houses published price lists, such lists were not widely circulated. In London, until the mid-1970s, these price lists named a buyer for every piece whether or not it had in fact been purchased. Those in the trade knew that many of the "buyers'" names were fictitious. One Christie's expert used names of players on his favorite soccer team. By pretending that every lot had sold, the auction houses sought to protect the value of their clients' property. Failing to sell at public auction meant a picture was "burned," and typically not of interest to the market for five years.

Still, the only way to track the prices of Impressionist and

Postimpressionist prices was at public auction. When in 1952 a Cézanne still life sold at the Gabriel Cognacq sale at the Galerie Charpentier in Paris, it was the first publicly traded modernist picture to reach the $95,700 (478,000 francs) price that Louisine Havemeyer had paid for Degas's *Dancers Practicing at the Barre* in 1912. Six years later on October 15, 1958, at Sotheby's sale of seven paintings owned by Jakob Goldschmidt, several American millionaires helped elevate the modern art market. Paul Mellon boosted prices for Cézanne when he bid a record $616,000 (220,000 pounds) for *Boy in the Red Waistcoat*. Another record price was paid for a van Gogh by Henry Ford II, who spent close to $400,000 (132,000 pounds) for *Public Garden with Couple and Blue Fir Tree*. ("Imagine an immense pine tree of greenish-blue, spreading its branches horizontally over a bright green lawn," van Gogh had written. "And gravel splashed with light and shade. Two figures of lovers in the shade of the great tree: size 30 canvas.") The Goldschmidt sale was the third in a series of Impressionist auctions in slightly over a year whose pictures happened to come from the estates of refugee collectors; its success was credited to Sotheby's publicity-minded chairman Peter Wilson, who began to expand the firm. But at least as important as Wilson's marketing abilities was the strength of the stock market. In November 1954 the Dow Jones industrial average had exceeded 300 for the first time since the 1929 crash. In 1964 Sotheby's bought Parke-Bernet and started holding auctions in New York.

Still, the most expensive Impressionist pictures did not approach the prices of the most costly old masters. On November 15, 1961, James Rorimer, director of the Metropolitan Museum of Art, bidding against the Cleveland Museum of Art (represented by Saemy Rosenberg), bought Rembrandt's *Aristotle Contemplating the Bust of Homer* at Parke-Bernet for $2.3 million. In 1944, when Siegfried Kramarsky loaned the Gachet portrait to an exhibition in Montreal, its insurance value was estimated to be $60,000. Twenty-six years later, in 1970, the art dealer Eric Stiebel appraised *Gachet* for a million and a half dollars.

22

Postwar

Frankfurt

IN 1958, thirteen years after the war, Hermann Josef Abs first pursued retrieving the Gachet portrait from the United States. Franz Koenigs's former assistant in Amsterdam, now in his late fifties, enjoyed a position as the most powerful banker in Germany. In 1934, the year after Hitler's ascent, Abs had become in his early thirties the youngest banker ever named a director of the Deutsche Bank. Although Abs had been associated with the Kreisau circle, members of the German elite who had worked secretly to oust Hitler, he declined to claim that he risked his life for the cause. Abs was a brilliant linguist, a shrewd financier, an Anglophile, a connoisseur of music, and a collector of art. Since the war he had helped orchestrate Germany's economic recovery and Frankfurt's ascent as the nation's new financial capital, where Deutsche Bank's towering steel-and-glass 509-foot world headquarters symbolized the nation's phoenixlike entry into the European commonwealth. In 1948 the Soviet Union's Berlin blockade had made it clear that the Russians would not pull their troops out of East Germany; the following year West Germany became a new nation, one of five members of the North Atlantic Treaty Organization (NATO), the diplomatic alliance designed to deter the Communist threat. Four years after the war, America depended upon West Germany as a crucial European ally. Between 1948 and 1952 the Marshall Plan poured $13.4 billion into western Europe: Germany reconstructed its bombed cities and rebuilt its economy.

Abs, like countless Germans, struggled to shed his past. Although he became an adviser and confidant of Konrad Adenauer, the new German chancellor (former mayor of Cologne, ousted by the Nazis), rumors about Abs's role as an influential banker under Hitler's government persisted; reportedly Adenauer declined to name Abs to a post in his cabinet because the banker could not completely disassociate himself from the Nazi regime.

The task of reconstructing the damaged Städelsches Kunstinstitut had fallen to Ernst Holzinger, who had been named its director in 1938, when the Nazis forced Georg Swarzenski to resign. A far more complex and intransigent problem than removing rubble and repairing the nineteenth-century building was how to fill the void left at the heart of the museum's collection by the Nazi confiscation of its extensive holdings of modern art. From the start, the idealistic Holzinger hoped to track down and bring back some of the pieces that Swarzenski had acquired, in particular *Portrait of Dr. Gachet*.

In this bleak postwar period, the confiscated portrait reminded the troubled but progressive city of the early twentieth century and its community of internationally minded collectors (including the *Gachet* donor Victor Mössinger, the newspaper publisher Heinrich Simon, and the leather manufacturer Robert von Hirsch) who had bought modernist art. Above all the painting symbolized the modern museum Georg Swarzenski had erected upon Frankfurt's collection of old masters. That the painting had inspired Benno Reifenberg's daring 1937 editorial in the *Frankfurter Zeitung*, voicing antipathy toward the Nazi regime, gave the canvas great weight. In retrospect, the melancholy van Gogh seemed emblematic of "the other Germany," the congregation of writers and scholars who had revered history, education, and science and had achieved breakthroughs in countless fields of knowledge. (Abs, a pragmatist, claimed that the citizens of Frankfurt only really began to appreciate the van Gogh portrait once it had been removed.)

Although anti-Nazi, Holzinger had been drafted into the German army in 1941, returning four years later to resume his job at the museum. The son of a Protestant theologian from Ulm, Holzinger

was a mild-mannered, ascetic intellectual who, like many in his generation, held tenaciously to his belief in the moral authority of great art. In the 1920s Holzinger had been a student of Heinrich Wölfflin, a leading theorist, whose *Principles of Art History* had swept the shift between Renaissance and Baroque art into a persuasive theory of stylistic polarities based on the formal concepts of linearity and painterliness, plane and depth. In 1955 Holzinger was among German art historians who helped organize *Documenta*, an exhibition of modern art one of whose unspoken aims was to respond to the 1937 *Degenerate Art* exhibition and to reestablish Germany as a champion of modernism. But Holzinger had a difficult mission. On the one hand he struggled to convince the Städel's conservative trustees to buy Max Beckmann's painting of the Frankfurt synagogue, which was finally acquired in 1972. On the other, he was attacked by leftist artists in Frankfurt whose work he declined to purchase.

In December 1958 Holzinger alerted Abs to an announcement in an art magazine that the collection of Felix Kramarsky (Siegfried's brother) would be auctioned in May at Parke-Bernet. Thinking mistakenly that Felix owned *Gachet*, Holzinger worried that the portrait might be sold to a museum, precluding any chance of its return to Frankfurt. Abs had known Siegfried Kramarsky in Amsterdam, where in the 1920s both were friends of Franz Koenigs. On January 21 Abs wrote Kramarsky, telling him that the Städel was anxious to recover the painting if it was available for purchase. Apparently the banker's overtures came to nothing. Meanwhile, in February Holzinger requested a city administrator to send him all documents related to the confiscation of *Gachet*. It seems he wanted to be able to recount exactly the circumstances of the confiscation and the efforts made by the Städel administrators to protest the Nazi government's seizure of the painting.

On December 25, 1961, Siegfried Kramarsky died of lung cancer at age sixty-eight. An obituary in the *New York Times* described him as a "retired banker and philanthropic leader who played a major role in aiding German Jewish refugees." It mentioned his support of the Weizmann Institute of Science in Israel, and the campaigns of the United Jewish Appeal. His art collection, the paper

noted, included "works by Van Gogh, Cézanne, Toulouse-Lautrec, Renoir, Seurat and Gauguin."

Shortly after Kramarsky's death, the critic Benno Reifenberg, still at the *Frankfurter Zeitung*, wrote a piece celebrating Holzinger's recent acquisition from a Swiss dealer of the Matisse still life with the blue background—the gift to the Städtische Galerie from Robert von Hirsch, auctioned in 1939 by the Propaganda Ministry at the Fischer sale in Lucerne. The year before, Holzinger had succeeded in buying back a painting (*White Dog*) by Franz Marc, also formerly in the museum's collection. In the newspaper Reifenberg suggested that with the death of Siegfried Kramarsky, it might now be possible for the Frankfurt museum to purchase *Portrait of Dr. Gachet*.

On April 4, 1962, Holzinger wrote Werner Kramarsky in New York. His letter served as a message of condolence and an inquiry about the van Gogh portrait. Explaining that he had heard that the Kramarskys had offered van Gogh's *Daubigny's Garden* to an American museum, he turned to *Dr. Gachet*, which he described as the greatest single loss suffered by the museum's modern collection because of the Nazi confiscations. Holzinger laid out the sequence of events: Göring had seized the painting and sold it to Franz Koenigs. Before the war, he claimed, secret negotiations had taken place with Koenigs about returning the picture to Frankfurt. In this, he seemed to refer to the memo written by Friedrich Krebs, in which the mayor mentioned that Koenigs said the picture might be repurchased for $60,000. If now the Kramarskys had any inclination to sell *Gachet*, the Frankfurt museum would be interested in acquiring it. Holzinger even briefly alluded to the subject of Germany's collective responsibility for the Nazis' crimes, something that complicated any moral case the German museum might have for restitution of the picture: "It would bring a good spirit back to the city, which stands in need of this spirit after it left in 1933 and later. It was our fault— I am certain of this, and have always said so."

Lola responded to Holzinger's letter on April 17, explaining that her son was away. (Later, he didn't recall receiving the letter.) She was scrupulously polite:

As to the Van Gogh paintings which you mention in your letter, they are part of my husband's estate and before matters pertaining to the settlement of the estate, such as death duties, are completed, we are not in a position to enter into any sale negotiations. However, we think we should let you know that the Dr. Gachet, by van Gogh, will not be for sale in the foreseeable future.

Soon after, Holzinger told Abs he learned that Reifenberg's article had upset Lola Kramarsky. At this point, both Abs and Holzinger seem to have given up on *Gachet*. Three years later, the museum director asked a city attorney if the museum could make a damage claim for the portrait's loss against the heirs of Hermann Göring. In a seven-page brief, the lawyer concluded that because the Propaganda Ministry had seized the painting before Göring got hold of it, its confiscation was covered by the statute legalizing the "degenerate art" confiscations by the Reich.

Like Holzinger, Heinz Köhn, director of the Folkwang Museum in Essen, had kept track of the Kramarsky paintings, in particular

Lola Kramarsky. She owned *Gachet* for more than half a century.

Cézanne's *Bibémus Quarry*, bought by Karl Ernst Osthaus from Vollard in 1907 and confiscated from the museum in 1937. After the war he had asked Walter Feilchenfeldt, the former Cassirer partner, if he might help the museum get the picture back. Before the war Feilchenfeldt and his wife, Marianne, had fled from Amsterdam to England and then to Switzerland. In 1947 he opened a gallery in Zurich; after his death in 1953, Marianne took over the business. At some point she told Saemy Rosenberg in New York of the Folkwang Museum director's wish to acquire the Cézanne. On Fifty-seventh Street, Rosenberg & Stiebel had maintained the flavor of an old-fashioned European gallery with an eclectic selection of traditional fine and decorative arts: old master paintings, tapestries, Renaissance bronzes, and eighteenth-century furniture, their specialty. The Kramarskys were regular clients, typically stopping in on Saturdays to inspect the new merchandise. (It was not unusual then for dealers to add to their inventories on a weekly basis.) Rosenberg told Lola he had a buyer for her Cézanne. He had also made it plain that if at any time the Kramarskys wanted to sell *Gachet*, the gallery would be delighted to buy it. Lola was deeply attached to the collection she and Siegfried had brought with them from Europe, but the payment of taxes forced her to sell certain pieces. In 1964, in response to Rosenberg's offer, she sold the magnificent Cézanne, the favorite of her Postimpressionist pictures.

Ten years later Lola, again pressed by tax obligations, sold the second of the three paintings Siegfried had acquired from Franz Koenigs: van Gogh's *Daubigny's Garden*. Questions of authenticity had haunted the picture—the version without the black cat—ever since Ludwig Justi had purchased it for the Berlin Nationalgalerie in the 1930s. Although van Gogh had mentioned only one version of the painting in his letters, scholars argued that the artist's reference did not preclude two pictures. (The other version was on extended loan from the Rudolf Staechelin Foundation to the Oeffentliche Kunstsammlung in Basel.) Typically, van Gogh made a "sketch" and then a more complete "study" of a subject. In 1986 the scholar Ronald Pickvance would write that the picture without the cat

has not fared well with restorers. . . . an addition has been made to the sky; the picture has been retouched; and the paint surface has been flattened.

In spite of this, the painting remains beautifully composed, the final homage to Daubigny that van Gogh had considered since his arrival in Auvers.

In the early 1970s scholars generally agreed that if there was in fact only one picture, the Kramarskys owned it; subsequently they accepted both versions as authentic. In the end Lola sold the picture (through Rosenberg & Stiebel) to the Hiroshima Museum of Art in Japan.

THE VON HIRSCH SALE, 1978

Robert von Hirsch was in his nineties when he died, in November 1977. The Jewish leather manufacturer who had escaped Frankfurt with his collection—by letting Göring have Lucas Cranach's *Judgment of Paris*—had lived in Switzerland ever since. (In 1945 the Cranach was returned.) While he had added to his collection, the nucleus assembled in Frankfurt before the war remained intact. In the exceptional quality of its medieval pieces and in its range, von Hirsch's collection reflected the refined but eclectic taste of his friend and advisor Georg Swarzenski. Von Hirsch's first acquisition, in 1907, was Toulouse-Lautrec's *Redhead in a White Blouse*; shortly thereafter he acquired Picasso's *Street Scene*. During the 1920s and 1930s von Hirsch acquired extraordinary pieces of medieval and Renaissance art—ivories, enamels, bronzes, and manuscript illuminations—as well as old master paintings. Despite his expulsion from Germany, in his will he bequeathed two pictures to the Städel: a drawing by Rembrandt (*Prodigal Son Feasting with Harlots*) and a Siennese painting attributed to Ugolino Lorenzetti, given in memory of Georg Swarzenski. He bequeathed other gifts, but he had stipulated that most of the collection be put up at auction; the sale took place at Sotheby's in London in June 1978.

Now Hermann Abs, frustrated in his attempts to return the Gachet portrait to Frankfurt, saw a chance for German museums to

acquire masterpieces of German art sent into exile by the Nazis. He persuaded the German government to use 15 million reichsmarks from a frozen cultural fund to make matching grants to German museums that wanted to acquire works of German art at the von Hirsch sale; he then orchestrated a strategy (at a meeting in Frankfurt) to prevent the curators from the ten participating German museums from competing against one another at the auction.

Like many estate sales in which collections built over decades are dispersed in a matter of minutes, the von Hirsch auction was a transitory memorial to the collector and also a watershed. Dealers, collectors, and museum curators flocked to the three-day event, knowing that many of the medieval pieces were of the sort not likely to come on the market again. The refugee collection, with its Dürers and its van Goghs, was a phenomenon of prewar Germany, and those at the sale (including not only Hermann Abs but Marianne Feilchenfeldt and Lola Kramarsky) watched a legacy of that era break up as the pieces flew off the auction block. Paradoxically, it was the character and aura of the large collection that attracted many people and enhanced the value of the individual pieces; yet that character was not something permanently attached to the objects once dispersed. As anticipated, the three-day event produced record prices. Walter Feilchenfeldt, son of the late Cassirer gallery director and one of the dealers commissioned to bid on behalf of the German museums, succeeded in buying a Dürer watercolor, whose price reached 640,000 pounds ($1.17 million) in less than a minute. The New York dealer Eugene Thaw bid 95,000 pounds on a Raphael drawing for the Cleveland Museum of Art. Two van Gogh drawings each sold for over $250,000. Altogether the sale's total exceeded $34 million; fifty-two art price records were broken. Thaw expressed "unease" at the sale's success:

> I don't blame Sotheby's. They did a superb job of merchandising, which is their responsibility to the consignor. I blame the current philistine approach to art collecting as investment which has taken away our society's ability to look at art without dollar signs in our eyes.

As a dealer, Thaw could observe the ability of the auction houses to exploit such a collection—by producing catalogs, garnering publicity, and gathering the significant players together to compete for works of art whose supply was dwindling. The von Hirsch auction marked the start of an era when record-breaking auction prices would become commonplace and the auction houses would dominate the art market.

Throughout the 1970s Lola Kramarsky remained a domineering figure, at times rigid and demanding. She turned eighty in 1977, but still insisted on going to work every day at the offices of Hadassah when she was in New York. From Europe she wrote a friend, "I hope you are as well as one can be in these days of turmoil all over the world. I dig into history and art in Spain, which makes one very much aware of survival." In May 1984 she suffered a cerebral hemorrhage, which left her incapacitated and blind, requiring nurses around the clock. She stayed at her apartment with her collection. The pictures whose history was closely bound to hers remained only technically in her possession. (*Gachet* was owned by a trust under the will of Siegfried Kramarsky, for which Lola and her three children were trustees.) Too ill to leave her room or to accept visits from friends, she entered a final difficult stage of her life during which the children would wrestle with the question of what to do with the painting.

PART VI

THE 1980s

23

The Metropolitan Museum
and the New van Gogh,
1984–1990

There was money in the air, ever so much money—that was, grossly expressed, the sense of the whole intimation. And the money was to be all for the most exquisite things—for all the most exquisite things except creation, which was to be off the scene altogether; for art, selection, criticism, for knowledge, piety, taste. The intimation—which was after all, so pointed—would have been detestable if interests other, and smaller, than these had been in question. . . . The Museum, in short, was going to be great.
—Henry James, *The American Scene*, 1907

In July 1984, *Portrait of Dr. Gachet* was packed in a crate, loaded onto a truck, and driven less than a mile across the park, now filled with the emerald foliage of summer, from the Kramarskys' apartment to the Metropolitan Museum of Art. There it was to be on indefinite loan, the length of its stay uncertain. The painting had been there often before, for at least six "summer loan" exhibitions. While in practical terms the accidental circumstances of Lola Kramarsky's health precipitated the move, what delivered the picture to the museum was the cumulative work of collectors, critics, dealers, and more recently art historians, whose exhibitions, purchases, and writings had over the course of almost a century created a world-renowned museum and had defined *Gachet* as a brilliant example of Postimpressionist painting and a revolutionary modern portrait that

prefigured the psychological portraits of the twentieth century. In the seven decades since Georg Swarzenski acquired the picture for the Städelsches Kunstinstitut, the question of whether it was a truly great painting had been answered. As it had in Frankfurt's old master museum, the painting found resonance at the Metropolitan, with its vast array of European painting, its portraits by the Dutch masters Rembrandt and Hals, and Degas's portrait of his friend Jacques Tissot, which like the van Gogh was a classic late-nineteenth-century characterization of the modern artist. In both practical and theoretical terms, the logical destination for the painting was the Metropolitan, now arguably the greatest museum in the world.

At the museum, *Portrait of Dr. Gachet* was not only safe but visible. The painting arrived at a moment when van Gogh was attracting unprecedented scholarly attention. *Gachet* had been at the Metropolitan for only three months when the museum opened the exhibition *Van Gogh in Arles*. This was followed two years later by a sequel, *Van Gogh in Saint-Rémy and Auvers*. These groundbreaking exhibitions were part of an effort by art historians to dismantle the persistent van Gogh legend and replace it with more accurately drawn historical information. Scholars grappled with the evidence (sparse as it was) about his illness and concluded that it had little to do with his accomplishments as a painter. In the *Saint-Rémy and Auvers* catalog, the British scholar Ronald Pickvance explained,

> In van Gogh's case, there was what has been seen as a pre-ordained progression from asylum (with the implied assumption of madness) to suicide, which has fueled the myth of the mad genius. But whatever his illness may have been—and some form of epilepsy seems the most probable, whether exacerbated by absinthe, glaucoma, Digitalis poisoning, or syphilis—the fact is that it did not directly affect his work.

Scholars rejected the long-standing idea that van Gogh's canvases were direct records of his psyche. Freed from this unilateral psychological view, art historians placed him among his contemporaries and sketched out his role in the avant-garde. Intent upon illu-

minating the ties between art and other intellectual endeavors of the period, they explored the ways van Gogh responded to Impressionism, sorted out his relationships to his contemporaries, particularly Gauguin, and unlocked his conscious and unconscious ties to politics and social class. Far from untutored mental patient whose isolation and failure drove him to suicide, van Gogh was reconstructed as an intellectual leader of the Postimpressionist generation and an influential figure among the artists who converged on Paris in the 1880s. In the course of the 1980s, Pickvance and others purged the lingering doubts about van Gogh as an artist of the highest order.

The 1980s also witnessed the heyday of van Gogh exhibitions; the Metropolitan's two shows were among nine exhibitions held in Europe, North America, and Japan. They culminated in 1990, the centennial of the artist's death, with a retrospective at the Rijksmuseum Vincent van Gogh in Amsterdam, followed by *Vincent van Gogh and Early Modern Art* at the Folkwang Museum in Essen. Every nation able to claim van Gogh did so. The 1984 *Gauguin and van Gogh in Copenhagen* reassembled the pictures of Denmark's extraordinary 1893 exhibition, to prove Scandinavia's early attention to modernism. *Van Gogh en Belgique* in Brussels in 1984 was followed by *Van Gogh à Paris* four years later. The Japanese, whose prints the artist so avidly collected, held a retrospective in Tokyo and in Nagoya. The Gachet portrait appeared in three of these exhibitions: in Copenhagen, where its first owner had encountered it almost one hundred years before; in Tokyo; and finally in New York.

The Metropolitan's two van Gogh shows were brilliant examples of the international loan exhibitions pioneered by the New York museum in the 1970s. At their best, such shows seemed an exalted marriage of the American tradition of public education and the German tradition of art scholarship—displaying often dazzling sequences of objects, offering provocative interpretations of their subjects, and advancing art history, while also drawing record crowds. They served various purposes and audiences, aimed not only at the international art public but also at the circuit of historians, critics, collectors, and dealers who ran the art world. With their

exhaustively researched and lavishly illustrated exhibition cata-
logs, museums joined the universities as publishers of state-of-the-art
art-historical research. Ronald Pickvance's catalogs of the Metro-
politan's van Gogh exhibitions became standard texts.

Portrait of Dr. Gachet remained at the Metropolitan for six years,
from 1984 to 1990. During the 1980s the art market experienced a
precipitous rise, and inevitably the museum felt its effects. Inflation
in the prices of pictures meant that the costs of insuring loan exhibi-
tions rose dramatically, increasing the need for government indem-
nity. Because the Gachet portrait was only on loan to the museum, it
was more directly affected by events in the art trade than pictures in
the permanent collection. As the portrait was on display in the gal-
leries of the Metropolitan, well-publicized sales of other paintings,
particularly other major van Goghs, at steadily higher prices had the
effect of boosting its value. Since its value also depended upon the
opinion of experts, their choice of the painting for various exhibi-
tions and as the subject of new interpretations also heightened its
worth. Inevitably, art dealers and other market professionals eyed the
melancholy van Gogh and wondered if it would be for sale.

THE METROPOLITAN

In 1984 the Metropolitan was an accounting in paint, porcelain,
stone, wood, and bronze of the fabulous wealth of New York, which
remained the nation's financial and cultural capital. The museum's
Beaux-Arts facade ran for four blocks along Fifth Avenue. A bank of
stone steps led up to the three-door entrance. Above the doors, long
banners of red, purple, royal blue, and gold quivered in the wind,
announcing the titles of current exhibitions and adding strokes of
color to the monolithic gray structure. In its ambition, grandiosity,
and spectacle, the museum had taken its shape and character from
the sprawling international city itself.

The Metropolitan's global outlook was reflected in its collec-
tions, now amounting to over 2 million objects: paintings, statues,
textile, tombs, prints, photographs, drawings, vases, armor, and amu-
lets. The Egyptian galleries alone held some 37,000 artifacts and

The Metropolitan Museum of Art, New York, 1995. From 1984 to 1990, *Gachet* was on loan to the museum, which held two groundbreaking van Gogh exhibitions.

works of art. In only slightly more than a decade the museum had brought its lackluster collection of Asian art into a league with those of the Museum of Fine Arts in Boston and the Freer Gallery in Washington. European paintings held their traditional position at the top of the grand staircase; this privileged location testified to America's claim as worthy heir to European culture and to the nation's decades-old position as an international power. American art, off in peripheral galleries, was viewed as tangential.

Gachet arrived at the Metropolitan at a moment of change and expansion. Following the dictates of a master plan, drawn up in 1970, the museum's directors had doubled the building's size; with newly constructed wings, the museum extended its reach over eleven acres of Central Park. The master plan had been proposed by Thomas Hoving, a medievalist and former New York City parks commissioner, who served controversially as the museum's director from 1966 to 1977. Known for making expensive acquisitions and staging spectacular exhibitions, Hoving had reoriented the Metropolitan, despite its historical collections, resolutely toward the present. From the sky, the museum appeared a colossal rectangular labyrinth of interlocking sections made of stone, steel, and glass.

New wings and galleries had opened: a wing opposite the museum's entrance to house the Robert Lehman collection went up in 1975 and another for the Egyptian Temple of Dendur in 1978; over the next four years the museum added galleries for American art and for art from the Pacific Islands, Africa, and the Americas. Plans were being laid for a four-story wing for twentieth-century art with 60,000 square feet of exhibition space. It would include twenty-two new galleries, designed by Kevin Roche and John Dinkeloo. Perpetual crowds teemed in numbers that effectively robbed all but isolated galleries of the silence that had once filled the traditional museum. Except in the worst weather the museum's steps were a gathering place and informal theater where people met and watched each other. The crowds (more than 4 million people a year) were one measure of the museum's success. Attendance at the two van Gogh exhibitions together exceeded 1 million. "Founded on the assumption that art was inseparable from education, American museums have addressed their primary appeal to the man in the street," wrote the author Calvin Tomkins, "rather than the artist, the scholar, or the connoisseur, who are nevertheless welcomed on their own terms—and it is for this reason that they have prospered and proliferated on a scale almost unknown in Europe."

The Metropolitan's entrance hall, rising several stories and leading to the galleries and to the museum shop, had become one of New York's great public squares, where the temple of art merged with the marketplace. Some complained about the burgeoning bookstore and added encounters with commerce. "The clatter and bang of the king-sized cash register that stands just outside the last room in the van Gogh exhibition," wrote the *New York Times* critic John Russell in 1984, "is the single most offensive sound that I have ever heard in a great museum." By the mid-1980s, merchandise (books, postcards, catalogs, and reproductions, and other "auxiliary activities") became an increasingly important source of income to the museum, which also depended upon funds from endowment, memberships, admissions, gifts, grants, and the city. In 1987 the museum's president attributed that year's $4 million operating sur-

plus to *Van Gogh in Saint-Rémy and Auvers* and several other popular
shows. (Revenues from van Gogh posters alone were $1.5 million.)
"The new museum," wrote Arthur Danto, art critic for the *Nation*,
"inevitably was to associate the consumption of art with the con-
sumption of food and with the purchase of goods in gift shops, from
which people could walk off with posters. . . ."

THE NEW NINETEENTH-CENTURY GALLERIES

The Metropolitan's curators set *Portrait of Dr. Gachet* with other
van Goghs at the heart of the collection of Impressionist and Post-
impressionist art. Only four years before the curators had separated
the nineteenth-century French canvases from the rest of the Euro-
pean paintings and placed them in their own set of galleries, named
for the French refugee investment banker and collector André
Meyer. The new nineteenth-century galleries took up half an acre of
space and contained over five hundred works of art. Their scale
spoke for the place of French nineteenth-century painting in the
museum, its popularity with the public, and its attraction for histo-
rians of art. Since the war, no field of art history had drawn as much
academic attention as modernism. "Books, dissertations, exhibitions,
catalogues, articles and critical reviews have been produced," wrote
historian Richard R. Brettell, "in an attempt to rethink, reattribute,
redate, retitle, and research virtually every artist, medium, artistic
movement, and critical stance in French art from 1850 until World
War I, and many of the methodological developments in this hotly
debated field have led to critical breakthroughs in other areas of the
history of art."

The André Meyer galleries brought the latest thinking in
museum design to the Metropolitan. At their center was a large, light-
filled space broken up by partitions, a plan allowing for maximum
flexibility in installing and rearranging the collection. For the most
part the installation reflected the well-established Paris-centered
vision of nineteenth-century art: the Impressionism of Monet, Degas,
Pissarro, and Sisley, followed by the Postimpressionism of Seurat,

Gauguin, Cézanne, and van Gogh as the culmination of a sequential history that originated with neoclassicism, romanticism, and the realism of Courbet.

But off the main gallery, the curators John Pope-Hennessey and Charles Moffett filled a large gallery with Salon paintings (by Meissonier, Cabanel, Gérôme, and Bouguereau) of the sort marketed by Goupil's when van Gogh was selling the gallery's prints. The reinstallation of academic pictures brought into public view an aspect of the "new art history" being practiced in American universities. By including the Salon painters, long condemned as kitsch and hidden in storerooms, the curators acknowledged that to see only the triumphant modernists (initially scorned and finally embraced) was to see only part of the story.

The form and content of the André Meyer galleries (completely reinstalled thirteen years later) suggested that art history, like contemporary art, was itself in flux and that the Metropolitan's curators were engaged in what had become a debate about the way to narrate the history of art. By now museum curators had begun to consider themselves more historians than connoisseurs, a word that conjured a bygone era when fine arts was an aristocratic calling that cloaked art in the mystifying language of aesthetics.

THE NEW VAN GOGH

A rigorously historical approach to van Gogh was exemplified in the Metropolitan's *Van Gogh in Arles* exhibition (October 18 through December 30, 1984), conceived by Charles Moffett, curated by Ronald Pickvance, author of the catalog, and organized by Susan Alyson Stein. (The curator Gary Tinterow also worked on the installation.) Extraordinary in its intense focus on a single period in the artist's life, the show contained sixty-five canvases and seventy-five drawings—40 percent of everything the artist had produced in Arles from February 20, 1888, to March 8, 1889, "almost 15 months, over 63 weeks, precisely 444 days," as Pickvance put it. Above all, the exhibition curators wanted to set the documentary record straight, to sweep away romanticized images of van Gogh, and to

replace the notion of the artist as an emotionally volatile, gifted amateur with a factually grounded account of the artist as a consummate professional, producing at full throttle.

Studying van Gogh's paintings, drawings, and letters, and finding out what he could about Arles in that time, Pickvance mapped out in the catalog the sequence of the artist's work, of his writings, and of various events, including his visit to the Mediterranean at Saintes-Maries-de-la-Mer. This coastal trip, Pickvance argued, had "a very positive and significant effect on his view of the South, and also on his artistic development." On June 4, 1888, van Gogh had written, "After a while [here], one's sight changes: you see things with an eye more Japanese, you feel color differently. . . . I am convinced that I shall set my individuality free simply by staying on here." Pickvance concentrated on documentation: maps, photographs, chronicles by Henry James and other nineteenth-century visitors to Arles. In the catalog, Pickvance (apparently following the scholars Jan Hulsker and Artemis Karagheusian) proposed a new sequence of the two hundred Arles letters—changes (categorized as "significant," "radical," and "more radical") that revised the dates on certain paintings and drawings. In attempting to remove the melodrama from van Gogh's story, Pickvance reduced the notorious conflict between Gauguin and van Gogh to a fight provoked in part by the weather: "During that 'dark' period from 19 to 23 December, it rained day and night. Ten times the average fell that month."

The Metropolitan's "one-man, one-place show," focusing on the artist's biography, was the culmination of a drive to establish a historically accurate portrait of van Gogh launched by Dutch scholars in the late 1960s, when they dominated the field of van Gogh studies. The presence of the collections of the van Gogh family in Amsterdam and of the Köller-Müller Museum in Otterlo had made the Netherlands a natural center of van Gogh scholarship. The Dutch scholars' approach was colored by their contention that van Gogh's years in Holland composed the decisive period in his career. In 1970 they set van Gogh studies on a firmer foundation by publishing a revised edition of Jacob Baart de la Faille's catalogue raisonné. The "new" de la Faille was written by a commission (estab-

lished in 1961) of eminent art historians, assisted by Annet Tellegen and Martha Op de Coul, who updated the official chronological list of van Gogh's complete oeuvre. The new catalog maintained the original de la Faille numbers (*Gachet* remained F753) and was written not in French but in English. Needless to say, given the catalog's scale, it still contained errors. The provenance of *Gachet* listed nine dealers or collectors and the Frankfurt museum. It included someone named "J. Keller" yet omitted Ambroise Vollard and also the as-yet-undiscovered Alice Ruben; it also left out the history of the painting's confiscation from the Städel by the Third Reich's Propaganda Ministry. The commission also praised the second version of the portrait, given by Paul and Marguerite Gachet to the Louvre and then hanging in the Jeu de Paume in Paris. (In a note in his manuscript, the late de la Faille had described it as "a very weak replica of the preceding one, missing the piercing look of F 753 and the 'grieving expression of our time,' [letter 643].") Certain experts thought that the commission failed to weed out all forgeries and falsely attributed pictures that had worked their way into the van Gogh canon. Later, Roland Dorn and Walter Feilchenfeldt, among others, questioned several pictures, including four self-portraits. The self-portraits had always been in great demand because of the intense interest in the artist's biography; few were in circulation. Van Gogh had given away five; Johanna sold five more (three to German collectors), but she insisted on keeping the rest. The four problematical canvases seemed to have surfaced only in the early twentieth century. They "lack," Dorn and Feilchenfeldt argued, "that inner self-control, the 'upright posture' van Gogh himself never abandoned in his self-portraits, even in the hours of his greatest isolation."

Meanwhile, a quiet assault on the van Gogh legend had begun when in the 1970s Jan Hulsker, a member of the de la Faille commission, proposed a new sequencing of the artist's mostly undated letters. In one of his most important determinations, Hulsker explained that a note discovered in the artist's coat pocket after his death was not, as had long been assumed, a final message. Instead, it was only a draft of a more optimistic letter, ultimately sent to Theo. On the revised letter van Gogh had drawn a number of sketches to

give his brother an idea of his recent paintings; these included *Daubigny's Garden* ("one of my most purposeful canvases") and pictures of "thatched roofs" and of "vast fields of wheat after the rain." Hulsker concluded that *Crows over Wheatfields*, so long interpreted as van Gogh's last canvas, had been painted earlier. Among the last canvases were the versions of *Daubigny's Garden*, the sun-filled images of a house and a green lawn bordered by beds of flowers. Suddenly, not only were the pictures painted in July 1890 seen in a different light, but even van Gogh's suicide appeared perhaps not to have been a long-premeditated event but possibly the result of circumstances on a particular day, the consequence of an illness against which he had few defenses. At the very least, Hulsker's work forced the reconsideration of numerous assumptions about van Gogh's biography and his art.

THE PARIS PERIOD

The "new" van Gogh also took shape in the work of the Canadian scholar Bogomila Welsh-Ovcharov, who for the first time closely studied the "Paris period"—the two years, from March 1886 to February 1888, when van Gogh lived with Theo and worked in the French capital. The Paris period fell between van Gogh's early years in Holland, celebrated by the Dutch, and the late years in the south of France when he produced what had been recognized as his finest works. Few facts were known about the artist's life in Paris because he had not written many letters. But above all, historians had ignored the Paris years because van Gogh's experience as one of hundreds of foreign painters working in close proximity did not fit the standard image of a genius who produced his masterpieces in isolation.

Welsh-Ovcharov had worked with Jan van Gelder in Utrecht when the field of van Gogh studies was sparsely populated. As a student in the Netherlands, she had easy access to the van Gogh collection in the Stedelijk, where most of the paintings were left unattended, stacked on the floor of the museum's basement. Anyone who bothered to inquire could see them. She spent hours alone

there, picking the canvases up, moving them about as she pleased, closely examining the surfaces of paint, and searching the backs for dealers' labels. As she proceeded with her work, she could see the van Gogh field becoming more crowded and sophisticated. In 1973 the city of Amsterdam opened the Rijksmuseum Vincent van Gogh (in a building designed by Gerrit Rietveld), where the van Gogh family collection was put on view. (In 1970 the Dutch government had finally acquired Vincent Willem van Gogh's collection, which had been on loan to the Stedelijk Museum, and agreed to build a museum to house it.) At the new museum the van Goghs were installed for the first time in a climate-controlled environment. Later, for protection, many paintings were covered with sheets of Plexiglas, and their backs were sealed.

In her dissertation Welsh-Ovcharov overthrew the idea of van Gogh as an isolated outsider and brought him from the edge of the French Postimpressionist movement to its center. She pointed out that from the moment he arrived in the French capital in 1886, van Gogh was intimately involved with the advanced painting of the time. She explained the specific interconnections between the Dutch artist and the French painters Louis Anquetin, Emile Bernard, Henri de Toulouse-Lautrec, Jakob Meyer de Haan, Charles Laval, Paul Sérusier, and Maurice Denis. She also corrected Gauguin's long-accepted claim (reiterated in John Rewald's influential 1956 text) that in the van Gogh–Gauguin relationship Gauguin had played the master; instead, she traced van Gogh's pioneering role in Postimpressionism.

In 1981 Welsh-Ovcharov's research reached a broader public through the exhibition *Vincent Van Gogh and the Birth of Cloisonism*, presented by the Art Gallery of Ontario in Toronto and the Rijksmuseum Vincent van Gogh in Amsterdam. Drawing on her earlier studies, Welsh-Ovcharov (now a professor at the University of Toronto) mapped out van Gogh's role in the evolution of the symbolist style. (Cloisonism was the term first used by a French critic to describe the paintings of van Gogh and his colleagues, where flatly painted shapes were bordered with dark outlines in a way reminiscent of cloisonné enamel and stained glass.) The show's catalog

(running almost 400 pages and including over 300 black-and-white and 32 color reproductions, as well as extensive footnotes) was one of the first van Gogh exhibition catalogs to serve also as an art history text.

SAINT-RÉMY AND AUVERS

Welsh-Ovcharov's 1981 show about van Gogh's Paris period was appropriately followed three years later by the Metropolitan's first *Arles* show. Then, in 1987, Ronald Pickvance, again working with the Metropolitan curators Susan Alyson Stein and Gary Tinterow, focused on the last period of van Gogh's work in the *Saint-Rémy and Auvers* exhibition, where they set out a highly dramatic array of seventy paintings and twelve drawings (including *Gachet*) created by the artist in the last seventy days of his life. To make an airtight case that van Gogh's illness "did not directly affect his work," Pickvance explained in the catalog the complexity and programmatic nature of the artist's method of painting. This method involved creating canvases not one at a time but in sequences—"defined groups and series that are organically connected." The multiple versions of olive orchards, cypress trees, and mountains made in Saint-Rémy, for instance, followed a method he had developed in Arles. In 1985 the German scholar Roland Dorn had begun to overthrow long-held assumptions about van Gogh's approach to painting by reconstructing the artist's plan to create a decorative cycle of paintings for the "Yellow House" in Arles that would depict the landscape and life of Provence. (Even Theo failed to understand the canvases as part of a larger whole, resembling chapters in a novel or segments of a mural.) According to Dorn, van Gogh began the "decoration" in August 1888 with a series of paintings of sunflowers, but soon expanded the project. In a matter of weeks he had completed seventeen canvases of identical size, "size 30." Uniting the cycle was the theme of contrast. The artist conceived of the canvases as "antithetical counterparts" in subject matter, form, and color—*Public Garden with Weeping Tree* (like the peaceful *Van Gogh's Bedroom*) began as a complement to the menacing interior of *Night Café*. By painting

"groups of works, series or 'decorations' " instead of single, isolated pictures, "he was hoping," Dorn argued, "to find an interpretation more suited to the multi-layered quality of reality," and to present "an original, 'personal view of the world,' as Maupassant put it." Van Gogh saw himself as following the "doctrine of realism" practiced by Zola and the Goncourts, whose books portrayed the contemporary world with evocative detail and explored the ethical issues about which he passionately cared. Dorn cast van Gogh as both a consummate craftsman and a cerebral painter. "Painting or drawing, artistic activity altogether, was 'intellectual work'; for van Gogh, it was based on 'sheer calculation' and demanded extreme intensity of application." Like ordinary professionals, he worried about such mundane matters as time and the necessity of making progress.

The *Saint-Rémy and Auvers* exhibition included eleven canvases in one of the series van Gogh painted in Auvers. These eleven were so-called double-square canvases, long horizontal pictures constructed out of two smaller squares. One of the double-square canvases was *Daubigny's Garden*; another was the famous *Crows over Wheatfields,* whose assumed "tragic and sinister" character Pickvance questioned. ("If one looks at the painting without imposing on it the sense of menace-filled tragedy that comes with the knowledge of hindsight, then the 'restorative forces' that van Gogh speaks of being expressed in the landscape can be felt.") Needless to say, Pickvance's refusal to see dark symbolism in *Crows* did not put the matter of its meaning to rest.

Van Gogh's ascent in the modernist canon coincided with the challenge to and eventual overthrow of the formalists by a new generation of art historians who chose to take multiple approaches to the subject, often drawing upon Marxism, semiotics, literary theory, and feminism. They questioned the formalists' vision of modernism as a Paris-based phenomenon, and they shifted the discussion away from style to subject matter and content. Where the formalists saw painting and sculpture as autonomous fields, following their own course of development, the new historians viewed them as rich, revealing documents of dynamic cultural, political, and social sys-

tems. These new approaches depended upon considering modernism not as a revolution to be defended but as a historical movement that had deep roots in the Western tradition, but which fed upon multiple sources of inspiration. In van Gogh's case the sources included "seventeenth century Dutch painting and the Barbizon school, Meissonier and Monticelli, European realist illustrations and stylized Japanese woodblock prints."

Many historians now sought to pry art history away from exclusively aesthetic concerns and refused to accept the idea that works of art were superior to other cultural documents. Radicals especially wanted to strip away the vestiges of aestheticism still clinging to the field—in which experts had prided themselves on possessing a good "eye" and an ability to discriminate quality—and to put the field on sounder intellectual footing. Those pieces celebrated as great works, they argued, had been so designated by critics, collectors, and curators whose views were those of the ruling classes in capitalist economies.

Marxists argued that art was a reflection of class ideology. Van Gogh's portrait of an old man in a top hat, in Griselda Pollock's view, "for all its instability" represents "a kind of truth, a fragment of the social relations on nineteenth century capitalism in the town." The long-standing notion of van Gogh as a sympathetic spokesman for the socially oppressed came under fire. "The whole romantic hogwash of van Gogh's humanitarian sympathy for the poor and destitute, which has bedeviled van Gogh scholarship for too long," Pollock wrote, "has obscured the fundamental and specific fact of his class position." This, she suggests, was "bourgeois." Pollock also emphasized that "commercial success was always on van Gogh's mind."

The art historian Linda Nochlin questioned the idea of van Gogh as a "genius" in an article she wrote on the images he made of weavers, in which she pointed out that he drew specifically upon the illustrations of a once-popular French draftsman, Paul Renouard. Far from unique, van Gogh's interest in the plight of the weavers, whose labor was a casualty of industrialization, was shared by various artists and writers in the nineteenth century.

Instead of seeing van Gogh as the important creative artist and the illustrators simply as aesthetically negligible minor sources of his inspiration, perhaps it would be more realistic to think of them all as fellow art workers, interested in the same subjects, moved by similar humanitarian impulses, moving within certain acceptable limits of engagement, and interested in developing similar naturalistic and expressive techniques, in exploiting the possibilities of certain innovative formal devices, akin to those of contemporary documentary photography, to achieve their effects.

Nochlin was one of several scholars who examined the ways van Gogh's art expressed not an idiosyncratic point of view but rather certain intellectual preoccupations of late-nineteenth-century Europe and reflected actual social and economic dislocations experienced at the time. In his 1984 *Painter of Modern Life*, T. J. Clark interpreted van Gogh's 1886 picture *The Outskirts of Paris* as a typical response to Baron Haussmann's dramatic overhaul of the city, which had moved the poor to its periphery. The picture's sense of doom, Clark argued, "is not to be explained as the mere bewilderment of a Dutchman in the big city: it is a characteristic note struck by Parisians when they deal with what has happened to Paris in their own time."

GACHET

In the 1980s historians also turned their attention to the Gachet portrait and, for the first time, unraveled the painting's complex content. "It was this painting which prompted Vincent to cite 'the modern portrait' as his greatest passion," Bogomila Welsh-Ovcharov observed in 1981, as she pointed out that its conception "depends upon a far greater variety of sources and personal interpretations than is commonly thought."

Previously another historian, A. Brown Price, had discovered that one of the sources for the revolutionary canvas was the conventional portrait by the nineteenth-century mural painter Pierre

Puvis de Chavannes ("an old man reading a yellow novel, and beside him a rose and some watercolor brushes in a glass of water"; "the ideal in figure [painting] to me.") Price figured out exactly which painting van Gogh was referring to: *Portrait of Eugène Benon*. She concluded that he must have seen it at an exhibition at Durand-Ruel in November and December 1887.

That van Gogh had invested the Gachet portrait with vast ambitions became clearer when in 1980 the Dutch scholar Evert van Uitert showed that the pose of melancholy was far more than a reference to the doctor as a specialist in nervous disorders; it was a means "to give expression to his own artistic ideals." Van Uitert argued that the yellow novels, *Germinie Lacerteux* and *Manette Salomon*, were not, as had been claimed, simply favorite books loaned by the artist to the doctor. Instead van Gogh had used them to align "the new art of portraiture" with "the modern novel," specifically as the Goncourts defined it in their preface to *Germinie*. The novel, the brothers contended, was "the great, serious, impassionate and living form of literary study and social inquiry," and also "contemporary moral history." The presence of the second book, *Manette Salomon*, van Uitert felt, also helped to shift the painting's melancholy theme away from the artist himself and toward the condition of French artists in the nineteenth century. He likened van Gogh's vision of the modern artist to that of the Goncourts, who describe the melancholy state of one of the artists in the novel:

> [He] came to that grief which seems in this century inevitably to crown the career and lives of the great painters of modern life. He was devoured by that fever of deception, that internal desolation which Gros called "the rage of the heart."

The significance of *Gachet* emerged also when Bogomila Welsh-Ovcharov examined the way van Gogh "fused" multiple sources in his construction of the portrait. She related van Gogh's use of evocative color to his use of color in his portrait of Eugène Boch, where in the blue background he claimed to "paint infinity." She tied the symbolic still life (books and a flower) to the still life in the Puvis *Portrait of Eugène Benon*. The pose of melancholy, she explained, van

Gogh borrowed specifically from Eugène Delacroix's *Tasso in Prison*, a source that carried emotional resonance through a circuitous chain of associations. When van Gogh visited Montpellier with Gauguin, he had seen Delacroix's portrait of Gustave Courbet's patron Alfred Bruyas and immediately asked Theo to send him a lithograph of Delacroix's portrait, *Tasso in the Hospital*. (Van Gogh also told Theo that Bruyas "had a certain family likeness to *us*," and he linked Bruyas and Theo as the devoted patrons of art.) These memories of Delacroix's portraits and of Montpellier were stirred by the encounter with Gachet, who happened to have written his thesis on melancholy when he was studying to be a physician at the University of Montpellier, and who told van Gogh he had met Bruyas. By clarifying van Gogh's sources, Welsh-Ovcharov threw light upon the trove of associations he brought to bear on the theme of melancholy.

Later, Judy Sund's interpretation of the portrait would be informed by feminist theory. She saw *Gachet* as "a companion piece" for one of the series of portraits of Mme Ginoux made in Saint-Rémy, based on Gauguin's drawing of the owner of the Arles café. In van Gogh's portraits she is seated, like Gachet, at a table, her head resting on her hand in the pose of melancholy. On the table are two books, Harriet Beecher Stowe's *Uncle Tom's Cabin* and Charles Dickens's *Christmas Stories*. Many had noticed the similarities between various *Arlésienne* portraits and *Gachet*, but had not ventured to explain their connection beyond pointing out that the pose was appropriate for Mme Ginoux, since she seems to have suffered some sort of emotional breakdown. Sund saw the portraits as a pair:

Van Gogh likely conceived these two portraits, in stereotypic terms, as gendered responses to adversity: the male harsh but honest and progressive, the female backward looking but comforting. Moreover, in addition to being conscious evocations of modern woman and man, the portraits of Ginoux and Gachet also can be read as projections of two sides of the artist himself: the sensitive and nostalgic side that dominated in Van Gogh's youth . . . and the dispirited but forward-looking side that waxed during his years in France.

"I should like to paint portraits which would appear after a century as apparitions," van Gogh had written. The painting's history gave proof he had achieved this aim. By unlocking the conceptual skeleton upon which van Gogh constructed his portrait, scholars enhanced the understanding of the emotive power that the painting had held over commentators and buyers for a hundred years, bringing the realization that it was the product not of madness or divine inspiration but of van Gogh's persistent pursuit of his artistic goals. In the course of the 1980s, van Gogh not only withstood the demanding inquiry of historians, but emerged as a painter of far greater intellectual substance than before. Even Pickvance, for example, who so methodically stripped van Gogh of mythology and pieced together the evidence of his quotidian life, helped to redraw the artist (who in Arles was capable of "sustaining a pace that no other artist of the nineteenth century could match") in a way that would convince a skeptical late-twentieth-century audience of his true stature.

24

The *Sunflowers,*

1987

What I should like to know is, who bid against you?
—Mary Cassatt to Louisine Havemeyer
(who on December 10 had paid $95,700 at a Paris auction
for Degas's *Dancers at the Barre*), December 25, 1912

ON MARCH 22, 1987, the Metropolitan Museum of Art closed the *Van Gogh in Saint-Rémy and Auvers* exhibition, and *Portrait of Dr. Gachet* returned to the galleries of nineteenth-century French art. Eight days later, the last privately held version of *Sunflowers* (*Les Tournesols*) was sold at Christie's in London. That the Metropolitan's curators had been unable to borrow any of the five *Sunflowers* versions (four in European and American museums) was noted with regret in the exhibition catalog. Van Gogh had painted this fifth *Sunflowers* canvas—fifteen stalks in a vase against a green-tinted yellow background—in January 1889, as a copy of one of the earlier pictures. It was slightly less than a yard square (39 by 30^1/$_4$ inches) and came from the estate of Helen G. Beatty, widow of the English collector Chester Beatty. Since 1983, the painting had been on loan to the National Gallery in London. In good condition, it was without question a rare and desirable painting. (The Berlin banker Paul von Mendelssohn–Bartholdy had bought it from the Paris dealer Eugène Druet in 1910.) Another differently composed canvas of *Sunflowers*, with a royal blue background, had been in an Osaka collection but was destroyed by bombing during World War II.

Since the war, the market for European and American art had gathered mass and momentum, like a giant wave. Its periodic dips were relatively slight and were followed by ever higher crests until the end of the 1980s, when there was a sudden surge—what the Japanese call a tsunami. Forty-five years of inflation in art prices reflected postwar economic prosperity, which came first to America, then to a reconstructed Europe, and finally to Japan.

The four-decade rise of the market for Impressionist and modern pictures, which was observed by art dealers firsthand, was confirmed by economists. William Goetzmann, a professor at the Yale School of Management who tracked painting prices at auction over three hundred years, described the period from 1940 to 1986 as the most recent of three bull markets. The first boom came in the late eighteenth century, running from 1780 to 1820. The second began twenty years later in 1840 and ended abruptly in 1870, with the out-

Vincent van Gogh, *Sunflowers*, 1888. One of the famous Arles paintings, it sold for $39.9 million in March 1987, launching the art market's late-1980s "crazy years."

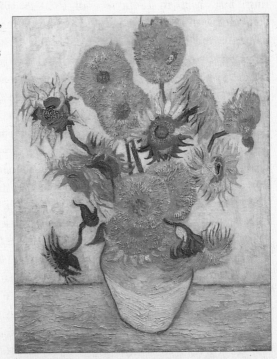

break of the Franco-Prussian War and the siege of Paris. (Manet, Degas, and Renoir had enlisted in the French army, while Monet and Pissarro had fled to England, where they met Durand-Ruel. The year before, van Gogh had joined Goupil's gallery in the Hague.) In the twentieth century, Goetzmann argued, art prices have followed the movement of the stock markets, and "demand for paintings increased when investor wealth grew." He found that the eighteenth- and twentieth-century bull markets "coincided with the rising consumer price levels." With far deeper pockets than ever, postwar collectors had precipitated a new era of art inflation; "The period since 1940 shows the most dramatic increase in art prices and is the most reliably estimated." He concluded that "this bull market in painting prices is unprecedented, as for the first time its span is global and so it is elevated by the wealth produced from various international stock markets."

Art had suffered three bear markets, according to the Yale economist: first, 1830 to 1840; second, 1880 to 1900 (a period that coincided with the decade, 1880 to 1890, during which van Gogh painted); and third, the Great Depression, 1930 to 1940. These downturns, Goetzmann noted, "corresponded to broad economic recessionary periods in Britain and the United States."

The Impressionist and modern auctions in New York in the spring of 1980 started the accelerated pace of record breaking that characterized the rest of the decade. At this moment inflation was running around 12 percent, and tangible property—from real estate to old master paintings, antiques, and all manner of collectibles—was touted as the only investment capable of maintaining its value. The crisis over the American hostages captured in Iran had lingered for six months. In April Jimmy Carter's secret rescue attempt failed. On May 12, at the sale of the Edgar and Bernice Chrysler Garbisch collection at Sotheby Parke Bernet, Picasso's 1923 *Saltimbanque with Arms Crossed* sold for $3 million, a price that broke the record for a work auctioned in New York and, more importantly, the record for a modern painting. In auction jargon, "modern" covers avant-garde art created in the period from the 1880s through World War II—including examples of Postimpressionism, fauvism,

cubism, German expressionism, dada, and surrealism. The buyer was the Bridgestone Art Museum, a Japanese corporate collection installed in a Tokyo office tower. The sale itself made $14.8 million. In superlatives that would typify art market reporting, the *New York Times* front-page story heralded the auction's total as "the most for an Impressionist and Modern art sale anywhere in the world." A turning point for the van Gogh market came the next night, at Christie's sale of ten pictures owned by Henry Ford II. First, the Picasso record was broken by a Cézanne portrait, *Peasant in a Blue Shirt*, which sold for $3.9 million. Moments later bidders sent the price of van Gogh's *Public Garden with Couple and Blue Fir Tree* (bought by Ford at the 1958 Goldschmidt auction for $414,000) to $5.2 million. This tripling of the price of a van Gogh meant that a modern picture had climbed to the level of the most expensive works of art, a category for decades held by old master paintings. The record price for any picture remained $5.6 million, paid ten years before by the Metropolitan Museum of Art for Velázquez's portrait *Juan de Pareja*. But the lush *Public Garden* was in striking range. Only weeks later, a nineteenth-century English canvas, Joseph Mallord William Turner's *Juliet and Her Nurse*, was auctioned in London for $7 million, usurping the Velázquez's place at the top of the market. Six months later, in November 1980 (days after Ronald Reagan won the presidential election), Wendell Cherry, a hospital chain magnate from Louisville, Kentucky, spent $5 million at Sotheby's on *Yo: Picasso* (*Ego: Picasso*), a self-portrait painted when the artist was nineteen years old. A number of New York art dealers scornfully observed that the collector had overpaid.

In the spring of 1981, stock prices fell and the art market was hit by a brief recession. Christie's cut its staff. Sotheby's closed its Madison Avenue headquarters in the Parke-Bernet building and moved east to a warehouse on York Avenue, renovated originally for less important sales. That May, when the prime rate had climbed to 18 percent, Christie's auctioned eight paintings (two of them by van Gogh) for a Swiss investment firm, Cristallina, and only a Degas portrait found a buyer. But by 1983 the art market was on the move again. High interest rates had succeeded in stopping the consumer

price index in its tracks. In January the rate of inflation plunged to 3.7 percent. Within a year the auction house publicists announced that the record for the most expensive work of art had been set again at a public sale. On December 6, 1983, the German government paid $11.7 million for a twelfth-century manuscript, *The Gospels of Henry the Lion*. Henry was count of Saxony, duke of Bavaria, founder of Munich, and a patron of science, literature, and art. (Funds for the manuscript's purchase had been raised from federal, state, and private sources by Hermann Abs.) The gospels' price stood for over three years; meanwhile, in keeping with the feverish acquisitiveness of the day, two canvases were sold for almost as much. First, in July 1984 Turner's tempestuous seascape *Folkestone* was auctioned at Sotheby's in London for $10 million. Then, again in only a matter of months, the Turner was eclipsed by a Renaissance painting by Andrea Mantegna, *Adoration of the Magi*, auctioned for just over $10 million by Christie's in London. The buyer, the J. Paul Getty Museum in Malibu, California, was the only American museum whose acquisition budget allowed it to purchase art at that price level. Endowed by the oil baron J. Paul Getty with a billion-dollar trust, the museum had an acquisition budget rumored to be around $100 million a year. The Getty curators spent this budget to bring fabulous pieces to the coast of southern California, where a new building was being constructed.

Within a week of the Mantegna sale a landscape, *Wheat Field with a Rising Sun*—painted by van Gogh from the window of his room in the asylum at Saint-Rémy—came up for auction in the estate of the American collector Florence Gould in New York. It "shows the sun rising over a field of young wheat; furrows rising up high into the picture toward a wall and a row of lilac hills," van Gogh had written. "The field is violet and yellow-green. The white sun is surrounded by a great yellow halo. Here . . . I have tried to express calmness, a great peace." The magnificent canvas, once owned by Paul Cassirer, sold for $9.9 million, a price close to the Mantegna record. *Wheat Field with a Rising Sun* (painted for the exhibition of Les XX in 1889) had doubled the price a van Gogh

had ever brought at auction and came close to hitting the auction record for any work of art.

In the early months of 1987, Charles Allsopp, head of Christie's United Kingdom operations, guessed that the Beatty *Sunflowers* would go for somewhere between 10 million and 15 million pounds. Although for run-of-the-mill pieces presale estimates were printed in auction catalogs, the estimate placed on *Sunflowers* was only available upon request. As the sale approached, Allsopp advised collectors that the price was going to be "nearer to" the upper limit of the estimate. By the night of the sale, "we did have fairly clear indications," Allsopp later said, "that even these estimates would be exceeded."

When the picture went for $39.9 million—almost four times the sum anyone, even in the heat of an auction, had ever squandered on a work of art—the price struck the art market like an electric shock. The buyer, Yasuda Fire and Marine, a Japanese insurance company, had won the painting in a bidding war with the Australian tycoon Alan Bond. Yasuda was about to celebrate its hundredth anniversary; coincidentally van Gogh had painted the picture the year the firm was founded. Recently, the insurance company's chairman had reportedly become friendly with one of Christie's experts. Six months before, assuming that auction estimates were reliable predictors of price, he had failed at an attempt to buy Manet's *Rue Mosnier with Street Pavers*. The Yasuda employee assigned to bid for *Sunflowers* had arrived at the auction with instructions to spend what was necessary. The picture had symbolic resonance for Japan, where the small *Sunflowers* incinerated in World War II had not been forgotten. Later the insurance chairman calculated the van Gogh had cost policyholders only about 5 yen, or 3 cents, apiece.

The $39.9 million price of *Sunflowers* reflected not simply the historical accident of Yasuda's birthday and the whim of its publicity-conscious executive but also the economic clout of Japan, which commanded wealth on an enormous scale, thanks to its ever-growing manufacturing sector, its high savings rate, and the strong

yen. The yen had been rising since the beginning of 1985, when it stood at 260 to the dollar. The revaluation of the Japanese currency had become official international monetary policy in September 1985 with the Plaza Accord, an agreement that followed a conference of the G-5 countries (the United States, Britain, France, Germany, and Japan) and whose stated aim was to diminish the United States' trade imbalance with Japan by letting the dollar fall against the yen. Besides its iron-clad currency, what also helped Japan's purchasing power was that soon after the Plaza Accord, Japan cut interest rates, a move with repercussions thousands of miles from Tokyo. "The money supply was booming in the United States and Japan alike," wrote James Grant in *Money of the Mind*, "and central banks, in deeds if not in words, had declared their intention to subordinate the fight against inflation to the battle for prosperity. The gold price climbed from $300 an ounce in January of 1985 to more than $400 an ounce by the closing months of 1986. Speculative real estate construction boomed in North America, Europe and Japan and the Japanese stock market took flight (by 1987, trading at more than 70 times earnings, a level unheard of in modern equity markets)." In a futile attempt to slow the Japanese economic ascension, President Reagan had levied penalties against Japan for breaking a trade agreement. A week before the *Sunflowers* sale, American currency—at 144.7 yen to the dollar—plunged to a post–World War II low. Denominated in British pounds, which had sunk with the dollar, *Sunflowers* was relatively inexpensive in Japan.

The art market inflation in the late 1980s was a fallout of the economics of a decade in which the stock markets in New York, London, Paris, Stockholm, and Tokyo boomed, and junk bonds and other instruments of leverage contributed to sometimes-overnight creation of massive individual and corporate wealth. The Dow Jones industrial average had doubled in three years between 1984 and 1987, from about 1000 to over 2000. Art, like stocks and real estate, soaked up money. In New York, individuals and corporations borrowed and bought. Prosperity thrived on credit. "By the standards of the late 1980s," according to James Grant, "the mid-1980s

were an era of antique caution." Junk bonds had billowed in the
course of a decade from a $15 billion to a $125 billion market
in 1986. Wall Street deal makers engineering leveraged buyouts
generated multimillion-dollar fees, some of which went into the art
market. Banks in America, Scandinavia, England, France, and Japan
were freely lending money to art dealers and also to investors
wanting to buy art.

The 1987 *Sunflowers* sale fundamentally changed the shape of
the art market, expanding not only demand, by alerting investors to
art as a speculative opportunity, but also—by enticing sellers to part
with precious, never-to-be-sold masterpieces—supply. Sophisticated
public relations departments at both Sotheby's and Christie's broad-
cast the van Gogh record price and the records in other fields, and
dealers adjusted their inventories upward. Several thousand Impres-
sionist, Postimpressionist, and modern canvases suddenly became
worth hundreds of thousands of dollars; hundreds were worth mil-
lions. Christie's and Sotheby's found they were drawing out Impres-
sionist landscapes, Cézanne bathers, Degas dancers, Manet scenes of
Paris, and early cubist still lifes, whose value as aesthetic objects or as
heirlooms laden with personal history paled against their immedi-
ately enormous financial worth.

Second and third generations in wealthy American families real-
ized that Impressionist pictures had become too expensive to keep,
as their opportunity cost—the loss imposed by not investing the
money tied up in a picture—soared. Michael Findlay, head of
Christie's Impressionist and modern department in New York,
noticed that collectors who had traditionally asked the auction house
for appraisals not more than every two years now wanted them after
every sale. If a minor Monet (typically bought at Wildenstein's or
Knoedler's in the 1940s or 1950s and left for decades on a living
room wall) jumped in value from $100,000 to $1 million, the fragile
canvas often was no longer only a fraction of the owners' net worth.
Its insurance cost rose; it sometimes required sophisticated and
expensive alarm systems and couldn't be abandoned for weeks at a
time in the summer while its owners went to the beach. While in the

1950s, 1960s, and 1970s the auction sales had a surfeit of dreary Sisleys and Pissarros, they now had an array of outstanding material. Later, dealers referred to the period immediately after the *Sunflowers* auction as "the crazy years."

American museums greeted the sale of *Sunflowers* with cries of despair. The year before, in 1986, Philippe de Montebello, the Metropolitan Museum's director, complained in the annual report that "the increasing cost of art on the one hand, together with limited funds for such purchases on the other, have inescapably diminished the number of truly note-worthy acquisitions." As private, nonprofit institutions, museums had built their collections largely upon the generosity of donors, generosity supported since 1917 by federal tax policy. Most of the Metropolitan's Rembrandts, its *Irises* by van Gogh, and countless other masterpieces were gifts, allowing their donors to obtain not insignificant deductions from their income taxes. But the 1986 Reagan-administration-sponsored Tax Reform Act changed the law so that donors to museums generally could not deduct the full appreciated value of works of art. Sponsors of the change argued that the former tax treatment had favored rich collectors. Its opponents pointed out that it had enabled American public collections to amass some of the world's most extraordinary holdings of art. The new Internal Revenue Code cut off gifts to museums like the blow of an axe: within a year, according to the American Association of Museums, the value of objects donated to some 2,000 museums had declined by an estimated $31 million, or over 30 percent. Museums continued to lobby to change the law.

In the context of history *Sunflowers* was expensive, surpassing the astronomical quantities of gold given by kings to celebrated artists to cover churches and chapels with frescoes or to commemorate their triumphs in monuments of stone. For decades the 310,400 pounds spent by Czar Nicholas II on the eve of World War I for Leonardo da Vinci's *Benois Madonna* had maintained in relative terms the highest price on record for a work of art, costing the equivalent in 1991 dollars of over $20 million. But in the second half of the 1980s multimillion-dollar art sales became commonplace. A benchmark of profligate spending on art like Thomas Gainsbor-

ough's *Blue Boy*—whose 1921 cost of 148,000 pounds (to California magnate Henry Huntington) was $4.3 million in 1991 dollars—was exceeded by more than one hundred works of art. These included not only old master paintings by Canaletto, Titian, Guardi, Pontormo, and Constable, and modern pictures by Picasso, Gauguin, Monet, Renoir, Cézanne, Manet, Degas, Toulouse-Lautrec, and van Gogh, but also canvases that had been painted by twentieth-century artists (Amedeo Modigliani, Léger, Matisse, Kandinsky, and Chagall) and were not particularly rare. *False Start*, a canvas by Jasper Johns (born in 1930), who famously used flags, targets, and maps as his subjects, sold in 1988 for $17 million.

At the New York and London auctions, Sachiko Hibiya, the head of Christie's Tokyo office, noticed dozens of Japanese businessmen, some of whom, out of the blue, walked away with twenty paintings from a single sale. Modern painting prices reached a level where they could join real estate, stocks, and bonds in a Japanese portfolio. When the market for Western art was rising fast, speculators could trade high-priced, "name" paintings as they traded land and other assets, and quickly generate money. In Japan, buying art became the fashionable thing to do. The Japanese were drawn to Impressionist art in part because of a powerful brand-name one-upmanship that also encouraged companies to manufacture the same products as their competitors. Japanese buying patterns suggested a taste for certain types of images—Renoir nudes, Chagalls with floating couples, and early blue- and pink-period Picassos. Picasso competed in price with van Gogh. *Acrobat and Young Harlequin*, a pink-period gouache on cardboard (confiscated by the Nazis from the Städtische Galerie in Wuppertal-Elberfeld and auctioned at the 1939 Lucerne sale for 80,000 Swiss francs) sold in November 1988 for $38.4 million to Tokyo's Mitsukoshi department store.

Japan had no indigenous auction business and no real tradition of collecting Western art. But at auctions Japanese speculators felt safe. Price estimates were printed in illustrated catalogs. The authenticity of each piece (produced after 1870) was guaranteed for six years from the date of the sale. The system of public bidding assured that at any given price there was at least one other individual also

willing to pay almost at that level. Dealers in Europe and America sniped that the auction houses hyped the estimates, read by naive buyers as price tags or standard international prices. But those in the art trade thrived. It took only two weeks for a London dealer to liquidate six Impressionist pictures at prices between $1 million and $6 million; he simply handed transparencies to a Tokyo dealer. Ikkan Sanada, a Japanese dealer with a gallery in New York, placed a four-hour reserve on a picture, transmitted its image to Japan via fax, and disposed of it before the time ran out. Without training, experience, or even much exposure to Western pictures, Japanese investors were indifferent to quality and often ignored peripheral issues of condition and provenance, issues that often accounted for differences in price (generally less of an issue for modern art than for old masters). In this way, many paintings headed for Tokyo. Rarely did dealers know the identities of the collectors in Japan. Between sellers and buyers stood a string of middlemen, each taking a cut.

In 1988 Japanese banks were lending money at 2 and 3 percent, and the resulting flood of cash produced a boom in both the stock and real estate markets. (Between the end of 1985 and 1989 the Bank for International Settlements reported that construction loans by Japanese banks grew at an annual rate of 20 percent.) With the yen rising in value against the dollar, dollar-denominated assets— e.g., American real estate and Western art—appeared cheaper and cheaper to Japanese buyers. By September 1988, at 134.4 yen to the dollar, the value of the Japanese currency had doubled from its postwar high of March 1987 (the month of the *Sunflowers* sale). In November and December 1988 Japan's currency continued to strengthen, to where only 123 yen were required to buy an American dollar.

In April 1987, a month after the Japanese purchase of *Sunflowers*, Sonja Kramarsky consigned for auction at Christie's van Gogh's *Trinquetaille Bridge*. Hugo von Tschudi, director of the Nationalgalerie in Berlin, had purchased the canvas from Paul Cassirer before World War I. In 1932 Siegfried Kramarsky had bought the canvas at a Paris auction for 361,000 French francs, or some $10,000, and he had given it to his daughter.

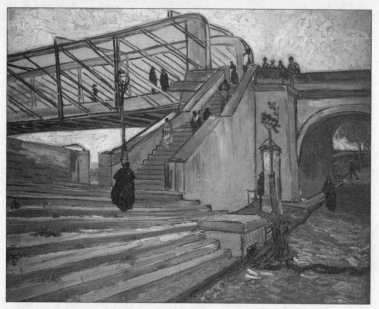

Vincent van Gogh, *Trinquetaille Bridge*, 1888. Sold in June 1987, shortly after *Sunflowers*, it made $20 million at auction.

Recently, the painting had been on loan to the Metropolitan Museum of Art.

The painting was relatively large—more than two feet high and a yard in width. Its subject was an outdoor staircase, leading to an iron bridge; there are several figures walking in the middle distance, most conspicuously a woman. "The Trinquetaille Bridge with all these steps is a canvas done on a gray morning," van Gogh wrote; "the stones, the asphalt, the pavements are gray; the sky pale blue; the figures colored; and there is a sickly tree with yellow foliage." That it was a beautiful but serious and subtle painting made its market value difficult to assess. (When a Christie's expert showed the painting to Alan Bond, the Australian industrialist seemed unimpressed.) At the June 29, 1987, sale, which took place in London, *Bridge* went for $20.2 million, making it the second most expensive picture ever sold at auction. The buyer was identified only as a European private collector. Dealers speculated the new owner was the group of investors that also owned van Gogh's *Railroad Bridge*, another Arles-period picture, on loan to the Kunsthaus in Zurich.

Bond, who presumably warmed to the picture, was the under-bidder. Both paintings were on view at the Kunsthaus in the early 1990s and then "disappeared."

When in 1984 the eighty-seven-year-old Lola Kramarsky became sick, her son Wynn took over her financial affairs, picked up her mail, and became the de facto curator of the family's art collection, which was on loan to the Metropolitan. Wynn later claimed that any emotional ties he might have had to *Gachet* had been broken long before; to the picture he felt only an "intellectual attachment" that came from his role of custodian, his experience traveling with the canvas to Tokyo, and his discussions with Ronald Pickvance and other scholars. He himself was a collector of contemporary drawings, and he was conversant with the debate over the dating of van Gogh's correspondence and other disputes in the field of van Gogh scholarship.

Calling himself the black sheep of the family, the Kramarskys' youngest child claimed to have blocked out any early memory of the picture. Like his father, he had worked in finance, as a broker for Bache & Co., a job he said he hated. In the 1960s he was active in Democratic politics, serving as an aide to New York mayor John Lindsay. Later he was appointed New York's commissioner of human rights, a post he resigned in 1982. Since then, he had spent much of his time collecting drawings. His New York office was filled with cerebral, often geometric, minimal black-and-white images by known and unknown artists. Buying drawings of artists who were not yet established demanded that he take risks, risks he compared to those his father took as an investor. He was chairman of the Drawings Center, a nonprofit gallery in SoHo that had held many pioneering exhibitions. In 1994 he told the editor of *Drawing*, "You don't own this material. You keep it in trust and, whenever possible, have other people look at it."

Short, stocky, resolutely informal, witty, irreverent, and quick on his feet, Wynn Kramarsky had not come from the rarefied private school background of his wife, Sarah-Ann ("Sally") Backer, who was the daughter of *New York Post* publisher Dorothy Schiff and the great-granddaughter of Jacob Schiff, legendary financier and philan-

thropist. Sally's great-aunt was Frieda Schiff Warburg, the matriarch of the New York branch of the Hamburg family, whose neo-Gothic house on Fifth Avenue and Ninety-second Street housed part of the Jewish Museum. Wynn's marriage had brought him into the circle of affluent civic-minded families of German Jewish descent who wielded influence in the financial, social, and cultural affairs of New York.

Wynn Kramarsky, for a time an active fund-raiser for the Metropolitan, possessed the financial experience, social ties, and sophisticated knowledge of art and the art market to steer the course of the Gachet portrait. He also had a direct tie to Christie's through his friend Stephen Lash, a former investment banker with S. G. Warburg & Co. One of the original band who had expanded Christie's American business in the early 1970s, Lash now was in charge of estates and appraisals at and a director of the auction house.

Kramarsky disliked the hypocrisy and pretension he encountered with certain dealers, who for years had wanted to get their hands on his family's pictures. "A two-week period did not go by, when somebody didn't call up to buy that [*Gachet*] or something else," he said. "French galleries, British galleries, all the big dealers at one time or another indicated interest in either that picture or in some of the other pictures in the collection."

In the early 1980s William Rubin, curator of paintings at the Museum of Modern Art, who had wanted a late van Gogh portrait to fill what he saw as a hole in the collection, asked museum director Richard Oldenburg to write Wynn Kramarsky and relay the museum's interest in *Gachet*. But Wynn said he never received such a letter and consequently never wrote back.

During Lola Kramarsky's extended illness, the trust set up for her benefit under Siegfried's estate needed additional funds to pay for extensive nursing care. At that point Sonja, Bernard, and Wynn Kramarsky began considering selling one of the paintings and decided it made sense to sell the piece that would generate the largest cash resource. Bernard Kramarsky wrestled with the idea of selling the picture. Recalling Lola's distress over selling the Cézanne, her eldest son believed she would not have wanted to sell the van Gogh. In his late sixties, Bernard had retired from running

his own business, a scrap metal company on Long Island. He was tall, almost skeletally thin, with olive skin and charcoal-colored circles around his eyes. He claimed not to think of himself as a collector, although he and his wife, Helga, had acquired a number of modern drawings. On the wall of their unassuming modern house with sliding glass doors and a small lawn in Great Neck, Long Island, was an Honoré Daumier sketch in pen and ink. Born in 1925 in St. Ingbert, a town in Saarland, Helga Sussel had been sent to France immediately after Kristallnacht. There she lived with 114 other refugee children in a château (Château de la Guette) near Paris. When the Germans invaded, the children were moved south; on June 21, 1941, she was sent to the United States, one of the few able to emigrate. Helga had not grown up with Impressionist paintings, and she admitted to finding *Gachet* an intimidating picture and one that would not fit easily into an informal house. Once at an exhibition of Watteau drawings at the Pierpont Morgan Library, Helga and Bernard had taken different paths in the galleries and bumped into each other in front of a drawing that had once been theirs. Helga felt as though they had come upon one of their children in an unexpected place.

Once the three Kramarskys had agreed to sell the picture, they learned that its sale required their mother's consent, although at that point she was incapable of granting it. To proceed, the Kramarskys had to get the permission of a state court, a step that took time and delayed *Gachet*'s sale at a moment when the market was being described as overheated.

"I don't think there was ever any doubt in our mind that whatever way we should sell it, we would do it through Christie's," said Wynn. "The relationship between Christie's and the family goes back many years. There's an intangible there." The family went so far as to reassure Christie's of this by formal letter on September 1, 1988. The picture was still in the museum.

The Kramarskys talked with Christie's experts about the state of the market. They discussed whether to sell the painting privately or not. The experts pointed out that in the past, they could have narrowed the field to twelve or maybe eighteen collectors who might

have wanted to bid on a van Gogh, and they would have known them all. But now, the auctioneers claimed, possibly two hundred or more could afford it. (In the four years between 1985 and 1990, ten van Goghs had sold for over $9 million.) Although only a fraction of these tycoons would have any interest in buying the picture, some might be completely new to the market and might not identify themselves until the day of the auction. The best way to reach all the potential buyers, they argued, was at a public sale. They convinced the Kramarskys to go to auction.

25

Museum to Auction,
February to May 14, 1990

*I dreamt of pinks and yellow and the new van Gogh that MOMA
got and "Irises" that sold for 53.9 million and wishing a van
Gogh was mine, I looked at my English hand-lasted shoes and
thought of van Gogh's tragic shoes.*
— An art dealer, in John Guare, *Six Degrees of Separation*, 1990

ON FEBRUARY 1, 1990, Christopher Burge arrived at the gaping
truck entrance to the Metropolitan Museum of Art to pick up *Por-
trait of Dr. Gachet*. The canvas had been bound in bubble wrap and
placed in a cardboard box. Seated in the back of an unmarked van
for twenty-three blocks, the president of Christie's held the portrait
on his knees. The news that the picture was to be sold had come the
week before in the *New York Times*:

> Vincent van Gogh's "Portrait of Dr. Gachet," completed six
> weeks before the artist's suicide in July 1890, is soon to be
> removed from the Metropolitan Museum of Art, so that it can
> be auctioned on May 15 at Christie's in New York.

As expected, the museum's director, Philippe de Montebello,
expressed his dismay about the departure of the canvas. "Generally
we do indicate to lenders that it's not appropriate for things to be
sold off our walls," he told the *Washington Post*, "but the current

times are exceptional. I can't rant and rave because I have to recognize it's understandable. It's the real world."

The code name for the May 15 Impressionist and modern sale was "Gachet 7068." The estimate Burge had put on the delicate canvas was $40 million to $50 million.

This estimate would appear in an auction catalog to be published about six weeks before the sale; it was relatively conservative. Even before Burge took hold of the famous painting, it was being insured by the auction house through a syndicate of brokers at Lloyds for $70 million. Insuring such a canvas was complicated except for total loss, since it was difficult to assess the financial impact of a scrape, a tear, or any other sort of damage. Insurance aside, according to a rule of thumb, the prices of Impressionist and modern pictures had multiplied ten times since the start of the decade, when van Gogh's *Public Garden with Couple and Blue Fir Tree* went for $5.2 million. The Kramarskys set the reserve, the minimum price they would accept at the auction, as "not less than $40 million." (The standard contract stipulated that the seller's reserve would not be higher than the figure the auction house gave as the low estimate.)

Whatever its estimates, the object's singularity and commodity value would prove to be the sum of its own travels, encounters, and associations. Since the painting's haunting glance first struck Alice Ruben at Vollard's gallery in 1897, countless decisions and circumstances had set the van Gogh en route to the auction house. In the 1890s *Gachet* was frameless and prized by artists who had rejected the naturalistic premises of the Impressionists. In Nazi Germany it became an exploitable artifact conveniently designated by officials of the Third Reich as "degenerate art." Snapped up by a Jewish financier who realized the value of assets that he himself could carry or have crated and shipped out, and long entwined in his immigrant family's past, its singularity was the sum of its history. Now again, the portrait's path was changing as the truck moved south.

To Burge, the meaning of the picture inside the box he gripped in his fingers was simple—it was perhaps the greatest van Gogh por-

trait that would ever come on the market. Although not one of van Gogh's most famous images, *Gachet* had enjoyed longtime recognition among artists, critics, dealers, collectors, museum curators, and scholars. Documented in van Gogh's letters, and originating from the collection of Johanna van Gogh, it had never been haunted by questions of authenticity. It had been brokered by two of the most influential European art dealers—Vollard and Cassirer. It was known to have been owned by an illustrious collector, Count Harry Kessler; an obscure but not insignificant Danish artist, Mogens Ballin; and a major German museum. The second version of the portrait, generally considered a less important picture, was nevertheless hanging in the Musée d'Orsay in Paris, a fact that only enhanced the value of the first.

After fifty years in a private collection, the Kramarskys' *Gachet* was fresh to the market. That the subject was a sad image of an old man was not a liability when many of collectors who could afford the picture were themselves old men. The timing of the sale, almost exactly one hundred years to the week after the portrait was painted, seemed a providential coincidence.

When Burge spoke of works of art he tended to identify them by location, rather than subject or style: the Gauguin in the Barnes collection, the Getty Ensor. Mapping the present distribution of the works of every major artist was critical to anyone in the trade. It was well known that among the scarce and closely watched van Goghs still closeted in private collections were four other portraits. Two—*Patience Escalier* and *Self-Portrait with Bandaged Ear*—were in the collection of the shipping tycoon Stavros Niarchos, one of whose residences was in Lausanne. Another self-portrait against a purple background was owned by the Whitney family in New York. Yet another self-portrait, with a green background (and dedicated to the painter Charles Laval), counted among the holdings of the heirs of the financier Robert Lehman. The booming market had enticed the Lehman heirs to consider selling their van Gogh portrait and certain other pictures, a consignment that Burge hoped to secure for the May 15 sale. As for the other van Gogh portraits, Burge doubted they would come on the market. Like the really fabulous Tahitian

Gauguins, most paintings by van Gogh in the "transcendental master-piece" category were already owned by museums. From the market point of view, the supply had pretty much run out.

A consignment agreement between the Kramarskys and the auction house, hammered out by lawyers, ran seven pages. For run-of-the-mill pieces, Christie's charged the seller a commission of 10 percent (15 percent for lots worth less than $7,500), in addition to fees for packing, shipping, customs duties, insurance, and cataloging. But the contract specifying the terms of the *Gachet* sale acknowledged the picture to be an expensive commodity whose owners could negotiate significant concessions from auction house experts, who if they sold it would be able to charge the buyer 10 percent of its multimillion-dollar price. For such works of art, the auction house typically waived the seller's fee; in this case the Kramarskys paid a commission of 3 percent. However, they obtained in turn extraordinary financial protection. Under standard consignment terms, the auction house took no credit risk; but the Kramarskys were assured, the moment the hammer fell, that Christie's would pay them the amount of the final bid, even if the buyer failed to pay the auction house. (And in addition, the buyer's payments would go into a special escrow account to protect the Kramarskys from the unlikely event that the auction house would itself fall prey to creditors.) The Kramarskys also shielded themselves from a sudden drop in the high-flying financial markets and other instances of force majeure. If both the Dow Jones industrial average and the Tokyo Nikkei stock average (which peaked in December 1989) fell by 30 percent from the date the agreement was signed in late December, or if there was a banking moratorium, national emergency, or international war, the Kramarskys had the right to withdraw the painting from the sale.

In transporting paintings, Burge often rested their boxes on his feet, letting his limbs absorb the impact of the irregular pavement of New York City's streets. Like all of van Gogh's paintings, *Gachet* was fragile—heavy impasto applied to a cheap fabric, now a hundred years old. Later, Burge gave Wynn Kramarsky a report on the painting's condition:

It has been relined . . . a glue lining (which is much preferable to a wax lining) and it was very sensitively applied. So sensitively, in fact, that the lining is no longer attached to the original canvas but merely lies behind it; whoever lined it was obviously so nervous of damaging the surface in any way that they applied very little glue between the two layers of canvas, which have subsequently separated. . . . The surface of the picture is in wonderful condition, without any of the flattening often associated with relining. There are, to be sure, one or two spots of old in-painting (quite normal for a painting of this age) dotted around the composition, but they are extremely insignificant and are only visible under close scrutiny with ultra-violet light. Also a light varnish.

From the moment a painter puts down the brush, a canvas begins to change. The version of *Sunflowers* in the Bayerische Staatsgemäldesammlungen (Bavarian State Galleries) in Munich was the only van Gogh Gisela Helmkampf, a conservator at the Metropolitan, knew to be a "virgin picture," untouched by restorers. Van Gogh left little room for the conservators to work, because his thick, extremely soluble paint trapped sediments in its grooves. Problematically, dirt evenly distributed across a canvas is difficult to remove bit by bit with uniformity. Also age affects various pigments in different ways. In painting clouds, for instance, van Gogh used several different types of white; some tones have shifted to gray, others toward yellow. Before the Gachet portrait appeared in the *Saint-Rémy and Auvers* exhibition, Helmkampf cleaned the painting—using the mildest technique, a "spit cleaning." Wynn Kramarsky insisted on watching the process. Helmkampf worked with a Q-Tip dipped in her own saliva, and began to lift a dark layer from the paint, which she told him looked like ashes, and which he realized had been deposited over the years when his father stood in his living room in front of the painting, talking and gesturing with a cigar.

CHRISTIE'S

Tall, thin, with unruly hair that was shifting from blond to gray, Christopher Burge still at forty-two hadn't completely lost the quizzical, boyish look of an Eton student. Since he had joined Christie's in the late sixties, the British auction house founded in 1744 had adapted to the global economy, transforming itself from an old-boy, London-oriented firm to a multinational, computerized, highly competitive corporation. Burge personified the firm's transition. Casually aristocratic, he had an easygoing manner and seemed at home among Americans, to whom he did not condescend. In a backbiting art market, he had few detractors and impressed people with his honesty and amusingly detached view of the auctioneer's sometimes two-faced profession. Rejected at Cambridge after he goofed off in his last year at boarding school, he had spent two years studying German in Munich. In 1969, after an interview with Peter Chance, the chairman of Christie's, who'd known his late father at school, Burge had started at the front desk of Christie's in London at a salary of 10 pounds a week. At this time, along with the army, the church, the family business (Burge & Co.), and the diplomatic corps, art auctioneering was one of the few acceptable professions for a gentleman. In 1973 Burge moved to New York to gather Impressionist paintings for the sales in London. (Christie's had opened a New York office in 1959.) The staff also had experts for books and jewelry (sent to Geneva). Burge was one of the crew that built the New York outpost into a full-scale auction house; they found a building, hired experts, scoured the countryside for material. The first Impressionist sale in America took place in May 1977. By the second half of the year, its staff now numbering around forty, Christie's added sales of old master paintings, contemporary art (previously the exclusive province of galleries), prints, and furniture. By 1990 in New York the auction house had over thirty departments, including American art, photography, silver, arms and armor, art nouveau, art deco and Arts and Crafts, Chinese painting, Chinese ceramics, and Japanese art. Quick on his feet, Burge had a rapid-fire style of talking that may have come from the

practice of auctioneering; it fit well into the pace of business in New York.

In the late 1970s, to lure property away from its more prominent rival Sotheby's, Christie's took the controversial step of slashing or eliminating the usual 10 percent commission its officials charged to sellers, making up the difference from the buyers, whom they slapped with a 10 percent fee. Sotheby's followed suit. This flexible commission structure allowed the auction houses to draw the best property away from the dealers, who typically charged sellers commissions of 30 percent. As the auction houses started to move in on the Impressionist and modern market, they inevitably made mistakes. In 1975 Christie's experts succeeded in persuading Chester Beatty to let Christie's auction his van Gogh portrait of Patience Escalier. Before the sale took place, a group of dealers offered the collector a sum considerably higher than the price the auction experts had estimated the picture would bring at a sale. Beatty traded the portrait to the syndicate. The auctioneers had both underestimated the price that the market would bear and made the mistake of not insisting that the collector sign a contract. As the auction experts learned, the market matured.

By 1985 Burge had become president of Christie's in North and South America. Already much of the most lucrative part of the business had gravitated to New York. Between 1986 and 1989, Christie's auction sales had tripled to 1.3 billion pounds; Impressionist paintings contributed almost 40 percent. Looked at geographically, New York generated sales of 699 million pounds, compared to sales of 478 million pounds in London.

PRICE

In Burge's view, *Gachet* had all the attributes necessary to come close to, or possibly surpass, the $53.9 million price set in 1987 by another van Gogh of its caliber: *Irises*, a record set at Sotheby's in November 1987, six months after the $39.9 million sale of *Sunflowers* and only weeks after the crash of the New York stock market. But, as Burge was well aware, the *Irises*' record had been recently tarnished. Three

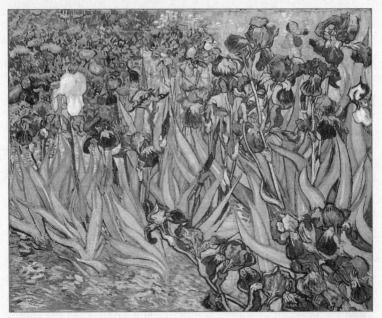

Vincent van Gogh, *Irises*, 1889. Selling for $53.9 million in November 1987, it became the most expensive painting sold at auction—until *Gachet*.

months before, in October 1989, Sotheby's revealed it had loaned the *Irises'* buyer Alan Bond half the purchase price; Bond had failed to meet the terms of the loan, and Sotheby's had taken control of the picture. The ravishing Saint-Rémy canvas was being held in a secret location. Bond's Australian brewing and publishing empire was reportedly near collapse. The unsettling news that the *Irises'* much-touted record had been financed by Sotheby's prompted a deluge of cynical and legitimate questions about the manipulative nature of the unregulated auction market. How real was the record? Had Sotheby's granting of credit pushed up the price of that painting? When exactly were the terms discussed and arranged? By January 1990 Sotheby's stopped offering buyers loans collateralized solely by works of art to be purchased at their auctions. The revelation of Sotheby's problems with *Irises* suggested that the art market, like the markets in junk bonds, real estate, and Japanese golf club member-ships, was heavily buttressed by credit. Many assumed that the pic-

ture was again for sale. Yet oddly, the beautiful *Irises* (at $53.9 million) remained something of a benchmark.

In estimating *Gachet*'s price, Christopher Burge also considered the sale of another van Gogh. The previous August, the Museum of Modern Art had bought a version of *Portrait of Joseph Roulin* in a private sale involving cash and an exchange of paintings, together worth reportedly some $40 million. (To finance the deal, the museum put seven pictures, including a de Chirico, a Mondrian, and a Picasso, on the auction block.)

THE PAPER-THIN MARKET

Despite the sums expended upon *Irises* and *Joseph Roulin*, Burge nevertheless could not help but worry about the upcoming sale. The less than four square feet of canvas that he was attempting to protect from the unpredictable jolts of a drive along Manhattan's potholed streets was an odd and imperfect financial instrument. As a commodity, a work of art has no intrinsic value; its price cannot be measured against financial standards like corporate profits or rental income; its "price," as the scholar Philip Fisher put it, "is a complex speculation on the work's future as a 'past.' " The Gachet portrait's value depended upon the fact that it was unique—in no way interchangeable with even a picture like *Irises*. Art collectors were not like shareholders of stock who, like thousands of others, possessed exactly identical assets and could trade shares five days a week at exchanges in New York, London, Paris, or Tokyo. Even in the Impressionist and modern segment of the market, theoretically the largest and most efficient, the Kramarskys (owning a highly desirable piece) had to wait months for the semiannual series of auctions held back-to-back by Christie's and Sotheby's in New York in May and November, and in London in June and December.

Recently the rhythmic smashing of price records at art auctions had obscured the fact that the art market was paper thin, idiosyncratic at every level and in every category, and ran on its own economics. Even in the best of times, it remained illiquid—a secretive world of undercapitalized dealers in New York, London, and various

cities in Europe, few if any of whom could have supplied the funds to purchase *Gachet* outright. If the auction sales rooms were theaters whose wider audience theoretically stretched to Tokyo and Stockholm, Burge recognized that in fact a realistically composed list of the potential buyers of *Portrait of Dr. Gachet* would have easily fit on an index card.

FALL 1989

At the Impressionist auctions in the fall of 1989, Sotheby's problems with *Irises* had surprisingly little impact. The sales in November in New York and December in London again produced a cascade of yet-higher prices. In those two months, twenty-seven paintings traded for over $5 million. The Getty spent $26.4 million on Manet's *Rue Mosnier with Flags*, and the philanthropist Walter Annenberg bought a blue-period Picasso, *Au Lapin Agile*, for $40.7 million. Earlier the London press reported that the Argentinean who had reportedly bought *Wheat Field with a Rising Sun* (painted from the asylum in Saint-Rémy) in 1985 for $9.9 million had obtained close to $50 million for the canvas. No one knew if this was simply wishful thinking, like the talk among dealers of the possibility of a $100 million picture, talk that among financial-minded people recalled talk about $100-per-barrel oil at the top of the energy market in the early 1980s. At that moment, in the prosperous cities of the world, for a great painting by certain of the Impressionists, Rembrandt, van Gogh, or Picasso, nothing seemed too much.

As several well-publicized numbers suggested, certain canny individuals had capitalized on the enviable ability to discriminate among some of the great works of Western art. In fact, their skills amounted less to connoisseurship than to market timing. There were numerous examples of profit taking, but none as stunning as the $42 million windfall made by the hospital chain tycoon Wendell Cherry, whom dealers had mocked for spending $5 million on *Yo: Picasso* in 1980, when he sold the youthful self-portrait in the spring of 1989 for $47 million. Outsiders looked at the art market with envy. In the fall of 1989 the print dealer David Tunick was spending late nights

closeted with investment bankers, mapping out a prospectus for a fund that aimed to raise $100 million for art investing, an amount the print dealer had begun to think would not be large enough.

Yet the ever-higher prices did little to comfort Burge, who knew the wild market was fueled by speculators, who habitually bought the wrong pictures and had no wish to hold on to them. Speculators relished the art market in part because of its scale. To be a major player, even in Impressionist paintings, required comparatively minor amounts of capital. Also increasingly evident was that the speculative market was funded largely by the bubble economy of Japan. One particularly indiscriminate Japanese investor was Yasu-michi Morishita, whose fortune came from real estate, the stock market, and a money-lending firm. At auctions that fall, Morishita's gallery, Aska International, reportedly spent over $100 million, including $11 million for van Gogh's *Quarry at Saint-Rémy* and $6.5 million for a forgettable picture of a woman and a child, *Homme est en mer* (*Man Is at Sea*), once owned by Paul-Ferdinand Gachet. In September, through his firm, Morishita paid $52 million for 6.4 percent of Christie's stock (which was later sold). Other Japanese collectors focused their extravagance on single pictures. On November 30 a real estate investor, Tomonori Tsurumaki, paid $51.65 million for Picasso's *Pierrette's Wedding* at a Paris auction, televised by satellite to Tokyo. Tsurumaki hung his canvas in a building at the Nippon Autopolis racetrack in Japan, a property he had recently developed.

The astronomical auction prices temporarily obscured some fundamental facts about paintings as long-term investments. Over the centuries art, in general, had not performed as well as government securities. In a 1986 article titled "Unnatural Value: or Art Investment as Floating Crap Game," the New York University economist William Baumol argued that art prices behaved at random: "Prices can float more or less aimlessly, and their unpredictable oscillations are apt to be exacerbated by the activities of those who treat such art objects as 'investments,' and who, according to the data, earn a real rate of return very close to zero on the average." Two Euro-

pean economists, Bruno S. Frey of the University of Zurich and
Werner W. Pommerehne of the Free University of Berlin, followed
with a study that looked at eight hundred of the "best known
painters of the world" from the mid-seventeenth century to 1987.
They contended that "the real rate of return on paintings [which
was 1.5 percent] is half the real return that one could get by buy-
ing public securities." Volatility was unnerving; investors got
annual rates of return ranging from a low of *negative* 19 percent to
a high of 26 percent. "Inflation which has reduced the returns of
financial investments has made investing in art comparably more
attractive," the economists wrote, but "still this return lies consider-
ably below the return of a corresponding investment in the financial
markets."

Impressionist pictures, however, had outperformed other vari-
eties of art, because they were originally cheap. (Rembrandt's *Aris-
totle Contemplating the Bust of Homer* had been expensive from the
time it was commissioned, costing the Sicilian Don Antonio Ruffo
500 florins in 1652.) Certain paintings by van Gogh, like others by
Cézanne, Gauguin, Manet, Matisse, Monet, and Renoir, had done
well—making "rates of return of around 10 percent per year." The
$53 million *Irises*, purchased in 1947 for $84,000 and held for forty
years, generated a "real return of about 12 percent per year." Still,
such returns were nothing compared with the quick-turnaround
profits of *Yo: Picasso*. William Goetzmann, the Yale economist, ar-
gued that "returns to art investment have exceeded inflation for long
periods, and returns in the second half of the 20th century have
rivaled the stock market." Still, he cautioned, the art market returns
"are no higher than would be justified by the extraordinary risks they
represent." The economists' cautionary conclusions were based only
upon statistics of public auctions and necessarily omitted the trans-
actions of private dealers. That the statistics also left out works of art
put up at auction but failing to sell meant they were biased upward.
Collectors, the economists decided, bought art not simply for its
financial potential, but also for an intangible "consumption benefit,"
such as prestige or aesthetic pleasure.

PREPARING FOR THE SPRING SALES

Given the state of the market, Burge had no trouble securing fine works of art for the May 15 sale. He successfully competed against Sotheby's for the van Gogh self-portrait, as well as paintings by Renoir, Toulouse-Lautrec, Modigliani, and Kees van Dongen, owned by heirs of Robert Lehman. He and his colleagues persuaded them that the presence of *Gachet* would only enhance the chances of their painting, estimated to bring between $20 million and $30 million. The self-portrait, slated as lot 32, might, compared with the other van Gogh, seem relatively cheap and possibly appeal to bidders who failed in an attempt to buy lot 21. For the second time in its history Christie's, in a policy reversal, gave the consignors a guarantee (reported to be $54 million) or a fixed sum for the group of pictures, no matter how well each lot fared at the auction.

Sotheby's had also assembled a critical mass of extraordinary pictures. In January, one week before Christie's announced the sale of the Gachet portrait, Sotheby's reported that it too had obtained an exceptional picture for the May sale—Auguste Renoir's *Au Moulin de la Galette*. Painted in 1876, the lovely canvas portrayed a scene on the terrace of an outdoor café, ringed by acacia trees, with an elegant crowd gathered at tables in the foreground and couples dancing in the background. The publisher of the *New York Herald Tribune*, John Hay Whitney, had bought the picture from Knoedler & Co. in December 1929 (less than two months after the New York stock market crash) for $165,000. Coincidentally, as with the van Gogh portrait, there was a second version in the Musée d'Orsay. Sotheby's experts predicted that, like the van Gogh, the picturesque Renoir would bring $40 million to $50 million. Three other pictures in Sotheby's sale, including a Kandinsky, came from the permanent collection of the Guggenheim Museum, whose director Thomas Krens had decided to raise funds to pay for the controversial acquisition of a collection of 1960s and 1970s minimal, environmental, and conceptual art from the Italian collector Count Giuseppe Panza di Biumo.

Christie's experts had fourteen weeks to prepare for the *Gachet*

sale. The first step was to "catalog" the painting: check the published provenance in the 1970 de la Faille catalog, remove the painting from its frame, examine the back of that frame for labels, and photograph the canvas for the auction catalog and for publicity shots. The catalog itself was due at the printers in about three weeks. Under this deadline and with eighty more pictures to catalog, the experts and assistants in the Impressionist and modern department had little time to check for the accuracy of the standard de la Faille provenance against dealers' account books, letters, and other primary sources.

Although lot 21 was to be listed in the auction catalog, Christie's experts had agreed also to publish a special hardback book devoted exclusively to the portrait. To prepare the text, Michael Findlay consulted Walter Feilchenfeldt, the dealer and author of *Vincent van Gogh and Paul Cassirer, Berlin*, and the scholar Roland Dorn, both of whom attempted to correct the errors in the 1970 de la Faille. Ambroise Vollard needed to be added as a dealer who had sold the picture. The portrait, Dorn wrote, "was part of a consignment that Vollard received in November 1896 from Jo van Gogh–Bonger for the gallery's second exhibition of works by van Gogh." He explained that a "J. Keller" listed as one of the picture's owners was probably a shipping agent.

The slim but elegant *Gachet* catalog was published in April, about six weeks before the sale. On the book's glossy jacket, the image of *Gachet* was bled to the edge. (An entire print run of catalogs arrived with paperback covers but was destroyed before the Kramarskys, promised a hardback, could learn of the error.) Inside, the text devoted to the picture ran nineteen pages, three of them filled with lists of the exhibits and publications in which the portrait had appeared. The provenance listed seven names: Johanna van Gogh, Ambroise Vollard, Mogens Ballin, Paul Cassirer, Harry Graf Kessler, Galerie Eugène Druet, and the Städtische Galerie in Frankfurt. Omitted was the still-undiscovered first buyer of the picture—Alice Ruben, whose name appears as "Mme Faber" in Vollard's account book. The auction experts also left out the history of the painting's confiscation by the Third Reich's Propaganda Ministry. Dorn had not bothered to mention this segment of its history

because he thought among experts it was common knowledge. (That Angerer had acted as Hermann Göring's agent in selling the van Gogh portrait had been disclosed in Germany in 1949 in the book *Kunstdiktatur im Dritten Reich* [*Art Dictatorship in the Third Reich*], by a former Berlin Nationalgalerie curator, Paul Ortwin Rave.) The text of the auction catalog was misleadingly incomplete, stating that the "*Portrait du Dr. Gachet* was deaccessioned by the museum prior to the Second World War and acquired by Siegfried Kramarsky." The term "deaccession" is used by museums when as a matter of course they sell pictures to thin out their collections. Bernard Kramarsky said he and his siblings (then in their teens) did not know the circumstances under which his parents had bought the painting; he said his parents had never discussed the painting's acquisition with their children and, as far as he knew, no records related to its purchase remained. Understandably, Burge and Findlay declined to press the Kramarskys on the origins of the painting. By sidestepping the painting's history with the Third Reich, the auction house experts presumably sought to avoid possibly embarrassing publicity about the exploitation of the picture by the Nazis.

In March, the J. Paul Getty Museum announced its acquisition of the free-floating *Irises*. The transaction brokered by Sotheby's for Alan Bond involved an exchange of cash and paintings, later sold at the auction house. All parties involved in the deal signed papers agreeing never to reveal the exact terms and figures, but it was assumed that Bond lost money and it was estimated that *Irises* cost the Getty between $30 million and $35 million. When he learned that *Dr. Gachet* was coming up for sale, George Goldner, the Getty's paintings curator, began to think about which van Gogh he preferred. "These things," he said later, "are a matter beyond a certain point of taste and personality. If you said 'I'm going to give you one of these two paintings as a gift,' I would probably take the *Irises*. I just happen to like it more as a painting. It's also in slightly better condition." The Getty's purchase meant the museum had effectively removed itself from the list of possible buyers.

As the sale approached, Burge continued to fret; at most, he esti-

mated there were five individuals in Asia, five in the United States, nine in Europe, and five others with no fixed address who might have the means and inclination to acquire the picture:

> If on a whim, they [some of the buyers] decide to go out to dinner instead of coming to the sale, then you have completely changed the face of the art market. When the press describes "pandemonium in the sales room, hands in the air, people falling over themselves to buy things," what it means is that two people were going at it on something . . . but basically just two people. . . . It's a fantastically thin market because although we target these hundreds of people who have expressed interest when it's on exhibition when it's traveling or when they've seen the catalogue, when we get down to that last meeting just before the sale and we say who is on lot 21 . . . the standard thing every time is that "so and so is off it—he told me yesterday he found something else he preferred" . . . "Well, she may be on it but frankly I think she got nervous because of what happened in Los Angeles" . . . "Well, there is so and so but I don't know, he hasn't picked up his tickets and I'm a bit worried. I've been trying to reach him everywhere because he said in Paris he was going to buy." [At the top of the market] when two bidders got into it, they didn't mind too much what they paid. If two Japanese wanted a Renoir, they'd battle it out hammer and tongs at three times the estimate, the audience gasping. . . . It's individual parallel situations superimposed on one another. Almost a private sale. I'm sitting there encouraging somebody and they come back fifteen times and they can't decide, then they say yes, we'll take it. That's all been compressed into 30 seconds or a minute. You've got someone else doing the same thing five seats away. . . . If you had 50 people, it would be a different market.

From the time Burge carried *Portrait of Dr. Gachet* through the auction house door, Christie's experts kept the painting locked in a vault. Burge, Lash, Findlay, and other experts took certain clients to see it. Christie's had scheduled preview exhibitions in Zurich and

Japan for the top lots of the May sales. But the Kramarskys refused to let *Gachet* travel. They made a single exception, permitting Burge to carry the painting, crated in an aluminum box, to Switzerland, where he showed it to a collector too ill to come to New York. Christie's declined to disclose the collector's identity, but everyone assumed it was Niarchos. At the Tokyo preview of Christie's auction, a videotape, with a Japanese narration about the picture, played in the gallery nonstop, a stand-in for the canvas itself.

26

Portrait of Melancholy
at Auction,
May 15, 1990

And those high prices one hears about, paid for works of painters who are dead and who were never paid so much while they were alive, it is a kind of tulip trade, under which the living painters suffer rather than gain any benefit. And it will also disappear like the tulip trade. But one may reason that, though the tulip trade has long been gone and is forgotten, the flower growers have remained and will remain. And thus I consider painting too, thinking that what abides is like a kind of flower growing.

—Vincent van Gogh to his mother

CHRISTIE'S STOOD in the corner of the Delmonico Hotel on the northwest corner of Fifty-ninth Street and Park Avenue, positioned where Manhattan's zone of steel-and-glass skyscrapers shifts into the grand residential stretch of prewar apartment buildings running north to Ninety-sixth Street. The postwar towers of Lever House and the Seagrams Building were six blocks to the south, Grand Central Station about a mile downtown. It was a short walk to the Museum of Modern Art and to the galleries that run along Fifty-seventh Street. Concentrated in the Midtown neighborhood of the British firm's New York salesroom were hotels, department stores, corporate offices, European shops, and other magnets for both local and international traffic. At the auction house, New York City's corridors of commerce and society literally converged.

At 10 A.M. on Friday, May 11, a pair of art handlers brought *Portrait of Dr. Gachet* out of the vault and hung it at the end of a long, narrow gallery whose walls were crowded with some thirty of the finest pictures to be auctioned on Tuesday, May 15. The remaining pictures flowed down a tunnel-like corridor and into a larger gallery. *Gachet* remained on view to the public, populated mostly by the art trade, for five days. Rapidly arranged exhibitions of pictures on their way to a sale have a haphazard and unstable look that reflects the constant and visible state of flux inside an auction house, where the commodities change weekly, from gemstones to lengthy color-field paintings that must be removed from their stretchers and rolled up in order to fit through a standard door. Christie's main auction room was a functional space about the size of a small movie theater. Its walls were covered with a bland synthetic carpeting that appeared unscathed even after the hammering of thousands of nails into the plaster behind it. Backstage, offices were cramped and photography studios were set up where need be, in corridors and spare corners.

The morning of May 15, Wynn Kramarsky consulted with his siblings, then with Stephen Lash and Christopher Burge, and lowered the reserve price on *Portrait of Dr. Gachet* from $40 million to $35 million. At a New York sale the night before, held by the Swiss auction house Habsburg Feldman, the majority of lots failed to sell, their consignors having set overly ambitious reserves. *Gachet*'s reserve decided, Kramarsky flew to Washington, D.C., to attend the opening of a Jasper Johns exhibition at the National Gallery of Art.

At 2 P.M. that afternoon, Christie's art handlers closed off the auction house galleries and began packing up the pictures scheduled to be auctioned that night. They lifted the canvases from the walls and lowered them into large cardboard boxes, stacking them between sheets of cardboard as tightly as possible in the order they would appear in the sale. They covered the boxes with thick, translucent sheets of plastic. Because there were a lot of "heavy hitters," they hauled the boxes to the vault. Lot 21 remained on the wall of the closed-off gallery, in case anyone appeared for a last-minute look. At

the end of the afternoon, it too went back to the vault. A television news program interviewed Michael Findlay briefly in front of the painting. "It's probably a good time to purchase great works of art," he said. "Prices, having risen quite astoundingly, have persuaded people who otherwise would have kept them to put on the market works such as this."

The afternoon of May 15 faded into a mild evening, and around 6:30 P.M. a crowd began milling on the corner of Fifty-ninth Street in front of Christie's revolving door. Taxis and limousines clogged the downtown side of the street as the dressed-up crowd assembled for the first of New York's spring auctions. Across Park Avenue, in a median strip, a rectangular bank of tulips was in bloom.

Coincidentally, on that same day in New York an exhibition of drawings titled *From Pisanello to Cézanne: Master Drawings from the Museum Boymans–van Beuningen, Rotterdam* opened at the Pierpont Morgan Library. Most of these drawings had come from the collection of Franz Koenigs. According to the catalog, the exhibition's title was "chosen to illustrate the breadth of both his [Koenigs's] acquisitions and his taste." At the time of the 1990 auction, Koenigs's children were still unaware that the German-born collector had bought the van Gogh portrait in Paris on May 21, 1938, coincidentally fifty-two years before, almost to the day. In its history of the Boymans collection the catalog explained that it was Koenigs's debt to Lisser & Rosenkranz that had forced him to give up his drawings collection to the bank. (The year before, the Netherlands had launched an official search for 491 "missing" drawings from the Koenigs collection. These were the drawings bought by Hans Posse in 1941 for the Führer-museum and stored in the Dresden print room. Removed from a repository near Dresden by Russian soldiers after the war, they had not yet been accounted for.)

By seven o'clock more than 700 people had packed their way into Christie's main room, 600 seated in thirty rows of folding chairs (which required tickets), the rest on their feet, sometimes four deep, along the sides and the back of the room. Facing the podium, to the left, was a raised platform where reporters from the monthly maga-

zines *Art News* and *Art in America*, and from the *Washington Post*, the *New York Times*, and the *Wall Street Journal*, stood scanning the audience. Several television crews had set up cameras. In the din as the crowd took its seats, European languages could be heard, mingled with Japanese. At the front stood auction-house experts and assistants, dressed in evening clothes, who were posted to spot bids in the room and to man telephones through which they talked to clients on other continents or in the audience, where cellular telephones were used for anonymity. Christie's Tokyo expert Sachiko Hibiya, who had flown from Japan for the sale, was prepared to call a collector in Tokyo. Tickets were also required to get a seat in the peripheral exhibition rooms, where the sale was to be broadcast on closed-circuit televisions sets. As the crowd filed in, Stephen Lash took Bernard and Helga Kramarsky and members of their family to a private room upstairs, where they could watch the proceedings on a video screen.

At about ten past seven, Christopher Burge was at the podium, glancing down at a stack of unbound pages from the auction catalog that served as his stage directions for the sale. As he began to speak, giving the customary welcome and requesting that people take their seats, the crowd settled down. The sequence of properties, which customarily proceeded in roughly chronological order, had been carefully planned, beginning with Daumier and six run-of-the-mill Impressionist pictures, each expected to bring over $1 million. As the most important lot, *Gachet* was placed one-third of the way through the sale. Burge dispatched the first five pictures. Although slightly rattled by the failure of lots 6, 7, and 9 (a Pissarro, a Sisley, and a Cézanne) to make their reserves, he sailed through, relieved that lot 8, the first of the Robert Lehman paintings—a Renoir nude—went for $6 million, just over its low estimate. At the thirteenth picture, the Manet *Bench*, estimated to bring at least $20 million, the bidding rose to $16 million and went no further. Still, at that price he had disposed of a major lot. Two small, saccharine Renoir portraits appeared and disappeared without finding buyers, but were quickly forgotten when the second Lehman picture, Toulouse-

Lautrec's portrait of Jeanne Fontaine in a red dress, brought $12.9 million—a price that fell almost exactly in the middle of its estimate. As Burge proceeded through the next two paintings, handlers backstage lifted the Gachet portrait out of a box and secured it to the wall of the turntable.

At about seven forty-five, the portrait swung into view. At the bottom of its ornate gilt frame was a white cardboard sign printed in black letters with the word "Christie's." This was a precaution to ensure that if, as had often happened, the press mistakenly credited the more famous Sotheby's with the sale, Christie's name would at least appear in all photographic images of the painting at the auction.

Christopher Burge opened the bidding for *Gachet* at $20 million. That price instantly appeared at the top of the currency converter, a large blackboard hanging off to the right at the front of the room where the bid was posted in dollars and electronically translated into pounds, French and Swiss francs, marks, yen, and lira. Thomas Ammann, a young Zurich dealer, was one of two people bidding from the start. The other was a private collector. Both were seated in the auction room. Burge kept the price rising in increments of $1 million. Charles Allsopp, chairman of Christie's in London, and Maria Reinshagen, from the Zurich office, were among the Christie's experts who were speaking with clients on telephones. Thomas Ammann and the collector in the audience continued to bid. Burge moved along fast. His sonorous voice called the numbers with a practiced note of slight surprise, as though he had come upon these figures in the air, and it was only natural to identify them.. At $35 million, Burge knew the picture had sold. On the telephone to a client in Japan, Sachiko Hibiya was waiting to jump in just before $40 million, but the bidding soared past her client's limit. At that point a youthful Asian man seated toward the back of the room raised a gold pen. Sachiko Hibiya was one of the few in the room to recognize Hideto Kobayashi, a Tokyo dealer who sold mostly contemporary Japanese art from a gallery on the Ginza. She caught his eye. Although he had registered for the sale, established credit with

the auction house, and been cleared to bid, he had made no sign to her that he was interested in the van Gogh portrait. That the Tokyo office had given him no extraordinary credit check didn't concern Hibiya. In Japan such things were a matter of faith. If a dealer bought a major painting at auction and then failed to pay, it would destroy not only his business but his reputation. Burge picked up Kobayashi's bid: "41 in a new place." At this point Maria Reinshagen, from Zurich, on a telephone, responded with a bid of 42 million. "Now, this telephone," said Burge.

> 42 million against you here now, 43 million back here now, 43 million dollars in the aisle, 44 million on the telephone, 45 million in the room now, 46 million, 47 million, 48 million 49 million, 50 million.

A bid of $50 million with a 10 percent commission meant that at this point *Gachet* had passed *Irises'* $53 million record price. The press office staff let out a shout, and a Japanese dealer began to clap. "Still going," called out Burge; "51 million dollars, 52 million."

Kobayashi was relatively calm. "I felt a sort of hot air running through the auction," he said later. At one point he hesitated, but at that point he found he needed more courage to step down than he did to keep on going. Reinshagen still had her collector on the phone. "Telephone's against you, sir," Burge said, pointing to Kobayashi:

> 53 million, 54 million on the telephone, 55 million in the room and against you, 56 million, 57 million.

And so it went:

> 70 million against you, sir, 71 million in the room against the telephone, 72 million, 73 million, 74 million, 75 million, 75 million selling in the room, all done then against the telephone, not yours, fair warning, for you sir.

Burge was gesturing to Kobayashi. And he swept his right hand back onto the podium and with his left dropped the hammer: "Sold." The numbers of the currency converter stopped moving:

Lot 21	$75000000
FINAL BID	
UK POUNDS	44692960
FRENCH FR	416400128
SWISS FR	104700000
DEUTSCH M	123375040
YEN '000	11310000
LIRA '000	90825040

At 10 percent, the buyer's commission amounted to $7.5 million, and brought the total price to be paid by Hideto Kobayashi to $82.5 million. At the final hammer, the crowd began to clap and to cheer. As much of the audience rose to its feet, craning to get a glimpse of the Asian man who had bought the picture, a woman in a black dress to the right of Burge reached over and took the bidding sheet from the podium. For some ten minutes Burge tried to quiet the room and proceed. Meanwhile, few watched *Gachet* swing out of sight as the sale moved on.

Although the lights were bright and the painting had been clearly visible at the front of the room, even those with the best seats caught only a glimpse of the blue canvas and had but a partial view of what had transpired. Like all auctions, this one was part scripted and part improvisation, moving along with secret bids made in advance and discreet signals delivered on the spur of the moment by players (including one who dared to bid $74 million) participating through surrogates. The audience watched the proceedings that night as through a scrim where only certain actors and certain gestures could be detected, and the rest of the stage was too dark for all but a few auction insiders to make out exactly what was going on.

The immediately notorious *Gachet* price had broken the $53 million *Irises* record by almost $30 million. In the course of almost a century—from 1897, when Alice Ruben spent 300 francs, or some $58, on the Gachet portrait—the price of the canvas had multiplied more than twenty-three thousand times. If Ruben had held the painting for ninety-three years and sold it for $82.5 million, the rate of return on her investment would have been 16.5 percent.

In a sale where over forty-four of the eighty-one pieces went for over $1 million, the 1890 portrait was not the only record. The van Gogh self-portrait dedicated to Charles Laval sold for $26.4 million. Altogether the five Lehman pictures brought $54 million. But the market was running confusing signals. Several expensive pictures went no higher than their low estimates. Chicago Art Institute officials failed to sell a Modigliani portrait that they had hoped would bring at least $4 million. Strikingly, almost one-third of the sale's $269 million total came from the $82.5 million that Hideto Kobayashi traded for *Gachet*.

Kobayashi tried to escape from the auction without talking to reporters. (He claimed to speak no English.) He rushed immediately to his Midtown hotel, where he checked the hour in Japan. It was morning, approaching the time when Tokyo's offices opened, and he called Ryoei Saito. Saito, age seventy-five, was honorary chairman of Daishowa Paper Manufacturing, Japan's second largest paper company. Kobayashi reported that he had succeeded in buying *Gachet*. Although Saito had not expected to pay so much, he voiced no regrets about the purchase.

As dealers filed out that night, they looked warily at each other and shook their heads. Perhaps they had misread the ominous signs. The applause at the end had been a slapping together of desperate hands in hopes that the spending spree was not yet over. The echo of Burge's voice calling out the figure "$75 million" must mean, they told each other, that the heyday of the art market was not at an end.

The canvas itself? Immediately after the sale, Christopher Burge, conspicuously relieved and ebullient, spoke with television reporters in the vault with *Gachet*, which he and an art handler had removed from its cardboard box and hung on a wire-mesh rack. Later that night, news of *Gachet*'s record price spread quickly and far. An electronic image of the portrait received worldwide scrutiny as a five-second byte on television screens. Some of the nightly news broadcasts ran a seconds-long clip of Burge calling out the last bids. On the *NBC Nightly News* the next day, a cartoon image of the picture appeared on an easel, dwarfed by a white price tag printed in red: "$82.5 million." (By 1990 the worldwide television audience was

estimated to be some 2.5 billion.) When *Irises* had sold for $53.9 million in 1987, Calvin Tomkins observed in the *New Yorker* that "all that remained of van Gogh's *Irises* was the reiteration of its record price." So quickly did *Gachet* pass through the public's consciousness that most outside the art world had no memory of what it looked like. So fleeting was its renown that many were confused about which picture had actually established the record price. If asked, most guessed that the most expensive painting in the world was either *Sunflowers* or *Irises*.

Beneath the buzz, a palpable sense of lateness lingered that night—lateness at the end of the century, lateness in the scarcity of van Goghs left to sell, lateness in the inflated art prices that only corporations or men whose financial wizardry had generated corporate-scale funds could afford.

SOTHEBY'S, MAY 17

The morning after the *Gachet* sale, a photograph of the painting appeared at the bottom of the front page of the *New York Times* under the headline, "$82.5 Million van Gogh Sets Auction Record."

Two nights after the Christie's sale, Sotheby's was prepared for Hideto Kobayashi. He entered the building by the back door and sat in a balcony room overlooking the auction, where he could operate without being scrutinized by reporters. This time, on Ryoei Saito's behalf the Tokyo dealer again went after the top lot—Renoir's *Au Moulin de la Galette*. This time, the paper magnate obtained his chosen picture for $78 million.

Like the Christie's sale, the Sotheby's auction brought one of the highest totals ever: close to $300 million of art was sold in slightly over an hour. Three paintings from the Guggenheim Museum brought $45 million. The Kandinsky *Fugue* sold for $20.9 million to the Swiss dealer Ernst Beyeler. Modigliani's *Boy with a Blue Jacket* went for $11.6 million to Klaus Perls, another old-line member of the trade, whose gallery was on Madison Avenue. For $15 million, Chagall's *Anniversaire* was secured by the Seibu Department Store. The Art Institute of Chicago had cashed in a Degas pastel, a Monet, a

Bonnard, and a Picasso—for a sum of $14 million. Taken together, the Impressionist and modern sales that week added up to over half a billion dollars. Japanese buyers had spent $340 million. Of that, Ryoei Saito accounted for almost half. But the press read the failure of twelve out of Sotheby's seventy pictures to sell as evidence that the art world's most expensive commodities were running into trouble. "Despite freakish prices for two great paintings," wrote the critic Robert Hughes in *Time*, "the auction market was showing ominous signs of instability."

Friday's *New York Times* reported the near-record price for Renoir's *Au Moulin de la Galette*, but failed to make the connection to Kobayashi. Several pages away, the paper named Ryoei Saito as the Japanese collector who three nights before had spent $82.5 million to acquire *Portrait of Dr. Gachet*. Not until the next morning, a Saturday, did the *Times* run on its front page an old photograph of Saito, whom the paper described as "the buyer of the two most expensive paintings ever sold at auction." The squandering of over $160 million, which translated into 24.4 billion yen, on two French pictures raised the specter of Tokyo's economic might. Saito's "purchases are considered likely to deepen already serious concern over the manner in which Japanese businessmen are amassing and displaying collections of Western Art."

Before the auctions, the general public had noticed neither the van Gogh portrait nor the Renoir scene of a café. The sums expended upon *Portrait of Dr. Gachet* and *Au Moulin de la Galette* by a Japanese businessman, whose name meant nothing in America, sounded as a wake-up call. Having watched the steel, automobile, and semiconductor industries and Rockefeller Center slip from their hands, Americans could not help but identify a rare van Gogh, recently hanging in the nation's foremost museum, as a potent symbol of the transfer of wealth to Asia. The *Gachet* portrait counted among the spoils of an economic war, which the Japanese seemed to be winning. Some American and European art dealers smugly observed that the Japanese had acquired second-rate Impressionist pictures and overpaid. Still, the torrent of French art pouring into Japanese coffers was read as evidence of America's slippage in the ranks of the great powers.

In the chorus of protests about Japan's role in the commodification of art, few recalled that since the late nineteenth century American industrialists—following the habit of kings, nobles, popes, cardinals, and more recently European entrepreneurs—had spent lavishly to import works of art. Moreover, in the long history of cultural exchange between Japan and the West, the current had flowed toward Europe and America. The Japanese had their own brilliant, completely distinct artistic heritage inspired by the art of China: hanging scrolls painted with ink and watercolor; folding screens in which landscapes and figures were often set against a ground of gold; ancient statues of Buddhist deities designed for temples and shrines; and ceramics created for the tea ceremony. Western observers had long recognized Japan's attention to aesthetics—"the nation of decorative arts par excellence," as one French scholar wrote in the 1880s. Japanese prints and decorative arts began surfacing in Paris not long after Commodore Matthew Perry steered American naval ships into Tokyo harbor in 1853, forcing Japan to sign a series of treaties opening its harbors to Western trade. In the 1870s the art dealer Siegfried Bing began importing Japanese bronzes, ceramics, and prints to France; in 1887 he sold Asian art in New York.

Van Gogh himself began to collect Japanese prints when he was in Antwerp in 1885. "My studio is not bad, especially as I have pinned a lot of little Japanese prints on the wall, which amuse me very much." During his two years in Paris he bought quantities of prints from Bing, and in the spring of 1887 he put on an exhibition of them at the café Le Tambourin. "Whatever one says," the artist wrote, "even the most vulgar Japanese sheets colored in flat tones are, for the same reason, as admirable as Rubens or Veronese." In Paris he acknowledged his stylistic debt to Japan in his portrait of Père Tanguy, in which against the background wall he painted several Japanese prints; he also made canvases that were painted copies of certain prints. In 1888 when he painted the self-portrait dedicated to Gauguin, which was sold at the Fischer sale, he cast himself as a *bonze,* or Japanese priest. He argued,

In a way all my work is founded on Japanese art. . . . Japanese art, decadent in its own country, takes root again among the French impressionist artists. It is its practical value for artists that naturally interests me more than the *trade* in Japanese things. All the same the trade is interesting, all the more so because of the direction French art tends to take.

Ironically, in the Gachet portrait, with its two novels by Jules and Edmond de Goncourt, van Gogh paid tribute to the two authors whose writings and whose collection of Japanese art contributed to its vogue in late-nineteenth-century Paris. When in March 1897 Edmond de Goncourt's collection of Chinese and Japanese art was auctioned in Paris, the catalog (prepared by Bing) listed over 1,500 pieces.

Since the end of the nineteenth century, the Museum of Fine Arts in Boston, the Cleveland Museum of Art, the Nelson Gallery–Atkins Museum in Kansas City, the Metropolitan Museum in New York, and the Freer Gallery in Washington, D.C., had amassed some of the world's great collections of Japanese art outside Japan. In 1890, the year van Gogh painted *Gachet*, the Boston Museum of Fine Arts founded its Japanese department, the first in an American museum. The museum's collection had been acquired mostly by Ernest Fenollosa, an American connoisseur who had been a professor of philosophy at the University of Tokyo and then a Japanese Imperial Commissioner of Fine Arts (1886–1890). In 1884 Fenollosa had written from Tokyo to a friend in Boston:

I bought several pictures dating from 700 to 900 A.D. Already people here are saying that my collection must be kept here in Japan for the Japanese. I have bought a number of the very greatest treasures secretly. The Japanese yet don't know that I have them. I wish I could see them all safely housed forever in the Boston Art Museum. And yet if the Emperor or the Mombusho (Ministry of Education) should want to buy my collection, wouldn't it be my duty to humanity, all things considered, to let them have it?

Fenollosa sold the collection, which included one thousand paintings, to Charles G. Weld, who bequeathed it to the Boston museum in 1911.

THE COLLAPSE OF THE MARKET

Only a month after the *Gachet* sale, London's June Impressionist and modern auctions did not fare well. An expensive Chagall, a painting typical of what Japanese investors had bought in bulk, failed to make its reserve. By then, the Japanese economy was moving into recession. In August 1990 Saddam Hussein invaded Kuwait, and the slowing art market came to a complete halt. The threat of war in the Middle East and the possibility of America being dragged into conflict by a small country seemed to have the greatest psychological impact on Europe, which felt vulnerable. The appetite for buying art seemingly disappeared. In December at a London auction, a still life that van Gogh painted in the asylum of Saint-Rémy estimated to bring over $16 million failed to sell.

By 1992, art dealers with a long perspective claimed the art market had not been in such bad shape since the depression. In the 1930s, however, collectors had been forced to sell. Now they held on. Even after collapsing by half, prices were still high. In the spring of 1992 Renoir's *La Loge*, a picture of a fashionable young woman (who reminded Harry Kessler of his mother) in a opera box, which a German collector had bought at the height of the market for $13 million, was sent back to the block at Christie's. The painting was not much larger than a piece of typing paper. The bidding reached $6 million, and Burge withdrew the picture. At that auction, the Japanese dealers so recently filling the rows of folding chairs in the New York Impressionist and modern auctions were nowhere in sight. The countless runners who had darted between dealers carrying color transparencies were gone; the pool of dealers contracted.

After her long and difficult illness, Lola Kramarsky died in February 1991. Soon after, experts from Christie's were invited to the apart-

ment to catalog the furniture and other pieces of decorative arts. The objects not wanted by the family were dispersed over the next few years at porcelain and furniture sales attended mostly by dealers.

Also in February 1991, the exhibition *Degenerate Art: The Fate of the Avant-Garde in Nazi Germany* opened at the Los Angeles County Museum of Art. While German scholars had held the first exhibition dealing with this dark phase of their nation's cultural history in 1962, *Entartete Kunst: Bildersturm vor 25 Jahren* (*Degenerate Art: After 25 Years*), and presented a second exhibition in 1987, the controversial subject of "degenerate art" had received little attention in North America. The Los Angeles show reassembled almost one-third of the 650 works that had been exhibited in the 1937 *Degenerate Art* show. Its 400-page catalog (with ten essays by German and American scholars) documented not only all the pieces in the Munich exhibition but also the paintings and sculpture sold at the 1939 Galerie Fischer auction in Lucerne. Buried in a footnote of a catalog essay ("On the Trail of Missing Masterpieces: Modern Art from German Galleries") by the German scholar Andreas Hüneke was the first report in English on what had happened to the van Gogh from when it left the Städel to the time it came into the Kramarskys' possession. According to Hüneke, *Portrait of Dr. Gachet*, as well as *Daubigny's Garden* and Cézanne's *Quarry*, had been confiscated by the Propaganda Ministry and "handed over to Hermann Göring."

Information about Hermann Göring's byzantine dealings in art came from papers stored for over forty years in archives in West Berlin. Discovered in the Berlin archives was a letter, dated May 18, 1938, from Franz Koenigs to Josef Angerer. In it, Koenigs asked Angerer to have his agent meet him at the Hôtel San Regis in Paris. In exchange for pounds sterling and sperrmarks, he would buy Cézanne's *Steinbruch*, van Gogh's *Garten Daubigny*, and the *Bildnis des Dr. Gachet*.

PART VII

JAPAN

27

12.4 Billion
Yen

And although only yesterday they paid over half a million francs for Millet's "Angelus" don't think that more souls will now feel what Millet had in mind, or that middle-class people or working men are now going to hang lithographs of this "Angelus" of Millet's in their houses, for instance.
—Vincent van Gogh to Wilhelmina van Gogh, Saint-Rémy, 1889

THREE WEEKS after the May 15 auction, handlers at Christie's packed *Gachet* into a foam-padded wooden crate and delivered it to Sotheby's, which had prepared Renoir's *Au Moulin de la Galette* for shipping. Together the two paintings were flown air freight to Tokyo and driven by truck to the Kobayashi Gallery on the Ginza, where guards carried them through the back door. There Ryoei Saito was waiting. Hideto Kobayashi and his assistants extracted the canvases from their crates and hung them in an alcove.

After spending a few hours with his new acquisitions, Saito left. Immediately, Kobayashi had the van Gogh and the Renoir crated up and sent to a climate-controlled, high-security "trunk room" or warehouse for art, kimonos, furniture, jewelry, and other valuables. Its exact location in Tokyo or its outskirts remained a secret. He later also arranged to have the van Gogh placed into a white cotton bag and set in a cloth-covered plywood box. The box was put on a shelf and left there; to all intents and purposes, *Gachet* was invisible.

Hiding the portrait away in a vault, which to the West violated the very purpose of the picture, in fact followed the Japanese custom of wrapping porcelain and other precious pieces of art and preserving them in boxes. "The real Japanese have *nothing on their walls* . . . drawings and curiosities all being hidden in drawers," van Gogh observed in 1888. (He had just read *Madame Chrysanthème*, a novel written in 1887 by Pierre Loti, which served as the basis of Puccini's opera *Madame Butterfly*.) The interior walls of an ordinary Japanese house were not built to hang Western canvases. Japanese art collectors typically stored scrolls and valuable porcelain in outbuildings constructed of stone beside their houses, which tended to be relatively small wooden structures, flimsy and flammable. In Japan, even the process of looking at a work of art takes a distinct form. Traditionally, Japanese collectors bring works of art out of storage only on special occasions, when they present them ceremoniously to guests. In the 1990s an auction-house expert visited a Tokyo collector to see a Jackson Pollock and found that, like *Gachet*, it had been kept in a box that when carried into the room stretched out the door and down a hall. But in the case of the Gachet portrait the warehousing had to do not only with Japanese custom but apparently also with an industrialist's desire to protect an expensive asset from creditors.

Shortly after the Christie's auction, reporters knocked at the door of Saito's Tokyo house, and the businessman emerged to defend his purchases. "The value of these paintings will be understood in 50 or 100 years," he said. "If I don't buy now, this art will never come to Japan." Peering into the interior, a *Washington Post* writer saw orchids filling the entrance in celebration of a recent birthday, a "waist-high blue and white porcelain vase," and calligraphy by Ikuo Hirayama, a contemporary Japanese artist. Saito claimed that he wanted the two paintings to go to the Shizuoka Prefectural Museum, some hundred miles south of Tokyo.

As honorary chairman of Daishowa Paper Manufacturing, Ryoei Saito maintained his singular grip on a firm founded in the 1930s by his father. The eldest of five brothers, he had inherited the company in 1961. Although Daishowa was now a public corporation, with

some $2.5 billion in sales and factories in Australia, Canada, and the United States, Saito ran it like a family enterprise. (In 1990, the family owned about 30 percent of Daishowa's shares.) The company had its headquarters in Fuji. "Like the smell of the paper mills that dominate this ocean-side city," the *Wall Street Journal* reported in 1991, "Ryoei Saito's power is pervasive here. The smokestacks of his factories obscure Mount Fuji. The bullet train from Tokyo streaks to halt at a station he helped to build. Posters of Mr. Saito's younger brother, the prefectural governor, line store windows at election time. One of Mr. Saito's four sons represents the region in the Diet. Mr. Saito's company financed the mayor's most recent campaign."

As Daishowa's president, Saito had been succeeded by two brothers, and by his eldest son, Kiminori. His three other sons held high posts in the company. In the late 1970s, when Daishowa had accumulated losses after a disastrously timed expansion, the Sumitomo Bank Ltd., its chief creditor, had forced Saito out of the presidency. But by the mid-1980s he had wrested control from a brother.

Saito's eccentricities stood in bald contrast to the uniform blandness cultivated by most Japanese executives. He owned a large black Cadillac, often parked outside his house. He visited Christie's auction preview exhibitions in Tokyo surrounded by a retinue of assistants. He learned that *Gachet* was to be auctioned from a magazine Christie's sent to dealers and collectors around the world. Saito's volatile pattern of art collecting followed the ups and downs of his economic fortunes. In the late 1960s he bought Impressionist and modern pictures for Daishowa's account, some through Tokyo's Fujii Gallery, where Hideto Kobayashi happened to work. But in 1983 after Sumitomo stripped him of power, the bank put Saito's collection up at auction at Sotheby's. Later, back in control, Saito began collecting again—this time, mostly Japanese art—including quaint, clichéd pictures of Mount Fuji. In 1978 Hideto Kobayashi left Fujii Gallery to set up his own business, which he stocked with contemporary Japanese paintings.

To buy *Gachet* and *Au Moulin de la Galette*, Saito borrowed from a bank against his real estate holdings and then repaid the short-term loan by selling shares of stock and land. Art dealers spec-

ulated that Saito's spending of 24.4 billion yen would theoretically lower the inheritance taxes on his estate because Japanese tax authorities calculated duties on art (as opposed to land) at a discount from its market value. But Kobayashi contended that taxes had nothing to do with Saito's purchase; he bought the painting, he said, simply because the image of the doctor appealed to him: "He saw himself." The international outcry over his acquisition of *Gachet* came as a shock to the collector and awakened him to the significance of his purchases.

Less than a year after Saito bought *Gachet*, he called a news conference to discuss his $23 million income tax bill—liabilities arising primarily from the land sales made to purchase his two European masterpieces. "I'm telling the people around me to put [the paintings] into my coffin and burn them with me when I die," he said. Reaction in the West was predictable. Later, Saito claimed he had been joking. "He didn't mean it literally," Kobayashi explained. "It's just that he appreciates the picture that much. . . . Most Japanese would understand [what he meant] because it is our custom." Within weeks, the *Wall Street Journal* predicted that Daishowa would lose as much as 13 billion yen that year.

Saito's purchase gave the Japanese art market a quick shot in the arm, but the effects lasted only about six months. Sachiko Hibiya at Christie's observed new galleries opening in Tokyo as late as the fall of 1990. But months later, as the bubble economy burst, the art market went into free fall. The Nikkei stock average had peaked on the last business day of 1989 at 38,915; by August 1992 it was at 14,309. Meanwhile, the inflated real estate market had also crumbled. Interest rates climbed, stopping the flow of money, and demand for art slackened; the prices of Impressionist and modern pictures began to collapse. The finishing blow was dealt by the bankruptcies of several prominent Tokyo art galleries and revelations of corruption throughout the market.

The most devastating scandal involved the Osaka trading company Itoman Corporation, which had used some $500 million,

much of it from its primary creditor, Sumitomo Bank, to buy thousands of paintings together with forged appraisals, which were then employed in an intricate black-market real estate investment program. For a while Itoman accumulated art at a fast enough rate to create a false sense that in late 1990 the art market was still appreciating. In the end, both Itoman's president and Sumitomo's chairman, Ichiro Isoda, resigned. As Japanese demand for Impressionist pictures evaporated, the country's art imports plummeted from a high of 614.7 billion yen in 1990 to 22.9 billion yen two years later. Following the bankruptcies of numerous art dealers, Japanese banks and lending companies began taking possession of pictures. The banks also repossessed paintings from the entrepreneurs and professionals who had bought them with borrowed money, only to discover that in the current market they would recoup only 10 to 20 percent of what they had paid. In Tokyo and elsewhere, French paintings were stacked by the thousands in bank vaults and trunk rooms. Western art dealers brought in to scan the material advised against selling to avoid inundating the market. Reluctant to accept the humiliation of registering a loss, the banks held on to the pictures. Now bankrupt, Tomonori Tsurumaki, the racetrack owner who had squandered 8 billion yen ($51.3 million) on Picasso's *Pierette's Wedding* via satellite, had reportedly in 1991 turned it over to creditors. (By 1997 art experts estimated the paintings taken by Japanese banks and lending companies to be worth as much as $3 billion.)

REVISION

In the summer of 1990 a young German scholar of Renaissance art, Markus Kersting, wrote to Ryoei Saito asking to borrow *Portrait of Dr. Gachet* for an exhibition, called *Revision*, he was organizing at Frankfurt's Städel that would reassemble some of the modern paintings the Nazis had confiscated from the museum. Forty-five years later, the devastation of World War II remained visible in the museum building, which looked across the Main River to the

postwar glass-and-steel towers of Germany's financial center; at either end of the nineteenth-century façade, stripped-down wings had replaced the sections destroyed by Allied bombing.

Kersting received no reply from Saito. He turned to Frankfurt's bankers with connections to the Japanese industrialist, but they refused to get involved. Saito owed money to a number of German banks; to borrow an asset of this size might be misread as an underhanded attempt to extract some sort of collateral. Hermann Josef Abs, chairman of the Städel's board, also declined to use his considerable influence in the international banking world to appeal to Saito for the loan of an object whose $82 million price was widely published. The risk was uninsurable, Abs thought. Recalling that recently an extremist had poured gasoline over papers at the Beethoven house in Bonn, incinerating the composer's manuscripts, he worried that the painting would be attacked by someone who wanted to prevent the owner from getting it back. Finally, a German government minister took up Frankfurt's cause and wrote the Japanese industrialist. Saito again failed to answer, and Kersting gave up. The *Revision* show opened in the fall of 1990, only months after the Christie's auction. In the exhibition catalog, Kersting wrote an extensive analysis of the van Gogh painting, calling it a "grievous metaphor" for Frankfurt's collection of modern art.

On November 11, 1993, Ryoei Saito was arrested on charges that two years before he had paid Shuntaro Honma, then governor of Miyagi Province, a bribe of some 100 million yen ($960,000) to change the zoning restrictions on a piece of forest land in the city of Natori, where Daishowa subsidiaries sought to construct a golf course and two thousand condominiums. The golf club, whose membership would command high fees, was named "Vincent" in honor of the Dutch Postimpressionist painter. The investigation of Saito's practices came out of a larger zenecon (general contractor) probe, which found that some eighteen large construction companies had customarily bribed mayors, prefectural governors, congressmen, and others at the highest levels of the government. Under arrest, Saito was incarcerated in the Tokyo Detention House and

stripped of his title of honorary chairman of Daishowa. In mid-December, too ill to remain in prison, he was sent to a hospital. On February 24, 1994, he was pushed in a wheelchair into Tokyo District Court, where he pleaded guilty to the charge. Saito's arrest meant the end of his close control of the overextended paper company. His downfall shocked Japan and underlined the determination of the new justice minister to root out the corruption that had been an entrenched part of Japanese business and politics under the Liberal Democratic Party. The prosecutions signaled the new government's drive to hold corporations accountable to tighter ethical standards, part of a wider shift in Japanese society, which had begun to question the high price of the small country's stupendous economic success. Just as thirty years ago *productivity* had entered the Japanese vocabulary, the term *quality of life* was suddenly gaining currency, as many decided that the blind chase for material wealth had left them in an electronically well-furnished labor camp—their families housed in small spaces, commuting long distances, and getting little time off.

In 1993 Daishowa Paper continued to lose money; its debt climbed to some 400 billion yen, and the price of its shares, along with those of other Tokyo stocks, was plunging. To restore confidence in the ailing paper company, Shogo Nakano, a new chairman, began a process of restructuring designed in part to separate out Saito's private holdings. The Saito family agreed to cut its share to 15 percent. Kobayashi claimed to have received countless offers to buy *Gachet* but denied that Saito, under house arrest, had any thought of selling it. Because Saito's finances were still so intricately mixed with Daishowa's, it was unclear to the West whether he, the firm, or creditors owned his two paintings. But by the end of 1993 many assumed that as Saito's career was finished, the picture was effectively on the market.

Trying to fathom *Gachet*'s situation put Christopher Burge in an awkward position. Facing a cultural barrier between East and West, the auctioneer struggled to determine how to maneuver. He couldn't telephone Kobayashi, since he spoke no Japanese, and the dealer claimed to speak no English. Also, in Japan a direct call would have

been a serious breach of decorum. Although Japanese colleagues might be too polite to say so, they conveyed the idea that it would be very bad form for Americans to approach Saito in the hope of learning if the pictures were for sale. From the Japanese point of view, members of the trade couldn't simply ask this question without immediately losing face. A once-important industrialist was in disgrace. To put oneself forward and inquire about the picture only showed insensitivity to his situation and might jeopardize any chance of ultimately getting one's hands on the canvases. But Burge and others in the Impressionist and modern market worried that while they were going along with Japanese customs the industrialist might negotiate to release his warehoused van Gogh. (If indeed the painting were available, Burge would recommend that it be sold not at auction but privately.) In late October 1995, Tokyo District Court sentenced Saito to a three-year prison term, suspended for five years.

In November 1995, for the first time in five years Christie's and Sotheby's both secured more than a handful of decent Impressionist and modern pictures, and by the end of both evenings sales over $100 million had been spent. On Tuesday, November 7, Christie's sold a 1932 Picasso for $20 million, $6 million less than the $26.4 million that a Japanese investor had paid for it at the height of the market. At Sotheby's on November 8, bidding on *The Thicket*, a landscape of trees that van Gogh had painted in Auvers, rose to $27 million. European and American dealers filled the salesrooms, seated in the closely packed rows of folding chairs, ringed by reporters standing four deep against the side and back walls. The empty seats patterning the evening sales during the nadir of the post-1990 depression had filled. There were even a few Asian dealers. The wary, beleaguered mood that had gripped New York in the wake of the assassination of Israeli prime minister Yitzhak Rabin seemed to have no impact upon the auction. More relevant was the record-high level of the New York stock market.

Meanwhile, in the fall of 1990 Congress had provisionally changed the tax regulations to once again give collectors incentives to donate their art to museums: in August 1993, a bill allowing donors to deduct the appreciated value of works of art was signed

into permanent law. That year Walter Annenberg gave the Metropolitan 50 percent interest in two van Gogh still lifes. (He had announced his intention to bequeath fifty modern paintings to the museum.) Funding from Annenberg also allowed the Metropolitan to purchase van Gogh's *Wheat Fields with Cypresses* (for $57 million) as well as the *Shoes* that had been in the Kramarskys' collection.

For six years Ryoei Saito kept *Gachet* locked in a warehouse. Customarily, once a year Kobayashi and others from his gallery went to check on the condition of the picture. In March 1996 the ailing Saito died. Months afterward dealers and auction experts still speculated on whether the late collector's van Gogh portrait was controlled by his heirs, his company, or his creditors.

On Tuesday, May 13, 1997, the day of the first of Christie's spring sales, when the stock exchange closed the Dow Jones average stood at 7,274. That week in New York, art collectors had paid some $313 million for Impressionist and modern paintings, a level of spending not seen since the spring of 1990, when over $500 million had been auctioned; at Christie's a Cézanne portrait of Mme Cézanne sold for $23.1 million. Shortly after the auctions, the *New York Times* reported that Saito's Renoir, *Au Moulin de la Galette*, had been privately sold through Sotheby's. An auction house official said he could neither confirm nor deny this. If and when *Portrait of Dr. Gachet* reappeared in the United States, its sale, like that of the Renoir, would likely be negotiated in secret.

For seven years, wrapped in cotton, the picture had lain inside a box, protected and entombed. Attempting to decode the social and economic practices that governed Japan, westerners still assumed that *Gachet*'s disappearance was only temporary, that the portrait's next entrance into the international market would be only a matter of time.

In June 1890, van Gogh wrote:

I've done the portrait of M. Gachet with a melancholy expression, which might well seem like a grimace to those who see it. And yet I had to paint it like that to convey how much expression and passion there is in our present-day heads in comparison with the old calm portraits, and how much longing

and crying out. Sad but gentle, yet clear and intelligent, that is how many portraits ought to be done. At times it might well make some impression on people.

There are modern heads that may be looked at for a long time, and that may perhaps be looked back on with longing a hundred years later.

NOTES

A NOTE ON THE ECONOMICS

To attempt to convey the value of the historical prices paid for *Portrait of Dr. Gachet* each time it was sold, those sums have been converted into U.S. dollars at the time; then the consumer price index was used to translate those dollars into 1995 dollars. This describes the hypothetical experience of taking the funds obtained for the painting, exchanging them for U.S. dollars, and then holding these dollars until 1995. But if, for instance, the 12,000 pounds paid in 1938 for *Gachet* and two other pictures had been held in British currency, they would have been worth considerably less half a century later than if they had been held in American dollars because Britain experienced a higher rate of inflation in the 1970s than did the United States. The work on the economic statistics was done by Timothy W. Guinnane at the Department of Economics, Yale University.

ABBREVIATIONS

BvBM	Boijmans Van Beuningen Museum, Rotterdam.
CL	*The Complete Letters of Vincent van Gogh* (Boston: Little, Brown and Company, 1978). Numbers refer to letters.
GStA PK	Geheimes Staatsarchiv Preussischer Kulturbesitz, Berlin.
HGK	Harry Graf Kessler (Harry, Count Kessler).
JvGB	Johanna van Gogh–Bonger.
PC	Paul Cassirer.
RdeL	*The Letters of Vincent van Gogh*, ed. Ronald de Leeuw, trans. Arnold Pomerans (London: Penguin Press, 1996). Numbers refer to letters.
SKA	Städelsches Kunstinstitut Archives, Frankfurt.
TvG	Theo van Gogh.
VGF	Van Gogh Foundation.
VvG	Vincent van Gogh.
VWvG	Vincent Willem van Gogh.

xiii "The Work of Art in the Age of Mechanical Reproduction," in Hannah Arendt, ed., *Illuminations: Essays and Reflections*, trans. Harry Zohn (New York: Harcourt, Brace & World, 1968), 222. First published in *Zeitschrift für Sozialforschung*, V, I, 1936.

Prologue: Sacred and Profane

xvii *"economic life"*: Michael Baxandall, *Painting and Experience in Fifteenth-Century Italy* (New York: Oxford University Press, 1972), 2.

xviii *"the same sentiment as the self-portrait"*: CL 638.

xviii *"expression of our time"*: van Gogh to Gauguin, CL 643.

xxii *"apparition"*: CL W22.

1. Van Gogh: Dealer, Preacher, and Painter

3 *Van Gogh:* See Roland Dorn, "Van Gogh," in Dorn, Leeman, et al., *Vincent Van Gogh and Early Modern Art, 1890–1914* (Essen: Museum Folkwang, 1990); JvGB, "Memoir of Vincent van Gogh," in CL xv–liii.

3 *"nor the old Dutch school have done"*: RdeL 418.

3 *"real country, characteristic and picturesque"*: CL 635.

4 *"great painter"*: G.-Albert Aurier, "The Isolated Ones: Vincent van Gogh," *La Mercure de France* (January 1890), trans. Ronald Pickvance, in Pickvance, *Van Gogh at Saint-Rémy and Auvers* (New York: Metropolitan Museum of Art, 1986), 313.

4 *"descendant of the old masters of Holland"*: ibid., 311.

4 *"Albert [Goupil] has given us the recipe"*: CL 500.

4 *"The way it used to be in Holland"*: CL 512.

5 *"purchase money invested for years to come"*: CL 538a.

5 *220 francs a month:* Walter Feilchenfeldt, "Vincent van Gogh—His Collectors and Dealers," in Dorn, Leeman, et al., *Early Modern Art*, 39; Paul Tucker, "The First Impressionist Exhibition," in Charles S. Moffett et al., *The New Painting* (San Francisco: Fine Arts Museum of San Francisco, 1986), 116 n. 76.

5 *"a purchase on your part"*: CL 364.

5 *"in practice that means doing portraits"*: RdeL 514.

6 *Goupil & Cie:* See "Goupil," in CL 2: 579–581.

6 *Goupil's had advanced:* Albert Boime, "Entrepreneurial Patronage in Nineteenth-Century France," in Edward C. Carter II, Robert Forster, and Joseph N. Moody, eds., *Enterprise and Entrepreneurs in Nineteenth- and Twentieth-Century France* (Baltimore: Johns Hopkins Press, 1976), 167.

7 *French Academy set history painting:* Patricia Mainardi, *The End of the Salon* (Cambridge: Cambridge University Press, 1993), 12–14.

7 *Andromache:* For the Georges Rochgrosse canvas, see ibid., 104.

7 *arrest of Charlotte Corday:* For Alfred Dehodencq's painting, see Robert Rosenblum, *Paintings in the Musée d'Orsay* (New York: Stewart, Tabori & Chang, 1989), 57.

7 *proliferation of genre scenes and landscapes:* Henri Loyrette, "The Salon of 1859," in Gary Tinterow and Henri Loyrette, *Origins of Impressionism* (New York: Metropolitan Museum of Art, 1995), 14.

7 *"a gloomy grandeur"*: Jules Castagnary, quoted in Loyrette, "1859," 15.

8 *"riverbank, or seashore":* Robert Herbert, *Impressionism* (New Haven: Yale University Press, 1988), 304.

8 *"That's magnificent, that's poetry":* RdeL 13.

8 *"real and existing things":* Gustave Courbet, "Letter to his Students," 25 December 1861, in Linda Nochlin, *Realism and Tradition in Art, 1848–1900* (Englewood Cliffs, N.J.: Prentice Hall, 1966), 35.

8 *at 2, place de l'Opera:* Dorn, interview.

9 *working-class subjects:* Linda Nochlin, *The Politics of Vision: Essays on Nineteenth-Century Art and Society* (New York: Harper & Row, 1989), 105.

10 *"approve of it without knowing why":* RdeL 404.

2. Paris, 1886–1887

11 *"Claude Monet landscape":* VvG to H. M. Livens, CL 459a.

12 *"intoxication of light":* Edmond Duranty, "The New Painting," in Linda Nochlin, ed., *Impressionism and Post-Impressionism, 1874–1904* (Englewood Cliffs, N.J.: Prentice Hall, 1966), 4–5.

12 *to benefit the state:* Daniel Sherman, *Worthy Monuments* (Cambridge: Harvard University Press, 1989), 17.

12 *the "new painting":* Duranty, "New Painting," 3.

12 *department stores, and 1.8 million citizens:* David Thomson, *Europe since Napoleon*, 2d ed. (New York: Alfred A. Knopf, 1966), 245.

13 *"unheard of in their native lands":* Kirk Varnedoe, "Nationalism, Internationalism, and the Progress of Scandinavian Art," in Varnedoe,

Northern Light: Realism and Symbolism in Scandinavian Painting, 1880–1910 (New York: Brooklyn Museum, 1982), 15.

13 *their eighth and last exhibition:* see Martha Ward, "The Eighth Exhibition: The Rhetoric of Independence and Innovation," in Moffett, *New Painting*, 421–73.

13 *"Egyptian" forms:* Robert Herbert et al., *Georges Seurat, 1859–1891* (New York: Metropolitan Museum of Art, 1991), 174.

13 *"neo-Impressionists":* ibid., 3.

13 *"rays of light":* Félix Fénéon, "The Impressionists in 1886," in Nochlin, *Impressionism*, 109.

14 *"a vehement activity of thought":* Julien Leclercq, "Vincent's Paintings at the Bernheim Jeune Gallery (1901)," in Bogomila Welsh-Ovcharov, *Van Gogh in Perspective* (Englewood Cliffs, N.J.: Prentice Hall, 1974), 70.

14 *"the final doctrine":* CL 539.

14 *the bleak suburban landscape:* See T. J. Clark, *The Painting of Modern Life: Paris in the Art of Manet and His Followers* (Princeton, N.J.: Princeton University Press, 1986), 23–30.

14 *twenty-four self-portraits and ninety still lifes:* Pickvance, *Arles*, 34–35.

15 *"start selling one day":* TvG quoted in John Rewald, *Post-Impressionism: From van Gogh to Gauguin*, 3d ed. (New York: Museum of Modern Art, 1978), 40.

15 *allowed Theo ... to promote:* Dorn, interview. See John Rewald, "Theo van Gogh as Art Dealer," in Rewald, *Studies in Post-Impressionism*, Irene Gordon and Frances Weitzenhoffer, eds. (New York: Harry N. Abrams, 1986), 7–115.

15 *on consignment from Camille Pissaro:* ibid., 10.

15 *20,000 francs for fourteen paintings by Monet:* ibid., 15, 20.

15 *from a Cabanel portrait:* ibid., 20.

15 *"Hôtel Drouot where all the public sales took place":* ibid., 14.

16 *average weekday crowd of 4,000:* Tucker, "Impressionist Exhibition," 106.

16 *attracted 16,000:* Ronald Pickvance, "Contemporary Popularity and Posthumous Neglect," in Moffett et al., *New Painting,* 260.

16 *several Paris art groups:* Martha Ward, "Impressionist Installations and Private Exhibitions," *Art Bulletin* 73, no. 4 (1991): 605.

16 *an average of some 2,000 canvases:* Mainardi, *End of the Salon,* 47.

16 *"accepted and rejected":* Henry Loyrette, "1859," 4.

16 *the attention of critics and dealers:* See ibid., 17–47.

16 *Paul Durand-Ruel:* For Durand-Ruel's biography see Anne Distel, *Impressionism: The First Collectors,* trans. Barbara Perroud-Benson (New York: Harry N. Abrams, 1990), 21–31; Robert Jensen, *Marketing Modernism in Fin-de-Siècle Europe* (Princeton, N.J.: Princeton University Press, 1994); and Harrison C. White and Cynthia White, *Canvases and Careers: Institutional Change in the French Painting World* (New York: John Wiley & Sons, 1965), 99, 124–129.

16 *"bought pictures from Claude Monet":* CL 535.

17 *the dealer had spent 70,000 francs:* Tucker, "Impressionist Exhibition," 106.

17 *"known to collectors":* Durand-Ruel, letter in *L'Evenement,* 5 November 1885, in Distel, *First Collectors,* 23.

17 *business magnates and financiers:* Jensen, *Marketing Modernism,* 33.

17 *Théodore Rousseau:* ibid., 53. "Durand-Ruel in his first daring coup bought up almost the entire production of several Barbizon painters" (ibid., 99).

17 *doubling the 20,000 francs:* letters from Sensier to Millet, 30 April and 12 July 1872, in Jensen, *Marketing Modernism,* 289 n. 13.

17 *the span of their work:* White, *Canvases and Careers,* 98.

17 *overcrowded, haphazardly hung:* See Mainardi, *End of the Salon,* 136–138. See Ward, "Impressionist Installations," 599–622.

17–18 *"a truly private and intimate space":* E. Bergerat, "Chronique parisien," *Gil Blas,* 17 May 1891, quoted in Ward, "Impressionist Installations," 618.

18 *"one hesitates":* Durand-Ruel, "Mémoires de Paul Durand-Ruel," quoted in Ward, "Impressionist Installations," 618 n. 65.

18 *"to double his profits":* Katherine Cassatt to Alexander Cassatt, 25 May 1881, in Nancy Mowll Mathews, ed., *Cassatt and Her Circle: Selected Letters* (New York: Abbeville Press, Cross River Press, 1984), 162–163. Archive of American Art, Carl Zigrosser Collection, C6, Philadelphia Museum of Art Archives.

18 *"than our French collectors":* Frances Weitzenhoffer, *The Havemeyers: Impressionism Comes to America* (New York: Harry N. Abrams, 1986), 41–42.

18 *prove a brilliant strategy:* Boime, "Entrepreneurial Patronage," 169.

19 *underline the artists' independence:* Ward, "Eighth Exhibition," 423.

3. Arles, 1888–1889

20 *"to execute an idea held in common"*: CL B6 (June 1888).

20 *"Japanese way of feeling and drawing"*: CL 605.

20 *"the note I seek in my painting"*: Paul Gauguin to Emil Schuffenecker, end of February or early March 1888, quoted in Claire Frèches-Thory, "Brittany, 1886–1890," in Richard Brettell et al., *The Art of Paul Gauguin* (Washington, D.C.: National Gallery of Art, 1988), 55.

21 *"studies of color"*: CL 501A.

21 *"only it must be disentangled"*: CL B19 (17).

21 *"clash and contrast"*: CL 533 (8 September 1888).

21 *decorative cycle*: See Dorn, "Van Gogh," 31–38.

22 *"disorder and carelessness"*: Edmond Duranty, "La nouvelle peinture" (Paris: E. Dentu, 1876), quoted in Loyrette, "Portraits and Figures," in Tinterow and Loyrette, *Origins*, 229.

22 *"Socratic type"*: CL 520.

22 *"terrible republican, like old Tanguy"*: CL B14 (9).

22 *personification of the French Revolution*: CL 520.

22 *"arbitrary colorist"*: ibid.

22 *"wild beast"*: CL B15.

22 *"old gold in the shadows"*: CL 520.

23 *"little hope"*: TvG to JvG, quoted in Ronald Pickvance, *Van Gogh in Arles* (New York: Metropolitan Museum of Art, 1984).

23 *"madman," "public danger," "special asylum"*: from a police report (3 March 1889), quoted in Pickvance, *Arles*, 240.

4. Saint-Rémy, May 8, 1889–May 16, 1890

24 *"radiance and vibrancy of our coloring"*: CL 531.

24 *"by cutting off his right ear"*: Théophile-Zacharie-Auguste Peyron, writing on 9 May 1889 in the asylum register, quoted in Pickvance, *Saint-Rémy*, 26.

24 *later as epilepsy*: CL W15.

24 *"my first attack"*: RdeL 592 (22 May 1889).

25 *"too cold"*: RdeL 605 (ca. 7 September 1889).

25 *Philippe Pinel*: On Pinel's "moral treatment," Jan Goldstein, *Console and Classify: The French Psychiatric Profession in the Nineteenth Century* (Cambridge: Cambridge University Press, 1987), 64–89.

25 *"gaining his confidence"*: Philippe Pinel, quoted in ibid., 85.

25 *had published over 150 accounts*: Elmyra van Dooren, "Illness and Creativity," in Tsukasa Kodera and Yvette Rosenberg, eds., *The Mythology of Vincent van Gogh* (Philadelphia: John Benjamins, 1993), 341–344. (See also Jen Hulsker, "The Borinage Episode," in Kodera and Rosenberg, *Mythology*, 323.)

26 *several diseases*: Pickvance, *Saint-Rémy*, 15.

26 *suffering from "melancholy"*: "At times I have attacks of melancholy and atrocious remorse," VvG wrote (CL W11, 10 April 1889); "This horror of life is less strong and the melancholy less acute" (CL 592, 25 May 1889).

26 *"slightly spoiled food"*: CL 605 (10 September 1889).

26 *"gold embroidery; it is magnificent"*: CL T12.

27 *manifesto published by Jean Moréas:* Jean Moréas, "Le Symbolisme," literary supplement, *Figaro*, 18 September 1886, in Henri Dorra, *Symbolist Art Theories* (Berkeley: University of California Press, 1994), 150–152.

27 *"in the same formidable unknown":* G.-Albert Aurier, "The Symbolist Painters," trans. H. R. Rookmaaker, quoted in Herschel Chipp, *Theories of Modern Art* (Berkeley and Los Angeles: University of California Press, 1968), 93.

27 *"to chase away science":* G.-Albert Aurier, "Essay on a New Method of Criticism, 1890–1893," in Chipp, *Theories*, 87.

27 *"mysterious centers of thought":* Paul Gauguin, "Diverses Choses, 1896–1897," in Chipp, *Theories*, 65.

28 *"to clothe the idea":* Moréas, "Symbolisme," 151.

28 *"almost always a symbolist":* Aurier, "Isolated Ones," 313.

28 *"profound, complex":* Aurier, "Isolated Ones," 312.

28 *"reflecting, iridescent, magical":* ibid., 311.

28 *"living on ideas and dreams":* ibid., 313.

28 *the term* symbolism: See John Rewald, *Post-Impressionism: From Van Gogh to Gauguin*, 3d ed. (Boston: New York Graphic Society, 1978), 133–166; Robert Goldwater, *Symbolism* (New York: Harper & Row, 1979).

28 *"of M. Meissonier":* Aurier, "Isolated Ones," 314.

28 *by Ernest Meissonier:* Rewald, "Theo van Gogh," 21.

28 *"the true artists":* Aurier, "Isolated Ones," 314.

29 *"the preposterousness of it":* CL 626a, VvG to Albert Aurier (12 February 1890).

29 *"get well quickly":* CL 630.

29 *"with all the impressionists":* CL T18.

29 *"guarantee your recovery":* CL T31 (29 March 1890).

29 *"two months":* CL 629.

29 *"an asylum by force":* CL 609.

30 *"attraction of the exhibition":* CL T29 (19 March 1890).

30 *"you are the only one who thinks":* Gauguin to VvG, March 1890, quoted in Susan Alyson Stein, *Van Gogh: A Retrospective* (New York: Wings Books, 1986), 159.

30 *"Red Vineyard":* Feilchenfeldt, "Van Gogh," 40.

30 *"cured":* Pickvance, *Saint-Rémy*, 73.

5. Auvers: Paul-Ferdinand Gachet, 1890

31 *"what went wrong with me":* CL 635.

32 *circle of Gustave Courbet:* Rewald, *Post-Impressionism*, 362–363.

32 *Jean-Martin Charcot:* Charcot's fame had helped put the notion of the subconscious into currency in Paris. (Debora L. Silverman, *Art Nouveau in Fin-de-Siècle France* [Berkeley and Los Angeles: University of California Press, 1989], 83–106.) See Goldstein, *Console and Classify*, 327–345.

32 *minimal chance of cure:* Goldstein observes, "So frequently did contemporaries level the charge that Charcot was far more absorbed in labeling than in treating his patients that his students regularly mentioned and responded to that charge in the spate of commemorative essays that appeared after his death in 1839."

(Goldstein, *Console and Classify*, 380.)

32 *Trained by Jean-Pierre Falret:* Paul Gachet, *Deux Amis des Impressionnistes: Le Docteur Gachet et Paul Murer* (Paris: Editions des Musées Nationaux, 1956), 32. For Falret, see Goldstein, *Console and Classify*, 385–386.

32 *"the great artists":* Paul-Ferdinand Gachet, *Etude sur la mélancolie* (Montpellier: Imprimeur de l'Academie, Editeur de Montpellier Medical, 1858), 45.

32 *"opium smoking Chinese":* ibid., 35.

33 *"this epoch is marked by numerous suicides":* ibid., ix–x.

33 *"elixir of Dr. Gachet":* Paul Alexis, "Auvers-sur-Oise," *Le Cri du peuple*, 15 August 1887, quoted in Pickvance, *Saint-Rémy*, 195.

33 *dyed with saffron:* Rewald, *Post-Impressionism*, 366.

33 *"rabid Republican":* ibid., 362.

33 *the workshop of a medieval alchemist:* JvGB, "Memoir," li.

34 *"to lessen its intensity":* CL 637.

34 *"physically and mentally, too":* RdeL W22.

34 *"things are going on quite well":* CL 638.

34 *"as if there were nothing the matter with me":* CL W21.

34–35 *"days seem like weeks to me":* CL 636.

35 *"don't they both fall into the ditch":* CL 648.

35 *"drawing on metal":* TvG to VvG, 23 June 1890, CL T38. According to Roland Dorn, it remains difficult to pinpoint exactly when van Gogh made this etching. See Dorn, Leeman, et al., *Early Modern Art*, 176.

6. The Portrait of Dr. Gachet

36 *"portraits ought to be done":* RdeL W23 (11 or 12 June 1890).

36 *painting Gachet's portrait:* See Welsh-Ovcharov, *Cloisonism*, 163–166; Evert van Uitert, "Vincent van Gogh and Paul Gauguin in Competition," *Simiolus* 2, no. 2 (1980): 87–102.

36 *"as quick as lightning":* CL 223.

36 *"in a single half hour":* CL 507.

37 *"the thing of the future":* CL B19 [17].

37 *"something of the eternal":* CL 531.

37 *"the simple means of portraiture":* CL B13 [8].

37 *their families and friends:* See "Portraits and Figures," in Tinterow and Loyrette, *Origins*, 183–231.

38 *German master Albrecht Dürer:* See Erwin Panofsky, *The Life and Art of Albrecht Dürer* (Princeton, N.J.: Princeton University Press, 1943), 156–171. Van Gogh was reminded of the Dürer by a print of Charles Méryon: "This Méryon, even when he draw bricks, or granite, or iron bars, or a railing of a bridge, puts into his etchings something of the human soul, moved by I do not know what inner sorrow. I have seen drawings of Gothic architecture by Victor Hugo. Well, without having Méryon's force and masterly technique, there is something of the same aesthetic. What is that sentiment? It has some relation to what Albrecht Dürer expressed in his 'Melancholia' " (CL 136).

38 *"Boy with a Skull"* and *"The Smoker":* Theodore Reff, "Painting and Theory in the Final Decade," in William Rubin, ed., *Cézanne: The Late Work* (New York: Museum of Modern Art, 1977), 18.

39 *"Tasso in the Hospital"*: Welsh-Ovcharov, *Cloisonism*, 163. He referred at different times to the Tasso portrait (CL 546).

39 *"the soul of the model in it"*: CL 531.

39 *"An old man reading a yellow novel"*: CL 517. See Aimée Brown Price, "Two Portraits by Vincent van Gogh and Two Portraits by Pierre Puvis de Chavannes," *Burlington Magazine*, November 1975, 718.

39 *"in spite of its inevitable griefs"*: CL 617.

40 *Jules and Edmond de Goncourt*: See Silverman, *Art Nouveau*, 17–39.

40 *thesis on melancholy*: Paul-Ferdinand Gachet, *Mélancolie*, 70.

40 *"as ill and distraught as you or me"*: CL 638.

40 *a form of neurasthenia or nervous collapse*: Goldstein, *Console and Classify*, 156.

40 *photographs of lunatics as diagnostic tools*: ibid., 154. Etrienne-Jean Georget commissioned Theodore Géricault to paint ten images of monomaniacs, which the artist completed between 1821 and 1924. Goldstein adds, ". . . the interest of the early psychiatrists in the physiognomy of insanity . . . —Georget's parallel commission to the painter Géricault to depict the monomaniacs—became under the supervision of Charcot, and with the benefit of the new technology of the camera, a giant and often grotesque archive of the iconography of nervous illness" (ibid., 380). Gachet himself made sketches of the artist Charles Méryon, who was incarcerated at Charenton.

41 *"for not being a doctor"*: CL 560.

41 *"writers of the nerves"*: Edmond de Goncourt, quoted in Silverman, *Art Nouveau*, 37.

41 *"why shouldn't we do the same"*: CL 442.

41 *"Melancholy and pessimism"*: RdeL W1.

41 *"always close to the pathological"*: Aurier, "Isolated Ones," 312. Six years later Emile Zola wrote, "Society is racked without end by a nervous irritability. We are sick and tired of progress, industry and science" (quoted in Silverman, *Art Nouveau*, 7).

42 *"their contrasts and harmony"*: CL W20.

42 *"infinity"*: CL 520.

42 *representational and abstract*: "The depiction is both Realist and Symbolist without any conflict between the two approaches" (Welsh-Ovcharov, *Cloisonism*, 163).

42 *"sensed mood of the person"*: Meyer Schapiro, *Vincent van Gogh* (1950. Reprint New York: Harry N. Abrams, 1980), 116.

42 *"assembled in a certain order"*: Maurice Denis, "Definition of Neo-traditionism" (1890), in Chipp, *Theories*, 94.

43 *"the clothes are a bright lilac"*: CL W22.

43 *"Christ in the Garden of Olives"*: CL 643.

43 *"nightmare of a Christ"*: RdeL B21 (20 November 1889).

43 *"the actual Gethsemane"*: ibid.

43 *"I follow you there"*: CL 643.

44 *"the precariousness of our existence"*: RdeL 649 (around 10 July 1890).

44 *"painters I have greatly loved"*: RdeL 651.

44 *"He has wounded himself"*: Gachet to TvG, 27 July 1890, quoted in JvGB, "Memoir," liii.

7. Paris: Theo van Gogh, 1891

49 *"stir up the public mind"*: CL T4 (16 March 1889).

49 *painted . . . from the original*: Roland Dorn, interview, 1996.

49 *physician with pictures*: Julius Meier-Graefe, *Entwicklungsgeschichte der Modernen Kunst* (Stuttgart, 1904), 119–120, claimed Gachet had as many as twenty-nine van Goghs. See Feilchenfeldt, "van Gogh," 43.

50 *"own brother"*: TvG to Anna van Gogh, in CL, liii.

50 *50 pictures*: Roland Dorn, interview, 1996.

50 *"A great artist is dead"*: Eugène-Guillaume Boch to TvG (4 August 1890), b1016 V/1962, quoted in Ronald Pickvance, *"A Great Artist is Dead": Letters of Condolence on Vincent van Gogh's Death*, ed. Sjraar van Heugten and Fieke Pabst, trans. Yvette Rosenberg, Ronald Pickvance, and Donald Gardner (Zwolle, the Netherlands: Waanders, 1992), 137.

50 *"by the younger generation"*: Camille Pissarro to TvG (30 July 1890), b818 V/1962, quoted in ibid., 109.

50 *"what a friend he was to me"*: Henri de Toulouse-Lautrec to TvG (31 July 1890), b1276 V/1962, quoted in ibid., 114.

51 *"times will change very shortly"*: CL T9.

51 *at his gallery*: See TvG to Gachet, 12 August 1890, quoted in Pickvance, *"Great Artist,"* 142.

51 *"purchasers some day"*: CL 638.

51 *"could you please give me a hand"*: TvG to Emile Bernard, 18 September 1890, quoted in Stein, *Van Gogh*, 236.

51 *served as the catalog*: Andries Bonger, "Catalogue des Oeuvres de Vincent van Gogh" (handwritten), VGF (1891), b 3055 V/1982.

52 *Les XX*: Paul Signac offered to help Octave Maus with the show, telling him, "There are at Tanguy's nearly one hundred canvases." (Rewald, *Post-Impressionism*, 384–385.)

52 *"the surrounding ones"*: Octave Mirbeau, "Style as Affirmation of a Personality," in Welsh-Ovcharov, *Van Gogh in Perspective*, 65.

52 *"the dealers and the juries"*: G.-Albert Aurier, "Choses d'art," *Mercure de France*, February 1892, quoted in Rewald, *Post-Impressionism*, 462.

52 *kidney disease*: Camille Pissarro to Lucien Pissarro, quoted in ibid., 69.

52. *Theo died*: See also Hulsker, "Borinage Episode," 323 n. 10.

8. Amsterdam: Johanna van Gogh–Bonger, 1891–1896

53 *Johanna van Gogh–Bonger*: See Han van Crimpen, "Johanna van Gogh: A Legacy, a Mission," in Kodera and Rosenberg, *Mythology*, 335–375.

53 *"in them I should find him again"*: JvGB to friend, in VWvG, "Memoir," lxv.

53 *"but she never thought of it"*: ibid., lx.

54 *"lonely and deserted"*: Diary of JvGB, 15 November 1891, in ibid., lxi.

55 *"bric-a-brac dealers"*: G.-Albert Aurier to his sister, March 1891, quoted in Rewald, *Post-Impressionism*, 386.

55 *"twenty with Oldenzeel in Rotterdam"*: Diary of JvGB, 24 February

1892, in VwVG, "Memoir," lxi–lxii.

56 *"What a triumph"*: Diary of JvGB, 3 March 1892, in VWvG, "Memoir," lxii.

56 *"increase in number"*: JvGB, preface to CL, xiii.

56 *"fitted into their place"*: ibid.

56–57 *published in Holland, and also in Germany*: *Brieven aan zijn Broeder* (Amsterdam: Maatschappij voor Goede en Goedkope Lectuur, 1914); *Briefe an seiner Bruder*, trans. L. Klein-Diepold and C. Einstein (Berlin: Paul Cassirer, 1914).

57 *"frail health . . . broken"*: JvGB, "Memoir," liii.

57 *"guilt and remorse"*: Pickvance, *"Great Artist,"* 15.

57 *have him institutionalized*: RdeL, xiii.

57 *"simplicity and sincerity"*: JvGB, "Memoir," li.

57 *second version of the Gachet*: See also J. B. de la Faille, *The Works of Vincent van Gogh: His Paintings and Drawings* (Amsterdam: Meulenhoff International, 1970), F754 in "Addenda." Jan Hulsker wrote: "Van Gogh's letters do not contain a single indication that he ever made a second version of the portrait, nor that he ever gave one to Gachet" (Jan Hulsker, *The New Complete van Gogh* [Philadelphia: J. M. Meulenhoff/John Benjamins, 1996], 460). About another canvas from the Gachet collection, *Study of Cows* (based upon an etching by Gachet, itself a copy of a Jacob Jordaens), Susan Alyson Stein wrote: "It is always possible that the painting was completed or reworked by Gachet after van Gogh's death, but this proposal cannot be seriously entertained without the benefit of sufficient technical examination of the

canvas" (*Masterpieces from the Musée des Beaux-Arts, Lille* [New York: Metropolitan Museum of Art, 1993], 177).

58 *tragic myth of van Gogh*: For the van Gogh legend, see Carol Zemel, *The Formation of a Legend* (Ann Arbor, Mich.: UMI Research Press, 1980); and Nathalie Heinich, *The Glory of van Gogh*, trans. Paul Leduc Browne (Princeton, N.J.: Princeton University Press, 1996).

58 *"flame of genius had died"; "lived his unjust life"*: Octave Mirbeau, "Vincent van Gogh," *L'Echo de Paris*, 31 March 1891, in Stein, *Van Gogh*, 267.

58 *"mad and sick men who were his brethren"*: ibid., 279.

58 *"who put his faith in that genius"*: A. C. Loffelt, "Vincent van Gogh," *Het Vaderland*, 18 May 1892, quoted in Zemel, *Legend*, 21.

58 *"sad drama of his life"*: Richard Roland-Holst in *De Amsterdammer*, 21 February 1892, quoted in Zemel, *Legend*, 25.

58 *"makes Vincent into a God"*: Roland-Holst to Jan Toorop, in ibid., 25. Jan Hulsker observes that Johanna's "laudable and informative essay should be read with some reservation" (Hulsker, "Borinage Episode," 309).

9. Copenhagen: The Danish Secession, 1893

60 *"such pictures by van Gogh"*: Johan Rohde, *Journal fra en Rejse i 1892*, June 1892, quoted in Stein, *Van Gogh*, 291.

60 *"rise in Denmark"*: Emil Hannover, "Den frei Udstillings Folle," in *Politiken*, 26 March 1893. Danish

translations were done by Birgitte Johannesson.

60 *the Free Exhibition:* See Merete Bodelsen, *Gauguin og van Gogh i Kobenhavn in 1893* (Gauguin and Van Gogh in Copenhagen in 1893) (Copenhagen: Ordrupgaard, 1984), 31–42; Håkan Larsson, "Flames from the South," licentiate's thesis, Jan-Gunnar Sjölin's Seminar, 1993.

60 *"European trailblazers":* Rohde, "Journal," 291.

60 *"10 to 20 pieces":* Rohde to JvGB, unpublished letter, quoted in Bodelsen, *Gauguin and van Gogh*, 24.

61 *"Art vegetates in Denmark":* Armand Dayot quoted in Emily Braun, "Scandinavian Painting and the French Critics," in Varnedoe, *Northern Light*, 67.

61 *radical painting:* Varnedoe, *Northern Light*, 15.

62 *in Munich in 1892 ... Berlin in 1898:* Peter Paret, *Berlin Secession: Modernism and Its Enemies in Imperial Germany* (Cambridge: Harvard University Press, 1980), 29.

62 *economic conditions of the profession:* ibid., 35–37.

63 *"skillful pastiches":* Roger Fry, "Vincent van Gogh," in *Transformations* (Garden City, N.Y.: Doubleday, 1956), 247.

63 *"much Northern Romantic art":* Robert Rosenblum, *Modern Painting and the Northern Romantic Tradition* (New York: Harper and Row, 1975), 74–75.

64 *"portrait of old man Tanguy":* Rohde quoted in John Rewald, *The History of Impressionism*, rev. ed. (New York: Metropolitan Museum of Art, 1961), 557.

64 *"into buying it":* W. Tengeler to JvGB, 22 June 1982, quoted in

van Crimpen, "Johanna van Gogh," 360.

64 *"reunited here by their work":* JvGB to Johan Rohde, 12 April 1893, quoted in Bodelsen, *Gauguin and van Gogh*, 19.

64 *"foreign art":* George Seligmann to Rohde, unpublished, undated letter, Johan Rohde collection, Royal Library, Copenhagen.

64 *"his best. Superb, excellent":* Seligmann to Rohde, unpublished, undated letter, Johan Rohde collection, Royal Library, Copenhagen.

65 *"an extraordinarily fine artist":* Seligmann, quoted in Kirsten Olesen, "From Amsterdam to Copenhagen," in Bodelsen, *Gauguin and van Gogh*, 30.

65 *"husband's death had left in the house":* ibid., 29.

65 *"in vociferous enthusiasm":* Dannebrog, 26 March 1893, quoted in ibid., 30.

65 *"hoarded up for centuries":* Berlingske Tidende, 28 March 1893, quoted in Bente Scavenius, *Fremsyn-Snæversyn: Dansk dagbladskunstkritik, 1880–1901* (Copenhagen: Borgen, 1983), 96.

65 *"fills his soul until it well-nigh bursts":* Johannes Jørgensen, *Politiken*, 16 April 1893, quoted in Olesen, "From Amsterdam," 30.

65 *"madness and suicide":* critic under pseudonym "Pincenez," *Social-Demokraten*, 25 May 1893, quoted in ibid., 30.

66 *"exhaustion and resignation":* "Den 'fri' Kunst," *Aalborg Stiftstidende*, 29 April 1893, quoted in Larsson, "Flames," 95.

66 *between 700 and 800 francs apiece:* ibid., 26.

66 *"The Olympia of Tahiti":*

Thadée Natanson, "Expositions: Oeuvres recentes de Paul Gauguin," *La Revue blanche* 5, no. 26 (1893), quoted in Brettell et al., *Gauguin*, 282.

66 *"like a funeral knell"*: Gauguin to Mette Gauguin, ed. Maurice Malingue, *Lettres de Gauguin à sa femme et à ses amis*, trans. Henry Stenning (Paris, 1946), quoted in ibid., 281.

66 *sum of 200 francs:* See Larsson, "Flames," 107; Bodelsen, *Gauguin and van Gogh*, 107–109. This *View of Arles From Montmajour* (F1452) was purchased by Hans Christian Christensen.

66 *was not for sale:* Bodelsen, *Gauguin and van Gogh*, 31–42. The absence of a dot beside the title of the painting "Portræt af Dr. G" indicated it was not for sale.

10. Paris: Ambroise Vollard, 1897

67 " *'Portrait of Dr. Gachet' "*: AV to JvGB, unpublished letter, VGF 3 February 1897, b1373/1962. I am indebted to Katherine Motley Hinckley for the translations of the Vollard letters. For Vollard, see John Rewald, "Paul Gauguin—Letters to Ambroise Vollard and André Fontainas," in Rewald, *Studies*, 168–214.

67 *ties to the Paris market:* John Rewald, "The Posthumous Fate of Vincent van Gogh, 1890–1970," *Studies*, 247.

67 *"oblivion, silence":* Paul Signac in his diary, 15 September 1894–95, quoted in Rewald, *Post-Impressionism*, 402.

67 *"for 800 and 1,000 francs":* JvGB to Durand-Ruel, 21 April 1894,

quoted in Rewald, "Posthumous Fate," 246.

68 *550 francs for three:* Durand-Ruel to JvGB, 21 May 1894, in ibid., 246.

68 *"not sold a single one":* Durand-Ruel to JvGB, November 1894, ibid., 247.

68 *moved to Oldenzeel's:* There are two small catalogs: *Vincent van Gogh*, Groningen: 21–26 February 1896, No. 64; and *Kunstzalen Oldenzeel, Tentoonstelling der Werken Vincent van Gogh* (Rotterdam: 1896), "No. 8. Portret van Dr. G." Oldenzeel showed over 50 canvases and 26 watercolors and drawings.

69 *Goupil's headquarters and the Opéra:* In 1861 Paris had an estimated 104 art dealers, half clustered on the Right Bank, near the Louvre and the Opéra (White and White, *Canvases and Careers*, 97.)

69 *"who like to poke about":* Camille Pissarro, *Letters to His Son Lucien*, ed. John Rewald (Mamaroneck, N.Y.: Paul P. Appel, 1972), 227.

69 *"he wants names":* ibid., 289.

69 *champion of neglected genius:* Jensen, *Marketing Modernism*, 54.

70 *worth more than 300,000 francs:* Ambroise Vollard, *Recollections of a Picture Dealer* (Boston: Little, Brown, 1936), 64.

70 *"not printmakers by profession":* ibid.

70 *advice of artists:* Rewald, "Paul Gauguin—Letters," 196.

70 *"so painterly, so supple":* Pissarro to Lucien Pissarro, 21 November 1895, *Correspondence de Camille Pissarro*, ed. Janine Bailly-Herzberg (Paris, 1980–1991), quoted in Cachin et al., *Cézanne*, 33.

71 *modern artists and collectors:* Jensen, *Marketing Modernism*, 270–273.

72 *only in republican Holland:* "Producing for the open market was the rule rather than the exception for the great majority of Dutch artists in Rembrandt's day" (Svetlana Alpers, *Rembrandt's Enterprise* [Chicago: University of Chicago Press, 1988], 94).

72 *among his commercial competitors:* ibid., 101, 110.

72 *largely in the careers:* McClellan, interview, 1997.

73 *"reputable canvases":* White and White, *Canvases and Careers*, 83.

73 *"homes of the bourgeoisie":* ibid., 91, 94, 126.

73 *their own bourgeois origins:* See ibid., 88.

73 *dealers, who created a demand for it:* Boime, "Entrepreneurial Patronage," 170. "An entrepreneur bringing off a project is like an artist bringing off a sketch, radical artists find their complement in the dealer who gambles on them."

74 *"Vollard cheerful":* Gertrude Stein, *The Autobiography of Alice B. Toklas* (c. 1933: reprint New York: Vintage, 1990), 30.

74 *sampled exotic "creole" food:* Vollard, *Recollections*, 81.

74 *"the sugar king":* ibid., 139.

74 *"to sell* anything*":* Mary Cassatt to Louisine Havemeyer, 6 September 1912, quoted in Weitzenhoffer, *Havemeyers*, 212.

74 *staved off his financial collapse:* Gary Tinterow, "The Havemeyer Pictures," in Alice Cooney Frelinghuysen et al., *Splendid Legacy: The Havemeyer Collection* (New York: Metropolitan Museum of Art, 1993), 47.

74 *"black Lorenzo de Medici":* Reva Castleman, "Introduction," in Una E. Johnson, *Ambroise Vollard Editeur* (New York: Museum of Modern Art, 1977), 15.

74 *"the cramped streets of the Latin Quarter":* ibid., 17.

75 *"The White Turkeys":* Bernard Denvir, *The Chronicle of Impressionism* (Boston: Little, Brown, 1993), 195.

75 *in the gallery's window:* Joseph J. Rishel, "A Century of Cézanne Criticism," in Cachin et al., *Cézanne*, 51.

75 *"kind of crocodile":* Paul Gauguin to Daniel de Monfried, 1899, quoted in Rewald, "Gauguin," 187.

76 *"as he is successful":* Gauguin to Monfried, ibid.

76 *Ginoux in Arles:* Feilchenfeldt, "Van Gogh," 41. According to Feilchenfeldt, "Vincent probably left more paintings (to the Ginoux) than has been assumed."

76 *100 francs for any picture:* ibid.

76 *"Room of the Restaurant":* Vollard to JvGB, unpublished letter, 29 March 1897, VGF, b1376 V/1962.

77 *to a high of 1,000 francs:* "List of the selections by Vollard, 6 rue Laffitte, Paris" (November 1896), unpublished, VGF b1437 V/1962.

78 *replaced by the "Portrait of Dr. Gachet":* Vollard to JvGB, unpublished letter, 3 February 1897, VGF, b1373 V/1962.

78 *what she was asking by 25 percent:* ibid.

78 *"reproductions made":* Vollard to JvGB, 16 February 1897, VGF, b1374 V/1962.

78 *fifty-four pictures in his possession:* Vollard to JvGB, unpublished letter, 7 March 1897, VGF, b1375 V/1962.

79 *"I didn't want to take them*

apart. . . . *Vollard":* Vollard to JvGB, unpublished letter, 29 March 1897, VGF, b1375 V/1962.

79 *assigned the picture:* For 6 canvases, 10 drawings, a Pissarro and a Renoir, he concluded he owed 2,340 francs.

80 *"self portrait and drawing f [florins] 1120":* JvGB's account book; 1120 florins was the equivalent of $449; Vollard, *Recollections,* 24, 62.

11. Copenhagen: Alice Ruben, 1897–1904

81 *"Dr. Gachet 200":* Ambroise Vollard Account Book.

81 *exhibition of Pierre Bonnard: Bonnard: The Late Paintings* (Washington, D.C.: The Phillips Collection, 1984), 243.

81 *Alice Ruben established the portrait:* Ruben's name did not appear in the provenance of *Portrait of Dr. Gachet,* F753, in J. B. de la Faille's catalogue raisonné published in 1928, 1939, and 1970.

82 *"renewal at the end of the 19th century":* Emil Hannover, "Den Frie Udstillings Folk," *Politiken,* 26 March 1893, quoted in Larsson, "Flames," 91.

82 *Poul Kuhn Faber:* Faber married Alice Ruben on October 3, 1893.

82 *"Maternité à la pomme":* I am grateful to Anne Gruson, with the Catalogue Raisonné de l'Oeuvre de Maurice Denis, for identifying this painting. It depicts Denis's wife Marthe holding her daughter Noële and Marthe's sister Eva with an apple in her hand.

82 *"Dr. Faber, Copenhagen":* Maurice Denis, "Carnet de dons et ventes," Archives Catalogue Raisonné Maurice Denis, Saint-Germain-en-Laye. The entry reads, "May 1897, 450 francs."

82 *in Vollard's exhibition:* Bernt Hjejle, *Gensyn med min barndoms verden* (Copenhagen: Gad, 1991), 70–72. Hjejle claimed that his father, the artist Hans Nikolaj Hansen, had traded his mother's van Gogh, *L'Arlésienne* (which he described as the version [F488] with books), to Mogens Ballin for a copper fire screen, made by the artist. The Swedish artist Bernt Grönvold loaned this *Arlésienne* to the Berlin Secession exhibition in 1912. (Walter Feilchenfeldt, *Vincent van Gogh and Paul Cassirer, Berlin* [Zwolle, the Netherlands: Waanders, 1988], 99.)

82 *Alice Ruben was the eldest:* I am indebted to Thor A. Bak for biographical information on the Ruben family.

83 *"their budding individuality":* Boime, "Entrepreneurial Patronage," 144.

83 *Heinrich Hirschsprung and Wilhelm Hansen:* Tone Skedsmo, "Patronage and Patrimony," in Varnedoe, *Northern Light,* 43–44. See also Kirk Varnedoe, *Northern Light: Nordic Art at the Turn of the Century* (New Haven: Yale University Press, 1988), 19.

84 *"that we belonged to the community":* Emil Hannover, *Erindringer fra Barndom og Ungdom* (Copenhagen: Forening for Boghaandvaerk, 1966), 53. Hannover became director of the Museum of Decorative Art in 1906 and of the Hirschsprung Collection in 1912.

85 *"van Gogh besides a lot of other things":* Hannover to Rohde, Paris, 24 May 1892, Hirschsprung Collection, Copenhagen.

85 *"amount of 4000 kroner"*: Alice Hannover to Harald Slott-Møller, 9 September 1893, Royal Library, Copenhagen.

85 *recuperating from tuberculosis:* On Ruben's illness, see Fr. E. Klee, *Beretning om Silkeborg Vandkuranstalt for 1892* (Copenhagen: F. Dreyer, 1893), patient number 129. According to the report, patient 129 had "pulmonary tuberculosis." See also unpublished letters from Ruben to Agnes Rambusch; from Ruben to Harald Slott-Møller; and from Hannover to Rohde in the Hirschsprung Collection and the Royal Library, Copenhagen.

85 *an extraordinary photograph:* This picture was discovered by the late Bernt Hjejle in a family album; it was published in *Berlingske Tidende* on May 20, 1990.

86 *"intimate relation"*: Walter Benjamin, "Unpacking My Library," in Arendt, ed., *Illuminations*, 67.

86 *awaited the birth of her first child:* In the late 1890s Ruben became a patron of and served as an agent for Danish symbolist Jens Ferdinand Willumsen. See Leila Krogh, ed., *Løvens Breve: J. F. Willumsen's breve til Alice Bloch, 1899–1923* (Frederikssund: J. F. Willumsens Museum, 1987).

12. Copenhagen: Mogens Ballin, 1897–1904

87 *"will make their mark"*: Letter from Gauguin to Mette, 5 November 1892, quoted in Larsson, "Flames," 43.

87 *Ida Levy:* For Mogens Ballin see Wladyslawa Jaworska, *Paul Gauguin and the School of Pont-Aven*, trans. Patrick Evans (Greenwich, Conn.: New York Graphic Society, 1972), 157–178. I am grateful to Jan Bredholt for biographical information on Ballin.

88 *"Undergrowth"*: Bodelsen, *Gauguin and van Gogh*, 120.

88 *"into the heart of the artist"*: Ludvig Find, quoted in ibid., 120.

88 *"hieratic tapestries"*: Emile Bernard to Emile Schoffenecker, 31 May 1890, quoted in Rewald, *Post-Impressionism*, 408.

88 *"sensation received"*: Denis, "Neotraditionism," 101.

89 *"greatest works of art are but a dim reflection"*: Ballin, "Jan Verkade," *Taarnet*, February 1894, 239, quoted in Larsson, "Flames," 39.

89 *"manifests itself in sacrifice"*: Ballin to Verkade, in Jan Verkade, *Yesterdays of an Artist Monk*, trans. John L. Stoddard (New York, 1930), 163.

89 *decorative arts workshop:* Jacob Thage, "Mogens Ballin (1871–1914)," in *Danske Smykker* (Danish jewelry) (Copenhagen: Komma & Clausen, 1990), 77.

89 *"art for the people"*: Ballin to the Altmeister at the monastery at Beuron, Germany, quoted in ibid.

90 *"only decorations"*: Verkade, *Yesterdays*, 94, quoted in Patricia Eckert Boyer, ed., *The Nabis* (New Brunswick, N.J.: Rutgers University Press, 1988), 113.

91 *agents for the Dutch artist's work:* See Feilchenfeldt, "Van Gogh," 41.

91 *Rodin and Camille Pissarro:* ibid., 42.

91 *"glorious names"*: Julien Leclerq, "Exposition d'Oeuvres de Vincent van Gogh," 15–31 March 1901, in Stein, *Van Gogh*, 310.

13. Berlin: Paul Cassirer, 1904

95 *"even fewer in England and America"*: Harry Graf Kessler, eulogy for Paul Cassirer, 1926, quoted in Georg Bruehl, *Cassirers: Streiter für den Impressionismus* (Leipzig: Edition Leipzig, 1991), 103. For Cassirer, see Paret, *Secession*, 69–75. German translations by F. Schramm, W. Washburn, and H. Möhlmann.

96 *"filled with contentment"*: R. M. Rilke, "Der Salon der Drei," in *Samtliche Werke* (Frankfurt am Main, 1965), v. 451, quoted in Paret, *Secession*, 70.

96 *"meant revolution," "virtually unknown in Germany"*: Paul Cassirer, preface of *Katalog XV*, October–November 1912–13, *Erste Ausstellung* in Feilchenfeldt, *Van Gogh and Cassirer*, 39.

96 *"Self-Portrait with Bandaged Ear"*: ibid, 14.

96 *"bewildered Berlin"*: Lovis Corinth, *Das Leben Walter Leistikows* (Berlin, 1910), quoted in ibid., 11.

96 *"brute force of the Norwegians"*: Hans Rosenhagen, "von Ausstellungen," *Die Kunst* 30, no. 1, (1902): quoted in ibid., 14.

96 *"Wheatfields"*: ibid., 15.

97 *"Portrait of a Man" ("Herrenportrait")*: P. Cassirer's *Einkaufsbuch* and *Verkaufsbuch*, July 1904, Paul Cassirer–Archiv. Walter Feilchenfeldt, Zurich.

98 *ambitions to rival Paris:* Jensen, *Marketing Modernism*, 67–68, 70–75.

99 *1.8 million:* Koppel S. Pinson, *Modern Germany*, 2d ed. (New York: Macmillan, 1966), 221.

99 *most important art market in central Europe:* Paret, *Secession*, 30.

99 *"conceited and aging culture of the West"*: Henry van de Velde, *Geschicte meines Lebens* (Munich: 1962), quoted in Sembach, *Van de Velde*, 17.

99 *one of eight:* Jensen, *Marketing Modernism*, 70

100 *cultural renaissance:* Paret, "The Tschudi Affair," *Journal of Modern History* 53, no. 4 (1981): 600.

100 *These German collectors:* The collectors included Franz and Robert von Mendelssohn, Paul von Mendelssohn-Bartholdy, Julius Stern, Oskar Schmitz (Dresden), the playwright Carl Sternheim, and Margarete Mauther, who would later translate van Gogh's letters. (Feilchenfeldt, *Cassirer*, 19, 36, 104–105.)

101 *income . . . of France:* Paul Kennedy, *The Rise and Fall of the Great Powers: Economic Change and Military Conflict from 1500 to 2000* (New York: Random House, 1987), 243

101 *"Plain at Auvers"*: Feilchenfeldt, *Cassirer*, 14. (F781). For a brief period, he also owned the 1889 *Les Peiroulets: The Ravine* (F661). (See Beatrice von Bismarck, "Harry Graf Kessler und die französische Kunst um die Jahr-hundertwende," *Zeitschrift des Deutschen Vereins für Kunstwissenschaft* 42, no. 3 (1988): 53.

101 *Tschudi . . . another landscape* (F516). Feilchenfeldt, *Cassirer*, 101.

101 *first Cézanne ever purchased:* Feilchenfeldt, "Cézannes' Collectors," 573.

101 *"in museums and exhibitions"*: Paret, "Tschudi Affair," 600.

101 *Tschudi "who infects them all"*: Mary Cassatt to Louisine Havemeyer, 13 November 1910, Nancy Mowll Mathews, *Cassatt and Her Circle*

(New York: Abbeville Press, Cross River Press, 1984), 301.

101 *"Poet's Garden" series:* Feilchen-feldt, *Cassirer,* 16. Meier-Graefe owned *The Poet's Garden* (F485) and *Portrait of Camille Roulin* (F537).

102 *"He destroys it":* Meier-Graefe, *Entwicklungsgeschichte der modernen Kunst,* 129, quoted in Christian Lenz, "Julius Meier-Graefe and His Relation to van Gogh," in Dorn, Leeman, et al., *Early Modern Art,* 50.

102 *"recognize as artistic":* Meier-Graefe, *Modern Art: Being a Contribution to a New System of Aesthetics* (New York: G. P. Putnam's Sons, 1908), 202.

102 *van de Velde:* Peter Selz, *German Expressionist Painting* (1957; reprint, Berkeley and Los Angeles: University of California Press, 1974), 63.

102 *"haunts me ceaselessly":* André Derain, *"Lettres à Vlaminck"* (Paris, 1955), 29, quoted in Marcel Giry, "Van Gogh and the Fauves," in Dorn, Leeman, et al., *Early Modern Art,* 268.

103 *the Brücke artists:* They saw a van Gogh exhibition organized by Cassirer that appeared at the Galerie Arnold in Dresden in November 1906, and then at Emil Richter's gallery in 1908 (Magdalena M. Möller, "Van Gogh and Germany," in Dorn, Leeman, et al., *Early Modern Art,* 312).

103 *"fragility of the imperial monarchy":* Harry Kessler, in "Eulogy for Paul Cassirer," 1926, in Bruehl, *Cassirers,* 104.

103 *grandson of Wilhelm I:* See Pinson, *Modern Germany,* 156–172; Gordon Craig, *Germany, 1866–1945* (New York: Oxford University Press, 1978), 38–60, 251–301.

103 *Wilhelm II was inept:* Craig, *Germany,* 270.

104 *"democracy would be the issue":* R. R. Palmer and Joel Colton, *A History of the Modern World* (New York: Alfred A. Knopf, 1961), 588.

104 *"descending into the gutter":* Die Reden Kaiser Wilhelms II, ed. Johannes Penzler (Leipzig, 1907), 3:61–62, quoted in Paret, *Secession,* 27.

104 *Anton von Werner:* See Paret, *Secession,* 14–19.

105 *"utterly dry and stiff":* Harry Graf Kessler, *Gesammelte Schriften,* ed. Gerhard Schuster (Frankfurt am Main, 1988), 2:79, quoted in Laird McLeod Easton, "The Red Count: The Life and Time of Harry Kessler, 1868–1914" (Ph.D. diss., Stanford University, 1991), 252.

105 *"taste and values of the majority":* Paret, *Secession,* 28.

105 *"approval on it":* ibid, 22.

105 *"well-painted Madonna":* Max Liebermann, *Die Phantasie in der Malerei* (Frankfurt am Main, 1978), 49, quoted in Paret, *Secession,* 87.

106 *"Rembrandt as Educator":* For Julius Langbehn see Fritz Stern, *The Politics of Cultural Despair* (Berkeley and Los Angeles: University of California Press, 1961), 97–182.

106 *fanatical nostalgia:* See ibid, xxvii.

106 *intellectually precocious generation:* Peter Paret, interview.

107 *"playful, experimental quality":* Paret, *Secession,* 73–74.

107 *"unbiased men":* Karl Scheffler, *Die fetten und die mageren Jahre* (Munich, 1948), 122, quoted in Paret, *Secession,* 74.

107 *outside the art trade:* ibid., 68–77. Information on the Berlin Secession comes from Paret, *Secession,* 69–79.

107 *"direction in art":* Max Liebermann, *Katalog der Deutschen Kunstausstellung der "Berliner Secession"* (Berlin, 1895), 15, quoted in Paret, *Secession,* 83.

108 *1903 Vienna Secession:* Emil Heilbut, "Die Impressionisten Ausstellung der Wiener Secession," *Kunst und Künstler* 1 (1903), 169–207.

108 *some 5,000 marks:* Paret, *Secession,* 206.

109 *" 'cashier' hands":* Dr. Volker, "Die Berliner Kunstausstellungen," *Hochland* 1 (1903): 252, 253, quoted in Paret, *Secession,* 110.

109 *Cassirer ignored the attacks:* For anti-Semitism after the market crash, see Craig, *Germany,* 84.

109 *"Cezanne the bearer of a philosophy of life":* Paul Cassirer, in *Deutsche und franzoesische Kunst,* ed. Alfred Walter Heymel (Munich, 1911), 162–163, 165, quoted in Paret, *Secession,* 195.

110 *"at higher prices":* PC to JvGB, 27 April 1905, unpublished letter, VGF, in Feilchenfeldt, *Cassirer,* 18.

110 *Tschudi acquired three:* ibid., 19. The three were *Still Life: Vase with Twelve Sunflowers* (F456), *Road Menders* (F658), and *Plain with Farm near Auvers* (F782).

110 *"Trinquetaille Bridge":* Feilchenfeldt, *Cassirer,* 22. Tschudi also bought *Vineyards in Auvers*; Oskar Schmitz bought *Langlois Bridge* and *Noon,* a painting after Millet; Carl Reininghaus, Vienna, bought *Bank of the Oise* and *Still Life: Vase with Oleanders and Books.*

110 *"sole agent for Germany":* PC to JvGB, 5 and 20 February 1907, unpublished letter, VGF, in Feilchenfeldt, *Cassirer,* 26.

110 *she loaned him seventy-five paintings:* ibid., 147.

110 *"Roses" and "Vase of Irises":* ibid., 28–29, 112.

110 *van Gogh's letters:* PC to JvGB, 13 May 1909, ibid., 31.

110 *German and Austrian collectors:* ibid., 41.

111 *outside of the Netherlands:* For van Goghs in collections before World War I, see Feilchenfeldt, *Cassirer,* 41–42.

111 *Carl Sternheim:* He owned F380, F489, and F428 (Feilchenfeldt, *Cassirer,* 91, 94, 99).

111 *Albert C. Barnes:* Richard J. Wattenmaker, "Dr. Albert C. Barnes and the Barnes Foundation," in Wattenmaker et al., ed., *Great French Paintings from the Barnes Foundation* (New York: Alfred A. Knopf, 1993), 6. Barnes also bought *The Smoker* (F534) (Feilchenfeldt, "Van Gogh," 45).

14. Weimar: Harry Kessler, 1904–1908

112 *"always first to make a discovery":* Annette Kolb, *Mass und Wert,* 1938, 4, 630, quoted in Laird McLeod Easton, "Red Count," 1.

112 *on Cranachstrasse:* For HGK and his Weimar house see Margot Pehle and Gerhard Schuster, *Harry Graf Kessler. Tagebuch eines Weltmannes* (Marbach am Neckar: Deutsche Schillergesellschaft, 1988), 214–224; Sembach, *Van de Velde,* 91–101.

113 *"women's tailor-made clothing":* HGK, "van de Velde's Tafelsilber," *Gesammelte Schriften* 2, ed. Gerhard Schuster (Frankfurt am Main, 1988), 91, quoted in Easton, "Red Count," 242.

114 *"intellectual and artistic gifts":* HGK, *Die deutsche Künstlerbund*

(Berlin, 1904), quoted in Paret, *Secession*, 135.

114 *"renewal of German culture":* HGK, 15 November 1905, quoted in Easton, "Red Count," 324.

114 *"aesthetic perfection":* Van de Velde, *Geschichte meines Lebens*, rev. ed., ed. Hans Curjel (Munich, 1986), 182, quoted in Easton, "Red Count," 355.

115 *"conflicts of my inner depths":* Hugo von Hofmannsthal, "Colors," fictitious letter, 26 May 1901, published in Hofmannsthal, *Die Prosaischen Schriften Gesammelt* (Frankfurt am Main: S. Fischer Verlag, 1920), quoted in Susan Alyson Stein, *Van Gogh*, 314.

115 *recalled in her memoirs:* Helene von Nostitz, *Aus dem alten Europa: Menschen und Städte* (Leipzig: Insel-Verlag, 1925), 73.

115 *"disdain of all":* van de Velde, in *Geschichte*, quoted in Easton, "Red Count," 355.

115 *"contortions of Ruth St. Denis":* Maurice Denis, *Journal*, vol. 2, 1905–1920 (Paris, 1957), 109, quoted in Easton, "Red Count," 356.

115 *"international vantage point":* HGK, September 1905, quoted in Bismarck, "Kessler," 47.

116 *"unnatural isolation":* HGK, September 1905, quoted in ibid.

116 *foreign service:* Easton, "Red Count," 227. HGK and his father spoke to Prince Hohenlohe, chancellor of Germany, in 1894, and also in 1895, but nothing came of it.

117 *"From Vollard for 1200 francs!":* Pehle and Schuster, *Kessler*, 76. Paul Signac wrote that Kessler "hopes in a few years to be able to have the *Poseuses* enter the Berlin Museum" (Signac, 2 January 1898, quoted in Françoise Cachin, "Les Poseuses," in Herbert, *Seurat*, 279).

117 *"gleaming eyes":* van de Velde, *Geschichte*, 159, quoted in Sembach, *Van de Velde*, 92.

118 *born into the new upper middle class:* For insights on Kessler's unusual social position, I am indebted to Beatrice von Bismarck.

118 *outsider:* See Easton, "Red Count," 50.

119 *"people are against it":* Lichnowsky, according to HGK, 20 April 1902, quoted in Easton, "Red Count," 230.

119 *School of Arts and Crafts:* Easton, "Red Count," 229.

119 *"Bremer burners":* HGK, 25 December 1901, *Eberhard von Bodenhausen and Henry Graf Kessler, Briefwechsel, 1894–1918*, ed. Hans-Ulrich Simon (Marbach am Neckar: Marbacher Schrifter, 16, 1978), 66, quoted in Easton, "Red Count," 245.

119–120 *"Germany otherwise lacks":* HGK to Hofmannsthal, 6 August 1903, in Easton, "Red Count," 232.

120 *the public to the Impressionists:* For HGK's exhibitions, see Pehle and Schuster, *Kessler*, 139–141.

120 *Saint Louis:* The Künstlerbund managed to have the subject of Saint Louis debated in the Reichstag in February 1904, only months before HGK bought *Gachet* (Paret, *Secession*, 148–154).

120 *"pivotal point that is Weimar":* HGK to van de Velde, in van de Velde, *Geschichte*, 284, quoted in Easton, "Red Count," 272.

120 *"tolerate such an exhibition":* Hermann Behmer, *Deutschland*, 17 February 1906, quoted in Easton, "Red Count," 333.

120 *"without a hearing"*: van de Velde, *Geschichte*, quoted in Sembach, *Van de Velde*, 94.

121 *"That shall be my only revenge"*: HGK to Bodenhausen, *Briefwechsel*, 18 July 1906, quoted in Easton, "Red Count," 324.

121 *Hugo von Tschudi*: See Paret, "Tschudi Affair," 589–618; and "Die Tschudi-Affäre," *Manet bis van Gogh* (Berlin: Nationalgalerie, 1997), 396–401.

121 *"to catch up now"*: Harry Graf Kessler and Hugo von Hofmannsthal, *Briefwechsel*, ed. Hilde Burger (Frankfurt am Main, 1968), 121–122, 26 September 1906, quoted in Easton, "Red Count," 344–345.

122 *Bernheim-Jeune*: Feilchenfeldt, "Van Gogh," 44.

122 *German collectors still liked*: Félix Fénéon to Karl Ernst Osthaus, 5 October 1907, quoted in Feilchenfeldt, *Cassirer*, 26.

122 *"sumptuous store"*: *L'Occident*, December 1903, quoted in Kirk Varnedoe, "Rodin and Photography," Albert E. Elsen, ed., *Rodin Rediscovered* (Washington, D.C.: National Gallery of Art, 1981), 217.

122 *Rodin pavilion*: Varnedoe, "Rodin," 217. For Druet, see 215–24.

122 *the Postimpressionists*: Druet held the following exhibitions: Maurice Denis, 1904; Henri-Edmond Cross, Kees van Dongen, and Berthe Morisot, 1905; Eugène Boch, 1906; Anna Boch, 1908; Cross and Paul Signac, 1911.

122 *photographs by Druet*: John Richardson, *A Life of Picasso* (New York: Random House, 1996), 51.

123 *acquired twenty canvases*: Michael C. Fitzgerald, *Making Modernism: Picasso and the Creation of the Market for Twentieth-Century Art* (New York: Farrar, Straus & Giroux, 1995), 30.

123 *Bernheim-Jeune gave Matisse a contract*: ibid., 70.

123 *promised stipends*: Pierre Assouline, *An Artful Life: A Biography of D. H. Kahnweiler, 1884–1979* (New York: Grove Weidenfeld, 1990), 96.

123 *La Peau de l'Ours*: Fitzgerald, *Making Modernism*, 22.

123 *relatively minor Nabi canvas*: "Catalogue de Tableaux Modernes," Hôtel Drouot, 16 May 1908, no. 14, "Maternité." HGK sold a number of pictures at this sale; the expert was Druet.

124 *"Kahnweiler's 'Ostpolitik' "*: Richardson, *Picasso*, 301.

124 *Druet exhibited thirty-five pictures*: Galerie E. Druet, *Quelques oeuvres de Vincent van Gogh*, 6–18 January 1908. The lenders included M. Aubry, M. E. Boch, M. M. Fabre, M. G. Fayet, M. W. de Heymel, Dr. J. Keller, Comte de Kessler, M. Michelot, and Amédé Schuffenecker.

124 *the Bernheims fared*: Bernheim-Jeune sold two small pictures to Gustave Fayet (Feilchenfeldt, "Van Gogh," 44).

124 *Twenty-three went to Cassirer's*: Magdalena M. Moeller, "Van Gogh and Germany," in Dorn, Leeman, et al., *Early Modern*, 312; Feilchenfeldt, *Cassirer*, 146.

124 *Druet . . . bought it himself*: Druet to HGK, unpublished letter, 11 February 1910, German National Literary Archives, Marbach am Neckar. He asked HGK to make the payments to the Bernheims.

125 *"demented serpents"*: HGK diary, 16 April 1890, quoted in James Fenton,

"Degas in the Evening," *New York Review of Books*, 3 October 1996, 50.

125 *"whose canvases show it like that"*: HGK, 17 August 1922, in Harry Kessler, *In the Twenties: The Diaries of Harry Kessler*, trans. Charles Kessler, intro. by Otto Friedrich (New York: Holt, Rinehart and Winston, 1971), 192.

126 *Renoir's "Madame Charpentier"*: Calvin Tomkins, *Merchants and Masterpieces: The Story of the Metropolitan Museum of Art*, rev. ed. (New York: Henry Holt, 1989), 107.

126 *"a joke at their expense"*: Virginia Woolf, *Roger Fry: A Biography* (New York: Harcourt, Brace, Jovanovich, 1940), 154.

126 *"horribly seasick"*: "Paint Run Mad: Post-Impressionists at Grafton Galleries," *Daily Express*, 9 November 1910, quoted in J. B. Bullen, *Post-Impressionists in England* (London: Routledge, 1988), 105–106.

127 *"price of a Rembrandt"*: Roger Fry, "The Salons and van Dougen [Dongen]," *Nation*, 24 June 1911, quoted in Bullen, *Post-Impressionists*, 232.

15. Frankfurt: The Old Master Museum and the New Portrait, 1911–1919

128 *"surrounds the pale yellow of his head"*: Registrar's book, 1912, Städelsches Kunstinstitut, Frankfurt am Main.

128 *"the painting of Dr Gachet"*: E. Druet to Georg Swarzenski, unpublished letter, 20 February 1911, SKA. Druet wrote Swarzenski on June 14, saying he had not yet received 6,000 francs for the first payment for *Dr. Gachet* (Druet to Swarzenski, 14 June

1911, SKA). On June 26 the Paris dealer again wrote: he had not yet received the payment owed in April and asked also for the payment due the first of July. Swarzenski responded that he had ordered the 6,000 francs paid on May 29 (Druet to Swarzenski, 26 June 1911, SKA).

129 *"Execution of the Emperor Maximilian"*: Paret, *Secession*, 191.

129 *"for a small landscape"*: William Glackens to his wife, 16 February 1912, quoted in Anne Distel, "Dr. Barnes in Paris," in Wattenmaker et al., *Great French Paintings*, 34.

129 *"Dancers Practicing at the Barre"*: Weitzenhoffer, *Havemeyers*, 208.

130 *before World War I:* The Wallraf-Richartz Museum in Cologne acquired *Portrait of Armand Roulin* (F453) and *The Langlois Bridge* (Dorn, Leeman, et al., *Early Modern Art*, 93). The Folkwang Museum bought *Boats with Men Unloading Sand* (F449) (ibid., 114).

130 *" its inhabitants"*: Karl Baedeker, *The Rhine, Including the Black Forest and the Vosges: Handbook for Travelers* (Leipzig: Karl Baedeker, 1911), 282.

131 *"making money and spending it"*: Amos Elon, *Founder: A Portrait of the First Rothschild and His Time* (New York: Viking, 1996), 35.

131 *banking dynasty:* ibid, 19.

131 *to grant the rights:* ibid., 159.

131 *Jewish population:* Baedeker, *The Rhine*, 282.

132 *the Louvre Palace:* Jeffrey Abt, "Museum," in Jane Turner, ed., *The Dictionary of Art* (London: Grove, 1996), 22: 357.

136 *"still-living masters of French painting"*: Swarzenski to Franz Adickes, 22 February 1910, Frankfurt City Archives, S 1525 II, 62.

136 *"in opposition to conventional reality"*: Georg Swarzenski, "Introduction," in *Arts of the Middle Ages* (Boston: Museum of Fine Arts, c. 1940), viii.

136 *Correspondence flew*: Beatrice von Bismarck, "Georg Swarzenski und die Rezeption des Französischen Impressionismus in Frankfurt: Eine Stadt 'Im Kampf um die Kunst'?" in *Revision* (Frankfurt am Main: Städtische Galerie im Städelschen Kunstinstitut, 1991), 31–33; see also Bernhard Maaz, "Fahrten ins Unbekannte und Wunderbare: Georg Swarzenski in Frankfurt am Main," in Johann Georg Prinz von Hohenzollern and Peter-Klaus Schuster, eds., *Manet bis Van Gogh* (Munich: Prestel, 1996), 308–312.

137 *"anarchist"*: Meier-Grefe, *Modern Art*, 101.

137 *"spiritual self-portrait"*: Panofsky, *Dürer*, 171. Panofsky argued, "The influence of Dürer's *Melencolia I*—the first representation in which the concept of melancholy was transplanted from the plane of scientific and pseudo-scientific folklore to the level of art—extended all over the European continent and lasted for more than three centuries" (170).

137 *identity and existence:* in Rosenblum, "Modern Painting," 62–64.

138 *"inner necessity"*: Wassily Kandinsky, *Concerning the Spiritual in Art* (New York: Wittenborn, Schultz, 1947), 32.

138 *"deriving from van Gogh"*: Wilhelm Worringer, quoted in Selz, *Expressionist Painting*, 1974.

139 *"as a personal pupil"*: Erwin Panofsky, "Three Decades of Art History in the United States," in Panofsky, *Meaning in the Visual Arts*

(Garden City, N.Y.: Doubleday, 1955), 333.

139 *nationalistic history paintings:* Françoise Forster-Hahn, "The Politics of Display or the Display of Politics," *Art Bulletin* 77, no. 2 (1995): 177.

141 *Swarzenski married Marie Mössinger:* Swarzenski's children were Uta (b. 14 August 1900); Hanns (b. 30 August 1903); Wolfgang (b. 19 August 1917); and Wilhelm Gottfried (b. 9 April 1920).

141 *"American princes of finance"*: Carl Vinnen, *Ein Protest deutscher Künstler* (1911), quoted in Paret, *Secession*, 183–184.

142 *"invasion" of French art:* see Paret, *Secession*, 197–199.

142 *"would like to call these works its own"*: Georg Swarzenski, from the *Frankfurter Zeitung*, 11 May 1911, and in *Im Kampf um die Kunst* (Munich, 1911), 20, quoted in Bismarck, "Swarzenski," 31.

142 *Victor Mössinger:* He gave Sisley's *Seine-Ufer* and Monet's *Häuser am Wasser* "in the same way": Georg Swarzenski, to Karl Ernst Osthaus, 4 November 1911, quoted in *Portrait du Dr. Gachet by Vincent van Gogh* (New York: Christie's, 1990), 28.

142 *buying French art for a decade:* Bismarck, "Swarzenski," 34–35; for von Hirsch's *The Shepherdess (after Millet)* (F699) and Hugo Nathan's *The Diggers* (F701), see Feilchenfeldt, *Cassirer*, 114.

143 *Frankfurt's Kunstverein:* Bismarck, "Swarzenski," 35–36; Feilchenfeldt, *Cassirer*, 186–187. See Frankfurter Kunstverein, *V. Van Gogh Ausstellung*, 14–28 June 1908 (Frankfurt am Main, 1908).

143 *Frankfurt's answer to the Vinnen* Protest: Bismarck, interview.

143 *the art of nineteenth-century France:* See Bismarck, "Swarzenski," 38.

143 *"triumph of the Germanic spirit":* Carl Gebhard, "Die Neuer-werbungen französischer Malerei im Städelschen Kunstinstitut zu Frankfurt am Main," *Der Cicerone* 4 (1912): 761–769, quoted in Ron Manheim, "The Germanic van Gogh," trans. Jane Hedley-Proele and Michael Hoyle, *Simiolus* 19, no. 4 (1989): 279.

143 *"between the mountains":* Geb-hard, quoted in Bismarck, "Swarzen-ski," 39.

143 *"of true substance":* Gebhard, quoted in Manheim, "Germanic van Gogh," 280.

143 *published the image of "Gachet":* August Macke, "The Masks," in Wassily Kandinsky and Franz Marc, eds., *The "Blaue Reiter" Almanac,* rev. ed., ed. Klaus Lankheit (New York: Viking, 1974), 203. "Does Van Gogh's portrait of Dr. Gachet not originate from a spiritual life similar to the amazed grimace of a Japanese juggler cut in a wood block?" (88).

144 *"disciples":* J. Meier-Graefe, 1914, quoted in Zemel, *Legend,* 128.

144 *"concert hall":* Georg Swarzenski, *Museumsfragen* (Frank-furt: Frankfürter Bibliophilen Gesellschaft, 1928), 15.

144 *"transmit artistic experience":* ibid., 14.

145 *life of the mind:* See Fritz Stern, *The Failure of Illiberalism: Essays on the Political Culture of Modern Ger-many* (New York: Columbia Univer-sity Press, 1992), 5–11.

145 *"spiritual inventiveness":* Swarzenski, *Museumsfragen,* 16.

145 *"constant intensification":* ibid., 24. See Markus Kersting, " 'Stete Intensivierung'—Sammlungsideen im Städelschen Kunstinstitut," in *Revi-sion,* 11–26.

145 *abruptly severed:* Feilchenfeldt, *Cassirer,* 41.

146 *"criticism of the government and the high command":* Paret, *Seces-sion,* 238.

146 *serve in the German army:* Richard Bessel, *Germany After the First World War* (Oxford: Clarendon Press), 5.

147 *"higher and purer things":* Paul Cassirer and Leo Kesternberg, "Zur Einführung!" *Der Bildermann,* no. 1 (5 April 1916), quoted in Paret, *Seces-sion,* 240.

147 *"the moods and possibilities of the War":* Max Beckmann, from *Briefe im Kriege,* 1914, quoted in Charles Werner Hartheusen, "Max Beckmann and the First World War," in Carla Schulz-Hoffmann and Judith C. Weiss, eds., *Max Beck-mann: A Retrospective* (Saint Louis: Saint Louis Art Museum, 1984), 70.

147 *rose to 1.2 million:* Kennedy, *Rise and Fall,* 269.

148 *"its spirit might come to its senses":* Julius Meier-Graefe, quoted in Schulz-Hoffmann and Weiss, *Beck-mann,* 202.

16. Frankfurt: Museum Masterpiece, 1920–1933

149 *"completely sealed":* Benno Reifenberg, in "Max Beckmann," *Ganymed* 3 (1921), quoted in *Beck-mann,* 452.

149 *"genius would remain undiscov-ered forever":* Fritz Stern, *The Failure of Illiberalism,* 135.

150 *"Revolution has won the day in Berlin"*: HGK, diary, 9 November 1918, in *In the Twenties*, 6.

150 *132 billion gold marks:* Gay, *Weimar Culture*, 152.

150 *to a beggar and not be thanked:* Malcolm Cowley, *Exile's Return* (New York, 1951), 81, quoted in Craig, *Germany*, 451.

150 *"nothing but a great swindle"*: Cassirer, as reported in HGK's diary, quoted in Gay, *Weimar Culture*, 10.

152 *"symbol of a new faith"*: Walter Gropius, "First Proclamation of the Bauhaus," in Selz, *Expressionist Painting*, 314.

152 *late van Gogh portrait:* Benno Reifenberg, "Die Erweiterung des Städelschen Museums," *Deutsche Kunst und Dekoration* 49 (October–November 1921): 27.

152 *expressionist pictures:* Kersting, " 'Stete Intensivierung,' " 88–172.

153 *"the well-to-do bourgeoisie"*: Selz, *Expressionist Painting*, 317.

153 *"From Representation to Symbol"*: *Vom Abbild zum Sinnbild* (Frankfurt am Main), no. 76 (June–July 1931).

153 *"new realism bearing a socialist flavor"*: G. F. Hartlaub, letter published in *Arts* (January 1931), quoted in Alfred Barr, "Introduction," in *Modern German Painting and Sculpture* (New York: Museum of Modern Art, 1972), n. 13.

155 *"modern art since Impressionism"*: Barr, *Modern German Painting*, 15.

155 *"of the modern age"*: Ludwig Justi, "Zum Ankauf des van Gogh," *Kunst und Wirtschaft* 13 (1932): 115–16, quoted in Manheim, "Germanic van Gogh," 281.

155 *"oversized heroes"*: Zemel, *Legend*, 109.

155 *"the greatest of our time"*: Meier-Graefe, *Vincent van Gogh*, trans. John Holroyd-Reece (New York: Dover, 1987), 2.

155 *"feels something of his tension"*: Meier-Graefe, *Vincent*, quoted in Lenz, "Meier-Graefe," 54.

156 *"the last protection in the world"*: ibid.

156 *"details appear by chance"*: Karl Jaspers, "Van Gogh and Schizophrenia," in Welsh-Ovcharov, *Perspective*, 100–101.

156 *"serpentine line . . . artist himself"*: Françoise Minkowska, "Van Gogh: Les Relations entre sa vie, sa maladie et son oeuvre," *L'Evolution psychiatrique* 3 (1933): 53–76, in Welsh-Ovcharov, *Perspective*, 103–104.

156 *"illustrator"*: Roger Fry, "Vincent van Gogh," in *Transformations*, 245.

156 *"the real theme of his art"*: ibid., 244.

156 *"in vain for further revelations"*: ibid., 248.

157 *art world figures:* Roland Dorn and Walter Feilchenfeldt, "Genuine or Fake?—On the History and Problems of Van Gogh Connoisseurship," in Tsukasa and Rosenberg, *Mythology*, 269. At the Wacker trial, testimony revealed that "for a small fee, 40 Marks or 25 guilders per picture, not only Hans Rosenhagen and Julius Meier-Graefe, but even de la Faille had given Otto Wacker expert opinions, transforming paintings that were otherwise hardly worth the canvas they were painted on into gems for which purchasers could be found at prices between 19,000 and 66,000 Marks" (ibid.).

157 *"the enemies of Weimar hated all Expressionists"*: Gay, *Weimar Culture*, 108.

158 *"Bolshevism in art"*: Dr. Schreiber-Wiegand, quoted in Stephanie Barron, "1937," in Barron et al., *"Degenerate Art": The Fate of the Avant-Garde in Nazi Germany* (New York: Harry N. Abrams, 1991), 15–16.

158 *"Kirchner and Heckel"*: ibid.

158 *"patrolling in vans and on horses"*: HGK, 13 October 1930, quoted in Craig, *Germany,* 542–543.

17. Frankfurt: "Degenerate Art," 1933–1938

161 *"works of modern painting:"* Dr. Max V. Brück to Friedrich Krebs, 8 December 1937, SKA, Gachet file, 10.

161 *"mystification, and madness"*: Georg Swarzenski, *Beckmann: His Recent Work* (New York: Buchholz Gallery Curt Valentin, 1946).

161 *National Socialist German Workers' Party:* See Craig, *Germany,* 571–578, on Hitler's taking of power.

162 *"savor strongly of 'Stop-Thief!' "*: HGK, 28 February 1933, in *In the Twenties,* 448.

162 *"means to that end"*: Hitler, 23 March 1933, quoted in Peter Adam, *Art of the Third Reich* (New York: Harry N. Abrams, 1992), 10.

163 *"not encouraging at all"*: Oswald Goetz, "The History of a Picture," in Fritz Messinger, *Ein vergessener Maler im Rijksmuseum Kröller-Müller* (Frankfurt am Main: R. G. Fischer, 1991).

163 *Gleichschaltung:* Craig, *Germany,* 578.

163 *image of the people:* Joseph Goebbels, letter to Wilhelm Furtwängler, April 11, 1933, in Michael E. Zimmerman, "Ontological Aestheticism: Heidegger, Junger, and National Socialism," in Tom Rockmore and Joseph Margolis, eds., *The Heidegger Case: On Philosophy and Politics* (Philadelphia: Temple University Press, 1992), 72, quoted in Anson Rabinbach and Gail Stavitsky, *Assault on the Arts: Culture and Politics in Nazi Germany* (New York: New York Public Library, 1993), 2.

164 *"authors and artists"*: Max Nordau, *Degeneration* (1892; Lincoln: University of Nebraska, 1968).

164 *"of the German future"*: Adolf Hitler, July 18, 1937, in George L. Mosse, *Nazi Culture: Intellectual, Cultural and Social Life in the Third Reich* (New York: Grosset and Dunlop, 1966; Schöken Books, 1981), 16.

164–165 *"it was for the select few"*: Hans Adolf Bühler, "Zum Geleit," *Das Bild* (1934), quoted in Peter Adam, *Art of the Third Reich,* 59.

165 *"decadence that lies behind us:"* Hitler, speech to NSDAP rally, Nuremberg Party Congress, 2 September 1933, quoted in Andreas Hüneke, "On the Trail of Missing Masterpieces," in Barron, *"Degenerate Art,"* 122.

165 *"Georg Swarzenski . . . is a Jew"*: Krebs, to Regierungspräsident, Wiesbaden, 27 April 1933, Frankfurt City Archives, file 1100/203, file 6341, file 6351.

165 *Swarzenski had "retired"*: Krebs to Regierungspräsident, Wiesbaden, 28 July 1933, Frankfurt City Archives, Swarzenski file; Göring (Preuss. Minister des Innern.) to Swarzenski, General direktor der Städtischen Museen, 24 October 1933, Frankfurt City Archives, Swarzenski file, 25.

166 *"the Frankfurt mother earth"*: *Frankfurt, 1933–1945: von der NS-*

Machtergreifung bis zur Zerstörung der Stadt (Frankfurt am Main: Presse und Informationsamt der Stadt, 1986), 7.

166 *directors and curators:* Barron, "1937," in *"Degenerate Art,"* 13. On Justi and Schardt, see Lynn Nicholas, *The Rape of Europa: The Fate of Europe's Treasures in the Third Reich and the Second World War* (New York: Knopf, 1994), 11–12.

166 *Prussian Academy:* Nicholas, *Rape of Europa*, 12–13.

166 *Swarzenski stubbornly refused:* See Fritz Stern, *Dreams and Delusions: National Socialism in the Drama of the German Past* (New York: Alfred A. Knopf, 1987), 134.

167 *Krebs was an "alter Kämpfer":* I am grateful to Andreas Hansert and Heike Drummer for information about Krebs.

169 *"cultural bolshevik" . . . in support of Beckmann:* Kersting, " 'Stete Intensivierung,' " 26–27 n. 82.

169 *"the German art of the next decade":* Goebbels, quoted in Jonathan Petropoulos, *Art as Politics in the Third Reich* (Chapel Hill: University of North Carolina Press, 1996), 24.

169 *"The myth is the Myth of the Blood":* Louis L. Snyder, *Encyclopedia of the Third Reich* (New York: Paragon House, 1976), 300.

169 *"to exterminate it":* Kessler, 15 July 1933, in *In the Twenties*, 462.

170 *source of competition:* Petropoulos, *Art as Politics*, 9. See also Craig, *Germany*, 646. In September 1934 at the Nuremberg party rally, Hitler denounced both the Goebbels and the Rosenberg camps (Adam, *Third Reich*, 57). But a year later he finally made it clear that modernism would not be allowed (Petropoulos, *Art as Politics*, 47).

170 *"to 'refine' the Nazi art criteria":* Nicholas, *Rape of Europa*, 10.

170 *"are simply locked":* Alfred Barr, "Art in the Third Reich—Preview, 1933," in Barr, *Defining Modern Art*, ed. Irving Sandler and Amy Newman (New York: Harry N. Abrams, 1986), 102, 170. "Notes on the film: Nationalism in German Films" was published in Lincoln Kirstein's *Hound & Horn*, January/March 1934. Barr's articles were published in the *Magazine of Art* in October 1945. (Nicholas, *Rape of Europa*, 6.)

170 *"van Gogh's greatest portrait":* The Museum of Modern Art, Department of Registration, Vincent van Gogh, Exhibition No. 44, Exhibition File (letter from Alfred Barr to Georg Swarzenski, 21 August 1935).

170 *"whether we shall receive permission":* The Museum of Modern Art, Department of Registration, Vincent van Gogh, Exhibition No. 44, Exhibition File (letter from Swarzenski to Barr, August 1935).

170 *the loan was not possible:* The Museum of Modern Art, Department of Registration, Vincent van Gogh, Exhibition No. 44, Exhibition File (Swarzenski to Barr, 3 September 1935).

171 *an American in Berlin:* The Museum of Modern Art, Department of Registration, Vincent van Gogh, Exhibition No. 44, Exhibition File. (Telegram from Barr to Swarzenski, 4 October 1935. "MRS. READ REPORTS KULTUSMINISTERIUM PROPAGANDAMINISTERIUM DO NOT OPPOSE LOAN VAN GOGH STOP CABLE COLLECT IF LOAN STILL POSSIBLE.")

171 *"I request a photograph":*

Telegram from Keudell, Reichs-propagandaministerium, to Wolters, director of the Städtische Galerie, 22 November 1935, SKA, Gachet file, 1.

171 *"all Nordic peoples depends"*: Wilhelm Schramm, "Van Gogh als niederländisches Problem," *Kunst der Nation* 2, no. 5 (1934): 2–3, quoted in Manheim, "Germanic van Gogh," 284.

172 *particularly Impressionist paintings*: Rust to Wolters, Frankfurt, 17 December 1935, SKA, Gachet file, 2. See Nicholas, *Rape of Europa*, 33.

172 *valuable modern pictures*: Wolters to Keller, Kulturamt, 18 December 1935, SKA, Gachet file, 3.

172 *Keller*: Keller to Krebs, 19 December 1935, SKA, Gachet file, 4.

173 *Friedrich Krebs*: Krebs to Rust, 19 December 1935, SKA, Gachet file, 5.

173 *Karl Haberstock*: Nicholas, *Rape of Europa*, 24, 32–33.

173 *"he rejected any such dealings"*: ibid., 33.

173 *the opportunistic Goebbels fell in line*: Petropoulos, *Art as Politics*, 52–54.

173 *the press*: Adolf Hitler, speech, 9 April 1929, in ibid., 54.

173 *"But I shall now intervene"*: Joseph Goebbels diary, 4 June 1937, quoted in Hüneke, "Trail," 123.

174 *"local communities"*: Goebbels decree, 30 June 1937, quoted in Barron, "1937," 19. In Nov. 1936, officials of the Propaganda ministry borrowed six paintings, including Beckmann's *Descent from the Cross*, from Frankfurt's Städtische Galerie for an anti-comintern exhibition, one of several "shameful art" shows. See Petropoulos, *Art as Politics*, 52.

174 *a commission to assist Ziegler*: Barron, "1937," 19.

174 *"help of the printed catalogues"*: Goetz, "History," 124.

174 *In the first two weeks*: ibid.

175 *Marc's paintings appeared*: ibid., 57.

175 *"Madness becomes method"* Mario Andreas von Lüttichau, " 'Entartete Kunst,' Munich 1937," in Barron, *"Degenerate Art,"* 61.

175 *"Crazy at any price"*: ibid.

175 *"German working people"*: ibid., 63.

176 *"offer it as art today"*: ibid., 71.

176 *eleven paintings acquired . . . for the Städel*: Revision, 157–172.

176 *"5,000 marks in 1919"*: von Lüttichau, "Entartete Kunst," 58.

176 *" 'Exhibition of Degenerate Art,' in Munich"*: Joseph Goebbels, address, 26 November 1937, quoted in Mosse, *Nazi Culture*, 152–153.

176 *"Great German Art Exhibition"*: See George L. Mosse, "Beauty without Sensuality," in Barron, *"Degenerate Art,"* 25.

177 *"international scratchings"*: Hitler, Munich, 18 July 1937, quoted in Barron, "1937," 17.

177 *"drummed with his fists"*: Paul Ortwin Rave, *Kunstdiktatur im dritten Reich* (Hamburg: Gebrüder Mann, 1949), 55–56, quoted in Nicholas, *Rape of Europa*, 20.

177 *Beckmann . . . for Amsterdam*: Doris Schmidt, "Biography," Beckmann Retrospective, 461.

177 *attracted 1 million more*: Petropoulos, *Art as Politics*, 57. It was in Frankfurt, June–July 1939.

177 *"last opportunity to study modern art"*: "Degenerate Art Popular in Reich," *New York Times*, 6 August 1937.

177 *"Scarcely a word is spoken":* Hannah Höch, journal, 11 September 1937, *The Photomontage of Hannah Höch* (Minneapolis: Walker Art Center, 1997), 61. Höch visited the exhibition on September 11 and 16. I am grateful to Paret for pointing to Höch's observations.

178 *"individual regions or the local communities":* Goebbels, quoted in Hüneke, "Trail," 124.

178 *572 drawings and prints:* Kersting, " 'Stete Intensivierung,' " 27 n. 87.

178 *"Argus-eyes of the brigands:* Goetz, "History," 124. The Nazis took other van Goghs: *Self-Portrait* (F476) from Munich; *Armand Roulin* (F493) from Cologne; *The Painter on the Road to Tarascon* (F448) from Magdeburg (later destroyed); *Daubigny's Garden* (F776), *Lovers* (F485), and *Harvest* (F628) from the Berlin Nationalgalerie (Feilchenfeldt, *Cassirer*, 42).

178 *shipped . . . to a warehouse:* Petropoulos, *Art as Politics*, 56.

178–179 *five more Frankfurt paintings:* memo (Wolters) to the Kulturamt, 2 December 1937, SKA, Gachet file, 6. The other canvases were Munch's *Mann mit Ente* (Man with duck), Cross's *Frauenakt* (Nude), and Monticelli's *Anstreicher* (Painter).

179 *"authority of the Führer":* [Rolf Hetsch], Der Präsident der Reichskammer der bildenden Künste, to Director, Städtische Galerie, 2 December 1937, SKA. Ziegler also wanted paintings by Gauguin (50,000 marks), Munch (8,000 marks), Monticelli (6,000 marks), and Cross (3,000 marks).

179 *he told the Propaganda Ministry:* Wolters [to Ziegler], 3 December 1937, SKA, Gachet file, 8.

179 *"There was a funeral atmosphere":* Goetz, "History," 125–126. *Gachet* was sent to Berlin December 14 (Keller to Krebs, 14 December 1937, SKA, Gachet file, 9).

179 *"no longer in the collection":* Max Brück, *Frankfurter Zeitung*, to Krebs, 8 December 1937, SKA, Gachet file.

181 *"relief for their own confusion":* [Benno Reifenberg], "Dr. Gachet," *Frankfurter Zeitung*, 9 December 1937.

181 *Swarzenski was with friends:* W. Swarzenski, interview, 1992.

181 *to force him to resign:* Kersting, " 'Stete Intensivierung,' " 26–27 n. 82.

181 *"more indignant than ever before":* Goetz, "History," 126.

181 *in complete agreement:* Wolters to Kulturamt, 12 December 1937, SKA, Gachet file, 12.

181 *Nazis issued a decree forcing Jews:* Craig, *Germany*, 635; Ron Chernow, *The Warburgs* (New York: Random House, 1993), 463.

182 *"the return of the painting":* Memo; Keller refers to Mössinger's letter of 14 December, 1937, SKA, Gachet file, 13.

182 *lengthy memo:* Kulturamt to Krebs, 15 February 1938, SKA, Gachet file, 15.

182 *"decent masters abroad":* Goebbels, in Hüneke, 124.

183 *arrived "undamaged":* Memo, Kulturamt to Krebs, 15 February 1938, SKA, Gachet file, 15.

18. Berlin: Hermann Göring and Foreign Currency, 1938

184 *"I intend to plunder":* Göring, quoted in Petropoulos, *Art as Politics*, 195.

184 *Josef (Sepp) Angerer:* For Josef (Sepp) Angerer, see NA RG 239/85, OSS/ALIU Consolidated Interrogation Report 2, Theodore Rousseau, "The Goering Collection," 15 September 1945, 14. "Bornheim ... reports that in 1937 Angerer called him up and obliged him by threats of Gestapo intervention to sell first the Cumberland Tapestry (Beauvais ca 1700) and later the Maximilian Court tapestry (Brussels 16th century). The former went to Hitler and the latter to Göring."

184 *protests against the sale:* Krebs, memo on "Dr. Gachet by van Gogh," 23 May 1938, SKA, Gachet file, 21.

185 *Hermann Göring:* For Göring's collecting, see Nicholas, *Rape of Europa*, 34–37, 127–133; Petropoulos, *Art as Politics*, 187–195.

185 *"pictures of the type":* Report, Krebs to Kremmer, 10 May 1938, SKA, Gachet file, 16.

186 *"floors throughout the house":* Albert Speer, *Inside the Third Reich*, trans. Richard and Clara Winston (New York: Collier Books, 1981), 178.

186 *ERR:* see Nicholas, *Rape of Europa*, 125–130, 132–140.

186 *"boasted of bringing books":* OSS Interim Report on Göring, 4.

187 *"daubs by modern German painters":* Sumner Welles, *The Time for Decision* (New York, 1944), 118–119, quoted in Nicholas, *Rape of Europa*, 36.

187 *"Langlois Bridge":* Petropoulos, *Art as Politics*, 197.

187 *amounted to 100 million reichsmarks:* ibid., 188.

187 *some 5,000 pieces:* ibid., 181.

187 *Special Project Linz:* See Nicholas, *Rape of Europa*, 41–49;

Petropoulos, *Art as Politics*, 90–91, 181–186; and National Archives, Record Group 77, Office of Strategic Services/Art Looting Investigation Unit, Consolidated Interrogation Report 4, Lane Faison, "Linz: Hitler's Museum and Library," 14 December 1945.

187 *Vermeer's "Artist in His Studio":* Nicholas, *Rape of Europa*, 47–49.

188 *"cared nothing about it":* Janet Flanner, *Men and Monuments* (New York: DaCapo Press, 1990), 226.

188 *to his deputy, Kremmer:* Hauptverwaltungsamt Report, 11 May 1938, SKA, Gachet file, 17.

188 *Kremmer drafted a statement:* Kremmer to Göring, 11 May 1938, SKA, Gachet file.

188 *consult the cultural administrators:* Hauptverwaltungsamt Report, to Kulturamt, 12 May 1938, SKA, Gachet file, 18.

189 *in the Städtische Galerie at all times:* Response to the Hauptverwaltungsamt letter, 12 May 1938, SKA, Gachet file, 19.

189 *the lawyers gave Krebs a more thorough review:* Hauptverwaltungsamt [Kremmer] to Krebs, 20 May 1938, SKA, Gachet file 20.

189 *Asking his superiors:* Krebs, 23 May 1938, SKA, Gachet file, 21.

189 *heard again from Johanna Mössinger:* Mössinger to Krebs, 27 May 1938, SKA, Gachet file, 22.

189 *Krebs lied:* Krebs to Mössinger, 30 May 1938, SKA, Gachet file, 23.

189 *Krebs turned to ... Philipp Prinz von Hessen:* Krebs to Philipp Prinz von Hessen, 30 May 1938, SKA, Gachet file, 23.

190 *Kommission:* Hüneke, "Trail," 125.

190 *"make some money from this garbage":* Josef Goebbels, diary, 29 July 1938, in Stephanie Barron, "The Galerie Fischer Auction," in *"Degenerate Art."*

190 *four art dealers:* Nicholas, *Rape of Europa*, 24.

190 *Sonderkonto Entartete Kunst:* see Petropoulos, *Art as Politics*, 80.

191 *Folkwang Museum in Essen:* In the 1920s, the city of Essen acquired the collection of the Folkwang Museum, founded by Karl Ernst Osthaus in Hagen.

192 *12,000 English pounds . . . and 800,000 reichsmarks:* GStA PK, I.HA Rep. 90, Nr. 2464, Preussisches Staatsministerium, memo, 18 May 1938. See also Petropoulos, *Art as Politics*, 79. Jonathan Petropoulos directed me to this and other documents on Göring's collecting.

192 *sperrmarks:* Sperrmarks, a blocked currency, could be spent only in Germany. In calculating their value, Tim Guinnane assumed the exchange to be about 8 sperrmarks to a U.S. dollar, a rate based upon an American currency dealer's records from the late 1930s.

192 *Koenigs had paid some 500,000 RM:* NA RG 260 438, Office of Military Government for Bavaria, Monuments, Fine Arts and Archives Section, to Rae, Taper, Doubinsky, on Angerer, 20 May 1947. I am grateful to Lynn Nicholas for giving me a copy of this document.

193 *Angerer's dealings:* Seemingly the day before Koenigs went to Paris to pick up the paintings, an official named Bergmann, in the Four-Year Plan's foreign currency office, documented the sale of *Dr. Gachet* and the two other paintings in a lengthy memo designed to get Funk's retroactive approval for Angerer's spending of foreign currency without the required permits. The memo goes through the complicated transaction— Hitler's approval of the idea of selling confiscated works abroad, Göring's request to Goebbels, Goebbels's consent to release three pictures, the sale to Koenigs for 12,000 pounds and 800,000 sperrmarks. These would be used by Angerer for the most part to pay for works of art that had already been purchased and inspected by Göring and the führer (Bergmann memo, 19 May, 1938, GStA PK, I.HA Rep. 90, Nr. 2464, B1.1–2).

193 *reconcile pieces of the transaction:* GStA PK, I.HA Rep. 90, Nr. 2464, B1.1–73.

193 *three eighteenth-century Gobelin tapestries:* F. Stern-Drey, Brussels, bill to Quantmeyer & Eicke, Berlin, 21 May 1938, GStA PK, I.HA Rep. 90, Nr. 2464, B1. 44.

193 *he also bought three minor tapestries:* ibid. One tapestry was based on a Watteau painting, another was decorated with a hunt scene, and the third depicted Pyramis and Thisbe.

193 *the Reich chancellery building:* GStA PK, I.HA Rep. 90, 2464, Legler (Staatssekretär des Preussischen Staatsministeriums) to Bürokasse, 29 March 1940.

193 *a Lucas Cranach painting:* Bacri Freres [to Angerer], 1 June 1938, GStA PK, I.HA Rep. 90, 2464, B1. 45.

193 *remaining 1,500 pounds to Göring:* Bergmann memo, 21 June 1938, 11; Göring to Neumann (Reichsbank), 23 June 1938, GStA PK, I.HA Rep. 90, 2464, B1. 4; Haberstock to Prussian State Min-

istry, unpublished statement, 5 April 1940, GStA PK, I.HA Rep. 90, 2464, B1. 70. On June 23 Angerer accounted for some of his dealings. He writes to Bergmann that on the order of Göring he bought six tapestries worth 400,000 in Venice from Dr. Alexandro Morandotti. In another letter to Bergmann, Angerer reports he bought two tapestries in Holland, which had been used as collateral for a loan to the Dresdner bank.

194 *to Haberstock's account:* Reichsbankdirektorium to Göring, 23 June 1938, GStA PK, I.HA Rep. 90, 2464, B1. 6.

194 *he would be reimbursed:* Bergmann to Funk, 29 June 1938, GStA PK, I.HA Rep. 90, 2462, B1. 12.

194 *"to camouflage his own machinations":* Petropoulos, *Art as Politics*, 80.

194 *Angerer went so far:* Angerer to Bergmann, 23 June 1938, 20. See also Göring to Funk, Berlin, 2 August 1938, GStA PK, I.HA Rep. 90, 2464, B1. 27.

194 *Prussian State Ministry 287,000 reichsmarks:* Quantmeyer & Eicke to Reichskanzlei, 15 June 1938, GStA PK, I.HA Rep. 90, 2464, B1. 18.

195 *Göring helped himself to ten other paintings:* Hüneke, 132 n. 21. Angerer sold Munch's *Embrace* and Signac's *Harbor* for 9,000 Swedish kronen, and Munch's *Melancholy* and *Encounter by the Sea* for 675 pounds (Angerer to Staatsministerium, Berlin, 16 November 1939, GStA PK, I.HA Rep. 90, 2464. B1. 57).

195 *had not paid the 800,000 sperrmarks:* Oberfinanzpräsident to Legler, 29 July 1938, GStA PK, I.HA Rep.

90, 2464, B1. 26. He informs Göring he has approved the application for a payment of 800,000 sperrmarks debited from the account of Rhodius Koenigs Handelsmaatschappij in Delbrück Schickler bank to the Prussian State Ministry account, also at Delbrück or at the post office.

195 *Four-Year Plan:* Bergmann memo, on Angerer, 29 June 1938, GStA PK, I.HA Rep. 90, 2464.

195 *Hoffmann revealed:* Krebs, 20 July 1938, SKA, Gachet file, 25.

195 *again politely inquired:* On the Mössinger-Krebs letters, 20 August–12 November, 1938, see SKA, Gachet file, 26–29.

196 *she wrote again on November 12:* Mössinger to Krebs, 12 November 1938, SKA, Gachet file, 28.

196 *Krebs acknowledged:* Krebs to Mössinger, 28 November 1938, SKA, Gachet file, 28. On June 16, 1939, Mössinger told Krebs that she learned of the upcoming auction of "degenerate art" and asked if she could be reimbursed (Mössinger to Krebs, 16 June 1939, 31).

196 *he had left Germany:* Harvard University Art Museums Archives, Paul J. Sachs files, letter from Georg Swarzenski to Paul J. Sachs, 19 September 1938.

196 *would receive 150,000 reichsmarks:* Legler, to the Städel, 24 January 1940, SKA, Gachet file, 24.

196 *Six of the thirteen:* Marc's *Tower of the Blue Horses* disappeared.

197 *she was owed nothing:* Kersting, " 'Stete Intensivierung,' " 27 n. 88.

196–197 *over 1,004 paintings . . . 3,825 watercolors:* Nicholas, *Rape of Europa*, 25.

197 *"degenerate art" sales had brought:* Petropoulous, *Art as Politics*, 80.

19. Amsterdam: Passage to Exile—Franz Koenigs and Siegfried Kramarsky, 1938–1940

198 *Koenigs telephoned:* Marianne Feilchenfeldt, August 1992.

199 *"more were jailed":* William L. Shirer, *The Rise and Fill of the Third Reich* (1950; reprint, New York: Ballantine, 1983), 477.

199 *paid with their property:* See Nicholas, *Rape of Europa*, 39.

200 *apparently more than 1 million guilders:* W. Koenigs, interview.

201 *Helmuth Lütjens:* Cassirer Gallery, Amsterdam, Stock Book, September 1938. Paul Cassirer–Archiv. Walter Feilchenfeldt, Zurich.

201 *Koenigs played the go-between:* For Koenigs's biography, I have relied upon Ger Luijten and A.W.F.M. Meij, *From Pisanello to Cézanne: Master Drawings from the Museum Boymans–van Beuningen, Rotterdam* (Rotterdam: Museum Boymans–van Beuningen, 1990), 9–12; and Albert J. Elen, *Missing Old Master Drawings from the Franz Koenigs Collection* (the Hague: Netherlands Office for Fine Arts, 1989), 9–13.

201 *educated by tutors:* Christine Koenigs, interview.

202 *He chose to live at a pace:* Marianne Feilchenfeldt, interview.

203 *relationships rather than financial analysis:* Hermann J. Abs, interview, August 1992.

203 *he had acquired 2,671 drawings:* Elen, *Missing Drawings*, 10–13.

204 *"lock of his property":* Benjamin, "Unpacking," 60.

204 *poured his assets into his drawings collection:* W. O. Koenigs, interview.

205 *a second collection:* Elen, *Missing Drawings*, 13. "Drawings from Koenigs' second collection can be easily distinguished form those in the first collection because *they do not bear the collector's mark*."

205 *Kramarsky had been in Koenigs's debt:* Hermann J. Abs, interview.

208 *270,000 . . . fled Germany:* Stern, *Dreams and Delusions*, 134.

208 *"much too late":* Nicholas, *Rape of Europa*, 43.

208 *"annihilation of the Jewish race":* Adolf Hitler, 30 Jan. 1939, quoted in Daniel Jonah Goldhagen, *Hitler's Willing Executioners* (New York: Alfred A. Knopf, 1996), 142.

208 *"new ways for raising money":* Dr. D. Cohen, *Zwervend en dolend* (Haarlem, 1955), 27, 75. The Dutch translations were done by Yolanda Vogelzang and Ester Wouthuysen.

209 *"Rhineland Industrialists":* K. Oppenheimer, interview.

209 *advertisement appeared in "Art News":* Nicholas, *Rape of Europa*, 2.

209 *"from German Museums":* Barron, "Fischer Auction," 135–169.

210 *570,904 Swiss francs, or some $132,000:* ibid., 144.

210 *"exile of such fine works":* Barr, quoted in *New York Times*, 13 August 1939.

211 *"I'd appreciate it if you would not tell":* Valentin to Kuhn, December 1940, in Jonathan Petropoulos, "Saving Culture from the Nazis," *Harvard Magazine*, March–April 1990, 41.

211 *the National Gallery:* Nicholas, *Rape of Europa*, 53. For the evacuation of the European museums, see 50–56.

211 *grand gallery at the Louvre:* This picture was on the cover of Lynn M. Nicholas's *The Rape of Europa.*

211 *"Winged Victory":* ibid., 55. The photograph is by Noel de Boyer.

211 *"followed the masterpieces":* ibid., 56.

211 *Lütjens arranged:* Cassirer Gallery, Amsterdam, Stock Book, 14 August 1939, Paul Cassirer–Archiv. Walter Feilchenfeldt, Zurich.

212 *"Trinquetaille Bridge":* unpublished inventory list, written by Raphael Rosenberg, Rosenberg & Stiebel archives; Eric Stiebel, interview, 1992.

212 *"It's going to rain tonight":* S. Kramarsky, interview.

212 *"I'm writing this during a blackout":* Beckmann in Stephan Lackner, "Beckmann's Exile in Amsterdam and Paris, 1937–1947," in Schulz-Hoffman and Weiss, *Beckmann,* 145.

213 *Saemy Rosenberg informed Paul Sachs:* See Harvard University Art Museums Archives, Paul J. Sachs files, letter from Saemy Rosenberg to Paul J. Sachs, April 16, 1940.

213 *Boymans–van Beuningen:* In 1997 the name changed to Museum Boijmans Van Beuningen.

213 *"to leave Rotterdam for good":* Hannema to Van der Vorm, 13 March 1940, in Christine F. Koenigs, "Under Duress," trans. Jonathan Bragdon, in Elizabeth Simpson, ed., *The Spoils of War: World War II and Its Aftermath—The Loss, Reappearance, and Recovery of Cultural Property* (New York: Harry N. Abrams, 1997), 238. For letter to van Beuningen, see ibid.

213 *"free property":* Franz Koenigs to Boymans directors, 2 April 1940, BvBM.

214 *pick the drawings up:* Lisser & Rosencranz to Boymans directors, 2 April 1940, BvBM.

214 *1 million guilders:* Hannema to van Beuningen, 8 April 1940, BvBM.

214 *"more than good":* Hannema to L&R directors, 9 April 1940, BvBM. On April 8, Lisser & Rosencranz directors wrote that Koenigs's paintings on loan to the Boymans were now in the bank's possession.

214 *accepted van Beuningen's offer:* Lisser & Rosencranz directors to Boymans directors, 9 April 1940, BvBM.

214 *Carpaccio drawings:* Koenigs to Hannema, 17 April 1940, BvBM.

215 *Nazis immediately began to rake through:* Nicholas, *Rape of Europa,* 97–114.

215 *"40 by Rembrandt, etc.":* Hans Posse to Martin Bormann, 14 October 1940, Consolidated Interrogation Report Linz, Attachment 60, in Elen, *Missing Drawings,* 15.

215 *Dirk Hannema:* Elen, *Missing Drawings,* 15. Hannema was under Arthur Seyss-Inquart, the Reichskommisar SS-Obergruppenführer.

215 *527 of the Koenigs drawings:* ibid., 15–16.

215 *"collector's fever":* Nicholas, *Rape of Europa,* 101.

216 *paintings formerly owned by Koenigs:* NA, RG 239, 85, OSS/ALIU, Report 2, 71.

216 *"the van Gogh":* Krebs report on trip, 29 August–11 September 1940, SKA, Gachet file, 36.

20. New York: Refugee, 1941

219 *"et omnia vanitas":* Goetz, "History," 128.

220 *exiled curators:* Colin Eisler, "Kunstgeschichte American Style: A

Study in Migration," in Donald Fleming and Bernard Bailyn, eds., *The Intellectual Migration: Europe and America, 1930–1960* (Cambridge, Mass.: Harvard University Press, 1969), 565.

220 *appraisal list:* Saemy Rosenberg, appraisal list, ca. 1940, Rosenberg & Stiebel archives, New York.

220 *quotas for Jews:* Chernow, *Warburgs,* 389.

220 *only 157,000 German Jews:* ibid., 446; Stern, *Dreams,* 134.

221 *"providential synchronism":* Erwin Panofsky, "Three Decades," 332.

221 *the center of modern art shifted:* Eisler, "Kunstgeschichte," 598–599.

221 *each held a van Gogh exhibition: Van Gogh Masterpieces,* Paul Rosenberg & Co., January 1942, no. 9; *The Art and Life of Vincent van Gogh,* introduction by Alfred M. Frankfurter (New York: Wildenstein, 1943), no. 62. During the war *Gachet* was also exhibited in *Paintings by van Gogh,* at the Baltimore Museum of Art, September–October 1942, and *Five Centuries of Dutch Art,* Art Association of Montreal, 9 March–9 April 1944.

222 *"Countless exhibitions":* Panofsky, "Three Decades," 327.

223 *"a more or less complete collection":* Joseph Choate, quoted in Tomkins, *Merchants,* 21.

223 *a byproduct of the war:* Harry B. Wehle, "French Painting from David to Toulouse-Lautrec," *Metropolitan Museum of Art Bulletin,* February 1941, 27.

224 *the portrait was delivered:* On January 21, 1941, Bertram S. Boggis, director of Duveen Bros., arranged for the picture to be collected from the gallery, at 720 Fifth Avenue, and delivered to the museum. It was "lent by a private collector" at 1130 Pine Avenue, Montreal. (Susan Alyson Stein, Department of European Paintings at the Metropolitan Museum of Art, letter, 31 March 1992.)

224 *"humiliated than any other":* Harry B. Wehle, "Preface," in *French Painting from David to Toulouse-Lautrec* (New York: Metropolitan Museum of Art, 1941), ix.

224 *and the Seligmanns:* Petropoulos, *Art as Politics,* 131.

224 *"presumably the second version":* ibid., 21–22. "In one of his letters to his brother, van Gogh included a sketch of the doctor's portrait. . . . The painting mentioned is the one in the Städtische Galerie, Frankfort, and this one is presumably the second version."

224 *1928 de la Faille catalogue:* The 1928 de la Faille describes the two versions, F753 and F754, and includes photographs of each. J.-B. de la Faille, *Oeuvres de Vincent van Gogh: Catalogue raissoné* (Paris and Brussels, 1928), 213.

225 *"laid down by Hitler":* "Göring Launches Nazi Art Purge," *New York Times,* 4 August 1937.

225 *the Fischer auction: New York Times,* 2 July 1939.

225 *"Van Gogh Masterpieces": Van Gogh Masterpieces* (New York: Paul Rosenberg, 1942). Under "Collections," the catalog lists "Count H. Kessler, Berlin; J. Keller, Paris, E. Druet, Paris."

226 *"These years . . . of global war":* Lola Kramarsky, address to Hadassah, 4 June 1958.

226 *discussed the administration of the "final solution":* Craig, *Germany,* 748–749.

227 *Paul Sachs:* For Paul J. Sachs (1876–1965), see Eisler, "Kunstgeschichte," 590–591.

227 *"somewhat delicate reasons":* Panofsky, "Three Decades," 330.

227 *250 art historians:* Karen Michaels, "Transfer and Transformation," in Stephanie Barron et al., *Exiles and Emigrés: The Flight of European Artists from Hitler* (New York: Harry N. Abrams, 1997), 305. Eisler cites fifty professors and twenty-eight museum directors ("Kunstgeschichte," 564).

228 *appreciation and connoisseurship:* See Eisler, "Kunstgeschichte," 550.

228 *"continental practice":* John Coolidge, "Walter Friedländer, 1873–1966," *Art Journal* 26 (spring 1967): 260, quoted in Eisler, "Kunstgeschichte," 559.

228 *"blue alpaca redingote":* Rewald, *Post-Impressionism*, 365.

228 *Erwin Panofsky:* See Eisler, "Kunstgeschichte," 582–583.

228 *"manifest themselves in the statues":* Panofsky, "The History of Art as a Humanistic Discipline," in *Meaning*, 14.

228 *collection of medieval art:* Hanns Swarzenski and Nancy Netzer, *Medieval Objects in the Museum of Fine Arts: Enamels and Glass* (Boston: Museum of Fine Arts, 1986), xv–xvi.

229 *"He is really alive":* Swarzenski, *Beckmann.*

231 *He was buried:* Perry Rathbone, interview, 1992.

21. "Exactly How Great a Painter Was He?" 1950s–1970s

233 *"Great a Painter":* Clement Greenberg, "Review of Exhibitions of Van Gogh and the Remarque Collec-tion," *Nation*, 6 November 1943, in *Clement Greenberg: The Collected Essays and Criticism*, ed. John O'Brian (Chicago: University of Chicago Press, 1993), 1:161.

233 *"under which man lives today":* Daniel Catton Rich, "Van Gogh," in *Van Gogh: Paintings and Drawings* (New York: Metropolitan Museum of Art, 1949), 10.

234 *the atomic bomb:* Kennedy, *Rise and Fall*, 440.

234 *Houghton Mifflin had pub-lished: The Letters of Vincent van Gogh to his Brother, 1872–1886*, and *Further Letters of Vincent van Gogh to His Brother, 1886–1889* (Boston: Houghton Mifflin: 1927, 1929).

234 *twenty-three paintings and nine-teen drawings:* The Art Institute of Chicago owned five van Goghs, including *Van Gogh's Bedroom* and *La Berceuse*; Carroll S. Tyson owned a *Sunflowers*; Stephen Clarke, *Night Café*; Samuel Lewisohn, *L'Arlésienne*; J. Robert Oppenheimer, *Portrait of Mademoiselle Ravoux*; John Spaulding, *Houses in Auvers.*

234 *"exhibiting the Sistine Chapel":* Harold Edgell, quoted in Walter Muir Whitehill, *The Museum of Fine Arts* (Cambridge: Harvard University Press, Belknap Press, 1970), 2: 644.

235 *"the most stimulating ex-hibition":* Russell Lynes, *Good Old Modern* (New York: Atheneum, 1973),135.

235 *"a circulation-promotion stunt":* Frankfurter, *Art and Life*, 12.

235 *"melodrama of the dialogue":* ibid.

235 *"These canvases alone, Mon-sieur":* Irving Stone, *Lust for Life* (London: Longmans, Green, 1934), 468.

235 *first examples of the artist's canvases:* Charles Sterling and Margaretta M. Salinger, *French Paintings: A Catalogue of the Collection of the Metropolitan Museum of Art* (New York: Metropolitan Museum of Art, 1967), 181–192. The museum acquired *Sunflowers* and *Cypresses* in 1949; *L'Arlésienne* in 1951.

236 *"understanding of contemporary artists":* "Foreword," in *Vincent van Gogh* (Houston: Contemporary Art Association of Houston, 1951). *Gachet* was no. 20.

236 *insured for $1.5 million:* Ann Holmes, "Van Gogh Sought a Shining Light," *Houston Chronicle*, 4 February 1951.

236 *the insurance value of the paintings:* Lynes, *Good Old Modern*, 133.

236 *"sad guy at his saddest":* Morris Frank, "Morris Akin to van Gogh," *Houston Chronicle*, 6 February 1951.

236 *an exhibition at the Municipal Art Gallery: Vincent van Gogh: A Loan Exhibition of Paintings and Drawings*, in cooperation with Wildenstein & Co., 3 July–4 August 1957.

236 *the rights to the novel:* Stephen Harvey, *Directed by Vincente Minnelli* (New York: Museum of Modern Art, 1989), 221–247.

236–237 *"have at last migrated"; "new talents":* Greenberg, *Collected Essays*, 2:215.

237 *a Pollock reportedly sold for more than $100,000:* Clement Greenberg, "The Jackson Pollock Market Soars" (1961), in *Collected Essays*, 4:107.

237 *"a resonance like that of van Gogh's:* ibid., 114.

237 *"popular biography:"* Rich, *Van Gogh*, 7.

237 *"a high moral religious drama":* Schapiro, *Van Gogh*, 12.

237 *"upheavals, nature suffering or disturbed":* ibid., 22–23.

238 *"few and far between":* Greenberg, "Review," 1:160.

238 *"on moralism or story telling":* Nochlin, *Politics of Vision*, xiii.

239 *exhibition at the Metropolitan:* Charles Moffett, *Van Gogh as Critic and Self-Critic* (New York: Metropolitan Museum of Art, 1974). In 1964, *Gachet* appeared in *Van Gogh and Expressionism*, Solomon R. Guggenheim Museum, July–September 1964.

239 *42 percent of its income:* James T. Patterson, *Grand Expectations: The United States, 1945–1974* (New York: Oxford, 1996), 61.

239 *"10 works":* Deirdre Robson, "Wildenstein," in Turner, *Dictionary*, 33:183.

239 *borrowing Kramarsky's "Gachet" three times:* Wildenstein, *Six Masters of Post-Impressionism* (April–May 1948), no. 70; *Vincent van Gogh: Loan Exhibition* (March–April 1955), no. 72; *Olympia's Progeny* (October–November 1965), no. 62.

241 *Public Garden with Couple and Blue Fir Tree:* For this canvas, F479, see Dorn, "Decoration," 379.

241 *"size 30 canvas":* CL 552.

241 *Rembrandt's "Aristotle":* Tomkins, *Merchants*, 338–339.

241: *estimated to be $60,000:* Saemy Rosenberg to S. L. Wolkenberg, 23 February 1944, Rosenberg & Stiebel archives.

241 *appraised "Gachet":* Eric Stiebel to Kramarsky Trust, 15 May 1970, Rosenberg & Stiebel archives.

22. Postwar Frankfurt

243 *Abs, a pragmatist, claimed:* Abs, conversation, August 1992.

244 *Holzinger alerted Abs:* Ernst Holzinger to Abs, 23 December 1958, SKA.

244 *wrote Kramarsky:* Abs to S. Kramarsky, 21 January 1958, SKA.

244 *Holzinger requested:* Holzinger to Dept. for Learning, Art, and Education, memo, 28 February 1959, SKA.

244 *"German Jewish refugees":* New York Times, 26 December 1961.

245 *"have always said so":* Holzinger to W. Kramarsky, 4 April 1962, SKA. "Ich glaube, es könnte mit ihm ein guter Geist wieder in diese Stadt, die solcher Geister so sehr bedarf, zurückkehren, nachdem 1933 und später soviel gute Geister sie verlassen haben—durch unsere Schuld, wie ich wohl weiss und immer ausspreche."

246 *"not be for sale in the foreseeable future":* Lola Kramarsky to Holzinger, 17 April 1962, SKA.

246 *Holzinger told Abs:* Holzinger to Abs, 5 May 1962, SKA.

246 *its confiscation:* Kersting, " 'Stete Intensivierung,' " 27 n. 88.

247 *for the Berlin Nationalgalerie in the 1930s:* Certain scholars questioned Justi's purchase, seemingly in retaliation for the role he played in revealing certain van Goghs in Wacker scandal to be forgeries (Dorn, interview).

248 *"the final homage to Daubigny":* Pickvance, *Saint-Rémy,* 285.

248 *accepted both versions as authentic:* Dorn, interview.

249 *Dürer watercolor:* "Reporter's Notebook," New York Times, 29 June 1978. The Dürer watercolor went to the Kunsthalle in Bremen.

249 *"without dollar signs in our eyes":* Eugene Thaw, "Hirsch: Ridiculous Prices and Art Market 'Groupies,' " *Times* (London) 12 July 1978, 14.

250 *"aware of survival":* Lola Kramarsky to Bernice Kaplan, 21 May 1977, read at Hadassah National Board Meeting, 2 June 1977.

23. The Metropolitan Museum and the New van Gogh, 1984–1990

253 *"was going to be great":* Henry James, *The American Scene* (1907; reprint, Bloomington: Indiana University Press, 1968), 192.

253 *packed in a crate:* Susan Alyson Stein, 31 March 1992, letter.

254 *"directly affect his work":* Pickvance, *Saint-Rémy,* 15.

257 *master plan:* ibid. See Philippe de Montebello, *The Met and the New Millennium* (New York: Metropolitan Museum of Art, 1994), 36.

258 *New wings:* Tompkins, Merchants, 379.

258 *"a scale almost unknown in Europe":* ibid., 12.

258 *"the single most offensive sound":* John Russell, "Are Crowds and Art a Happy Mix?" *New York Times,* 4 November 1984.

259 *van Gogh posters: Annual Report for the Fiscal Year July 1 through June 30, 1987* (New York: Metropolitan Museum of Art, 1987), 4.

259 *"walk off with posters":* Arthur Danto, *Beyond the Brillo Box* (New York: Farrar, Straus & Giroux, 1992), 2.

259 *nineteenth-century galleries:* Grace Glueck, "The Met Reclaims More than 500 19th Century Treasures," *New York Times,* 23 March 1980.

259 *"debated field":* Richard R. Brettell, "Modern French Painting

and the Art Museum," *Art Bulletin* 77, no. 2 (1995): 166–169.

259 *museum design:* Ada Louise Huxtable, "The New Galleries Are 'Near Perfect,' " *New York Times*, 23 March 1980.

260 *"precisely 444 days":* Pickvance, *Arles*, 11.

261 *"significant effect on his view":* ibid., 84.

261 *"staying on here":* CL 500 (June 4, 1888).

261 *"significant," "radical":* Pickvance, *Arles*, appendix 1, 260–263.

261 *"Ten times the average fell that month":* ibid., 204.

261 *"one-man, one-place show":* ibid., 11.

262 *"a very weak replica":* Faille (1970), F754.

262 *several pictures:* Welsh-Ovcharov, in *Paris Period*, lists "works rejected" and "undecided attributions" (236–237).

262 *"his greatest isolation":* Dorn and Feilchenfeldt, "Genuine or Fake?" 296.

262 *Jan Hulsker . . . proposed a new sequencing:* Jan Hulsker, *Van Gogh door van Gogh: De brieven als commentaar op zijn werks* (Amsterdam: Meulenhoff, 1973). See also David Sweetman, *Van Gogh* (New York: Crown Publishers, 1990), 355.

263 *"my most purposeful canvases":* CL 651.

263 *stacked on the floor:* Bogomila Welsh-Ovcharov, interview.

264 *Rijksmuseum:* Gerald van Bronkhorst, "Vincent Willem van Gogh and the Rijksmuseum's Pre-History," *Van Gogh Museum Journal*, 1995, 25–84.

265 *the last seventy days of his life:* Pickvance, *Saint-Rémy*, 18.

265 *"did not directly affect his work":* ibid., 15.

265 *"series that are organically connected":* ibid., 16.

265 *Roland Dorn:* Dorn first presented his revolutionary ideas in "Vincent van Gogh's Concept of 'Décoration,' " a talk given at the Vincent van Gogh International Symposium, Tokyo, 17–19 October 1985, and in his thesis for Johannes Gutenberg University, 1986. In 1990 he published *Décoration: Vincent van Goghs Werkreihe für das gelbe Haus in Arles* (Hildesheim: Georg Olms, 1990).

265 *segments of a mural:* Dorn, Leeman, et al., *Early Modern Art*, 37.

265 *a series of paintings of sunflowers:* Dorn, "Décoration," 375.

265 *"antithetical counterparts":* ibid., 377–379.

265 *"Public Garden with Weeping Tree":* This is the first in the *Poet's Garden* series—*Poet's Garden I* in the Art Institute of Chicago (see ibid., 378).

266 *"Maupassant put it":* Dorn, Leeman, et al., *Early Modern Art*, 37.

266 *"doctrine of realism":* ibid.

266 *"intensity of application":* ibid.

266 *double-square canvases:* Pickvance, *Saint-Rémy*, 258–285.

266 *"tragic and sinister":* ibid., 276.

266 *"without imposing on it":* ibid., 276.

266 *put the matter of its meaning to rest:* Judy Sund argued that the controversial *Crows* is "a reflection of his continuing preoccupation with death, its message of mortality . . . [and] seems tinged by an excitement born of the artist's faith in the afterlife evoked by the Scriptures" ("The Sower and the Sheaf," *Art Bulletin* 70, no. 4 [1988], 675).

266 *literary theory, and feminism:* Nochlin, *Politics*, xiv.

267 *"woodblock prints":* Pickvance, *Saint-Rémy*, 18.

267 *"capitalism in the town":* Griselda Pollock, "Stark Encounters," *Art History* 6, no. 3 (1983): 353.

267 *"specific fact of his class position":* ibid., 350.

267 *"commercial success":* ibid., 331.

268 *"achieve their effects":* Nochlin, *Politics*, 114–115.

268 *"note struck by Parisians":* Clark, *Painting of Modern Life*, 30.

268 *" 'the modern portrait' ":* Welsh-Ovcharov, *Cloisonism*, 164.

268 *"personal interpretations than is commonly thought":* ibid., 163.

268 *another historian:* Price, "Two Portraits," 714–718.

269 *"his own artistic ideals":* van Uitert, "Van Gogh and Gauguin," 94.

269 *"the modern novel":* ibid.

269 *"contemporary moral history":* Edmond and Jules de Goncourt, *Germinie Lacerteux* (1879; reprint, New York: Penguin, 1984), in ibid., 96.

269 *" 'the rage of the heart' ":* Edmond and Jules de Goncourt, *Manette Salomon* (Paris: Charpentier, 1881), 84, quoted in ibid.

269 *"fused" multiple sources:* Welsh-Ovcharov, *Cloisonism*, 164.

269 *"paint infinity":* CL 520.

270 *"a certain family likeness to us":* CL 570.

270 *"companion piece":* Judy Sund, *True to Temperament: Van Gogh and French Naturalist Literature* (Cambridge: Cambridge University Press, 1992), 238.

270 *"waxed during his years in France":* ibid., 242–43.

271 *"as apparitions":* CL W22.

271 *"no other artist":* Pickvance, *Arles*, 11.

24. The *Sunflowers*, 1987

272 *"who bid against you?":* Mary Cassatt to Louisine Havemeyer, 25 December 1912, quoted in Weitzenhoffer, *Havemeyers*, 209.

272 *noted with regret:* Philippe de Montebello, "Director's Foreword," in Pickvance, *Arles*, 6.

272 *a copy of one of the earlier pictures:* Dorn, Leeman, et al., *Early Modern Art*, 115–120. See *Sunflowers*, (London: Christie's, 1987).

273 *three bull markets:* William N. Goetzmann, "Accounting for Taste," *American Economic Review* 83, no. 5 (1993): 1373.

274 *"demand for paintings increased":* ibid., 1370.

274 *"broad economic recessionary periods":* ibid., 1373.

275 *"sale anywhere in the world":* Rita Reif, "A Picasso Goes for $3 Million Record Sale," *New York Times*, 13 May 1980.

275 *"Public Garden with Couple and Blue Fir Tree":* Christie's catalog referred to the picture (F479) as *Le Jardin du poète, Arles*.

275 *"Juan de Pareja":* Tomkins, *Merchants*, 363.

276 *"Gospels of Henry the Lion":* R. W. Apple, "Germans Buy Rare Medieval Book," *New York Times*, 7 December 1983.

276 *"a great peace":* CL B 21.

277 *"would be exceeded":* Charles Allsopp, letter, 18 September 1996.

278 *"modern equity markets":* James Grant, *Money of the Mind* (Farrar, Straus & Giroux, 1992), 389.

279 *"an era of antique caution"*: ibid., 384.

280 *"acquisitions"*: Philippe de Montebello, *Recent Acquisitions: A Reflection, 1985–1986* (New York: Metropolitan Museum of Art, 1986), 3.

280 *Tax Reform Act:* In an attempt to prevent wealthy individuals from structuring deductions in such a way as to avoid paying any taxes, the IRS required them to calculate their taxes not only in the standard way but also under the "alternative minimum tax"; they paid whichever tax was higher. The 1986 Tax Act amended provisions of the alternative minimum tax, to provide that donors of works of art were allowed to deduct only what they had paid for the works and not their appreciated value.

280 *objects donated . . . declined:* Grace Glueck, "Gifts to Museums Fall Sharply After Changes in the Tax Code," *New York Times,* 7 May 1989.

283 *"The Trinquetaille Bridge with all these steps"*: CL 552.

284 *"intellectual attachment"*: W. Kramarsky, interview.

284 *"have other people look at it"*: "Werner Kramarsky Talks with Paul Cummings," *Drawing* (May–June 1994), vol. xvi, no. 1, 7.

285 *"pictures in the collection"*: W. Kramarsky, interview.

285 *William Rubin:* William Rubin and Richard Oldenburg, interviews, summer 1994. According to Oldenburg, a quick search of the Museum of Modern Art files failed to turn up a letter.

285 *would not have wanted to sell:* B. Kramarsky, interview.

286 *intimidating picture:* H. Kramarsky, interview.

286 *"an intangible there"*: W. Kramarsky, interview.

25. Museum to Auction, February to May 14, 1990

288 *"tragic shoes"*: John Guare, *Six Degrees of Separation* (New York: Random House, 1990), 46.

288 *"at Christie's in New York"*: Rita Reif, "A van Gogh Now at Met Is to Be Auctioned," *New York Times,* 24 January 1990.

289 *"It's the real world"*: Philippe de Montebello, quoted in Judd Tully, "Taking the Pulse of the Art Market," *Washington Post,* May 15, 1990.

292 *"also a light varnish"*: C. Burge to W. Kramarsky, unpublished letter, 8 February 1990.

294 *699 million pounds:* Christie's, annual report, 1989.

295 *unsettling news:* Rita Reif, "A \$27-Million loan by Sotheby's Helped Alan Bond to Buy 'Irises,' " *New York Times,* 18 October 1989.

296 *"work's future as a 'past' "*: Philip Fisher, *Making and Effacing Art: Modern American Art in Culture of Museums* (New York: Oxford University Press, 1991), 28.

297 *London press reported:* Anthony Thorncroft, "New Money Outbids the Old," *Financial Times,* 4 March 1989.

298 *"zero on the average"*: William Baumol, "Unnatural Value; or, Art Investment as Floating Crap Game," *American Economic Review,* May 1986, 10.

299 *"public securities"*: Bruno S. Frey and Werner W. Pommerehne, "Art Investment," *Southern Economic Journal* 56 (October 1989): 400.

299 *"in the financial markets"*: ibid., 403–404.

299 *500 florins in 1652:* Alpers, *Rembrandt*, 100.

299 *"12 percent per year":* Frey and Pommerehne, "Art Investment," 396.

299 *"the extraordinary risks they represent":* Goetzmann, "Accounting for Taste," 1370.

299 *"consumption benefit":* Frey and Pommerehne, "Art Investment," 406.

300 *"Au Moulin de la Galette":* Rita Reif, "Renowned Renoir to Be Auctioned in May," *New York Times*, 17 January 1990.

301 *scholar Roland Dorn: Portrait du Dr. Gachet by Vincent van Gogh* (New York: Christie's, 1990), 28.

301 *"works by van Gogh":* Roland Dorn to Diana Kunkel and Michael Findlay, 24 February 1990.

301 *"J. Keller": Portrait du Dr. Gachet*, 28.

302 *Kunstdiktatur im Dritten Reich:* Paul Ortwin Rave, *Kunstdiktatur im Dritten Reich* (Hamburg: Gebrüder Mann, 1949), 65. "He [Göring] had him [Angerer] seize, above all, works of art which had value in foreign countries, and which could bring in foreign currency."

302 *"and acquired by Siegfried Kramarsky": Portrait du Dr. Gachet*, 28.

302 *"slightly better condition":* George Goldner, interview, 1992.

303 *"a different market":* C. Burge, interview, 1992.

26. Portrait of Melancholy at Auction, May 15, 1990

305 *"a kind of flower growing":* VvG to Anna van Gogh, CL 612.

307 *"[Koenigs's] acquisitions":* Luijten and Meij, *Pisanello*, 10.

307 *for 491 "missing" drawings:* In 1992, the Russian minister of culture revealed that the Koenigs drawings had been found; in 1995, these 307 drawings were exhibited in *Five Centuries of European Drawings: The Former Collection of Franz Koenigs* at the Pushkin Museum of Fine Arts in Moscow. (Josefine Leistra, "A Short History of Art Loss and Art Recovery in the Netherlands," in Simpson, *Spoils*, 57.)

311 *rate of return:* I am indebted to Jay Diamond, publisher of *Grant's Interest Rate Observer*, for calculating the rate of return on the portrait. Assuming Koenigs paid $53,000 for *Gachet* in 1938, if he had held it and sold it for $82.5 million, the rate of return would have been 15 percent.

313 *"record price":* Calvin Tomkins, "Irises," *New Yorker*, 4 April 1988, 67.

313 *"Sets Auction Record":* Rita Reif, "82.5 Million van Gogh," *New York Times*, 16 May 1990.

314 *"freakish prices for two great paintings":* Robert Hughes, "Bumps in the Auction Boom," *Time*, May 28, 1990.

314 *Friday's "New York Times":* Rita Reif, "Café Scene by Renoir Is Sold for $78.1 Million," *New York Times*, 18 May 1990.

314 *named Ryoei Saito:* Rita Reif, "Businessman Identified as Buyer of van Gogh," *New York Times*, 18 May 1990.

314 *"two most expensive paintings":* Steven R. Weisman, "One Man, Two Masterpieces, and Many Questions in Japan," *New York Times*, 19 May 1990.

314 *"collections of Western Art":* ibid.

315 *"the nation of decorative arts par excellence":* Victor Champier, *Catalogue illustré de l'Union centrale,*

quoted in Silverman, *Art Nouveau*, 127.

315 *sold Asian art in New York:* Silverman, *Art Nouveau*, 126.

315 *"Japanese prints on the wall":* CL 432.

315 *"Japanese sheets colored in flat tones are":* (ca. March 1888) CL W3.

316 *"the trade is interesting:"* CL 510.

316 *Jules and Edmond de Goncourt:* See Silverman, *Art Nouveau*, 17–39.

316 *"to let them have it?":* Fenollosa to Edward Sylvester Morse, 27 September 1884, quoted in Thomas Lawton and Linda Merrill, *Freer: A Legacy of Art* (Washington, D.C.: Freer Gallery of Art, 1993), 132.

318 *"Degenerate Art":* See Barron, ed., *"Degenerate Art"*; Peter-Klaus Schuster, *Nationalsozialismus und "Entartete Kunst": Die "Kunststadt" München, 1937* (Munich: Prestel, 1987).

318 *"handed over to Hermann Göring":* Hüneke, "Trail," 132 n. 21.

27. 12.4 Billion Yen

321 *" 'Angelus' of Millet's":* CL W13.

321 *carried them through the back door:* Hideto Kobayashi, interview, 25 January 1996; Yoshiko Fukushima, interpreter.

322 *"The real Japanese have nothing on their walls":* CL 509.

322 *"will never come to Japan":* Fred Hiatt, "Japan's Highest Bidder," *Washington Post*, 19 May 1990.

322 *"white porcelain vase":* ibid.

323 *"most recent campaign":* Yumiko Ono and Marcus W. Brauchli, "Japanese Tycoon Who Dazzled Art World Hits Rough Patch," *Wall Street Journal*, 28 May 1991.

323 *sons held high posts in the company:* ibid.

323 *by selling shares of stock and land:* Kobayashi, 25 January 1996.

324 *"saw himself":* Kobayashi, interview, T. Nakayama, 20 May 1994.

324 *"burn them with me when I die":* Ono and Brauchli, "Japanese Tycoon."

324 *"it is our custom":* Kobayashi, 20 May 1994.

325 *as much as $3 billion:* Carol Lutfy, "The Lady Vanishes," *New York Times Magazine*, 30 March 1997, 38; Yuzo Saeki, "Silver Lining Gilds Art Market Collapse," *Nikkei Weekly*, 3 October 1992.

326 *risk was uninsurable:* Hermann J. Abs, interview, August 1992.

326 *Saito was arrested:* Kay Itoi, "Saito Arrested," *Art Newsletter* 19, no. 7 (1993): 3. Together the construction projects were estimated to be worth some 85 billion yen.

327 *pleaded guilty: Mainichi Daily*, 25 February 1994, B16.

327 *to cut its share:* Kay Itoi, *Art Newsletter* 19, no. 14 (1994): 2.

328 *Christie's sold a 1932 Picasso:* Carol Vogel, "Picasso Is King as Art Auction Tops $100 Million," *New York Times*, 8 November 1995.

329 *condition of the picture:* Kobayashi, interview, January 1996.

330 *"a hundred years later":* RdeL W23 (11 or 12 June 1890).

SELECTED BIBLIOGRAPHY

BOOKS

Adam, Peter. *Art of the Third Reich.* New York: Harry N. Abrams, 1992.

Alpers, Svetlana. *Rembrandt's Enterprise.* Chicago: University of Chicago Press, 1988.

The Art and Life of Vincent van Gogh. Catalog by Georges de Batz. Introduction by Alfred M. Frankfurter. New York: Wildenstein, 1943.

Arts of the Middle Ages. Boston: Museum of Fine Arts, c. 1940.

Assouline, Pierre. *An Artful Life: A Biography of D. H. Kahnweiler, 1884–1979.* New York: Grove Weidenfeld, 1990.

Baedeker, Karl. *Frankfurt.* Hamburg: Karl Baedeker, 1953.

——. *The Rhine, Including the Black Forest and the Vosges: A Handbook for Travelers.* Leipzig: Karl Baedeker, 1911.

Barr, Alfred H. *Defining Modern Art.* Edited by Irving Sandler and Amy Newman. New York: Harry N. Abrams, 1986.

Barron, Stephanie, et al. *"Degenerate Art": The Fate of the Avant-Garde in Nazi Germany.* New York: Harry N. Abrams, 1991.

——. *Exiles and Emigrés: The Flight of European Artists from Hitler.* New York: Harry N. Abrams, 1997.

Baxandall, Michael. *Painting and Experience in Fifteenth-Century Italy.* New York: Oxford University Press, 1972.

Bazin, Germain. *The Museum Age.* Translated by Jane van Nuis Cahill. New York: Universe Books, 1967.

Benjamin, Walter. *Illuminations: Essays and Reflections.* New York: Harcourt, Brace & World, 1968.

Bessel, Richard. *Germany after the First World War.* New York: Oxford University Press, 1993.

Birmingham, Stephen. *"Our Crowd": The Great Jewish Families of New York.* New York: Harper & Row, 1967; Syracuse, N.Y.: Syracuse University Press, 1996.

Bodelsen, Merete. *Gauguin og van Gogh i Kobenhavn in 1893* (Gauguin and van Gogh in Copenhagen in 1893). Copenhagen: Ordrupgaard, 1984.

Boime, Albert. "Entrepreneurial Patronage in Nineteenth-Century France." In Edward C. Carter II, Robert Forster, and Joseph N. Moody, eds., *Enterprise and Entrepreneurs in Nineteenth- and Twentieth-Century France.* Baltimore: Johns Hopkins University Press, 1976.

Boyer, Patricia Eckert, ed. *The Nabis.* New Brunswick, N.J.: Rutgers University Press, 1988.

Brettell, Richard, et al. *The Art of Paul Gauguin.* Washington, D.C.: National Gallery of Art, 1988.

Bruehl, Georg. *Cassirers: Streiter für den Impressionismus.* Leipzig: Edition Leipzig, 1991.

Bullen, J. B. *Post-Impressionists in England.* London: Routledge, 1988.

Cachin, Françoise, and Bogomila Welsh-Ovcharov. *Van Gogh à Paris.* Paris: Editions de la Réunion des Musées Nationaux, 1988.

Cachin, Françoise, et al. *Cézanne.* Philadelphia: Philadelphia Museum of Art, 1996.

Chernow, Ron. *The Warburgs.* New York: Random House, 1993.

Chipp, Herschel. *Theories of Modern Art.* Berkeley and Los Angeles: University of California Press, 1968.

Clark, T. J. *The Painting of Modern Life: Paris in the Art of Manet and His Followers.* Princeton, N.J.: Princeton University Press, 1986.

Claus, Jürgen. *Entartete Kunst: Bildersturm vor 25 Jahren.* Munich: Haus der Kunst, 1962.

Craig, Gordon A. *Germany, 1866–1945.* New York: Oxford University Press, 1978.

Danto, Arthur. *Beyond the Brillo Box.* New York: Farrar, Straus & Giroux, 1992.

Denvir, Bernard. *The Chronicle of Impressionism.* Boston: Little, Brown, 1993.

Distel, Anne. *Impressionism: The First Collectors.* Translated by Barbara Perroud-Benson. New York: Harry N. Abrams, 1989.

Doiteau, V., and E. Leroy. *La Folie de Vincent van Gogh.* Paris: Editions Aesculape, 1928.

Dorn, Roland. *Décoration: Vincent van Goghs Werkreihe für das gelbe Haus in Arles.* Hildesheim, Germany: Georg Olms, 1990.

———. "Vincent van Gogh's Concept of 'Décoration.'" Paper presented at Vincent van Gogh International Symposium, Tokyo, October 17–19, 1985.

Dorn, Roland, Fred Leeman, et al. *Vincent Van Gogh and Early Modern Art, 1890–1914.* Essen: Museum Folkwang, 1990.

Dorra, Henri. *Symbolist Art Theories.* Berkeley and Los Angeles: University of California Press, 1994.

Dowbiggin, Ian. *Inheriting Madness: Professionalization and Psychiatric Knowledge in Nineteenth-Century France.* Berkeley and Los Angeles: University of California Press, 1991.

Duncan, Carol. *Civilizing Rituals: Inside Public Art Museums.* London: Routledge, 1995.

Eagleton, Terry. *Literary Theory: An Introduction.* Minneapolis: University of Minnesota Press, 1983.

Easton, Laird McLeod. "The Red Count: The Life and Times of Harry Kessler, 1868–1914." Ph.D. diss., Stanford University, 1991.

Eckstein, Modris. *Rites of Spring: The Great War and the Birth of the Modern Age.* New York: Houghton Mifflin, 1989.

Edvard Munch: Symbols and Images. Introduction by Robert Rosenblum; essays by Arne Eggum et al. Washington: National Gallery of Art, 1978.

Eisler, Colin. "Kunstgeschichte American Style: A Study in Migration." In *The Intellectual Migration: Europe and America, 1930–1960,* edited by Donald Fleming and Bernard Bailyn. Cambridge, Mass.: Harvard University Press, 1969.

Elen, Albert J. *Missing Old Master Drawings from the Franz Koenigs Collection.* The Hague: Netherlands Office for Fine Arts, 1989.

Elon, Amos. *Founder: A Portrait of the First Rothschild and His Time.* New York: Viking, 1996.

Elsen, Albert, ed. *Rodin Rediscovered.* Washington, D.C.: National Gallery of Art, 1981.

Faille, J. B. de la. *L'Oeuvre de Vincent van Gogh: Catalogue raisonné.* 4 vols. Paris and Brussels, 1928.

———. *Vincent van Gogh.* Preface by Charles Terrasse. Paris: Editions Hyperion, 1939.

———. *The Works of Vincent van Gogh: His Paintings and Drawings.* Amsterdam: Meulenhoff International, 1970.

Faith, Nicholas. *Sold: The Rise and Fall of the House of Sotheby.* New York: Macmillan, c. 1985.

Fallows, James. *Looking at the Sun: The Rise of the New East Asian Economic and Political System.* New York: Pantheon, 1994.

Feilchenfeldt, Walter. *Vincent van Gogh and Paul Cassirer, Berlin: The Reception of Van Gogh in Germany from 1901 to 1914.* Rijksmuseum Vincent van Gogh, Cahier Vincent 2. Zwolle, The Netherlands: Waanders, 1988.

Fest, Joachim. *The Face of the Third Reich.* New York: Random House, 1970.

Fischer, Chris. *Fra Bartolommeo: Master Draughtsman of the High Renaissance.* Rotterdam: Museum Boymans–van Beuningen, 1990.

Fisher, Philip. *Making and Effacing Art: Modern American Art in a Culture of Museums.* New York: Oxford University Press, 1992.

Fitzgerald, Michael. *Making Modernism: Picasso and the Creation of the Market for Twentieth-Century Art.* New York: Farrar, Straus & Giroux, 1995.

Flanner, Janet. *Men and Monuments.* 1957. Reprint with new introduction by Rosamond Bernier. New York: Da Capo Press, 1990.

Fleming, Donald, and Bernard Bailyn. *The Intellectual Migration.* Cambridge, Mass.: Harvard University Press, Belknap Press, 1969.

Frankfurt, 1933–1945: von der NS-Machtergreifung bis zur Zerstörung der Stadt. Frankfurt am Main: Presse und Informationsamt der Stadt, 1986.

Frèches-Thory, Claire, and Ursula Perucchi-Petri. *Die Nabis: Propheten der Moderne.* Zurich: Prestel, 1993.

Frelinghuysen, Alice Cooney, et al. *Splendid Legacy: The Havemeyer Collection.* New York: Metropolitan Museum of Art, 1993.

French Painting from David to Toulouse-Lautrec: Loan from French and American Museums and Collections. New York: Metropolitan Museum of Art, 1941.

Friedrich, Otto. *Before the Deluge: A Portrait of Berlin in the 1920s.* New York: Harper and Row, 1972.

Fry, Roger. *Transformations.* Garden City, N.Y.: Doubleday, 1956.

Führer durch die jüdische Gemeindeverwaltung und Wohlfahrtspflege in Deutschland, 1932–1933. Edited by A. Nachama and H. Simon. Berlin: Editions Hentrich, 1995.

Gachet, Paul. *Deux Amis des Impressionnistes: Le Docteur Gachet et Paul Murer.* Paris: Editions des Musées Nationaux, 1956.

———, ed. *Lettres des Impressionistes au Dr. Gachet et à Murer.* Paris: Grasset, 1957.

Gachet, Paul-Ferdinand. *Etude sur la mélancolie.* Montpellier: Imprimeur de l'Academie, Editeur de Montpellier Medical, 1858.

Gay, Peter. *Weimar Culture: The Outsider as Insider.* New York: Harper & Row, 1969.

Goetz, Oswald. "The History of a Picture." In Fritz Messinger, *Ein Vergessener Maler im Rijksmuseum Kröller-Müller* (A forgotten painter in the Rijksmuseum Kröller-Müller). Frankfurt am Main: R. G. Fischer, 1991.

———, ed. *Essays in Honor of Georg Swarzenski.* Chicago: Henry Regnery, 1951.

Gogh, Vincent van. *The Complete Letters of Vincent van Gogh.* Introduction by V. W. van Gogh, preface and memoir by J. van Gogh–Bonger. 2d ed. 3 vols. Boston: Little, Brown, 1978.

———. *The Letters of Vincent van Gogh.* Edited by Ronald de Leeuw; translated by Arnold Pomerans. London: Penguin Press, 1996.

Goldhagen, Daniel Jonah. *Hitler's Willing Executioners.* New York: Alfred A. Knopf, 1996.

Goldstein, Jan. *Console and Classify: The French Psychiatric Profession in the Nineteenth Century.* Cambridge: Cambridge University Press, 1987.

Goldwater, Robert. *Symbolism.* New York: Harper & Row, 1979.

Goncourt, Edmond and Jules de. *Germinie Lacerteux.* Translated by Leonard Tancock. New York: Penguin, 1984.

———. *Manette Salomon.* Paris: Charpentier, 1881.

Grant, James. *Money of the Mind.* New York: Farrar, Straus & Giroux, 1992.

Green, Nicholas. *The Spectacle of Nature: Landscape and Bourgeois Culture in Nineteenth-Century France.* Manchester, U.K.: Manchester University Press, 1990.

Greenberg, Clement. *Clement Greenberg: The Collected Essays and Criticism.* Ed. John O'Brian. Chicago: University of Chicago Press, 1993.

Guare, John. *Six Degrees of Separation.* New York: Random House, 1990.

Hamilton, George Heard. *Painting and Sculpture in Europe, 1880–1940.* Penguin Books, 1967. 6th ed., New Haven: Yale University Press, 1993.

Hammacher, A. M. *Genius and Disaster: The Ten Creative Years of Vincent van Gogh.* New York: Harry N. Abrams, 1968.

———. *Van Gogh: A Documentary Biography.* London: Thames and Hudson, 1982.

———. *Van Gogh en Belgique.* Musée des Beaux-arts de Mons, 1980.

Hannover, Emil. *Erindringer Fra Barndom og Ungdom* (Memoirs from childhood and youth). Copenhagen: Forening for Boghaandvaerk, 1966.

Hansert, Andreas. *Bürgerkultur und Kulturpolitik in Frankfurt am Main.* Frankfurt am Main: Waldemar Kramer, 1992.

———. *Geschichte des Städelschen Museums-Vereins Frankfurt am Main.* Frankfurt: Städelschen Museums Verein, 1994.

Harvey, Stephen. *Directed by Vincente Minnelli.* New York: Museum of Modern Art, 1989.

Heinich, Natalie. *The Glory of van Gogh.* Translated by Paul Leduc Browne. Princeton, N.J.: Princeton University Press, 1996.

Herbert, John. *Inside Christie's.* London: Hodder and Stoughton, 1990.

Herbert, Robert. *Impressionism: Art, Leisure and Parisian Society.* New Haven: Yale University Press, 1988.

Herbert, Robert, et al. *Georges Seurat, 1859–1891.* New York: Metropolitan Museum of Art, 1991.

Hjejle, Bernt. *Gensyn med min barndoms verden* (My childhood world revisited). Copenhagen: Gad, 1991.

Hochman, Elaine S. *Architects of Fortune: Mies van der Rohe and the Third Reich.* New York: Weidenfeld & Nicolson, 1990.

Hohenzollern, Johann Georg Prinz von, and Peter-Klaus Schuster, eds. *Manet bis Van Gogh: Hugo von Tschudi und der Kampf um die Moderne.* Berlin: Nationalgalerie, 1997.

Holt, Elizabeth G. *The Triumph of Art for the Public, 1785–1848.* Princeton, N.J.: Princeton University Press, 1979.

Howe, Thomas. *Salt Mines and Castles: The Discovery and Restitution of Looted European Art.* Indianapolis: Bobbs-Merrill, 1946.

Hughes, Robert. *Nothing If Not Critical: Essays on Art and Artists.* New York: Alfred A. Knopf, 1990.

Hulsker, Jan. *The Complete van Gogh: Paintings, Drawings, Sketches.* New York: Harry N. Abrams, 1980.

———. *The New Complete van Gogh: Paintings, Drawings, Sketches.* Revised and enlarged edition of the catalogue raisonné of the work of Vincent van Gogh. Amsterdam: J. M. Meulenhoff; Philadelphia: John Benjamins, 1996.

————, ed. *Van Gogh door van Gogh: De brieven als commentaar op zijn werks.* Amsterdam: J. M. Meulenhoff, 1973.

————. *Vincent and Theo van Gogh: A Dual Biography.* Edited by James M. Miller. Ann Arbor, Mich.: Fuller, 1990.

Jaworska, Wladyslawa. *Gauguin and the School of Pont-Aven.* Translated by Patrick Evans. Greenwich, Conn.: New York Graphic Society, 1971.

Jay, Martin. *The Dialectical Imagination: A History of the Frankfurt School and the Institute of Social Research.* Boston: Little, Brown, 1973.

Jensen, Robert. *Marketing Modernism in Fin-de-Siècle Europe.* Princeton, N.J.: Princeton University Press, 1994.

Joachimides, C. M., N. Rosenthal, and W. Schmied, eds. *German Art in the 20th Century.* Munich: Prestel, 1985.

Johnson, Una E. *Ambroise Vollard Editeur.* New York: Museum of Modern Art, 1977.

Kandinsky, Wassily. *Concerning the Spiritual in Art.* New York: Wittenborn, Schultz, 1947.

Kandinsky, Wassily, and Franz Marc, eds. *The "Blaue Reiter" Almanac.* 1912. Rev. ed. edited by Klaus Lankheit. New York: Viking, 1974.

Kennedy, Paul. *The Rise and Fall of the Great Powers: Economic Change and Military Conflict from 1500 to 2000.* New York: Random House, 1987.

Kessler, Harry Graf. *In the Twenties: The Diaries of Harry Kessler.* Translated by Charles Kessler with an introduction by Otto Friedrich. New York: Holt, Rinehart & Winston, 1971.

Klee, Fr. E. *Beretning om Silkeborg Vandkuranstalt* (Annual Report of the Silkeborg Sanitorium 1892). Copenhagen: F. Dreyer, 1893.

Kodera, Tsukasa, and Yvette Rosenberg, eds. *The Mythology of Vincent van Gogh.* Philadelphia: John Benjamins, 1993.

Krogh, Leila. *Clövens Breve: J. F. Willumsen's breve til Alice Bloch, 1899–1923.* Frederikssund: J. F. Willumsen Museum, 1987.

Lane, Barbara Miller. *Architecture and Politics in Germany, 1918–1945.* 1968. Reprint, Cambridge, Mass.: Harvard University Press, 1985.

Larsson, Hakan. "Flames from the South." Licentiate's thesis, Jan-Gunnar Sjolius Seminar, 1993.

Lawton, Thomas, and Linda Merrill. *Freer: A Legacy of Art.* Washington, D.C.: Freer Gallery of Art, 1993.

Lovgren, S. *The Genesis of Modernism: Seurat, Gauguin, van Gogh and French Symbolism in the 1880s.* Revised edition. Bloomington: Indiana University Press, 1971.

Luijten, Ger, and A. W. F. M. Meij. *From Pisanello to Cézanne: Master Drawings from the Museum Boymans–van Beuningen, Rotterdam.* Rotterdam: Museum Boymans–van Beuningen, 1990.

Lynes, Russell. *Good Old Modern.* New York: Atheneum, 1973.

Maier, Charles. *The Unmasterable Past: History, Holocaust, and German National Identity.* Cambridge: Harvard University Press, 1988.

Mainardi, Patricia. *The End of the Salon.* Cambridge: Cambridge University Press, 1993.

Makela, Maria. *The Munich Secession: Art and Artists in Turn-of-the-Century Munich.* Princeton, N.J.: Princeton University Press, 1990.

Masterworks from the Musée des Beaux-Arts, Lille. New York: Metropolitan Museum of Art, 1992.

Mathews, Nancy Mowll, ed. *Cassatt and Her Circle: Selected Letters.* New York: Abbeville Press, Cross River Press, 1984.

Maurice Denis. Lyon: Réunion des Musées Nationaux, Musée des Beaux-Arts de Lyon, 1994.

Mayeur, Jean Marie, and Madeleine Rebérioux. *The Third Republic from Its Origins to the Great War, 1871–1914.* Translated by J. R. Foster. Cambridge: Cambridge University Press, 1984.

Meier-Graefe, Julius. *Entwicklungsgeschichte der Modernen Kunst.* Stuttgart: J. Hoffmann, 1904.

———. *Modern Art: Being a Contribution to a New System of Aesthetics.* New York: G. P. Putnam's Sons, 1908.

———. *Vincent van Gogh.* Translated by John Holroyd-Reece. New York: Dover, 1987.

Metropolitan Museum of Art. *Annual Report for the Fiscal Year July 1 through June 30, 1987.* New York: Metropolitan Museum of Art, 1987.

Modern German Painting and Sculpture. New York: Museum of Modern Art, 1972.

Moffett, Charles S., *Van Gogh as Critic and Self-Critic.* New York: Metropolitan Museum of Art, 1974.

Moffett, Charles S., et al. *The New Painting: Impressionism 1874–1886.* San Francisco: Fine Arts Museums of San Francisco, 1986.

Moffett, Kenworth. *Meier-Graefe as Art Critic.* Munich: Prestel, 1973.

Montebello, Philippe de. *The Met and the New Millennium: A Chronicle of the Past and a Blueprint for the Future.* Reprinted from *The Metropolitan Museum of Art Bulletin*, Summer 1994. New York: Metropolitan Museum of Art, 1994.

———. *Recent Acquisitions: A Reflection, 1985–1986.* New York: Metropolitan Museum of Art, 1986.

Mosse, George L. *Nazi Culture: Intellectual, Cultural and Social Life in the Third Reich.* New York: Grosset & Dunlop, 1966; Schocken Books, 1981.

Newman, Sasha M., et al. *Félix Vallotton.* New Haven: Yale University Art Gallery; New York: Abbeville Press, 1991.

Nicholas, Lynn. *The Rape of Europa: The Fate of Europe's Treasures in the Third Reich and the Second World War.* New York: Alfred A. Knopf, 1994.

Nochlin, Linda. *The Politics of Vision: Essays on Nineteenth-Century Art and Society.* New York: Harper & Row, 1989.

————, ed. *Impressionism and Post-Impressionism, 1874–1904.* Englewood Cliffs, N.J.: Prentice Hall, 1966.

————, ed. *Realism and Tradition in Art, 1848–1900.* Englewood Cliffs, N.J.: Prentice Hall, 1966.

Nordau, Max. *Degeneration.* 1892. Reprint, Lincoln: University of Nebraska, 1968.

Nostitz, Helene von. *Aus dem alten Europa.* Leipzig: Insel-Verlag, 1925.

Palmer, R. R., and Joel Colton. *A History of the Modern World.* New York: Alfred A. Knopf, 1961.

Panofsky, Erwin. *The Life and Art of Albrecht Dürer.* Princeton, N.J.: Princeton University Press, 1943.

————. *Meaning in the Visual Arts.* Garden City, N.Y.: Doubleday, 1955.

Paret, Peter. *The Berlin Secession: Modernism and Its Enemies in Imperial Germany.* Cambridge, Mass.: Harvard University Press, Belknap Press, 1980.

Patterson, James T. *Grand Expectations: The United States, 1945–1974.* New York: Oxford University Press, 1996.

Paul, Barbara. *Hugo von Tschudi und die modern französische Kunst im deutschen Kaiserreich.* Mainz: Philipp von Zabern, 1993.

Pehle, Margot, and Gerhard Schuster, eds. *Harry Graf Kessler Tagebuch eines Weltmannes.* Marbach am Neckar, Germany: Deutsche Schillergesellschaft, 1988.

Petropoulos, Jonathan. *Art as Politics in the Third Reich.* Chapel Hill: University of North Carolina Press, 1996.

The Photomontages of Hannah Höch. Minneapolis: Walker Art Center, 1997.

Pickvance, Ronald. *English Influences on Vincent van Gogh.* Nottingham: University Art Gallery, Arts Council of Great Britain, 1974.

————. *"A Great Artist is Dead": Letters of Condolence on Vincent van Gogh's Death.* Edited by Sjraar van Heugten and Fieke Pabst, translated by Yvette Rosenberg, Ronald Pickvance, and Donald Gardner. Amsterdam Rijksmuseum Vincent van Gogh, Cahier Vincent 4. Zwolle, The Netherlands: Waanders, 1992.

————. *Van Gogh in Arles.* New York: Metropolitan Museum of Art, 1984.

————. *Van Gogh in Saint-Rémy and Auvers.* New York: Metropolitan Museum of Art, 1986.

Pinson, Koppel S. *Modern Germany: Its History and Civilization.* 2d ed. New York: Macmillan, 1966.

Pissarro, Camille. *Letters to His Son Lucien.* Ed. John Rewald. Mamaroneck, N.Y.: Paul P. Appel, 1972.

Portrait du Dr. Gachet by Vincent van Gogh. New York: Christie's, 1990.

Rabinbach, Anson, and Gail Stavitsky. *Assault on the Arts: Culture and Politics in Nazi Germany.* New York: New York Public Library, 1993.

Rave, Paul Ortwin. *Kunstdiktatur im dritten Reich.* Hamburg: Gebrüder Mann, 1949. Berlin: Argon, 1988.

Reischauer, Edwin O., and Marius B. Jansen. *The Japanese Today.* Cambridge, Mass.: Harvard University Press, Belknap Press, 1995.

Reitlinger, Gerald. *The Economics of Taste: The Rise and Fall of Picture Prices, 1760–1960.* London: Barrie and Rockliff, 1961.

Rewald, John. *Cézanne and America: Dealers, Collectors, Artists and Critics, 1891–1921.* Princeton, N.J.: Princeton University Press, 1989.

———. *The History of Impressionism.* Rev. ed. New York: Museum of Modern Art, 1961.

———. *Post-Impressionism: From van Gogh to Gauguin.* 3d ed. New York: Museum of Modern Art, 1978.

Rich, Daniel Catton. *Studies in Post-Impressionism.* Irene Gordon and Frances Weizenhoffer, eds. New York: Harry N. Abrams, 1986.

Richardson, John. *A Life of Picasso.* New York: Random House, 1996.

Rosenblum, Robert. *Modern Painting and the Northern Romantic Tradition.* New York: Harper and Row, 1975.

———. *Paintings in the Musée d'Orsay.* New York: Stewart, Tabori & Chang, 1989.

Rosenblum, Robert, and H. W. Janson. *Art of the Nineteenth Century—Painting and Sculpture.* London: Thames and Hudson, 1984.

Roskill, M. W. *Van Gogh, Gauguin and the Impressionist Circle.* Greenwich, Conn.: New York Graphic Society, 1970.

Roxan, David, and Kenneth Wanstall. *The Rape of Art: Hitler's Plunder of the Great Masterpieces of Europe.* New York: Coward-McCann, 1965.

Rubin, William, ed. *Cézanne: The Late Work.* New York: Museum of Modern Art, 1977.

Sander, Jochen, Hans Joachim Ziemke, and Ulrike von der Osten. *Städels Sammlung im Städel.* Frankfurt am Main: Städelsches Kunstinstitut, 1991.

Scavenius, Bente. *Fremsyn-Snoeversyn: Dansk dagbladskunstkritik, 1880–1901.* Copenhagen: Borgen, 1983.

Schapiro, Meyer. *Vincent van Gogh.* 1950. Reprint, New York: Harry N. Abrams, 1980.

Schjerjon, W., and W. J. de Gruyter. *Vincent van Gogh's Great Period: Arles, Saint-Rémy and Auvers-sur-Oise.* Amsterdam: De Spieghel, 1937.

Schulz-Hoffmann, Carla, and Judith C. Weiss, eds. *Max Beckmann: A Retrospective.* Saint Louis: Saint Louis Art Museum, 1984.

Schuster, Peter-Klaus, ed. *Nationalsozialismus und "Entartete Kunst": Die "kunststadt" München, 1937.* Munich: Prestel, 1987.

Selz, Peter. *German Expressionist Painting.* 1957. Berkeley and Los Angeles: University of California Press, 1974.

———. *Max Beckmann.* New York: Museum of Modern Art, 1964.

Sembach, Klaus-Jürgen. *Henry van de Velde.* Translated by Michael Robinson. New York: Rizzoli, 1989.

Sherman, Daniel J. *Worthy Monuments.* Cambridge: Harvard University Press, 1989.

Sherman, Daniel J., and Irit Rogoff, eds. *Museum Culture.* Minneapolis: University of Minnesota Press, 1994.

Silverman, Debora L. *Art Nouveau in Fin-de-Siècle France.* Berkeley and Los Angeles: University of California Press, 1989.

Simpson, Elizabeth, ed. *The Spoils of War: World War II and its Aftermath—The Loss, Reappearance, and Recovery of Cultural Property.* New York: Harry N. Abrams in association with the Bard Graduate Center for Studies in the Decorative Arts, 1997.

Snyder, Louis. *Encyclopedia of the Third Reich.* New York: Paragon House, 1989.

Sonnabend, Martin. *Georg Swarzenski und das Liebieghaus.* Frankfurt: Frankfurter Societäts-Druckerei GmbH, 1990.

Spaulding, Frances. *Roger Fry: Art and Life.* Berkeley and Los Angeles: University of California Press, 1980.

Speer, Albert. *Inside the Third Reich.* Translated by Richard and Clara Winston. New York: Collier Books, 1981.

Stein, Gertrude. *The Autobiography of Alice B. Toklas.* C. 1933. Reprint, New York: Vintage Books, 1990.

Stein, Susan Alyson. *Van Gogh: A Retrospective.* New York: Wings Books, 1986.

Sterling, Charles, and Margaretta M. Salinger. *French Paintings: A Catalogue of the Collection of the Metropolitan Museum of Art.* New York: Metropolitan Museum of Art, 1967.

Stern, Fritz. *Dreams and Delusions: The Drama of German History.* New York: Alfred A. Knopf, 1987.

———. *The Failure of Illiberalism: Essays on the Political Culture of Modern Germany.* New York: Columbia University Press, 1992.

———. *The Politics of Cultural Despair.* Berkeley and Los Angeles: University of California Press, 1961.

Stone, Irving. *Lust for Life.* London: Longmans, Green, 1934.

Sund, Judy. *True to Temperament: Van Gogh and French Naturalist Literature.* Cambridge: Cambridge University Press, 1992.

Swarzenski, Georg. *Beckmann: His Recent Work.* New York: Buchholz Gallery Curt Valentin, 1946.

———. *Museumsfragen.* Frankfurt: Frankfurter Bibliophilen Gesellschaft, 1928.

Swarzenski, Hanns, and Nancy Netzer. *Medieval Objects in the Museum of Fine Arts: Enamels and Glass.* Boston: Museum of Fine Arts, 1986.

Sweetman, David. *Van Gogh.* New York: Crown Publishers, 1990.

Thage, Jacob. "Mogens Ballin (1871–1914)." *In Danske Smykker* (Danish jewelry). (English translation, Martha Gaber.) Copenhagen: Komma & Clausen, 1990.

Tinterow, Gary, and Henri Loyrette. *Origins of Impressionism.* New York: Metropolitan Museum of Art, 1994.

Tomkins, Calvin. *Merchants and Masterpieces: The Story of the Metropolitan Museum of Art*. Rev. Ed. New York: Henry Holt, 1989.

Thomson, David. *Europe Since Napoleon*. 2d ed. New York: Alfred A. Knopf, 1966.

Turner, Jane, ed. *The Dictionary of Art*. New York: Grove, 1996.

Van Gogh: Paintings and Drawings. New York: Metropolitan Museum of Art, 1949.

Van Gogh Masterpieces. New York: Paul Rosenberg, 1942.

van Uitert, Evert. *Vincent van Gogh in Creative Competition: Four Essays from Simiolus*. Zutphen, The Netherlands: 1983.

Varnedoe, Kirk. *Northern Light: Realism and Symbolism in Scandinavian Painting, 1880–1910*. New York: Brooklyn Museum, 1982.

———. *Northern Light: Nordic Art at the Turn of the Century*. New Haven: Yale University Press, 1988.

Verdi, Richard. *Nicholas Poussin, 1594–1665*. London: Royal Academy of Art, 1995.

Verkade, Jan. *Yesterdays of an Artist Monk*. Translated by John Stoddard. New York, 1930.

Vincent van Gogh. Houston: Contemporary Arts Association of Houston, 1951.

Vincent van Gogh: A Loan Exhibition of Paintings and Drawings. Los Angeles: Municipal Art Gallery, 1957.

The Vincent van Gogh Exhibition. With essays by Ronald Pickvance et al., catalog text by Haruo Arikawa. Tokyo: National Museum of Western Art, 1985.

V. van Gogh Ausstellung. Frankfurt am Main: Frankfurter Kunstverein, 1908.

Vollard, Ambroise. *Recollections of a Picture Dealer*. Boston: Little, Brown, 1936.

Watson, Peter. *From Manet to Manhattan: The Rise of the Modern Art Market*. New York: Random House, 1992.

Wattenmaker, Richard J., et al. *Great French Paintings from the Barnes Foundation*. New York: Alfred A. Knopf, 1993.

Weber, Nicholas Fox. *Patron Saints: Five Rebels Who Opened America to a New Art, 1928–1943*. New York: Alfred A. Knopf, 1992.

Wechsberg, Joseph. *The Merchant Bankers*. Boston: Little, Brown, 1966.

Weisberg, Gabriel P. *Art Nouveau Bing: Paris Style, 1900*. New York: Harry N. Abrams, 1986.

Weitzenhoffer, Frances. *The Havemeyers: Impressionism Comes to America*. New York: Harry N. Abrams, 1986.

Welsh-Ovcharov, Bogomila. *Vincent van Gogh and the Birth of Cloisonism*. Toronto: Art Gallery of Ontario, 1981.

———. *Vincent van Gogh: His Paris Period, 1886–1888*. Utrecht: Editions Victorine, 1976.

———, ed. *Van Gogh in Perspective*. Englewood Cliffs, N.J.: Prentice Hall, 1974.

White, Harrison C., and Cynthia White. *Canvases and Careers: Institutional*

Change in the French Painting World. New York: John Wiley & Sons, 1965.

Whitehill, Walter Muir. *The Museum of Fine Arts*. Cambridge: Harvard University Press, Belknap Press, 1970.

Woolf, Virginia. *Roger Fry: A Biography*. New York: Harcourt, Brace, 1940.

Zemel, Carol. *The Formation of a Legend: Van Gogh Criticism 1890–1920*. Ann Arbor, Mich.: UMI Research Press, 1980.

Ziemke, Hans-Joachim. *Das Städelsche Kunstinstitut—Die Geschichte einer Stiftung*. Frankfurt am Main: Städelsches Kunstinstitut, 1980.

PERIODICALS

Baumol, William. "Unnatural Value: or, Art Investment as Floating Crap Game." *American Economic Review*, May 1986, 10–14.

Bismarck, Beatrice von. "Harry Graf Kessler und die französische Kunst um die Jahrhundertwende." *Zeitschrift des Deutschen Vereins für Kunstwissenschaft* (Berlin) 42, no. 3 (1988): 47–62.

Boime, Albert. "Van Gogh's *Starry Night*: A History of Matter and a Matter of History." *Arts Magazine* 59 (Dec. 1984): 66–103.

Brettell, Richard R., et al. "The Problematics of Collecting and Display, Part 2." *Art Bulletin* 77, no. 2 (1995): 166–185.

Bünger, Barbara C. "Max Beckmann's *Ideologues*: Some Forgotten Faces." *Art Bulletin* 71, no. 3 (1989): 454–479.

Fenton, James. "Degas in the Evening." *New York Review of Books*, 3 October 1996, 48–53.

Frey, Bruno S., and Werner W. Pommerehne. "Art Investment: An Empirical Inquiry." *Southern Economic Journal* 56 (October 1989): 397–407.

Goetzmann, William N. "Accounting for Taste." *American Economic Review* 83, no. 5 (December 1993): 1370–1376.

Hofstadter, Dan. "Van Gogh in Saint-Rémy and Auvers." *New Criterion*, March 1987, 53–56.

Hughes, Robert. "Bumps in the Auction Boom." *Time*, 28 May 1990.

———. "Do I Hear $5 Million? Sold!" *Time*, 1 December 1986.

Itoi, Kay. "Saito Arrested." *Art Newsletter* 19, no. 7 (1993): 3.

McClellan, Andrew. "Watteau's Dealer: Gersaint and the Marketing of Art in Eighteenth-Century Paris." *Art Bulletin* 78, no. 3 (1996): 439–453.

Manheim, Ron. "The Germanic van Gogh: A Case Study of Cultural Annexation." Translated by Jane Hedley-Proele and Michael Hoyle. *Simiolus* 19, no. 4 (1989): 277–288.

Penna, Ian. "Daishowa Paper Manufacturing Co., Ltd.: A Corporate Profile," unpublished paper, University of Melbourne, Victoria, Australia (February 1996).

Petropoulos, Jonathan. "Saving Culture from the Nazis." *Harvard Magazine*, March–April 1990, 34–42.

Plaut, James. "Hitler's Capital: Loot from the Master Race." *Atlantic*, October 1946, 75–80.

Pollock, Griselda. "Van Gogh and the Poor Slaves: Images of Rural Labour as Modern Art," *Art History* 11 (Sept. 1988): 407–432.

Price, Aimée Brown. "Two Portraits by Vincent van Gogh and Two Portraits by Pierre Puvis de Chavannes." *Burlington Magazine*, November 1975, 714–718.

Rewald, John. "Gachet's Unknown Gems Emerge." *Art News*, March 1952, 16–18, 63–66.

Sund, Judy. "The Sower and the Sheaf," *Art Bulletin* 70, no. 4 (1988): 660–676.

Tafel, Verena. "Paul Cassirer als Vermittler Deutscher Impressionistischer Malerei in Berlin. Zum Stand der Forschung." *Zeitschrift des Deutschen Vereins für Kunstwissenschaft* 42, no. 3 (1988): 31–44.

Tompkins, Calvin. "Irises," *New Yorker*, 4 April 1988, 37–67.

Ward, Martha. "Impressionist Installations and Private Exhibitions." *Art Bulletin* 73, no. 4 (1991): 599–622.

Wehle, Harry B. "French Painting from David to Toulouse-Lautrec." *Metropolitan Museum of Art Bulletin*, February 1941, 27.

Zemel, Carol. "The Spook in the Machine: van Gogh's Pictures of Weavers in Brabant." *Art Bulletin* 67, no. 1 (1985): 123–137.

ARCHIVAL MATERIAL

Geheimes Staatsarchiv Preussischer Kulturbesitz, Berlin, Rep. 90, Nr. 2464, Bl. 1–70.

Harvard University Art Museum Archives, Cambridge, Mass., Paul J. Sachs Papers.

Hirschsprung Collection, Copenhagen, Johan Rohde–Emil Hannover Correspondence.

Museum of Modern Art, Department of Registration, New York, Vincent Van Gogh, Exhibition No. 44. Exhibition File.

National Archives, Washington, D.C.
 Record Group 239. Records of the American Commission of the Protection and Salvage of Artistic and Historic Monuments in War Areas.
 Record Group 260. Records of the United States Occupation Headquarters. World War II. Ardelia Hall Collection. Records of the Collecting Points.

Rijksmuseum Vincent van Gogh/van Gogh Foundation Archives, Letters of Ambroise Vollard.

Royal Library, Copenhagen, Alice Ruben Hannover Correspondence.

Städelsches Kunstinstitut und Städtische Galerie, Frankfurt am Main, Archives Related to the Confiscation of Art.

Stadtarchiv Frankfurt, Georg Swarzenski Files.

INDEX

*Note: Titles are works by van Gogh
unless otherwise indicated.*

Grateful acknowledgment is made to the following for permission to reprint materials from their collections or archives.

Sonya Binkhorst, Roland Dorn, Bernard Kramarsky, Werner Kramarsky, Museum Boijmans Van Beuningen, Rotterdam, Rijksmuseum Vincent van Gogh, Städelsches Kunstinstitut, and Wolfgang Swarzenski.

Excerpts from materials in The Museum of Modern Art, Department of Registration: van Gogh, Exhibition No. 44, Exhibition file (letter from Alfred H. Barr, Jr., to Georg Swarzenski, 21 August 1935; letter from Georg Swarzenski to Alfred H. Barr, Jr., August 1935; letter from Georg Swarzenski to Alfred H. Barr, Jr., 3 September 1935; telegram from Alfred H. Barr, Jr., to Georg Swarzenski, 4 October 1935).

Excerpts from *Cézanne* by Françoise Cachin et al. By permission of the Philadelphia Museum of Art.

Excerpt from letter from Katherine Cassatt to Alexander Cassatt, September 19, 1881, Philadelphia Museum of Art Archives, Personal Papers, AAA/CZC.

Excerpts from Laird Easton's dissertation on Harry Kessler's diaries.

Exerpt from letter from Dirk Hannema to Willem van der Vorm, translated by Jonathan Bragdon, in "Under Duress" by Christine Koenigs, appearing in *The Spoils of War*, edited by Elizabeth Simpson, Abrams, 1997. By permission of Jonathan Bragdon, Christine Koenigs, and Archives of the Museum Boijmans Van Beuningen, Rotterdam, Franz Koenigs Collection.

Excerpts from *A Forgotten Painter in the Rijksmuseum Kroeller-Mueller* by Fritz Metzinger. By permission of the author and R. G. Fischer Verlag.

Excerpt from *Letters to His Son Lucien* by Camille Pissarro, translated by John Rewald, Paul P. Appel, Inc., 1972. By permission of the publisher.

Excerpts from *The Complete Letters of Vincent Van Gogh*. By permission of Little, Brown and Company in conjunction with the New York Graphic Society. All rights reserved.

ILLUSTRATION CREDITS

Insert

Page 1, above: Vincent van Gogh, *Self-Portrait Dedicated to Paul Gauguin*, 1888. Collection: Fogg Art Museum, Harvard University Art Museums, Cambridge, MA. Bequest from the Collection of Maurice Wertheim, Class of 1906.

Page 1, below: Henri de Toulouse-Lautrec, *Portrait of Vincent van Gogh*, 1887. Collection: Van Gogh Museum (Vincent van Gogh Foundation), Amsterdam.

Page 2, above: Paul-Ferdinand Gachet, ca. 1890. Collection: Van Gogh Museum (Vincent van Gogh Foundation), Amsterdam.

Page 2, center: Theo van Gogh. Collection: Van Gogh Museum (Vincent van Gogh Foundation), Amsterdam.

Page 2, below: Johanna van Gogh with Vincent Willem, 1890. Collection: Van Gogh Museum (Vincent van Gogh Foundation), Amsterdam.

Page 3, above: Gyula Halász (Brassaï), *Ambroise Vollard (Portrait d'Ambroise Vollard)*, 1932 or 1933. Gelatin-silver print, $15^1/_4$ x $11^1/_2$" (38.7 x 29.2 cm.). Copyright Gilberte Brassaï. Collection: The Museum of Modern Art, New York. David H. McAlpin Fund. Copy Print copyright 1997. The Museum of Modern Art, New York.

Page 3, center left: Paul Cézanne, *Portrait of Ambroise Vollard*, 1899. Copyright Photothèque des Musées de la Ville de Paris, Paris.

Page 3, center right: Alice Ruben with *Portrait of Dr. Gachet* and Maurice Denis's *Maternité à la Pomme*, 1897. Collection: Odrupgaardsamlingen, Copenhagen.

Page 3, below: Félix Vallotton, *Mogens Ballin and Marguerite d'Auchamp*, 1899. Private collection.

Page 4, above: Paul Cassirer, ca. 1910. Copyright Ullstein Bilderdienst, Berlin.

Page 4, below left: Pierre Bonnard, *Portrait of Eugène Druet*, ca. 1912. © 1998 Artists' Rights Society (ARS), New York/ADAGP, Paris.

Page 4, below right: Edvard Munch, *Harry Graf Kessler*, 1906. Collection: Staatliche Museen zu Berlin–Preussischer Kulturbesitz Nationalgalerie, Berlin.

Page 5, above: Georg Swarzenski, 1912. Courtesy Rosenberg & Stiebel, New York.

Page 5, below: Städelsches Kunstinstitut, Frankfurt. Collection: Städelsches Kunstinstitut, Frankfurt. Photograph copyright: Ursula Edelmann.

Page 6, above: Degenerate art stored in Schloss Niederschöhausen. Collection: Bildarchiv Preussischer Kulturbesitz, Berlin.

Page 6, center: Hermann Göring in Amsterdam, June 1940. National Archives, Washington, D.C. Courtesy Jonathan Petropoulos.

Page 7, above: Marianne Breslauer, *Franz Koenigs*, Amsterdam, 1937. Courtesy Marianne Feilchenfeldt.

Page 7, below: The Kramarskys and Chaim and Vera Weizmann on the *Rex*. Courtesy Kramarsky family.

Page 8, above: Auguste Renoir, *Au Moulin de la Galette*, 1876. Musée d'Orsay, Paris.

Page 8, center: Christie's auction, May 15, 1990. Copyright Archive Photos/Reuters/ R. Stubblebine.

Page 8, below: Ryoei Saito. Copyright Gamma Liaison/Kaku Kurita.

Text

Page ii: *Portrait of Dr. Gachet*, 1890. Courtesy Christie's Images.

Page xviii: Vincent van Gogh, *Sketch of* Portrait of Dr. Gachet, 1890. Collection: Van Gogh Museum (Vincent van Gogh Foundation), Amsterdam.

Page 34: Vincent van Gogh, *Portrait of Dr. Gachet*, 1890. Collection: Städelsches Kunstinstitut, Frankfurt. Photograph copyright: Ursula Edelmann.

Page 38: Eugène Delacroix, *Tasso in the Hospital of St. Anna, Ferrara*, 1839. Collection: Oskar Reinhart Collection "Am Romerholz," Winterthur, Switzerland.

Page 39: Pierre Puvis de Chavannes, *Portrait de Eugène Benon*, 1882. Private Collection.

Page 50: Vincent van Gogh, *Portrait of Dr. Gachet*, 1890. Collection: Musée d'Orsay, Paris.

Page 71: Maurice Denis, *Homage to Cézanne*, 1900–1901. Collection: Musée d'Orsay, Paris.

Page 98: Buying and sales book, 1904. Paul Cassirer–Archiv. Walter Feilchenfeldt, Zurich.

Page113: Harry Kessler's house, ca. 1910. Bildarchiv Foto Marburg, Marburg, Germany.

Page 138: Max Beckmann, *Portrait of Georg Swarzenski*, 1921. Collection: Städelsches Kunstinstitut, Frankfurt. Photograph copyright: Ursula Edelmann.

Page 148: Max Beckmann, *Descent from the Cross*, 1917. Oil on canvas, 59$^1/_2$ x 50$^3/_4$" (151.2 x 128.9 cm.). The Museum of Modern Art, New York. Curt Valentin Bequest. Photograph copyright 1997 The Museum of Modern Art, New York.

Page 168: Friedrich Krebs. Collection: Stadt Frankfurt am Main.

Page 175: Max Beckmann's *Descent from the Cross* in the *Degenerate Art* exhibition, Munich, 1937. Staatliche Museen zu Berlin, Preussischer Kulturbesitz.

Page 191, above: Paul Cézanne, *Bibémus Quarry*, ca. 1895. Museum Folkwang, Essen, Germany.

Page 191, below: Vincent van Gogh, *Daubigny's Garden*, 1890. Collection: Hiroshima Museum of Art, Hiroshima.

Page 197: Inventarbook, 1912. Collection: Städelsches Kunstinstitut, Frankfurt. Photograph copyright: Ursula Edelmann.

Page 202: Leopold, Count von Kalckreuth, *Portrait of Franz Koenigs*, 1906. Collection: Museum Boijmans Van Beuningen, Rotterdam.

Page 206: Siegfried and Lola Kramarsky. Courtesy Kramarsky family.

Page 230, above: Frankfurt am Main, 1937. Copyright Michel & Co., Frankfurt.

FOR THE BEST IN PAPERBACKS, LOOK FOR THE

In every corner of the world, on every subject under the sun, Penguin represents quality and variety—the very best in publishing today.

For complete information about books available from Penguin—including Puffins, Penguin Classics, and Arkana—and how to order them, write to us at the appropriate address below. Please note that for copyright reasons the selection of books varies from country to country.

In the United Kingdom: Please write to *Dept. EP, Penguin Books Ltd, Bath Road, Harmondsworth, West Drayton, Middlesex UB7 0DA.*

In the United States: Please write to *Penguin Putnam Inc., P.O. Box 12289 Dept. B, Newark, New Jersey 07101-5289* or call 1-800-788-6262.

In Canada: Please write to *Penguin Books Canada Ltd, 10 Alcorn Avenue, Suite 300, Toronto, Ontario M4V 3B2.*

In Australia: Please write to *Penguin Books Australia Ltd, P.O. Box 257, Ringwood, Victoria 3134.*

In New Zealand: Please write to *Penguin Books (NZ) Ltd, Private Bag 102902, North Shore Mail Centre, Auckland 10.*

In India: Please write to *Penguin Books India Pvt Ltd, 11 Panchsheel Shopping Centre, Panchsheel Park, New Delhi 110 017.*

In the Netherlands: Please write to *Penguin Books Netherlands bv, Postbus 3507, NL-1001 AH Amsterdam.*

In Germany: Please write to *Penguin Books Deutschland GmbH, Metzlerstrasse 26, 60594 Frankfurt am Main.*

In Spain: Please write to *Penguin Books S. A., Bravo Murillo 19, 1° B, 28015 Madrid.*

In Italy: Please write to *Penguin Italia s.r.l., Via Benedetto Croce 2, 20094 Corsico, Milano.*

In France: Please write to *Penguin France, Le Carré Wilson, 62 rue Benjamin Baillaud, 31500 Toulouse.*

In Japan: Please write to *Penguin Books Japan Ltd, Kaneko Building, 2-3-25 Koraku, Bunkyo-Ku, Tokyo 112.*

In South Africa: Please write to *Penguin Books South Africa (Pty) Ltd, Private Bag X14, Parkview, 2122 Johannesburg.*